# The *Intelligence* Files
## Today's Secrets, Tomorrow's Scandals

D1114497

# The *Intelligence* Files

### Today's Secrets, Tomorrow's Scandals

by

## Olivier Schmidt

CLARITY PRESS, INC.

© 2005 ADI

ISBN: 0-932863-42-6

**In-house editor: Diana G. Collier**

**Cover photo: Surveillance Specialties, Ltd.,**
**600 Research Drive, Wilmington, MA 01887. Tel: 800-354-2616**

Library of Congress Cataloging-in-Publication Data

The Intelligence files : today's secrets, tomorrow's scandals / [edited] by
Olivier Schmidt.
    p. cm. — (The Intelligence files)
Includes bibliographical references and index.
ISBN 0-932863-42-6
1. Intelligence service—Case studies. 2. Espionage—Case studies. I.
Schmidt, Olivier. II. Series.
 JF1525.I6I5768 2005
  327.12—dc22
                        2004023888

CLARITY PRESS, INC.
Ste. 469, 3277 Roswell Rd. NE
Atlanta, GA. 30305

http://www.claritypress.com

To Mi-Ma, Papa-Man and Therese

# Table of Contents

Introduction                                                                    9
    *Intelligence* and the ADI

Chapter 1                                                                       18
    Car-bombed Environmentalists and the FBI:
    COINTELPRO Resurrected?

Chapter 2                                                                       23
    The Secret History of the Wildlife Conservation
    Movement

Chapter 3                                                                       53
    Switzerland: Anti-Money-Laundering
    and Domestic Surveillance

Chapter 4                                                                       63
    "Son of Star Wars"—Alive and Well . . . in Norway!

Chapter 5                                                                       74
    The Trumped-up Proof of Libyan Terrorism

Chapter 6                                                                       83
    Secrecy Rights for Citizens:
    The Fight for Public Encryption

Chapter 7                                                                       98
    Pinochet Today, Kissinger Tomorrow?

Chapter 8                                                                      112
    Losing a Spy Elite:
    The Chinook Crash and Operation Madronna

Chapter 9                                                                      127
    The Sinking of the *Kursk* and
    "Retired" US Navy Spy Edmond Pope

Chapter 10                                                                     137
    "Bloody Sunday":
    The Search for the Truth Continues

Chapter 11                                                              156
    New Europe's Old Belgium: Murder, "Passive
    Corruption" and the Pink Ballet

Chapter 12                                                              169
    Bull's "Supercannon" and Moyle's "Suicide"

Chapter 13                                                              181
    The FBI's Wen Ho Lee Scandal:
    Much Ado About Something Chinese

Chapter 14                                                              192
    Terrorists' Networks and Traffic Analysis
    Before and After September 11

Chapter 15                                                              202
    Now You See Them, Now You Don't:
    Executive Outcomes and Sandline International

Endnotes                                                               223

Index                                                                  233

# INTRODUCTION
## *Intelligence* and the ADI

    I had been invited to serve more or less as the "contradictor" to ordained knowledge at the closed Western European Union (WEU) meeting on the future of EU intelligence, "Developing a European Intelligence Policy", held in Paris on 13-14 March 1997. There were only one or two non-military speakers in attendance; I was the only person without security clearance from at least one Western government. My presentation had been carefully organized around strictly publicly-accessible information—what is often called "open-source intelligence"[1]—and I had just ventured where angels fear to tread.

    "What Mr. Schmidt has just said about secret French-American cooperation concerning the variable-thrust rocket ramjet is not exactly correct but we can't talk about it here."

    That was Admiral Pierre Lacoste, who had been head of the French foreign intelligence service (Direction générale de la sécurité extérieure [DGSE]) when its agents sank the *Rainbow Warrior* in Auchland harbor, New Zealand, in July 1985, and got caught.

    "What Mr. Schmidt said about secret French-American cooperation in nuclear weapons and between Megajoule and the National Ignition Facility is not exactly correct, but we can't discuss it here."

    That was powerful conservative French MP, Jacques Baumel, then president of the WEU political commission and author of the 13 May 1996 WEU report, *A European Intelligence Policy,* on setting up a unified Western European "intelligence unit".[2] Mr. Baumel is sometimes referred to as the "civilian godfather of General de Gaulle's French atomic bomb".

    Vice-Admiral Michel d'Oléon, a good friend and a former head of intelligence for the WEU (often referred to as the EU's "ministry of defense"), looked at Lacoste, then at Baumel and the senior brass around the table, and only half jokingly stated:

    "Then what are we going to talk about?"

    It was a good question.

    What Lacoste didn't want me telling other senior European military officers was that the next-generation air-to-air missile would be based on secret US-French cooperation since France had successfully developed the engine (a variable-thrust rocket ramjet) that the US didn't have, and the US had the guidance and tracking avionics that France didn't have. Recognizing

manner. Dr. Ruth A. David, Deputy Director of the CIA for Science and Technology, the first woman to become a CIA Deputy Director, opened the meeting with a speech concerning the present and future dangers of Information Warfare, quoting extensively from a recent presentation by former CIA Director, John Deutch, before a Congressional committee. Dr. David, who had been with the CIA for just over a year, "knew her business", having "earned her stars" in information sciences and technology, and served at a managerial level at Sandia National Laboratory in Albuquerque, New Mexico, before taking up her CIA job. One of the communications security and encryption specialists at the meeting had apparently served under her at Sandia and had positive remarks to make. She and I exchanged email addresses and I noted that she had a "real" one, meaning her name and CIA included in the address. I mentioned that as head of science and technology, she—as opposed to almost all other senior CIA officials—was obviously "obliged" to have a public email address, and she agreed.

Dr. David's more or less "official policy" paper was followed by a much more "off-the-cuff" and lively presentation by someone "who's been there, and back": former NSA leading counsel, Stewart Baker. Having been involved for several years in the "nuts and bolts" of international negotiations (including in France) and laws on cryptography (see our chapter concerning the fight for public encryption), as well as questions on public protection of communications, Mr. Baker stressed that "a lot of the hype on infowar is ideologically driven". His examples were well chosen. If former Princess Diana's telephone conversations can be tapped and leaked to the tabloid press, why hasn't someone done the same with the email of the rich and powerful? Mr. Baker's answer is that there is a "decent" level of security on the Internet. But vendors always have new products to sell, and the government is truly worried about powerful encryption becoming "just another button to click" on standard computers used by organized crime. Mr. Baker's fears about public encryption mirrored those of the Clinton administration and later proved to be only half right: encryption has become "just another button to click" but that hasn't stopped law enforcement and anti-terrorism work.

My presentation, "Intelligence behind the Journal *Intelligence*", included a dozen examples of "advanced technology in intelligence, and intelligence on advanced technology", followed by "six intelligence rules" developed by *Intelligence* journal: 1) Ten years minimum to develop a network, 2) Simplest explanations are the best, 3) In-depth background knowledge necessary, 4) "Simmer" your intelligence instead of "boiling" or "fast frying" it, 5) Wide coverage and good information management required, and, finally, 6) Astuteness, which is not a rule at all but an "untrainable" quality necessary for good intelligence

As for my French-US intelligence "misunderstanding", it concerned the notion that French and US intelligence never got along together. The presentation saluted two major French intelligence figures who also worked with US and Allied intelligence before and during World War II: Colonel Gaston Pourchot and Colonel Paul Paillole. Colonel Pourchot, who died in 1991, was Allen Dulles' principal source of intelligence during the war and furnished

the Allies with a complete German order of battle two weeks before the Normandy invasion. Colonel Paillole, who died in late 2002, was the only professional French intelligence officer to have headed a service before the war, during the Occupation and after Normandy, and was the only Frenchman to have received Allied "Bigot" security clearance and be permitted to enter the London War Room where even General Charles de Gaulle was not allowed.

On 15 October 2002, Colonel Paillole died in Paris at the age of 97.[10] His impressive list of "services to the country" was duly noted in epitaphs in the French and Belgian press, but they failed to fully portray the personality and character of this great man for those of us who knew and worked with him. I met him for the first time in the mid-1980s when, with Fabrizio Calvi, we were preparing to write a book on the OSS (the predecessor of the CIA) and the French Resistance during World War II. I was already the subject of a thick file at French DST counter-espionage as a "troublemaker" for publishing *Intelligence* and he had every reason to consider me and my co-author unwelcome.

We knew from Alain Guerin, author of the five-volume history of the French Resistance, that Colonel Paillole had played a major part in the clandestine intelligence battle during the war and had had contacts with the Allies. Indeed, Guerin seems to have been the first author to have recognized Col. Paillole's role and the Colonel remained indebted to Guerin, although the latter was an established French Communist journalist and writer. Guerin recommended that Calvi and I meet Paillole to describe our book project to him, which we did.

Paillole, a tall, erect and well-built man of imposing stature even in his late 80s when we first met, immediately decided to "open the doors" for Calvi and me, and we were able to meet and interview many of the surviving figures of French Resistance intelligence who had worked with the Allies. This tie with Paillole almost automatically meant that most Gaullist Resistance figures would not receive us, since the official Gaullist history of the Resistance would prefer to ignore association with the Allies as much as possible, and Paillole's contribution in particular.

Probably the most important person we met through Paillole was Colonel Gaston Pourchot, Vichy's last deputy military attaché in Bern, Switzerland. Working in the US National Archives in Washington on recently-declassified OSS documents, we found proof that Pourchot was the major source of Allen Dulles' incredible "intelligence take" which was forwarded directly to "Wild Bill" Donovan, head of the OSS, and to US President, Franklin Delano Roosevelt. The OSS archives had handwritten notes from Dulles saying: "Go ask Pourchot" or "Go see P." In a long interview, Pourchot confirmed this work for Dulles, adding: "We knew it was the shortest path to Roosevelt."

When we asked what was his greatest intelligence "coup" during the war, there was no hesitation: "the complete German order-of-battle two weeks before Normandy" (with documents to prove the claim). We learned that Calvi and I were the only persons outside French intelligence with whom he had ever spoken concerning his World War II role and we asked—rather naively—why he had

agreed to see us? "Because my commander (Paillole) told me to", was his reply.

In the US National Archives, I found a copy of the US Army citation given Colonel Pourchot. I also found a copy of a very important document which was signed by US Army Colonel Sheen and by Colonel Paillole,[11] giving the latter full counter-espionage and arrest authority on all liberated French territory following the Normandy invasion. When I gave a copy of the document to Paillole, he found it difficult to hold back his tears as he thanked me and explained that he had asked French military archives for a copy of the same document (which he had signed in 1944) and was refused: it was classified for one hundred years as a "secret of war"! French military archives later "validated" the copy I had given Paillole, confirming that the document was indeed an exact copy of the classified document retained in their files.

In post-Word War I France, intelligence was still under the control of the military and still associated with the disaster of the Dreyfus case (French military intelligence had been caught falsifying documents to convict Jewish officer, Louis Dreyfus, of spying for the Germans). Paillole entered military counter-espionage in 1935. With very little resources, he built up a network of German double agents who were able to identify all Abwehr agents working in France before World War II. Paillole's service even gave the Daladier government a complete description of how Adolf Hitler was going to invade France and also provided the dates. The government, probably still thinking about the Dreyfus case, didn't believe Paillole and never checked his intelligence. Hitler did exactly what Paillole had advised the French government he would do. Daladier later wrote to Paillole admitting that the intelligence was correct, that the error was political and that his government was responsible.

During the German occupation of France, all of Paillole's superiors had to leave intelligence. Paillole changed identities, set up the "Travaux Ruraux" rural works organization, and continued clandestine counter-espionage work until France was completely occupied. He was essentially the highest-ranking prewar French intelligence official to continue with his intelligence network, through Colonel Pourchot, going straight to the Allies (much to the disapproval of the Gaullist arm of the Resistance). Just before complete occupation of France, he and the essential archives of his service managed to get to Algeria and reestablish contact with the Allies.

To add insult to injury between Paillole and Charles de Gaulle, the document signed by Paillole with Colonel Sheen, head of Allied counter-espionage, proved that Paillole knew about the Normandy invasion and "hit the beaches" with the Allies while de Gaulle, not trusted by Churchill and Roosevelt, "had to wait it out" in London. De Gaulle was quick to "even the score": as soon as Paris was liberated, he called in Paillole and told him that his counter-espionage service should be divided into a civilian service and into a military service. Paillole replied that he would not oversee such a division of his service as long as German troops were still on French soil. De Gaulle fired him on the spot, turned his service over to someone else and divided it up as planned, with an ensuing series of spy scandals.

Pourchot didn't do any better with De Gaulle. The aging colonel told

Calvi and me that De Gaulle asked him to take over French intelligence after the war. Pourchot agreed on two conditions: 1. All French intelligence officers would have to go through military training, even Resistance members; 2. All decorations given to Resistance members would be reexamined by the military to see if the medals and prestige were merited or not. De Gaulle refused, Pourchot returned to artillery and post-war French intelligence was a well-known catastrophe punctuated by resounding scandals.

Participants at the DataNet Security Conference in Miami in 1997 had, of course, heard of former CIA director, Allen Dulles, whose name is often associated with the label, "master spy". But when it came to the "nuts and bolts" of intelligence during World War II, he was serving more as a convenient "mailbox" for President Roosevelt, often forgetting to attribute the merit for the transmitted intelligence where it belonged. That, however, is discussed in the book on the OSS and the French Resistance published by Fabrizio Calvi and me.

Our other book with the major French publisher, Hachette,[12] *Intelligences Secrètes: Annales de l'Espionnage*, is a set of «best» 1980 spy stories based on the work of the French Association for the Right to Information («Association pour le Droit à l'Information or ADI, in French) and material which has appeared in ADI journals, including *Parapolitics, Intelligence Newsletter (Le Monde du Renseignement*, in French) and *Intelligence.* In *Intelligences Secrètes* (in French), sixteen extensively-documented chapters covered the Nugan-Hand CIA bank; Irangate-Contragate central figure, Richard Secord; major international Italian contraband dealer, Angelo de Feo; the head of the secret Italian P2 masonic lodge, Licio Gelli; American-Italian financier and secret intelligence dealer, Francesco Pazienza; senior CIA officer, John Arthur Paisely; KGB «double» transfuge, Vitali Yurtchenko; KGB mole inside the NSA, Ronald Pelton; KGB mole inside the Pentagon, John Walker; Israeli double agent in the US, Jonathan Pollard; British MI5's "Clockwork Orange II" campaign against Prime Minister Harold Wilson; the KGB and strange deaths in Moscow; the Russian downing of flight KAL 007; post-World War II Nazis recruited by Allied intelligence services; "honorable" war criminals such as Yoshio Kodama and Ryoichi Sasahawa; and Latin American death squads.

Besides the persons who are the subjects of entire chapters, those most cited in that book included CIA counter-espionage specialist, James Jesus Angelton; Nazi war criminal, Klaus Barbie; the Vatican's murdered banker, Roberto Calvi; CIA chief, William Casey; CIA officer and Contragate figure, Thomas Clines; Salvadorian death squad leader, Roberto d'Aubuisson; Italian Fascist killer, Stephano delle Chiaie; CIA chief, Allen Dulles; Mossad officer, Rafi "Dirty" Eitan; KGB "transfuge", Anatoli Golistine; MI5 chief, Roger Hollis; CIA officer turned KGB agent, Edward Howard; Libyan leader, Muammar Qadhafi; US President, John F. Kennedy; US intelligence wheeler-dealer, Michael Ledeen; post-World War II Nazi-hunter, John Loftus; assassinated senior Italian politician, Aldo Moro; central Contragate figure, Oliver North; Italian anti-mafia judge, Carlo Palermo; KGB double agent, Stanley "Kim" Philby; US president, Ronald Reagan; Italian intelligence

# Car-bombed Environmentalists and the FBI: COINTELPRO Resurrected?

In June 2002, a federal jury in California determined that the FBI and the Oakland, California, police department had violated the civil rights of two environmental activists by unfairly accusing them of car-bombing themselves. The victory, including a $4.4 million award, marked one of the rare occasions that the FBI has been held to account for breaching the very laws it is enfranchised to enforce.

The win was neither easy nor quick. It came 12 years after a bomb placed inside the car of environmentalist organizers Judi Bari and Darryl Cherney exploded as they drove through the San Francisco Bay area city of Oakland to rally support for their campaign to stop the logging of northern California's ancient redwood trees—and five years after Bari died of breast cancer. As *Intelligence* reported on the case over the years, Bari, Cherney and their supporters worked doggedly to convince the courts to force the FBI to disclose evidence that ultimately proved compelling to the jury. In the end, the grueling effort paid off in the disclosure of the kind of information the Bureau often conceals. However, it failed to resolve the issue of who did put the bomb in the couple's car.

The bomb explosion on 24 May 1990 gravely injured Bari, who was in the driver's seat, and hurt Cherney less seriously. Hours later, the FBI and the Oakland Police Department (OPD) arrested both victims—but never charged them—and never cleared them either. As Bari clung to life in the critical care unit, and Cherney was interrogated repeatedly without a lawyer, the police and FBI ignored or covered up every piece of evidence that might have led them to the real perpetrators. Instead, they used the blast as an opportunity to vilify nonviolent activists who had become a thorn in the side of the big timber corporations. Even though they had no evidence to press charges, authorities brazenly accused Bari and Cherney of knowingly transporting the bomb, alleging that it had accidentally exploded during transit. Bari and Cherney promptly sued the FBI and the OPD—as well as individual officers of both agencies—for false arrest, illegal search, slanderous statements and conspiracy.[1]

The bombing occurred during "Redwood Summer", an Earth First! campaign to get support from city-based organizations for its work in

California's vast, isolated north. The battle was to save some of the nation's last stands of centuries-old first-growth redwood trees, towering evergreens, from lumber companies. Bari and Cherney were leaders of Earth First!, a cutting-edge environmental organization, which had long been in the sites of the FBI and other law enforcement agencies.

It took six years of litigation simply to include the individual FBI and OPD officers as defendants in the case. Finally, in October 1997, US District Court Judge Claudia Wilken, who presided over the case in her Oakland courtroom, granted Cherney—and Bari's estate—the right to sue the individual officers by refusing to grant them immunity. FBI special agents Frank Doyle, John Reikes, Stockton Buck, John Conway, Walter Hemje, and Philip Sena, as well as OPD sergeants Robert Chenault and Michael Sitterud, Judge Wilken ruled, must face the activists' claims that they conspired to violate their First Amendment rights.

Defendant Doyle was a 20-year veteran of the FBI Terrorist Squad.[2] Cherney and Bari learned that in April 1990, four weeks before they were bombed in Oakland, Doyle was head instructor at an FBI-sponsored week-long "Bomb Investigators' Training Course" at the College of the Redwoods in Eureka, in northern California. For practice, attendees blew up cars with pipe bombs. It was Doyle who responded to the scene of the Cherney-Bari bombing and directed the collection of evidence. At least four of the FBI and OPD who responded to the bombing and worked under Doyle, had attended that FBI bomb school. Doyle was the source of the accusation that Cherney and Bari were transporting a pipe bomb on the back seat of their car—when damage to the car and Bari's injuries clearly indicated that the bomb was hidden under the driver's seat and triggered by a motion device. Even though Doyle reportedly knew within hours about the motion detonator, the press was not told.[3] An expert from the FBI headquarters' laboratory in Washington, DC, Supervisory Special Agency David R. Williams, confirmed that the bomb had been placed under the driver's seat.

Nonetheless, in early 1990, it was Judi and Darryl who faced impending charges, based on a series of outright lies told by Oakland Police officers and FBI agents in the immediate aftermath of the bombing. Initially, Judge Claudia Wilken declared that the case would be limited to questions of police misconduct. "The FBI is not on trial here. The United States government is not on trial. At issue is the conduct of the officers who investigated this case and whether in the course of that investigation they violated the rights of the plaintiffs," Wilken said. Many disagreed with that narrow assessment. In 1999, Wilken tried to further limit the legal issues surrounding the case by ruling that the individual officers were entitled to "qualified immunity," a liability exemption generally granted to law enforcement authorities in their routine handling of criminal investigations. A three-judge appeals panel overturned that ruling.

At the time of jury selection in 2002, lawyers for Earth First! argued that investigators violated the pair's rights by ignoring the evidence and treating them as terrorists. "Our lawsuit will hopefully increase public awareness so we can put pressure on our government so we can hold our FBI accountable,"

to Senator Patrick Leahy, then Chairman of the Senate Judiciary Committee, to continue hearings into FBI abuses. Citing "FBI handling of situations such as Ruby Ridge, Waco, Wen Ho Lee, and the Oklahoma City bombing," he urged the Senate Judiciary Committee to investigate the Judi Bari/Darryl Cherney case. Pope stated in his letter to Sen. Leahy: "No freedoms are more important to the people of the United States than the freedom of speech and freedom of assembly. This includes the right to carry out nonviolent protests against policies and practices which citizens believe are wrong or destructive. The Redwood Summer Campaign which Judi and Darryl were organizing when the bombing occurred, was such a nonviolent protest." "It was all a big lie," Cherney stated at the time. "The FBI never wanted to catch the bomber. They wanted to destroy Earth First!."

In post-September 11 America, there is now increasing concern about how fair the trial involving persons labeled by the FBI and any US police force as "terrorists" can be in present day America. Indeed, during questioning for the Bari/Cherney trial, a number of potential jurors stated that they might have qualms about sitting in judgment of a case involving alleged terrorist tactics. But after the verdict, Robert Bloom, an attorney for the activists, said the ruling "shows what the FBI did then, it shows America what the FBI does now . . . This verdict is critical for everyone to understand how law enforcement works in this country," he said. "This jury got a look at a new side of the FBI and saw their secrets. This jury told the truth."[8]

The perpetrator has still not been apprehended but persons familiar with the trial believe the person may be an FBI informant.

Update:  As we go to press, the Bari/Cherney case once again made the headlines: "FBI to Pay $2 Million In Earth First! Suit-Activists were arrested, called eco-terrorists after bomb exploded in their car".[9] Cherney and the Bari estate were expected to receive the sum in the following days.  It is one of the largest settlements ever paid out as a result of the FBI's action.

# The Secret History
# of the Wildlife Conservation
# Movement

## INTRODUCTION

During the closing months of the Cold War, President George H.W. Bush courted popularity among a powerful constituency of fashionable eugenic/green utopians by sending CIA veteran Curtis "Buff" Bohlen to strongarm the UN into imposing a global ban on the ivory trade. Thirteen years later, as US warplanes again visited fire and brimstone on Iraq, the reputed site of the Garden of Eden, his son Dubya reversed the old Bonesman's decision. With Washington's blessing, South Africa, Botswana, and Namibia were granted permission to auction off 60 tons of stockpiled elephants' teeth in three years' time. This surprise move came just days after Bush Junior, who would later effectively scrap the nuclear test ban treaty, added the decommissioned Minuteman II Delta Nine ICBM silo and launch facility to an already long list of South Dakota national parks.

"The fact that here we are in 2002 turning our most powerful weapon system into a national park, while there are people in other parts of the world that are creating and hiding weapons of mass destruction—it goes to show the difference between America and other nations of the world," declared Craig Manson, now doing Bohlen's old job as assistant interior secretary overseeing the National Park Service and the Fish and Wildlife Service for the new administration. "It illustrates who's truly dedicated to the cause of peace and who is not."

Manson used to be a launch-control officer at the Delta Nine Facility, one of a select cadre of young officers who were trained to help kill about 350 million Russians, Chinese and East Europeans, on the assumption that, if push ever came to shove, the victims (not to mention about 100 million Americans likely to be immolated in counter-strikes) would be better off dead than Red. Recently, he happily recalled those good ol' days, telling local media how he used to sit in one of Delta Nine's sweaty hot seats stripped to his underpants, awaiting an order to blow up the world.

But that was then, and this is now. The mafia now runs Russia with a little help from the old KGB and a lot from the IMF, America has a new Mikado and the Lord High Executioners of yesteryear have had to find other work to do. Manson, who boasts that his job is "the best in Washington," is

perhaps the most high-profile of these recycled Pooh-Bahs. Shortly after dabbing a spot of greenwash on his redundant doomsday machines, the personable Afro-American flew to Valparaiso, Chile, where he performed a diplomatic somersault before the 1997 meeting of the Convention on International Trade in Endangered Species (CITES).

It would be difficult to exaggerate the scale of the diplomatic and media blitz which the US mounted to force CITES to place an international ban on the ivory trade in the first place. Throughout 1988-9, the CIA's Bohlen and his cohorts of environmentally-friendly spooks generated headlines around the world and raised hundreds of millions of tax-sheltered dollars for wildlife charities on the back of claims that Africa's carnivorous Blacks had long been killing off elephants at the rate of 100,000 a year. While assuredly a great number of elephants had died—indeed the black rhino was almost wiped out—no sooner was the ban in place than it could be shown that for more than a decade, an artificially and hideously inflated trade in ivory and horn trinkets had in fact been controlled by apartheid South Africa's secret police, and winked at by the CIA and its Western European allies. The deliberate vulgarization of this historic trade had been adopted as an instrument of economic warfare which might be used both to deny existing African nations one of their signature natural resources, and to provide a golden goose that would help finance the then on-going war against the ANC in South Africa and Namibia.

But in 1999, CITES was shamed—despite ferocious US opposition—into allowing a first "one-off" sale of ivory stockpiles. The facts of the previous market's manipulation had been irreproachably established by a judicial commission of inquiry which took sworn statements from many hundreds of witnesses. These facts spoke for themselves but were studiously ignored by the mass media. For their part, mainstream conservation organizations, many of whom are little more than fronts for the Western intelligence agencies, sought to milk a few dollars more from their gullible publics by screaming that any relaxation of the ban on trade in new ivory would encourage poaching.

The facts still speak for themselves. The deliberate economic sabotage of Africa is as serious now as ever it was—perhaps it is even worse than ever—but its focus has shifted. Since the Boers were booted out of office, Africa's criminal gangs have turned to shipping contraband minerals rather than looted animal and vegetable products. Ivory poaching has fallen to an historic low. Enforcement officers in 150 countries have seized less ivory in the past thirteen years than they did in a single month in 1989.

Zimbabwe, which hosted the CITES Conference of the Parties in June 1997, had never reconciled itself to the outright loss of its right to profit from selling ivory. It seized the opportunity to plead with delegates to reverse what President Robert Mugabwe described in his opening address as an act of "ecological colonialism". The findings of Mr. Justice Mark Kumleben's judicial commission of enquiry on the use of the international environmental movement as cover for covert action were circulated among the delegates. The public had known little or nothing of these findings, but the evidence they contained had the desired effect. Despite vociferous US opposition, 77 nations

voted to allow the southern African countries to resume a limited and strictly supervised trade in ivory in 18 months' time. Even the 13 members of the European Union (Ireland does not subscribe to CITES), not normally to be outdone by Washington in the political homage they pay to nature, felt it prudent to abstain when the issue came to a vote. When the result was announced, the African delegates danced through the congress hall singing the liberation anthem, "Ishe Komberera Africa" (God Bless Africa!), watched by stony-faced delegates from America and Europe.

For millions of kind-hearted people in Britain, Europe and North America, the decision to resume the international trade in ivory seemed not only cruel but incomprehensible. If this special report helps to explain why it was taken, then perhaps both Africa and the environmental movement will have been done a service.

## DIMENSIONS OF THE WORLD CONSERVATION "ESTATE"

By 1989, what the International Union for the Conservation of Nature and Natural Resources (IUCN) calls the World Conservation Estate had come to include some 8,500 national parks and other "strictly protected" areas covering almost eight million square kilometers of land in 169 territories. This green archipelago of national parks, national forests, national monuments and national landscapes occupied more land than India, Pakistan, Bangladesh, Sri Lanka, Nepal, Bhutan, Afghanistan, Iran and Burma put together. When a further 40,000 less fiercely guarded areas were included in the reckoning, the area taken up by the World Conservation Estate more than doubled. By 1989, it had already extended across some ten per cent of the earth's land surface.

Since 1989, vast new areas have been added. Developing countries are routinely required to proclaim new Wildland Management Areas in return for Western aid or loans. In effect, the poorer their economic performance, the more land they have had to take out of useful production. In Tanzania, for example, 40 percent of the national territory is now enclosed within strictly protected zones. To the eyes of a previous age, the huge areas of land the former colonial powers have required the developing world to set aside for nature would look more like an empire than a mere "estate". It may, in fact, be useful to regard the World Conservation Estate as a new and unprece- dented form of empire—in many senses virtual, but also very real.

The holdings of the World Conservation Estate were put together by a series of committees, rather than by some charismatic warlord. This method of accumulating power, in an age when public culture emphasizes democratic values, has obvious advantages. If a virtually real empire's geography cannot readily be drawn on a map, then no one can really know where its confines lie. If the bureaucrats who created it omitted to select an emperor from among themselves, or to establish a capital, or to design a flag to fly over their dominions, then that, too, is likely to make it harder for those who suspect their motives to anticipate their ambitions. And if their empire happens to lie outside any of the conventional definitions of established politico-legal power,

About a year ago Mr. Pearson (Secretary of State for External Affairs) remarked in private that he wondered how good our claim was to some areas of the Arctic ... Probably of much greater concern is the sort of de facto US sovereignty which has caused so much trouble in the last war and which might be exercised again.

A squad of Royal Canadian Mounted Police went with the Inuit, charged with keeping "the Eskimos self-supporting and independent." But they were also ordered to enforce the wildlife laws. This meant that the relocated Eskimos could not hunt musk ox and caribou, the skins of which were essential for blankets and warm clothing in the winter, when temperatures fell to -55° F. A standard operating procedure in concentration camps and jails is to use nature to torment nature. Naked or nearly so, prisoners are required to lie in their own filth, and to lap their food from the floor. The shivering Inuit were similarly encouraged to scavenge the dustbins of the police commissary, and then punished for doing it once they were caught. Those aboriginals chosen for "rehabilitation" had been deliberately selected from among their fellows because they had taken most readily to "the white man's way of life." They were not hunters, and, "It was recognised in the department that the cyclical nature of hunting could and did lead to periodic famine and starvation. This was considered the natural state for the Inuit. The goal of the relocation was to restore the Inuit to what was considered their proper state."

According to a spokesman for the Commission, "there have been hundreds of such rehabilitation projects over the years," during which a substantial number of human lives were lost. Despite that, the colonists did manage to survive well enough to dress their children in scouts' uniforms and hang out bunting when the Queen of England visited their settlement. They could not guess that Greenpeace would shortly follow after her, demonize their trade in sealskins, bankrupt it, and then represent them to the world as enemies of nature.

## DEPLOYING ENVIRONMENTALISM IN THE FORMER COLONIES

In actuality, the World Conservation Estate represents the physical gains made by what E. Max Nicholson called "the environmental revolution," a revolution which began with the capture, by a cabal of environmental zealots who also happened to be imperial insiders, of the British government's bureaucratic machine during the period of post-war reconstruction which followed the defeat of Nazi Germany. But its deeper tendencies lay in the British conquest and colonization of Africa in the late 19th century.

An ecological war, the template for much that was to follow, was being fought as the 19th century opened. Cecil Rhodes and his faction had successfully persuaded the British Empire to invest its soldiers' blood and its subjects' treasure on delivering the goldfields of the Rand to them. British generals had less success in persuading the Boers to meet them in open

battle. Lord Kitchener therefore ordered the Boers' standing crops to be burned, their livestock slaughtered, their farms destroyed, and their women, children and elderly carried off and put in concentration camps. Wildlife commandos were sent out to kill game animals which might otherwise supply the partisans with food.

When peace came to the Transvaal, one of the first acts of the new administration, led by the imperial pro-consul, Lord Alfred Milner, was to establish a vast game park covering 11,000 square miles in the eastern low veldt. The Tsonga people, who had occupied the land before he evicted most of them, nicknamed its warden, Major James Stevenson-Hamilton, "skukuza" or "he who sweeps away or turns everything upside down," a name proudly adopted for the main tourist lodge in the Kruger National Park. The reserve's location, on the ill-defined frontier with Portugal's Mozambican possessions, helped stabilize the border. Animals which had survived the holocaust on the Portuguese side drifted in to recolonize the park. The evicted blacks became a proletariat, forced to sell their labor to the mines Milner and his party now controlled.

Kitchener's atrocities had excited widespread international opprobrium, but the British could afford to ignore it. As cholera and typhus swept the concentration camps, vice-president Theodore Roosevelt had assumed office as US Commander-in-Chief, succeeding the murdered President McKinley. In return for a free hand in southern Africa, London winked at the American annexation of Hawaii and Roosevelt's conquest of the Philippines. In addition, under the Hay-Pauncefote Treaty of 1901, Britain formally acknowledged US hegemony in the Caribbean, which London had claimed since Tudor times. These mutually-agreeable concessions were the first fruits of a process through which the Rhodesian faction, which controlled the Imperial government, enlisted the aid of the United States in the encirclement of Germany and, ultimately, in the European wars for empire which it had previously been US policy to avoid.

Rhodes did not survive the ruin of the Republics he overthrew. He had expected to die young, and he left no children. But he had allowed for that. Rhodes died in the confident belief that the political lobby he had created at the heart of the state machine of the then-greatest empire in history would continue faithfully to represent his views long after he was gone. Rhodes' American biographer, Rhodes Scholar Robert I. Rotberg, called the great man's ambitions "protean." By contrast, G. K. Chesterton called them "babyish." The two verdicts, the one dutiful, the other dismissive, represent interpretations of the same facts, which are not really disputed. The auto-didact Rhodes revealed himself, in his *Confession of Faith* (1877), as a political utopian who excoriated "two or three ignorant pig-headed statesmen" —but especially Lord North, whom he blamed for the loss of England's American colonies—for establishing discord among "a band of brothers" who might otherwise have created a world empire under Anglo-Saxon rule.

As Governor of Uganda, Sir Harry Johnson cleared the ancient Kingdom of Bunyoro of its inhabitants in order to establish an elephant sanctuary in what is today called the Murchison National Park. Johnson won scientific immortality as the discoverer of the okapi, whose bones and skin

were handed to him by pygmies. He had rescued them from an entrepreneur who intended to display the little people as Darwinism's missing link between men and monkeys at the Paris Exhibition. The second Baron Rothschild, Rhodes' principal financial backer, was more interested in domestic animals than wild ones; he sent Rhodes the Jersey cows which formed the South African foundation herd. But none did more than the heirs to Rothschild's title and his extended family either to uncover nature's secrets or to encourage those who enlisted in the war to save the wild.

Lord Walter Rothschild, who invited Milner to become vice-chairman of De Beers in 1923, drove to Buckingham Palace in a carriage pulled by zebras, and had 58 species of wild birds, 18 new mammals, 14 previously unknown plants and 153 varieties of insects and butterflies named after him. The melancholy Lord Charles was happy to sustain the Society for the Promotion of Nature Reserves (SPNR), until he killed himself. Lady Miriam, a cipher expert who helped crack the German codes at Bletchley Park, became the world's leading authority on fleas. Kim Philby's friend, Lord Victor Rothschild, was another SPNR stalwart while he was working as a spy in the Commercial Section of MI5, and sitting in Harry Johnson's old chair at the board of the British Museum of Natural History. Baron Edmond de Rothschild would lecture the World Wilderness Congress in Johannesburg on the techniques of ecologically sustainable strip mining in 1977. Like him, Baroness Guy de Rothschild became a member of The 1001: A Nature Trust, as did Edmund, the chairman of the N. M. Rothschild Bank, who displayed a life-sized statue of the tumescent goat-god, Pan, the Lord of rural misrule, in the lobby of his London headquarters. Lord Grey, the Milnerite Foreign Secretary, left his huge collection of birds' eggs to form the basis of the British national collection. Teddy Roosevelt soon found a way into Grey's affections by uttering bird calls as the two strolled together in the New Forest, discussing the division of the world. Grey chaired the Committee of the Imperial Defence Staff which recommended the establishment of MI5 and MI6 as bureaucracies within the Civil Service in 1909.

So far as they can be rationally explained, many of the ideas which inspired Rhodes, and through him, his followers, can be derived from the work of William Winwood Reade, an unsuccessful novelist whose passionate account of world history, *The Martyrdom of Man*, sold millions between its initial publication in 1872 and the outbreak of the Second World War. Rhodes, devouring this curious mixture of musings on the hermetic secrets of the pyramids and the science-fiction possibilities of the future, found it "a creepy book," and so it is. He also said, mysteriously, that 'It had made me what I am.'" Reade was a religious fanatic whose hatred of established religion reveals his allegiance to what has been called the oldest heresy. He was an agnostic who had discovered in Charles Darwin's theory of natural selection both the reason for man's lost innocence and the direction in which he must go, or be driven, to find utopia in the future. "To develop to the utmost our genius and our love, that is the only true religion," he declared. God had absented himself and had no interest in saving man, but perfection in this world could be achieved through toil and the willing acceptance of suffering.

In 1927, the South African soldier-politician, Jan Christian Smuts, a leading Milnerite who also attached mystical significance to an evolutionary conception of the corporate organic state, introduced the term "holism" into the marketplace in holy ideas. Smuts had been Rhodes' agent before circumstances compelled him to take arms alongside his own people. He became one of the principal architects of their surrender, as the author of the 1913 Land Act, which confined South Africa's majority population to just seven per cent of its territory. Smuts turned to philosophy during a sabbatical year he had felt obliged to take after ordering the use of bombers and machine guns to quell the white mineworkers' strike on the Rand in 1926.

When the Second World War broke out, the most valuable animals in the London Zoo, including the giant pandas which Julian Huxley had been the first to import to Europe, were transferred to an outlying zoo at Whipsnade. Huxley joined the Morale Committee, "set up to assess the value of the evidence provided by the Home Intelligence machinery." Harold Nicolson, parliamentary secretary at the Ministry of Information, records in his diaries that on 8 October 1940, they discussed the shape of things to come. "Go round to see Julian Huxley at the Zoo. . . . While we are at supper a fierce air raid begins and the house shakes. We go on discussing war aims. He feels that the future of the world depends upon the organisation of economic resources and the control by the USA and ourselves of raw materials."

After working with a committee set up by MI6 at Electra House to consider foreign propaganda requirements, Huxley took leave of absence from the Zoo for a series of tours in the United States designed to attack the isolationists. The circle of his friend, H. G. Wells, included the associates of Tory MP, Admiral Reginald "Blinker" Hall, who had been Director of Naval Intelligence (DNI) during the Great War, and continued to run a private intelligence network during the peace.

Hall's protégé, William "A Man Called Intrepid" Stevenson, sent Huxley to Camp X, the joint Anglo-American facility in Canada, where his zoologists' skills were put to use. The scientist designed cyclonite mine casings which looked like piles of elephant turds, projected for use in the Far East. More practically, his "tire-poppers", which resembled sheep pellets, were dropped in tens of thousands before the German columns rushing to contain the Normandy landings. The order for their deployment came from Solly (later Lord) Zuckerman, a pioneer of Operational Research at Combined Operations and, as Huxley's successor to the Secretaryship at London Zoo, the man responsible for reopening the immensely profitable panda trade with China in 1956, despite UN and US trade embargoes. Zuckerman was the government's Chief Scientist when he joined WWF's Youth Leadership panel in 1961.

In 1946, Huxley was nominated for "the job in Reconstruction" which he craved, moving into the old Gestapo headquarters on Avenue Foch as UNESCO's first director. His appointment was fiercely opposed by President Truman, who believed him to be a Communist. It was true that Huxley had hymned Stalin's land reforms at the height of the Kulak famines, and it was also true that he and Wells were patrons of the Association of Scientific

Workers, a COMINTERN front. Equally, however, both men had sat on the board of the Kiboo Kift Kin (KKK), a proto-Fascist "Greenshirt" organization sworn to restore the Saxon kingdoms and bring about land reforms. Huxley had been just as enthusiastic about the Tennessee Valley Authority's giant dams, which were making so much money for General Electric. The true social engineer does not care whose flag flies over utopia, as long as he is allowed his part in building it.

The International Council for Bird Preservation was the only international environmental agency Britain was prepared to support prior to 1948. This had less to do with the zoological fact that birds migrate across frontiers than with the political fact that their nominee, Phyllis Barclay-Smith, ran the organization. Barclay-Smith had played an essential role in precipitating the Young Turks' coup at the Royal Society for the Protection of Birds (RSPB) which had allowed it to be used as an intelligence front. During the war, birdwatchers occupied the highest positions in the British intelligence apparatus. John Bevan was head of Deception at the London Controlling Section (LCS), its most secret agency, reporting directly to Field Marshal Alan Brooke in the Forward Operational Planning Section (FOPS) of the War Cabinet. The LCS mascot was a statuette of the goat-god Pan, the Lord of Lies, brought into Churchill's bunker by Dennis Wheatley.

After the war, Viscount Alan Brooke, who, as head of Home Forces, had chaired FOPS, became president of Peter Scott's Wildfowl Trust at Slimbridge. The "choleric Orangeman" had always been better known to the public as an ornithologist than as a soldier, having previously been—like Allenby before him—a vice-president of the RSPB. Bevan, no less than Lord Aubrey Buxton, an heir to the Barclays banking fortune, became the Wildfowl Trust's treasurer. Michael Bratby, Scott's coauthor in a number of ornithological works, was its secretary. His wartime role had been as Bevan's personal representative in Washington. Another ardent birdwatcher, Peter Fleming, had represented the Deception Planners in the Far Eastern theatre of the war.

It is perhaps no wonder that Peter's brother, Ian Fleming, named his hero, James Bond, after the author of *A Field Guide to the Birds of the West Indies*. *The Field Guide for Europe* was produced by Guy Mountford, who had been a real-life spy for the Foreign Office's Peter Vansittart and Claude Dansey's Z Network when he worked for General Motors in Paris between the wars—where, no doubt, he first encountered Prince Bernhard, who was similarly engaged, though on behalf of the opposing faction. Mountford, seconded to Washington during the war, became David Ogilvy's right-hand man at Ogilvy and Mather after the war. He is credited as one of the principal founders of the WWF network, and was the author of the original Project Tiger proposal.

However, the principal architect of the World Wildlife Fund/Worldwide Fund for Nature (WWF) complex of nature trusts—as well as of the IUCN-World Conservation Union, was E. Max Nicholson. As a member of the International Commission on National Parks, and one of the chairmen of the First World Conference on National Parks held in Seattle in 1962, E. Max Nicholson enthusiastically subscribed to the eugenic theory that time spent in the wilderness can cure the degenerate.

As nature is man's ancestral home and nurse, and as land-scape is his modern mirror, the achievement of a fresh recognition by mankind of the potential for the renewal and for the healing of a sick society through creative intimacy with the natural environment could bring a transformation of the kind and scale which our degenerate and self-disgusted, materialist, power-drunk and sex-crazed civilization needs ... A civilization which through its own intellectual advances has gone far to cripple supernatural religion as a living force has probably no option but to return in some form to the wilderness from which religion itself sprang.

Nicholson's prior service to government had related to what might be regarded as its most morally difficult, even nefarious, practices. Between the world wars, Nicholson was the first director of Political and Economic Planning (PEP), the satellite of the British Royal Institute for International Affairs (RIIA) at Chatham House, London, which drew up the first National Plan for Britain. As a political utopian, he was ideally suited to the task of social engineering. PEP's work provided the blueprint for the post-war welfare state. Nicholson had worked in Washington as Controller of all non-US dry-cargo shipping during the Battle of the Atlantic. There he did less well. The Battle of the Atlantic was almost lost, because of the extent to which Churchill and his "bodyguard of lies" strategy feared protecting the convoys too well in case the Germans guessed their naval codes had been broken. Sixteen million tons of Allied shipping were allowed to go down in the three years, 1940-42. In March 1943, 97 vessels were sunk in less than three weeks. Once the policy restriction on attacking U-boats was lifted, in May— "the month of the thunderbolt"—42 submarines were lost in 21 days and the German wolfpacks withdrew from the North Atlantic.

In 1939 Nicholson had been called in by the newly-formed Ministry of Information (MOI) to advise on ways of spreading war propaganda among the civilian population. As Kenneth Clarke put it: "We need the best bounders we can get!" His previous collaboration with the Secret Intelligence Service (MI6) and the Security Service (MI5) was presumably thought to qualify him for the job. The papers left by the Morale Committee and the Home Morale Advisory Committee of the MOI are scattered and fragmentary, and later efforts to persuade the members of these committees to talk about their work met with little success. Several of those contacted claimed to have been ashamed of it. "The propagandists' preoccupation with class distanced them from the public. . . . The propaganda was framed as if for an alien people." Nicholson's contributions included the assertion that the English masses "had never consciously fought for an ideal." The Oxford-educated Anglo-Irishman recommended that the profanum vulgus should only be approached in colloquial and humorous terms, since they would become suspicious if lofty sentiment and reasoned argument were used. In his semi-autobiographical account, *The Environmental Revolution: A Handbook for the New Masters of the Earth*, Nicholson asserted that the extraordinary success of the crusade which he did so much to launch defied rational analysis

As private secretary to five successive Lords Chancellor, the "twittering bird-watcher," as Hugh Dalton jealously spoke of Nicholson, held the Foreign Secretary "in the palm of his hand." He was at the height of his influence in 1948, and no doubt mindful of the lessons learned at the Ministry of Information, when the Foreign Secretary authorized the establishment of the Information Research Department (IRD), a covert agency created by MI6 to feed anti-Communist propaganda to the mass media.

Between 1952 and 1966, while the Inuit were being restored to their proper state in nature, Nicholson served as director-general of the world's first state conservation body, the Nature Conservancy, which was charged with setting up a national network of nature reserves in Britain. The Conservancy's Royal Charter contained "a satisfyingly vague job description" of the chief executive's role, one which allowed Nicholson to exercise "lots of power and little responsibility." As he later put it, "Our views and decisions could not be readily gainsayed, especially since no one knew at the time what such an agency ought and ought not to do."

A Society for the Promotion of Nature Reserves (SPNR) had been formed in Britain in 1912. But despite the support of such imperial grandees as Lord Grey of Falloden, Lord Rothschild and Lord Ullswater, the Society had made little progress, and was practically moribund by 1940. The Yellowstone model of land use, which was developed to suit the needs of an expansionist United States, was slow to be adopted in the European colonial empires. The first national park to be proclaimed in any British colony—at Nairobi in Kenya—did not open for business until December 1946, at a time when the British Empire had been bankrupted by the recent war. Thereafter, parks began to be proclaimed at a frenetic rate in all the derelict colonial empires, a process which has accelerated rather than slowed down since former imperialists conceded political authority to "tribes with flags."

The occult power of British "Feathermen" seems likely to have been the cause of bewilderment and alarm which swept the Swiss League for the Protection of Nature at the war's end. The League had been trying, since 1913, to persuade the Great Powers that some international machinery for the protection of nature was needed. While the ashes of Europe were still hot, the League convened an international conference which led to the establishment of the International Union for the Protection of Nature (IUPN), appointing the League as its agent. Soon, the whispering galleries of Europe were filled with accusations of "Swiss imperialism" and suggestions that the Swiss, previously "indifferent" to nature's charms, now wished to "monopolize" nature conservation efforts. Dr. Charles Bernard, president of the League, complained: "We found ourselves repeatedly up against obstacles . . . We have been criticized and attacked from many sides, violently, and, to us, incomprehensibly. We were accused of sinister projects, the worst intentions were attributed to us."

In 1948, at a meeting chaired by Julian Huxley, the Swiss League agreed that IUPN should be placed under UNESCO's wing. Huxley and his director of research, the Sinophile disciple of the Red Vicar of Thaxted, Joseph Needham, successfully argued that its proceedings should remain immune

to peer review by the International Association of Scientific Unions, on the grounds that "the question of nature conservation involved so many matters beyond the bounds of pure science." With this, Max Nicholson's initial hostility to the idea suddenly melted away. He provided the new body with a constitution, written by draftsmen at the Foreign Office, which kept it beyond the control of the United Nations as well. Not only governments and government agencies, but private lobby groups like the Society for the Protection of the Flora and Fauna of the Empire, London Zoo and the RSPB would be represented on this camel of a committee. IUPN's potential as the center of a green network of networks festooning the globe was vast; but so was the British national debt. It was banished to the basement of the Museum of Natural History in Brussels and kept starved of cash. There matters rested until the time came to wake up environmentalism's Sleeping Beauty.

Nicholson had "shed no tears in bidding farewell to the Swiss League," and shed no more when Dr. Charles Bernard, who had been conceded the office of president of IUPN, "had to be replaced at the Copenhagen Assembly of 1954 by a scientist of standing..." In 1956, the year of Suez, the United States adopted a "forward" policy in regard to Africa, and IUPN was renamed, "at American insistence," as Nicholson has noted, the International Union for the Conservation of Nature and Natural Resources (IUCN). Its chief executive, Secretary-General Jean-Paul Harroy, became Deputy Governor of the Belgian Congo, where he presided over the shambles of his country's scuttle out of Africa. IUCN's headquarters was discreetly moved to neutral Switzerland, which was apparently no longer suspected of imperialistic ambitions, well before the great convulsions which accompanied British imperial collapse had occurred.

The first of a new generation of green non-governmental organizations (NGOs) arrived in Geneva as the British Empire crumbled. The African Wildlife Leadership Foundation (AWLF)— since renamed the African Wildlife Foundation (AWF), which "Buff" Bohlen led to victory in the Save the Elephant Campaign of 1989—was the creation of a band of great white hunters who belonged to the Sierra Club, and whose other club was in Langley, Virginia. The Sierra Club was founded in March 1961 by Russell Train, a rock-hard Republican whose family had arrived in America aboard the Mayflower, and who claimed descent from the royal Scottish line of the earls of Erroll. Train, the youngest tax judge on the Federal Bench, was not a stereotypical environmentalist, and never developed into one despite his subsequent generalship of the environmental revolution. As an instance, he is one of the few who can claim to have shot an elephant with tusks weighing more than 100 lbs on either side of its mouth. He served on the main board of Union Carbide, whose corporate negligence is widely considered to have caused the Bhopal disaster. Billionaire Dr. Luc Hoffman, who for many years served with Train as a vice-president at WWF-International, was on the main board of the family company when one of its subsidiaries, which was manufacturing the ingredients of Agent Orange in what outwardly appeared to be a food flavoring factory, blew up and showered the town of Seveso in Italy with toxins.

Train learned about life's harsh realities in one of war's crucibles, the Office of Strategic Services (OSS), daughter-agency of Britain's SIS and the

evolutionary precursor of the modern CIA. His coterie of friends was chosen from within that circle, and none was closer than the distinguished zoologist, Dr. Harold Coolidge. A member of the presidential family whose fortune derived from shrewd investments in United Fruit, Colonel Coolidge had been one of "Wild Bill" Donovan's most valued advisors on matters pertaining to China and South East Asia. He knew the territory well. In 1928, he had been the veterinary officer for the Field-Kelly Expedition of 1928, during which President Theodore Roosevelt's sons, Kermit and Theodore Jr., had trekked through Indo-China and back to become the first sports hunters to track and kill a giant panda. The brothers fired simultaneously into its back, so that both could claim equal honor. Its skin went to the Field Museum, in Chicago. Its penis was forwarded to London Zoo, which wanted to resolve the vexed (and still vexing) problem of its anatomy.

Coolidge had been Train's patron and guru in the OSS, and it was natural he should become the only zoologist on AWLF's board. Equally natural was the inclusion of Kermit Roosevelt, Jr., not only the son of Coolidge's old friend, but the CIA agent who saved Guatemala for United Fruit. Kermit Roosevelt was something of an expert in overthrowing regimes. He had helped plot the colonels' coup which had unseated Egypt's King Farouk. He claimed he led Operation Ajax, which helped placed the Shah of Iran on the Peacock Throne. And his support for Nasser during the Suez crisis had led, albeit indirectly, to the fall of Prime Minister Anthony Eden's administration in Britain.

Another board member of AWLF, Arthur "Nicky" Arundel, controlled extensive press and radio interests in the Virginia hunt country, where he regularly chased the fox. He, too, was a CIA veteran. General Edward Lansdale had made good use of his skills as a propagandist in Vietnam, and he knew Africa, having collected gorillas there for the Washington Zoo. Board member, Phillip Crowe, a passionate hunter, had spied on the British in India for the OSS, before being sent to spy on the Chinese Communists. When a $12 fee registered AWLF as a tax-exempt charity, Crowe was US ambassador to South Africa, which had recently quit the British Commonwealth. The remaining four members of the first Board of AWLF included Maurice Stans, Eisenhower's Director of the Budget, and Edward C. Sweeney, of the Subversive Activities Board.

When Max Nicholson heard that these gentlemen planned to establish themselves in the soon-to-be-independent Tanganyika Territory—which, although it had been held in trust from the League of Nations since the first German defeat, was practically a British colony—he was not pleased. Even if AWLF's intention never was to do more than set up a College of African Wildlife which would teach Africans American principles of land use management, it is not difficult to see why he might have been alarmed. Nicholson flew to Washington to reason with the people, but he was coolly received. "The Americans didn't see the point in a global organization or a world fund," he told Fred Pearce, forgetting, in his frustration, that he had voiced precisely the same objections when the Swiss League proposed to set up IUPN. "We had to be quick," he remembered. "Other groups were

about to attempt the same thing, though not on a global scale. If those rival groups had started first, the whole future of conservation movements would have been different. In particular, people in the US wanted to set up a US-dominated organization".

The following October, the Nicholson Plan was revealed to the world. WWF's first board of trustees included four Foreign Office panjandrums, if we include the American-born wife of the Colonial Secretary, the Marchioness of Lansdowne. The others were:

- the Marquess of Willingdon, former Viceroy of India, whose family controlled much of Uruguay's beef trade;
- SAS founder David Stirling's brother-in-law, Lord Dalhousie, Governor-General of Southern Rhodesia;
- Sir Ernest Kleinwort, a keen ornithologist, had invested heavily in Nazi Germany before the war;
- Hitler's banker, Hermann Abs, convicted of war crimes in absentia by the Yugoslavs, who was able to escape from custody in the American sector and rehabilitate himself as the architect of the wirkschaftswunder, repaying the British loans with interest and subsequently joining WWF-International as a trustee. His previous administrative experience included membership of the Supervisory Board at I.G. Auschwitz, the artificial rubber plant whose slaves kept the Wehrmacht on wheels.
- Kenneth, later Lord, Keith was one of Britain's most aggressive corporate raiders and a protege of the SIS prophet of blitzkreig, Sir Kenneth Strong. Keith had been Eisenhower's chief of intelligence at SHAEF and custodian of Ashcan, the luxury hotel where leading Nazis of interest to Operation Paperclip—set up to use their talents against the Russians—were debriefed.
- Special Operations Executive's Guy Mountford.
- Peter Scott, Aubrey Buxton and David Attenborough, who weren't spies but kept company with them.

Between 1970-72, with the help of the South African cigarette tycoon, Anton Rupert, and one of his Rembrandt-Rothmans-Reemtsma Corporation's top salesmen, Charles de Haes, Prince Bernhard of the Netherlands, then president at WWF-International, established The 1001: A Nature Trust. The 1001, intended to make WWF-International financially independent of its national appeals, was a rich man's club. It was also a private international relations network, with members also active in the Bilderberg Conferences, the Trilateral Commission, the International Chamber of Commerce, the rival Orders of Malta, the Club of Rome, the Aspen Institute, the Draper Fund, et cetera.

The membership list is regarded as strictly confidential, but rosters for 1978 and 1986 show that the proprietors of much of the Western world's mass media either subscribed to The 1001 or were actually on the governing boards of principal WWF Trusts. Several of these had strong personal

connections to the Western intelligence community. It would require an entire book to list them all, but here are just two: Hugh Waldorf Astor, director/chairman of the London *Times*, 1956-67, was a veteran of the British Military Intelligence Corps and served in F Division of the Secret Intelligence Service (SIS or MI6) under Roger Hollis; and William "Bill" Astor, leader of the "Cliveden Set", the pre-war appeasement faction, restored something of the family honor by devising double-cross operations for British Naval Intelligence during the war. His first wife was on the SIS staff; his second wife was the daughter of an MI5 officer.

Bill's side of the family controlled the world's oldest newspaper, the *Observer*. Its Foreign Service, which provided the KGB agent, Kim Philby, with his job in Beirut, was paid for out of the Secret Vote. Max Nicholson was on its board when the paper's editor, David Astor, published a series of articles by his friend, Julian Huxley, which led to the creation of WWF as "an International Red Cross for Wildlife" and "a New Noah's Ark." David, a veteran of the Special Operations Executive (SOE), was accused by Philby of working for SIS. In fact, many prominent wildlifers have had a history within SOE, the private army of "soldiers of the hunter class" which had been tasked to "set Europe ablaze" under the auspices of Churchill's Ministry of Economic Warfare. Julian Huxley himself had been part of the secret organization from which it sprung, the Z Network, a spy ring set up to "shadow" SIS in the corporate sector, financed by South Africa's Joel brothers and Ernest Oppenheimer of De Beers.

Huxley's wildlife documentary, *The Private Life of the Gannet,* was paid for from SIS funds, and produced by the Z agent and film tycoon, Alexander Korda, whose London Films provided deniable cover for William "A Man Called Intrepid" Stephenson's British Security Coordination (BSC) in wartime New York. It won an Oscar. Korda's own blockbuster, *The Private Life of Henry VIII*, similarly financed, was the first of a series of propaganda productions designed to overcome isolationist objections to further US involvement in European wars. As the warclouds gathered, Korda's assistance helped secure Huxley the position of Secretary at the London Zoo, in which capacity the zoologist toured central Europe, equipped with a perfect excuse for asking impertinent questions, not all of them, of course, zoological. Huxley established Pets' Corner on the Fellows' Lawn after seeing how popular the concept was among visitors to Berlin's Tiergarten.

Huxley was then called upon to adjudicate in what came to be known as the Young Turk's Revolt, led by Max Nicholson, at the Royal Society for the Protection of Birds. Nicholson had accused the elderly widow who ran the Society of a variety of crimes and misdemeanors, although there was little evidence that she was guilty, unless it was of being old and being a woman. Nevertheless, Huxley found against her. As a result, Maxwell "The Man Who Was M" Knight, a Fellow of the London Zoological Society and head of MI5's counter-intelligence department, B1(b), was able to dispatch a professional ornithologist, Robert Lockley, on spying missions to Heligoland, a popular rendezvous both for Hitler's U-boats and for migratory birds. Lockley used RSPB cover to conceal his mission. Lockley had been a tenant of

Skokholm, the island where *The Private Life of the Gannet* was filmed. His account of his attempts to farm rabbits there, *The Private Life of the Rabbit*, was to inspire the best-selling novel, *Watership Down*, a popular account of the struggle for survival among the coney population of the English Downs.

Knight had been one of the founders of the British Fascisti, but efforts of the incoming Labour government of 1945 to have him sacked for helping William "Lord Haw Haw" Joyce escape to Nazi Germany, failed. They were foiled by the BBC's representative of the Security Executive in charge of oversight of the intelligence services, Malcolm Frost. Frost, then head of the BBC Natural History Unit, felt it would be better to "let Knight down gently" by giving him a part-time job. As the lovable "Uncle Max," the anti-semitic spymaster became a national media star on the BBC Nature Parliament radio program and, alongside Peter Scott, on BBC TV's flagship nature program, *Look*. His Special Branch minders were tasked to comb the countryside for hedgehogs to show to the children. Knight continued to draw two salaries, one from the BBC and one from MI5, until shortly before his death in 1968, when WWF launched a nationwide campaign for funds to build a children's library at the British Museum in memory of the "gay cavalier of conservation."

The Astors eventually disposed of their *Observer* property to Tiny Rowland's Lonrho. Princess Alexandra, the wife of Lonrho founder, Angus Ogilvy, succeeded Prince Philip as president of WWF-UK. Family member, David Ogilvy, chairman of the advertising giant, Ogilvy and Mather, was both a member of the executive board of WWF-US, and Special Advisor for Public Awareness at WWF-International for many years. Ogilvy produced "A Plan for Predetermining the Results of Plebiscites", "Predicting the Reactions of People to the Impact of Projected Events", and "Applying the Gallup Technique to Other Fields of Secret Intelligence" for SOE, whose wartime interests in Washington he represented, in 1943. His great US rival, Harold Burson, president/chairman of the giant Burson-Marsteller advertising agency, was both a member of The 1001 and a director of WWF-US, 1979-81. Many of his executives have served on secondment with WWF-International or its satellites.

Atlantic Richfield (ARCO) acquired the *Observer* from Lonrho in 1980, and its boss, Robert O. Anderson, who made a killing from the TransAlaska oil pipeline protested by environmentalists, joined WWF-International's board the following year. Anderson, who financed the Aspen Institute, was already in The 1001, as was his principal subordinate, Thornton Bradshaw, a trustee of New York Zoo Conservation Foundation, chair/CEO of RCA, and a director of NBC.

## THE SPOOKS' USE OF ENVIRONMENTALISM

As the colonial powers relinquished their holds on—or were tossed out of—Africa, control of the old colonial game reserves was taken out of the hands of colonial governors and their legislative councils—which were to become templates for the sovereign parliaments of the newly-independent states—and placed in the hands of quasi-autonomous private boards of trustees: the great and the good of planter society. Incoming governments

found that their legislatures had no right of oversight in their countries' own national parks, and that within the parks themselves, private armies of game guards were authorized to enforce a code of laws which radically differed from the customary, common and statute law which applied elsewhere.

It was explained that the protection of nature had been "taken out of politics" because conservation was too important a matter to leave to partisan dispute. With few exceptions, the new administrations agreed that this certainly seemed a good idea. Throughout the post-colonial period until the present day, such parks have effectively served as Western enclaves inside supposedly sovereign states. They are heavily subsidized by the West, and the services of Western or Western-educated wa-benzi managers and technical tourists are required to keep them going.

Strictly protected parklands in sub-Sahara Africa occupy an area larger than Britain, France, Germany, Switzerland, Italy, and Spain put together. Somewhere between 35 and 50 million people who would otherwise have been self-supporting may have been made destitute as a result. Management bans on the use of DDT and other insecticides in the protected areas, on the ground that they might damage the environment, have permitted a vast resurgence of malarial mosquitoes. The kingdom of the tsetse fly now extends across 30 million square kilometers. As the parasites carried by these and other disease vectors have evolved immunity to the drugs employed against them, vast areas have become uninhabitable either by man or his domestic animals.

In addition, development agencies have encouraged private owners of land to farm wild animals for the zoo trade and tourist hunters, as a cash crop. WWF-International has been particularly active in promoting this form of "sustainable utilization." Many countries south of the Sahara, a region which was a net exporter of food in the 1960s, have since become prey to endemic famine. Despite enormous investments in the "scientific management of nature," fewer than thirty northern white rhino, not long ago numbered in thousands and present in half-a dozen countries, survive. The black rhino, which was being shot as vermin in Kenya in 1944, is now extinct outside heavily guarded enclosures. Africa's most characteristic mammal, the elephant, vanished across the greater part of its range in the space of two decades.

A memorandum of a meeting classified "geheim"—secret—was circulated to members of the South African cabinet on 18 September 1991. During the course of the meeting, Dr. Anthony Hall-Martin, of the National Parks Board, had informed his Minister that many of the details of South Africa's long history as a wildlife outlaw were known to journalists of the *Observer*, the London *Sunday Times*, the *Financial Times*, the *Wall Street Journal,* the Johannesburg *Sunday Times*, Reuters, and other major media outlets. Hall-Martin expressed his grave concern that a concerted international publicity blitz aimed at South Africa would be mounted not later than March, 1992, the date of a CITES conference in Kyoto, which would reconsider the 1989 ivory ban. He was particularly worried that the activities of a wildlife commando of ex-Special Air Service mercenaries, raised by the British condottiere David Stirling, and financed by Prince Bernhard through The 1001

and WWF-South Africa, would be used to embarrass the government. The mercenaries had been provided with safe houses by South African President de Klerk's principal intelligence advisor, superspook Craig Williamson. They had been permitted to buy, in defiance of international law and at a tenth of its street value, millions of rands' worth of rhino horn from government stocks, which had since disappeared and could not be accounted for. They had agreed in writing to conceal any evidence of apartheid South Africa's complicity in the wildlife holocaust which they uncovered both from the media and the international authorities. Hall-Martin was told that his information would at once be laid before Roelf Meyer, the Minister of Defence, as "something of a dramatic nature would have to be done." Whatever that may have amounted to, nothing appeared in the Western mass media even remotely suggesting that the elaborate machinery, which the environmental revolution had established under international law to protect the earth's wild places, had, in fact, entirely failed to register the wildlife crime of the century. When an academic inquired as to why the world's largest private nature charity had chosen to ignore the evidence pointing to Pretoria's involvement, Rob St. George, WWF-International's communications director, told him: "the subject never came up."

The conservation industry has consistently attributed these losses to the population explosion, peasant poaching, the corruption of black officials and the venality of Arab and Chinese traders. But in 1996, a South African judicial commission of inquiry confirmed that profits from the illegal trade in poached ivory, rhino horn and other plundered resources taken from the sub-continent were used by the country's former regime to finance the destabilizing wars which white South Africa waged against its neighbors. After sifting thousands of documents and hearing sworn evidence from 150 witnesses, Mr. Justice Kumleben concluded that, for more than a decade, the Military Intelligence Division of the South African Defence Force (SADF) had run a string of dummy companies which funneled vast quantities of stolen wildlife products onto the international market. Evidence of official involvement in high-profile poaching was presented to the US Congress by the Monitor Consortium in 1988.

During that same year, a series of documents and letters from the files of the former Portuguese Fascist secret police, PIDE (International Police for the Defense of the State), became available in English.[3] This material had been widely available in French and Portuguese since 1974, but had previously been ignored by the English-language media, Anglophone scholarship and the international conservation industry. Under the terms of a 1970 agreement codenamed Operation Timber by its Portuguese sponsors, the South African, Rhodesian and Portuguese secret services offered military aid to UNITA's leader, Jonas Savimbi, revealed in the papers to have been a Portuguese secret agent. In return for arms and material, Savimbi licensed the operations of European logging companies in areas UNITA occupied. Huge quantities of valuable timber and other forest products were shipped south along Namibia's Golden Highway to the Cape for most of the following quarter-century.

The damage done to southern Angola's primeval teak forests soon became visible on photographs taken from space. Yet, despite protests by

the UN High Commissioner for Namibia, Sean MacBride, and anti-apartheid groups, no comment on the desecration was issued in Geneva, the world capital of the international conservation industry. After working as a Portuguese secret service agent, Savimbi and UNITA went to work for the CIA under CIA officer, John Stockwell,[4] and continued to attack the leftist MPLA established in the capital, Luanda. According to Stockwell, Savimbi and UNITA were working for him well before MPLA sought and obtained Cuban backing to fight UNITA and another CIA-backed pseudo liberation movement, the FNLA of Holdon Roberto.

Savimbi's trade in timber was rapidly supplemented by parallel trades in ivory, horn, diamonds, cobalt, drugs, currency, weapons, and even slaves. In 1984 when a Namibian newspaper, the *Windhoek Observer*, published a detailed account of what was going on, substantiated by photos of the goods in transit and aerial shots of the river-island commissary which controlled the trade, the paper was unceremoniously shut down by the South African military authorities. In 1988 Savimbi boasted to a reporter of *Paris-Match* that his men had sent the tusks of 100,000 elephants to South Africa.[5]

But even before Savimbi blurted out his inconvenient truths, a ten-month investigation by the US Attorney General's office had concluded that SADF members "have been actively engaged in killing and smuggling of wildlife species—including elephants and rhinos—for personal gain and profit." The investigation linked former Rhodesian prime minister, Ian Smith, to South African-controlled militarized mafias trading guns and wildlife products on the international market. The racket appears to have originated shortly after Smith's Unilateral Declaration of Independence in 1966, among members of the Selous Scouts, a fearsome paramilitary force raised within the game department by Alan Savory, the chief ecologist of the Rhodesian National Parks. The Scouts shared Gonarhezou National Park—which also served as an internment camp for political prisoners, including Joshua Nkomo—with "Special Air Safaris," as the Rhodesian SAS came to be known among the criminal fraternity. When the Smith regime collapsed in 1979, many Scouts, SAS men and Rhodesian policemen "took the gap" south, where they continued to ply their staggeringly lucrative trade in stolen wildlife products.

In 1989 the Commonwealth Secretariat published *Apartheid Terrorism: The Destabilization Report*. It described in some detail the use of the ecological weapon in South African campaigns, which it estimated, had cost the Front Line States 1.5 million human lives and US$45 billion during the previous decade. The authors noted that when 200 kg of documentation was recovered from RENAMO's main operational base in Mozambique's Gorongoza National Park by government troops in 1985, the papers clearly revealed that the pseudo-gang, originally created to serve Rhodesia's UDI regime, was being supplied with South African weapons in exchange for poached ivory and horn. According to former RENAMO fighters, many recruits were forcibly indoctrinated prior to their induction into one of the world's most fearsome terrorist armies at a RENAMO base about a mile from Skukusa Lodge, the main tourist honeypot in South Africa's Kruger Park. The elephant population of Mozambique fell from an estimated 54,800 in 1979 to 8,000 or

less by 1988. The white rhino, which WWF had reintroduced from South Africa during the last days of the Portuguese colonial regime, became locally extinct in Mozambique for the second time in a century. The black rhino, once endemic, was also wiped out.

It should be noted that IUCN-World Conservation Union, and other quasi-autonomous agencies of the international "Green Orchestra" have important duties under international law to ensure the proper oversight of the World Conservation Estate. These they ignominiously failed to carry out. The South African-Israeli "Atoms for Apartheid" collaboration involved building ICBM launching pads in a bird park. The forests of the St. Lucia wetlands, a World Heritage Site protected under the RAMSAR convention, burned for days after an ARMSCOR weapons test went wrong. The National Intelligence Service (NIS), formerly the Bureau of State Security (BOSS), built itself a multi-million rand facility at Jackal's Besie in Kruger Park.

Perhaps we should not judge the South Africans too harshly. Back in Britain, a nuclear-proof bunker was constructed on National Trust land set aside for the use and enjoyment of the public. It coordinated attempts, during Operation Desert Storm, to bomb Iraq back to the Stone Age. But this article is not concerned with judging South Africans, or the British, the Americans or any other nation. It simply asks: what is the point of having international law enforcement agencies which do not enforce international law—or if they cannot enforce it, at least could widely publicize the fact that it has been broken, and arouse global public opinion?

## A LITTLE COST-BENEFIT ANALYSIS

IUCN and WWF had in the past consistently opposed calls for tighter controls on the international ivory trade, and denied that elephants needed any special protection. In 1988, however, the US-based African Wildlife Foundation (AWF) reversed its previously passionate opposition to controls and began reporting that a million or more elephants had been slaughtered by African "poachers" over the previous ten years. AWF's 1988 launch of the "Year of the Elephant" campaign to "save" the species served to galvanize Western public opinion, generating headlines around the world and raising hundreds of millions of tax-sheltered dollars for environmental charities over the next few years.

The money-making potential of all this is not negligible. The admission fee to The 1001: A Nature Trust, was $10,000, but it has since been hiked to $25,000. A "club within the club" organized by Rupert, one of many active or former members of the South African Afrikaner Broederbond in The 1001, has raised $1 million each from its 25 members.[6]

In 1990 the *Cook Report*, a popular investigative series transmitted on the main British commercial channel, published details of a major internal audit commissioned by WWF-International from outside experts. In particular, it revealed that WWF's flagship Project Panda to save the cuddly bears from extinction had entirely collapsed and that the prestigious Project Tiger was in a shambles. There was fierce criticism of many other projects worldwide. "I had no idea that it might land us in such a pickle," Prince Philip wrote to

WWF director-general, Charles de Haes. "Whatever we do with it, we are bound to get into trouble." Prince Philip recommended that all copies of the Report should be impounded, numbered, and locked in vaults. Access to it was to be denied both to the charity's trustees and its staff.

An even more damning internal audit was issued by IUCN's Dr. Simon Anstey. When WWF was launched in October 1961, its first appeal was for money to "save" the African black rhino, whose numbers it put—probably, quite conservatively—at 100,000 head. However, as Anstey discovered, the charity spent peanuts on only two black rhino projects prior to 1979. By then, numbers had fallen to 14,000 and WWF-International launched a "Year of the Rhino" campaign to "save" the survivors. It raised $1.3 million, encouraging WWF's scientific consultants to work hard to implement two major "Scientific Action Plans" of 1980 and 1981 which they hoped would save the species. In addition the team leader, Dr. Kes Hillman Smith, delivered 14 papers containing specific recommendations for the rhinos' salvation.

WWF-International's management, under Rothmans executive, Charles de Haes, invested nothing in its own scientists' specific recommendations. The cash raised from the public was instead spent so rapidly on quasi-military operations "that a deficit of US$73,000 existed in 1981." At least 40 per cent of the money was spent in Zambia, where armed patrols led by white planters arrested 187 suspects and recovered two rhino horns in 1981. The death of one suspect led to a charge of murder, which was reduced to manslaughter, then dropped. Following this and every single other intervention by the "Panda People" anti-poaching units across the sub-continent, Anstey reported, 90 percent or more of the local rhino population was lost to more-or-less organized poaching. Vehicles were sent with no spares, or had low-capacity fuel tanks, high petrol consumption and a wheelbase that made them unserviceable in the bush. Radios didn't work. An aircraft provided in Tanzania's Selous National Park was airborne for four months over a period of four years. With this incompetence and continued poaching, black rhino numbers were down to 8,800 by 1984, and had more than halved again by 1987.

In 1980 WWF International's Conservation Committee voted US$300,000 for a "highest priority" project in the Sudan. Some bicycles and a motorbike were all that was sent. All the northern white rhinos in that country were subsequently lost. Similarly, money voted for the Garamba reserve in Zaire took four years to begin to get there.[7] By then, its white rhino population had dwindled to fifteen. These were practically the only northern whites known to survive outside a Czechoslovakian zoo. On the other hand, the southern white rhino, "saved" by Dr. Ian Player and his colleagues, were being put on display to demonstrate the excellence of South Africa's conservation efforts.

Operation Genesis, "generously funded" by WWF, established the world's third largest herd of white rhino—248 animals—at Pilanesberg National Park, a Garden of Eden in the Praetorian bantustan of Bophuthatswana. There, it offered visitors to Sol Kertzner's Sun City casino complex a daytime alternative to gambling and girls—the chance to kill a rhino for $15,000, plus $500 a day for the cost of the safari. Pilanesberg, in the crater of an extinct volcano said to contain a diamond pipe, had been created in the usual

fashion—by evicting the Welgeval community who had lived there. They belonged to one of the endangered South African tribes, the Bakgatla. They were black freeholders whose land had been deeded to them by Christian missionaries. The UN Commission on Human Rights wrote to WWF-International, on 6 August 1980 demanding "clarification" of WWF's role in their forcible relocation. "In a letter dated 14 August 1980," the Commission later reported, "The Fund . . . provided a certain amount of information which it considered adequate . . . but that did not suffice to dispel doubts about the facts alleged."

Both WWF-International's black rhino projects prior to 1979 involved interventions in wars. Uniquely, Project 906, in Chad, involved an anti-poaching operation which was aimed against the army and civil service of a sovereign government. Landrovers, lorries and aircraft were deployed to save the rhinos as government forces came under siege from French-backed rebels in 1973-74. The coup succeeded and the Chadian government fell. However, as Anstey noted, insofar as the rhino were wiped out, he did not view the project as a success. In 1973, WWF-International provided money for the translocation of 83 animals (six died) from one of the border zones in which the Rhodesian army was sowing with mines, to the Gonarhezou National Park, a penal colony and military bivouac which has never been open to the public since. An international ban on commerce with Rhodesia, imposed by the United Nations, was in force at the time. The British trustees of WWF-International, who agreed to spend tax-sheltered charity funds on subsidizing it, were apparently happy, in addition to defying UN rules, to give aid and comfort to a rebel in arms against their own Crown or, to clarify the point, to an intransigent racist white settler outlaw regime determined to maintain minority white dominance in Black Africa.

## CENSORING THE MASSIVE FAILURES OF ENVIRONMENTAL PROGRAMS

In October 1989, as the Berlin Wall was being torn down, a ban on the world commerce in ivory was agreed in Lausanne at a conference of CITES. Although not officially accredited to the conference, CIA veteran Curtis Bohlen acted throughout as the Bush administration's plenipotentiary within the US delegation. Soon afterwards, he joined the Cabinet—responsible for Oceans—representing the US President (and former CIA director) at the Earth Summit in Rio in 1992. His role in securing the decision taken in Lausanne was documented by Ray Bonner, formerly the *New Yorker* East Africa correspondent, later with the *New York Times* in Vienna. In *At the Hand of Man: Peril and Hope for Africa's Wildlife*, Bonner chronicled occult diplomatic and economic pressure, the deployment of surrogate organizations, deceit, bureaucratic manipulation and racial politics which were used to bring about US-approved results. Bonner's book was withdrawn from sale shortly after its British publication in 1993, in circumstances which remain obscure.[7] The author, who had concluded that it was "easier to penetrate the CIA" than to find out what was happening inside WWF-International during this period, has since preferred not to discuss his encounter with the conservation industry.

Bonner's unhappy experience among the "Gardeners of Eden" is by no mean unique. The role of the South African military in the despoliation of Africa's wildlife has been an open secret for many years. Yet it remained hidden from plain view. Western journalists are under immense moral pressure to reveal nothing to the public which might damage what is widely regarded as a noble, even a holy, cause. A more practical deterrent is the fact that conservation-led journalism is simple, upbeat and glamorous. Nobody knows better than a working journalist that whistle-blowers are likely to end up with split lips. Positive stories and photographs about the war to save the wild sell newspapers, magazines and coffee-table books. The broadcast media have evolved an entire genre, the wildlife documentary, in order to create and satisfy a taste for "evolutionary Gothic" tales of sex, consumption and struggle for survival among the lower species.

When Mr. Justice Kumleben published sworn detailed evidence describing the scale of the failure of the world conservation movement to protect African rhinos and elephants, no mention of it appeared in the British mass media. In the United States, the *Christian Science Monitor* was the only major news outlet whose editors thought that what had really happened to Africa's elephants and rhinos might interest the urban public. However, in November 1996, Channel 4, the British commercial broadcaster, whose founders meant it to be an "alternative" source of news and commentary on current affairs, commissioned a 60-minute documentary film intended to take the "Kumleben Report" as its starting point, and develop the story from there. In January, before filming in South Africa had even begun, Channel 4 froze the film's budget and ordered the filmmakers, newly arrived at the Cape from Kenya and Namibia, to come home. Since the crew's flights and hotel accommodation within South Africa had been pre-booked and were already paid for, they did not return immediately, but instead went to work at a frenetic pace, their aim being to lay down as many interviews as possible with the major players while the money lasted, and argue later.

In the event, argument proved futile. Channel insiders revealed that a personal approach had been made to Channel 4 chief executive, Michael Grade, by the South African billionaire, Johan Rupert, CEO of the giant Richemont Group, which has a major stake in European high fashion, perfumery, jewellery, tobacco and drink. Johan's father, Dr. Anton Rupert, had recruited Grade's father and his uncle, the showbiz Lords Grade and Delfont, into the select ranks of The 1001: A Nature Trust. Grade had also accepted a call from Lord Aubrey Buxton, Extra Equerry to Prince Philip, the Duke of Edinburgh, who had been president at WWF-International between 1980-96. Buxton, who wrote "The Birds of Arakhan" while serving with Combined Operations in Burma, was a member of the Barclays banking family and the former head of Anglia Television, one of the most powerful men in British broadcasting. He was one of WWF's founder-trustees, a former treasurer at London Zoo, a founder of the nature history series, *Survival*, and reckoned the third-best shot at a rising bird in England.[8]

In 1988-89, every major TV station—and all the big environmentalist organizations—combed film archives all over the world for the footage they

needed to illustrate the conservation industry's shock announcement that Africa's elephants, hitherto depicted as vandals which needed to kept in check by constant culling, were being slaughtered at a rate of 100,000 a year by wicked (black) men. *Survival*, described in *The Guinness Book of Records* as the world's longest-running factual natural history TV series, couldn't help. The BBC Natural History Unit couldn't find any useful material, although Buxton's fellow WWF founder-trustee, Sir David Attenborough, had spent much time over the previous three decades filming all over Africa. While the libraries were crammed with photographs of the latter-day Gilgamesh and his peers talking to gorillas, searching out tribes of socio-pathic chimpanzees, and watching, wide-eyed, predation of every sort except those which really upset the balance of nature—all-out assaults employing automatic rifles, grenades, rocket-launchers and even helicopter-gunships. It seemed that there had been a universal failure to notice the giant fly-blown corpses of the rhinos and elephants, the world's two largest land animals, which littered Africa. That, as Sherlock Holmes remarked of the watchdogs which did nothing in the night, was the curious incident that Channel 4, having been briefed in detail about the historic background to the wildlife tragedy and what the interviewees might be expected to say, had agreed to address, then dropped like a hot potato.

No details of what was regarded as having gone wrong were ever given in private. No public announcement drew attention to the case of the film that had disappeared. News nevertheless passed across the bush telegraph. When foreign broadcasters began making inquiries about obtaining the rights to the unmade program's 28 filmed interviews so that they might finish the documentary, Channel 4's lawyers informed the production house that releasing the footage might leave it open to prosecution under the Defamation Act. Apparently, a British court might be asked to consider whether the questions concerning wildlife destruction that had been asked of former cabinet ministers, ambassadors, chiefs of police, a billionaire, a professor of law, and a Getty Prize winner, constituted evidence of malice on the part of the questioner. As a result of these legal hypotheses, British TV audiences are unlikely ever to hear—among other things—Colonel Marion Clifford, head of the Special Task Unit of the South African Police, charged with investigating the so-called "Third Force" murders, describe how the murderers, who slaughtered 10,000 or more innocent people,[9] were trained on properties and in premises rented out, in due bureaucratic form, from the National Parks Board, whose director sat, ex officio, on the Scientific Advisory Board of Dr. Rupert's South Africa Nature Foundation, since renamed WWF-South Africa.[10]

## THE "UNINFLUENTIAL MINORITY" MARCHES ON...

In 1970, when Max Nicholson published his Handbook for the "New Masters of the Earth", the forests of south-east Asia were wreathed in Agent Orange and the local peasantry, practical people, had been obliged, in order to feed themselves, to take up fish-farming in the craters left by earthquake bombs. According to Nicholson, "It has been aptly said that one thing in the

world is invincible—an idea whose time has come. Such an idea, in these days, is the care of man's environment, or, in a word, conservation. Until very lately this idea was present only in a primitive form in the minds of a small and relatively uninfluential minority".

In 1974, Robert Strange McNamara, 8th US Secretary of Defense and the architect of the Vietnam War, was warmly welcomed when he joined the main board at WWF-International. McNamara, a trustee of Robert O. Anderson's Aspen Institute and a member of the US Population Crisis Committee, was a social engineer who subscribed to the "lifeboat ethic". "What happens if you share space in a lifeboat," Dr. Garrett Hardin asked the readers of *BioScience* in 1974. "The boat is swamped and everybody drowns. Complete justice, complete catastrophe." In 1976, the Environmental Fund launched its campaign to deny international food aid to any country failing to adopt contraceptive policies. President Lyndon Johnson had already required the Indian government to adopt "positive" population control policies in return for food to feed the starving. These were administered by the Minister for Health and Family Planning, Dr. Karat Singh, the Maharajah of Jaipur, and involved the forcible castration and sterilization of thousands of peasants.

During the run-up to the 1996 US presidential election, then CIA director John Deutch noted that, having saved the world from Communism, America still had to save it from itself. In "The Environment on the Intelligence Agenda", a keynote address to the World Affairs Council in Los Angeles, Deutch quoted former US Secretary of State, Warren Christopher, as saying that "our ability to advance our global interests is inextricably linked to the way we manage the Earth's natural resources." The CIA director pointed out that environmental factors "influence the internal and external political, economic, and military actions of nations important to our national security. . . . Environmental trends, both natural and man-made, are among the underlying forces that affect a nation's economy, its social stability, its behavior in world markets, and its attitude to its neighbors." He promised that, with the Cold War at an end, the CIA would, in future, be devoting much attention to environmental affairs.

The speech scandalized many environmentalists, for the links their movement has to the security services, and even the environmental impact of war itself, have gone largely unmentioned in the vast literature, both popular and scientific, which is devoted to the new green ethic associated with ecologism. According to the oil tycoon, Maurice Strong, who has served the environmental cause in many capacities, including those of chairman of the board at IUCN and vice-president at WWF-International, war and warlike activities are not a problem. "Our security is threatened more by environmental risk than by traditional military conflicts." By contrast, the military metaphors employed by the environmental movement demand the total mobilization of society to face an overwhelming threat. The battle to save the planet is a wildfight whose leaders summon green guerrillas, ecowarriors and humaniacs to join them in their crusade to liberate nature's holy places. According to former vice-president Al Gore, the advantage of using such language is that "we are used to organizing a total response to threats posed to our national

security. We are used to mobilizing the nation's assets and our own thinking and emotions to confront this kind of threat."

## CONCLUSION

In the face of global warming, diminishing bio-diversity with its associated massive disappearance of species, and increasing pollution throughout the world, there is legitimate and widespread public concern for the environment and for wildlife preservation. It is extremely disturbing that such vast potential support for conservation efforts has been, in the many cases presented above, used by major intelligence services and powerful Western political cliques as a cover for their covert support of the Apartheid South African regime and many pseudo liberation movements whose real policy was to fight and hold off real anti-colonial and liberation movements. Shrewdly, these Western elites and secret services realized that public support for the environment and conservation could provide more or less a blank check that involved little or no oversight or critical evaluation—a perfect setup for cutting down forests of valuable tropical wood and wholesale "culling" of diminishing great game for strictly monetary purposes.

While we, the public, are shocked by what these Western elites and spy organizations have done, we must recognize that our support of such environmental efforts has largely been uncritical and our oversight far from a priority, particularly during the Cold War, on which the media and ruling Western elites focused our attention. But this general rule holds true: if spies and their powerful political masters are not kept in check by the public, we only find out about their misdeeds much later as we start piecing together the bits of information that slowly become available. While the end of Apartheid and colonial regimes means southern Africa is no longer fertile grounds for such dangerous secret policies, there is no guarantee against their reappearance if local governments and the world public drop their guard.

What should we conclude? It is crucially important to note that what this article describes was a class/cultural problem long before it became a political one. The revolutionary environmental elite despises the nation-state. They infiltrate its public institutions only to destabilize and destroy the *res publica*. They are anti-republican and anti-democratic precisely because they consider themselves cleverer and altogether wiser than the common herd. Nonetheless, the bureaucracies of deceit, considered as bureaucracies, can be held responsible. For better or for worse, they are formally, in law and in fact, agencies of the nation-states and are answerable to the three great estates of any realm: executive, legislative and judiciary.

There is no tangle that some can weave, that others cannot disentangle. In this article, we have tried to sketch, in bare outline, something of the secret history of the "conservation revolution". Since, by definition, so much of it has been hidden, and so much of what is said of it has been false, this can serve as little more than a preliminary essay. While it may contain errors of judgment, we have tried hard to avoid errors of fact. The central point is that the real battle to save our global ecosystems lies in the hands of

those willing both to scrutinize and employ our political and cultural institutions, imperfect though they are, to the general and mutual good of both nature and humankind.

# Switzerland:
# Anti-Money Laundering
# and Domestic Surveillance

In the world of international finance—and particularly in Switzerland—a very serious problem has arisen: how to distinguish between hot money traveling from foreign origins to financial havens for varying reasons—capital flight, politically-enabled looting/corruption, tax evasion, money-laundering from the sale of drugs or other activities of organized crime, etc.—and capital for the purpose of financing "terrorist" groups. After all, those whom Western governments and international finance deem terrorists apply the same or similar well-known sleazy financial practices. Switzerland's laidback attitude towards the sources of incoming wealth has been a key to its own financial prosperity. Having significant sections of its capital inflow arriving from shady sources for shady reasons, Switzerland is faced with the embarrassment of having to draw the line. Providing banking services to certain individuals or organizations, post 9/11, is apparently less acceptable, more onerous, than sheltering money on behalf of some of the world's most notorious political despots or organized crime capos.

That's not all: Swiss intelligence has an equally serious problem distinguishing between people with large Swiss bank accounts, "subversives" who merit spying on, and ordinary Swiss citizens, who have been submitted to an extraordinary degree of domestic surveillance.

A full sixteen months after the 11 September 2001 attacks against the World Trade Center in New York and the Pentagon in Washington which unleashed the worldwide "war on terrorism", Swiss authorities made an important decision: anti-money laundering rules would be applied with a view to prohibiting access to funds which might be used for support of terrorist activities. No one fell off their chair because the news was announced rather discreetly, as is the case with most Swiss anti-money laundering and intelligence-police measures. Only specialists, and *Intelligence*, had been following these developments and knew. No one seemed to be aware that Switzerland, a leading destination for hot money from around the world, didn't engage in anti-money laundering as related to terrorism. On the other hand, Switzerland had extremely strict anti-terrorism legislation which had been on the books since 1998—laws that the world was to imitate after 11 September.

In October 2001, *Intelligence* had headlined, "Switzerland—No More Money Laundering ... Again"[1], noting that parallels between the evolution of Swiss anti-money laundering and Swissair were striking: "down and out" before the 11 September terrorists' attacks in the US, they both suddenly rebounded with government backing. The failing airline had benefited at the time from particularly good press. On 15 October 2001, *Newsweek* headlined, "Storming the Fortress of Hidden Terrorist Funds", claiming Swiss investigators and lawmakers were hot on the money-laundering trail of al Qaeda and other networks, and it only took . . . sixteen months . . . to apply the "hot" new measures. In addition to ABN AMRO, several other financial institutions were found to have relationships with the Qaeda-associated Al Shamal bank; including Credit Lyonnais (Suisse) and American Express. On 17 October, the AGEFI wire service headlined, "No Pity for Money Launderers", claiming banking secrecy would be more limited in the future and European Union anti-money laundering rules and regulations would be extended to Switzerland. At the time, *Intelligence* stated: "A 'wait-and-see' attitude seems to be in order."

The OECD's Financial Action Task Force on Money Laundering (FATF) hadn't been "waiting and seeing". In late 1997, a heavy item figured on the agenda of its annual meeting in Paris: the examination of the case of Switzerland and that country's continued lack of a law requiring that suspicious deposits be reported. The then current Swiss banking law "encouraged" reporting such deposits, but it was not illegal not to report them. In addition to the "heavy" Swiss item, there was an overall "heavy" agenda and the FATF meeting ended before the Swiss case could be examined. Just barely under the wire, the Swiss hurried to push through a second reading of a bill that would make reporting suspicious deposits legally binding.[2] This would mean that when the Swiss case was going to be at the top of the agenda for the 1998 annual FATF meeting, everything was to be in order.

The Swiss government did "get down to work". In early 1998, the Swiss federal police appointed a former banker, Daniel Teleshkaf, to head its new anti-money-laundering unit called for by the new banking law that was to help Switzerland avoid criticism by the OECD's FATF. Teleshkaf was supposed to be working with a similar anti-money laundering unit set up by the federal finance administration and headed by a young legal expert, Niklaus Huber.[3]

Although little or nothing had been said about it publicly, the Swiss federal police or internal security service, Bundespolizei (Bupo), was engaged in the process of reorganization at the time. Similar to the anti-money laundering process, many secret recommendations had already been implemented but there was serious "internal" resistance to the full implementation of the reorganization plan. In a country where discretion is almost a trademark, no one wanted disgruntled intelligence officers to go on strike as they once did in Greece. Specialists weren't expecting anything to be heard in public of these discussions or negotiations . . . unless they broke down.[4]

Bupo had been created in 1889 as a direct result of foreign pressure. At the time, Bismarck, the Chancellor of the German Reich, had been angered by the "subversive" democratic activities of German refugees on Swiss soil and demanded that the Swiss government clamp down on the German exiles.

The demand was accompanied by barely veiled military threats (France had lost the Franco-Prussian war in 1870), and the Swiss government reacted by setting up the political police.

In 1989, it had been revealed that during the Cold War, the Bupo, assisted by the police of the Cantons (member states of the Swiss Confederation), had kept under surveillance and registered some 900,000 persons on the sole grounds of their political opinions. Foreign residents and people suspected of Communist or leftist sympathies were the prime targets of this extraordinary state-sponsored snooping activity. But it was gradually revealed that even leading figures of the Swiss establishment, such as editors of large circulation newspapers, had Bupo files.

The discovery of Bupo's unlawful snooping activities caused public outrage. People's anger increased after the government, bowing to massive public pressure, decided to grant individual applicants access to their files. Eventually, as more than 350,000 people applied for and received copies of their secret files, many suddenly understood why their professional careers had faltered for apparently inexplicable reasons in the 1960s, 1970s, and 1980s.

One woman found out she had been fired from her job as a bank clerk in the 1970s because she married a man considered "politically suspect" by Bupo. Two members of the federal parliament discovered they were registered in 1989 merely because they had signed a public and perfectly lawful appeal against genetic technology. Internal security regarded them as part of a political environment inclined to terrorism because, that same year, a number of bomb attacks were carried out by unknown perpetrators against genetic research facilities . . . in Germany.

In March 1990, 35,000 people (an extraordinary number for Switzerland) demonstrated in the capital, Bern, for the abolition of the political police. In the autumn of 1991, a Schweiz ohne Schnueffelstaat ("No State Snooping in Switzerland") committee gathered more than the necessary 80,000 signatures under their "Initiative" for the abolition of political policing. The "Initiative" instrument is unique to Switzerland. It allows changes to the Constitution to be made on the basis of a popular vote, even against a majority in Parliament.

The wording of the Initiative, "No State Snooping in Switzerland", was unequivocal:

> The political police are abolished.
> In exercising political and ideological rights, nobody shall
> be subjected to surveillance.

The "snooping scandal" resulted in an almost fatal blow to Swiss internal security. In view of overwhelming public criticism and distrust, Bupo could not even consider continuing its normal surveillance activities. Moreover, the disclosure of thousands of secret personal files, some of which contained information provided by "friendly" foreign secret services, temporarily led to Swiss services being excluded from international intelligence cooperation.

The "snooping scandal" also highlighted the amateurism and technological backwardness of Swiss internal security activities. Ninety-seven percent of the information gathered by Bupo was considered useless after closer scrutiny. Bupo did not have a computerized database. Instead, information was stored on typewritten or hand-written filing cards. Thus, in the wake of the snooping scandal, Bupo had two options: to close down or to thoroughly reorganize and modernize.

The government quickly made up its mind. In November 1989, a parliamentary commission investigating the snooping scandal, while strongly denouncing prevailing internal security practices, noted that "the State needs preventive internal security" and stressed that, in this context, registration of innocent third persons was "unavoidable".

However, in the aftermath of the scandal, the advocates of continued political policing were acting under the Damocles sword of the "No State Snooping in Switzerland" Initiative. Up to the early 1990s, opinion polls showed a strong majority in support of the abolition of internal security. Aware of this, the supporters of political policing, led by the Federal Minister of Justice and Police, Arnold Koller, opted for a strategy of "sitting out" reigning popular discontent. While the government could not prevent a vote on the Initiative, it could designate the date of the vote. As a result, the referendum vote on the Initiative was simply postponed on the grounds that the government needed time to come up with a counter-proposal to the Initiative.

In the meantime, the government prepared for renewed snooping. By 1990, Bupo was equipped with ISIS, an automated information system for storing and processing data on persons related to external or internal threats to state security. As the political establishment was well aware, in the aftermath of the snooping scandal, that any attempt to introduce legislation to this effect would be stopped by a referendum vote, ISIS and new rules on internal security were put on a semi-legal basis in 1992 by way of government ordinances.

Bupo was soon at work again and quickly regained the confidence of its foreign partners. During the Gulf War in 1991, Bupo was literally flooded with intelligence from foreign services, while at home, it was assiduously gathering information on people suspected of sympathies with Iraq. It was later learned that 150 municipalities in eastern Switzerland had provided Bupo with the personal data of all their Iraqi residents, stored by a private computer firm hired by the municipalities for their data management.

The reorganization of Bupo was accompanied by an impressive public relations campaign by the federal government aimed at changing the negative public perception of internal security. With the fall of the Berlin Wall, the old justification of political policing—the prevention of subversive Communist activities against the state—no longer held water. As in other countries, "international organized crime", "terrorism" and "violent extremism" became the new terms used by the government to legitimize continued intelligence gathering on persons not suspected of any offense. It should be noted that anti-money laundering—perhaps the only common ground between international organized crime, terrorism and violent extremism—was not listed as a priority. Subsequently, in what critics decried as an exercise of perception

management, government officials banished the commonly used term "political police" from their vocabulary and replaced it with "preventive policing", similar to the replacement of "invasion" by "pre-emptive attack" in the discourse by the Bush administration and the major US media concerning Iraq.

In 1994, the Federal Ministry of Police and Justice ran its highly publicized campaign, "1994—Year of Internal Security". The message was that without internal security, Switzerland risked becoming a safe haven for political extremists, terrorists, drug traffickers and criminal organizations (once again, money launderers didn't make Bupo's first string). Although there was no indication of any serious rise in crime in Switzerland, the campaign succeeded in fuelling subjective sentiments of insecurity among the population and contributed to a growing acceptance of internal security activities and the police in general. The same year, a new provision was included in the Federal Penal Code making "membership in a criminal organization" a punishable offense. There were no anti-money laundering laws on the book. That issue was far from Bupo's concern or that of politicians worried about "national security".

In addition to Bupo, overall federal police services were modernized and enhanced. In the 1990s, new automated databases in the field of policing were set up at a quick pace, among them: RIPOL, a criminal search system; DOSIS, a database on drug-related crime; ISOK, on organized crime; ISIS, the internal security computer; AUPER, a database on asylum seekers; and ZAR, the central database on foreigners.

DOSIS, ISOK and ISIS differ from RIPOL by focusing on proactive, "preventive" intelligence gathering. "Suspects" can be registered without being subject to official police investigation. The three systems also contain very sensitive and unverified intelligence concerning non-suspects such as contacts of persons under surveillance.

There are two separate police structures at the federal level: Bupo and the Bundesamt fuer Polizeiwesen (BAP) federal police office. Unlike Britain and Germany, where intelligence services and police are distinct bodies, Bupo serves as both the federal judicial police in charge of investigations concerning certain offenses under the Federal Prosecutor (arms traffic, illegal technology transfer and other serious crimes considered a threat to state security) and as the intelligence service tasked with the protection of internal and external state security. Bupo is attached to the Office of the Federal Prosecutor.

As for BAP, before 1990, it was no more than a subsidiary coordination structure without operational powers, serving and assisting the judicial police of the Cantons. At the time, a thorough reorganization and reinforcement of BAP was under way. The trend was towards making BAP a central police authority, comparable to the German BKA federal office of criminal investigation.

BAP is comprised of seven separate central criminal investigation departments: organized crime, drug trafficking, counterfeiting, migrant trafficking, pornography, the national Interpol unit, and an office on money laundering. Since the mid-1990s, staff has increased from just seven to 93.

More recently, the central services were linked more closely through the creation of two inter-service coordination structures: a "crime analysis" unit, functioning as an information hub for the various specialized criminal investigation services tasked with drawing up crime analyses for prosecution authorities; and an "operations" unit coordinating inter-cantonal and international investigations concerning drug trafficking and counterfeiting.

These new developments suggested that Switzerland was actively setting up a powerful central police authority, inspired by both the German BKA and by Europol (the European Union central police and internal security service).

The new internal security activities and policing in Switzerland were probably best illustrated by the Bundesgesetz zur Wahrung der Inneren Sicherheit (Federal Law on the Protection of Internal Security). The law, commonly known as the "Internal Security Law" (SPL), was approved by Parliament in March 1998. Opponents of political policing launched a referendum campaign against the bill. But times had changed, and the campaign failed to gather the necessary 50,000 signatures by a margin of 300. Then, since the time was clearly ripe, on 7 June 1998, the "No State Snooping in Switzerland" initiative finally came to a vote—some ten years after the referendum on the abolition of Switzerland's internal security service had been proposed. The Swiss electorate rejected by a crushing 75 percent a proposal, probably unique in a Western country, for the simple abolition of the Bupo "political police".[6] The proposal was submitted as an obligatory referendum question in accordance with the Swiss Constitution, having been requested by more than 100,000 citizens, and supported by the Social Democratic Party, the Greens and labor unions. The defeat meant the end, at least for the time being, of the country's largest opposition movement since the end of World War II. Thus, the Internal Security Law entered into force on 1 July 1998, just weeks after the defeat of the "No State Snooping in Switzerland" Initiative. The SPL had placed Bupo secret intelligence activities on a statutory footing for the first time.

In an apparent concession to public concern, the law states that as a rule, Bupo and the security services of the Confederation and the Cantons are not authorized to gather or process information on political activities relating to the exercise of freedom of expression and freedom of organization. This general rule was, however, crucially weakened by an exception clause: the gathering and processing of the above types of information were authorized where there were "reasons to suspect" that organizations, or their members, "use the exercise of their political rights as a pretext for perpetrating or preparing acts of terrorism, illegal intelligence or violent extremism." Note again the clear lack of anything targeting money laundering. The law fails to define the terms "reasonable suspicion", "terrorism" and "violent extremism". Thus, critics claim that the clause amounts to actually authorizing continued "preventive" snooping on individuals and groups on political grounds, without any need for Bupo to substantiate its suspicion of a crime.

Interestingly, attempts supported by the Staenderat, the federal parliament's Upper House, to extend the scope of internal security activities to "organized crime"—which would probably have included money laundering—

did not materialize. The idea of giving internal security services a role in fighting organized crime was strongly contested by the judiciary and regular police, both on the federal level and in the Cantons. The dispute ended in a compromise formula. Under the Internal Security Law, Bupo was not tasked with gathering intelligence or carrying out investigations relating to organized crime or money laundering, but was merely required to forward relevant information it accidentally came across to the appropriate authorities.

The SPL also establishes an obligation for public authorities, administrations, and data registers to spontaneously inform Bupo, whenever they become aware of "concrete threats" against internal or external security. Bupo has direct access to all information stored in public registers such as ZAR, AUPER, social security and health care registers. Moreover, the federal government could decree that, for a limited period of time, "private organizations with public functions" must send information on security threats to the federal police. The law does not specify what is meant by "public functions", but, according to the prevailing interpretation, the provision is applicable to any private organization offering aid or assistance of some form to a wide public, such as charities and legal aid organizations.

The law authorizes internal security services of the Confederation and the Cantons to gather information without the targeted persons being aware. It authorizes video and audio recordings, for purposes of surveillance of "occurrences" at any place open to the public (from public squares to restaurants). These activities may be carried out without a criminal investigation being ordered and with no requirement of approval by a judge. Note that these provisions of the law come several years before the 11 September 2001 attacks would encourage similar laws throughout the world. Swiss internal security services could also monitor movements and contacts of targeted persons for the purposes of establishing personal profiles. In doing so, the services can, for example, contact an employer behind the targeted person's back or accept information provided by "spontaneous" private informers, such as neighbors and colleagues. Finally, surveillance measures may be extended to "contact persons", meaning family members, friends, and colleagues of a targeted person.

Even after the conclusion of a penal procedure, the Federal Police may retain certain personal data gathered in connection with the procedure: data on accused (not necessarily guilty) persons, where there are "clues" ("Anhaltspunkte") suggesting that they can provide information on threats against internal or external security; and data on non-accused persons—witnesses— where there are "verified clues" ("gesicherte Anhaltspunkte") that they are associated with members of a "terrorist, violent extremist or criminal organization", again irrespective of their awareness. This provision has far-reaching implications. The law prohibits the use by Bupo of telephone tapping and video or audio surveillance of private rooms outside a criminal investigation. But Bupo may collect and process sensitive personal data on innocent persons, obtained in the course of a criminal investigation through the use of these surveillance methods.

All these data are stored and processed in the internal security computer, ISIS. By 1994, according to official figures, around 40,000 persons

had been registered in ISIS. Since then, no figures have been disclosed. There are no effective restrictions as to the types of data stored in the system. Thus, sensitive information on a registered person's race, sexual behavior, health, and political opinion may be stored, irrespective of whether or not the person is suspected of an offense. All law enforcement authorities and authorities responsible for internal security on the national and cantonal levels have access to ISIS data.

By ordinance, the federal government designates other parties inside the country "fulfilling public functions" to which personal data from ISIS may be sent "in specific cases". The federal police may also, in specific cases, send ISIS data to security organs of foreign countries, if this is considered "imperative in order to protect important security interests" of Switzerland or the receiving state.

In the aftermath of the snooping scandal, individuals were granted a right of access (with certain restrictions) to their own internal security police files. The new Internal Security Law abolishes this right. Under the new law, a person may merely request the federal data protection commissioner to check whether his/her personal data are being processed in accordance with the law. That is also the case in France where you cannot have access to information on yourself held by intelligence services nor, ipso facto, can you challenge the validity of any of that intelligence. In Switzerland, all applicants only receive a form letter from the data protection commissioner, confirming either that no data are being processed unlawfully or that the data protection commissioner has sent a "recommendation" to the federal police concerning the correction of errors. There is no right of appeal against these stereotype answers. Moreover, it remains the commissioner's secret how data protection will correct erroneous data concerning an applicant, when the applicant himself is denied access to his file. In the US, the Electronic Privacy Information Center (EPIC) has published an extensive country-by-country directory of privacy data protection rights which change all the time.

The Swiss law gives only one exception to the rule of denied access. In "exceptional cases", the data protection commissioner may inform an applicant in an "appropriate way" of contents in his or her file, if the applicant would otherwise suffer "considerable, irreparable damage". This is only provided a disclosure does not entail a "threat to internal or external security". Again, the problem lies in the fact that an applicant will not be able to ascertain or substantiate any damage ensuing from information stored in ISIS, without first having seen the file.

The abolition of people's right of access was sharply criticized by the Special Commissioner for internal security files, Rene Bacher, himself: "For privacy to be protected, not only theoretically but also in practice, every citizen must have the possibility to check, through the right to information, whether what has been stored on him is actually correct or not—because any registration [in ISIS] is undoubtedly negative. But what police have found about a person is not automatically true. Sources of information are often unreliable, mistakes and errors unavoidable". For his part, a senior official of the Federal Ministry of Police and Justice justified the abolition of right of access to people's own personal data as follows: "This solution was found because experience

from abroad shows that, despite a theoretical right of access, prevailing security requirements lead to access being denied in most cases."

A parliamentary committee of six had been mandated with monitoring internal security activities in the early 1990s, when ISIS went into operation. However, Heiner Busch, a leading German expert on policing, now living in Switzerland, is doubtful about the effectiveness of parliamentary control. He points out that the members of the Committee are bound by secrecy and are largely dependent on information provided to them by internal security officials. The Committee presents a report once every four years. According to Busch, the first report did not even contain statistical information that would have provided some insight into the extent of internal security activities. Commenting on individuals' right of access to their own data, Busch emphasizes that persons registered in ISIS without being suspected of any offense actually have fewer rights than persons under criminal investigation. Indeed, the latter have a right to see all incriminating information used in a criminal procedure.

Advocates of internal security have praised the new law for putting an end to unlawful political snooping on innocent citizens. But has it really done so? Critics find the law has given political policing an appearance of legitimacy. This has been achieved by formally establishing a link between political policing and the prevention of threats against public security such as "terrorism", "violent extremism" and "organized crime". Opponents of internal security argue that it will be easy for Bupo and, increasingly, regular police services, to continue to register innocent people merely on the grounds of their political dissidence by construing their alleged "affiliation" with an "environment" regarded as a security threat. The case of the two members of parliament who were registered because they signed an appeal against genetic technology is an illustration of how political policing is likely to be justified in the future.

The original report on the new internal security law by Nicholas Busch was published by the organization, Fortress Europe?, in its *Circular Letter* (n. 55) in August 1998. As one can see, the main concern was "national security" which did not include "organized crime" and its specialized subdivision, money laundering.

The following year, in 1999, money and security were linked together when there were major cases of Swiss banking secrets being leaked to the press and foreign authorities. On 9 January 2000, a Swiss official stated that an investigation into the leaks of Switzerland's vaunted bank secrets had turned up 13 people in eight countries who illegally received data on other people's Swiss bank accounts. The "individuals" (not "services") from Germany, France, Britain, the Netherlands, Austria, Italy, the United States and Israel, received the information from Swiss bank employees and from private detectives. Swiss prosecutors had reportedly uncovered about 60 related cases of suspected industrial espionage and abuse of banking secrecy.[7] The Bupo was at work and it involved "subversives" and money.

In September 1999, another intelligence and security scandal hit the press following publication of the official Brunner Report which related how Swiss intelligence had supposedly been taken out of the hands of the military, reorganized and given new resources. In early June 2000, Jacques

Pitteloud was nominated to the post of Intelligence Coordinator, the first sign of the new reform. Pitteloud, 38, a former member of Swiss military intelligence, was from the Valais region and trained as a lawyer and a diplomat, quite a mixture for a young man who was supposed to reorganize a national intelligence service.[8]

The new "reorganization" didn't promise anything good for anti-money laundering. In November 2000, *Intelligence* noted that four of the Finance Ministry's six officials—yes, six officials for all of Switzerland—charged with combating money laundering had resigned, officially because of an internal dispute within the Money Laundering Control Authority and linked to procedural matters.

This led to resignations, including that of the deputy director, Michele Tonelli, who had recently taken up the position. According to the government, personal matters and a "strong job market" were the main reasons behind the resignations, along with the high exposure of anti-money laundering jobs and the heavy workload. Indeed, if only six officials were all that were available. Specialists say frustration is rife among such officials because of inadequate means at their disposal (particularly when compared to the resources put into "state security" that doesn't involve anti-money laundering). The resignations were not the first among those charged with fighting money laundering in Switzerland. Daniel Thelesklaf and Mark Van Thiel, two top officials in charge of money laundering at the Justice Ministry, stepped down accusing the government of failing to come up with a clear strategy for dealing with money laundering.

In its November 2000 article, "Switzerland: Recycling Spies & Money Laundering Fighters",[9] *Intelligence* mentioned that some past intelligence initiatives of Hans Wegmuller, who had recently been appointed head of the Services de Renseignements Strategiques (SRS), had found their way into the local press, and for good reason: Wegmuller tried to recruit journalists to spy on each other. During the 1990 parliamentary investigation of the snooping scandal mentioned above, the Commission d'Enquête Parlementaire (CEP) examined the activities of the Groupe des Renseignements Strategiques (GRS) and accusations that GRS officer, Wegmuller, tried to place informants inside the Union Suisse des Journalistes and the Mouvement pour la Paix. The day the GRS learned that Swiss television was going to reveal Wegmuller's attempts to recruit a journalist, all surveillance of the two organizations ceased and the journalist was given a job at the television station. The CEP report furnishes details on how Wegmuller made his approach to journalists and Peace Movement members.

In short, when Swiss authorities get exposed, they stop everything, reorganize intelligence and anti-money-laundering, and start anew . . . with more of the same.[10]

# "Son of Star Wars"
# Alive and Well... in Norway

The northern lights, often described as among the most beautiful natural phenomena known to man, appear to have acquired a highly classified security significance within an ongoing "son of Star Wars" program. The US defense community seems to believe that the aurora borealis—which appears as streamers of many colors ascending from above the northern horizon, supposedly of electrical origin—provides a natural model of the larger near-earth space environment as it might become if ever it were to be disturbed by a high-altitude nuclear explosion.

Military planners have long feared that such an explosion, calculated to disable defense and civilian communications and computer systems worldwide, would become the first horseman of the nuclear apocalypse. Although the "Evil Empire" of former American president Ronald Reagan is no more, these fears are now being put forward to explain why a highly-sophisticated US radar system has been deployed—with the approval and funding of the Norwegian government—at Vardo, an isolated coastal village above the Arctic circle, where a US-designated Creek Chart radar installation presently operates, cheek-by-jowl with the Russian military bases on the Kola Peninsula.

Codenamed "Have Stare" in the US, the space tracking and intelligence radar has already been used at Vandenberg US Air Force Base, California, to successfully test a National Missile Defense (NMD) system, which is designed to take up where Reagan's Star Wars left off in the late 1980s. According to the "element descriptive summaries" in the 1998 US Defense Department program, Have Stare—the existence of which was classified until 1993—is a "high resolution X-band tracking and imaging radar with a 27-meter mechanical dish antenna. Have Stare will be deployed as a dedicated surveillance sensor to support the mission of space object catalogue maintenance of deep space object and mission payload assessment." When deployed, according to the Defense Department, the radar will "retain its original design features and their inherent potential to support other missions." Security analysts have suggested that the Have Stare system—emitting a 200-kilowatt beam—will be used for the spectral analysis and signature measurement intelligence of missiles and aircraft exhaust plumes at great distances.[1]

On 24 March 1998, the Norwegian Defense High Command (DHC) issued a press release stating that Norway was establishing a new radar system called "Globus II" at Vardo, about 65 kilometers from the Russian border. Work on the site was due to begin the following month, and the radar would become operational by the year 2000. The statement claimed that the Vardo radar was a joint Norwegian/US enterprise, represented by Norwegian Military Intelligence and the USAF Space Command, and an important task was to monitor objects in space, both active satellites and space junk.

In an interview with the Norwegian daily newspaper, *Bergens Tidende*, published on 4 April 1998, the manager of the Globus II project, Tom Rykken, confirmed that it was actually called Have Stare in the US: "Globus is the name we have used for radars in Vardo for a long time. What the radar is called elsewhere in the world is of no interest to us. It moves to Norway and we contend that Norway is entitled to call the radar whatever we like. We are a sovereign nation and we are not obliged to adopt an American name." Rykken also stated that during its time at USAF Vandenberg, the radar had participated in a NMD test program, but claimed that these tests had a "completely different application than the function the radar will have in Norway. The National Missile Defense is an American effort and does not include Norwegian areas. The radar will have no such function in Norway." He insisted that the purpose of Globus II was exactly as described in the Norwegian DHC press release, pointing out that the project had gone through a "national decision process which builds on this description." Globus II will enhance the ability of Norwegian Military Intelligence to "monitor its geographical area of interest and the main function of the radar is to monitor objects in space." He also claimed that Have Stare was being located in Norway "on these conditions and is subjected to full Norwegian control from day one."

Asked if Globus II was a continuation of Globus I (which was also based at Vardo as part of a project to monitor Russian SLBM [submarine-launched ballistic missiles] tests), Rykken at first objected to the expression "continuation", then admitted that Globus II was "an update, technologically speaking" and finally claimed that using the name Globus "does not mean that different radars by this name have anything to do with each other." When *Bergens Tidende* asked about "auroral measurements", Rykken stated that this was not within the "use areas we have envisioned, however the Norwegian Defense and Research Establishment is running a parallel project to make sure the radar is applied in such a way in Norway that we get the best out of it."

The Norse project manager's view has, however, been contradicted elsewhere. An unnamed former US Army space official, quoted in the authoritative magazine *Inside Missile Defense* on 15 April 1998, was adamant that Globus II was for "intelligence collection" and went on to speculate that because the US may be losing some of its early warning and military intelligence radar capabilities elsewhere, most notably in Turkey, the Vardo site could provide the Pentagon with an ideal backup. Have Stare was apparently considered for installation at Pirinclik, Turkey, which currently operates an American AN/FPS-79 tracking radar following the December

1995 decommissioning of its AN/FPS-17 system. Have Stare will be "not a replacement but a surrogate" for other systems in case they are shut down. In mid-1996, the deputy director of the Ballistic Missile Defense Organization (BMDO), Rear Admiral Richard West, told the US Congress that "if needed," existing forward-based radars such as Have Stare and Cobra Dane in Alaska, "could also be used to support the NMD system, as part of an upgraded early warning radar network."

The Federation of American Scientists (FAS), previously known as the Pugwash Group—its Cold War icon was the clock whose hands clicked so perilously close to midnight during the era of nuclear brinkmanship— warned that there is more happening under the midnight sun than immediately meets the eye. John Pike, then director of the FAS Space Policy Project and a leading US expert on military space, scathingly set out their case. The US Congress, he said, transferred Have Stare from the intelligence budget to the Air Force in 1991. Once the successful test of the system had been completed at USAF Vanderberg in 1995, the Air Force sought a classified overseas location. The location was revealed, according to Pike, when the Norwegian DHC released information about a new radar in Vardo.

"I am surprised that Have Stare is to be deployed in Norway," said Pike. "Since the radar was mentioned in NMD plans, I had anticipated it would go to Misawa, Japan. There, it would be useful for getting a close look at North Korean ICBMs launched towards the US," one of the fears currently motivating the NMD program. Pike described the Norwegian description of the radar project as a "thin cover story which only creates the impression that Norway has something to hide. I have no doubt that they will be doing debris tracking, but there is no way Have Stare would be moving to Norway if debris tracking were its only or even its primary function."

Have Stare, like the Globus I generation of US radar systems located in Norway, will be capable of observing Russian submarine-launched ICBMs from the Barents Sea and perhaps from Plesetsk as well. But scientific logic says that putting the system in Norway means there is more going on "than simple space objects surveillance and it's probably connected with NMD mid-course discrimination", according to Allen Thomson, a well-informed US defense commentator. "Some NMD mid-course discrimination radars would have to look through the auroral zone. The aurora affects radio frequency propagation and it would be prudent to have a good understanding of their effect on a highly-sensitive X-band radar like Have Stare before building an operational system." Norway is a good site for these studies "and the timing isn't bad either as the present solar cycle is on the rise, bringing with it increased solar activity", according to Thomson.[2] "Note that all three explanations proposed for Globus II are compatible with each other", he added. "The radar could get a lot of NMD-applicable auroral data while conducting debris surveys and also take a look at occasional Russian launches."

In April 1998, Norwegian politicians began to wake up to implications of the Have Stare radar deployment in Vardo when the Socialist Party leader, Erik Solheim MP, tabled a number of questions for the Secretary of Defense, Dag Jostein Fjarvoll. Solheim asked if Globus II has "an affiliation with the

rest of the Star Wars program" which he described as "very dangerous because it contributed to making nuclear war thinkable, although as wishful thinking." He also asked why the government failed to provide a full explanation about the radar and its function, claiming the lack of information had created "uncertainty in Norway and fear in Russia." He wondered how the Norwegian DHC can claim to have "full national control" over the project when the Pentagon had earlier selected a classified overseas location to deploy the system, stating "It is interesting to know whether the information that the radar will collect will be passed on to the Americans. . . . We can then suppose that the radar will also collect information which Norwegian sources cannot interpret easily" and some of that information will go to the US.

The chairman of the Norwegian parliamentary defense committee, Hans Rosjorde MP, in an interview with *Bergens Tidende*, on 5 April 1998, confirmed that the Norwegian Parliament had been informed about Globus II "in connection with budget propositions, and that the defense committee "as a defense committee, not necessarily involving the Parliament" had been briefed by Defense Secretary Fjarvoll earlier that year, although the American name Have Stare was not mentioned by the minister during the committee briefing, because it has to do with "the heritage of Globus I and is more site-related than function-related". Thus, in addition to omitting the name, Fjarvoll failed to make clear to the defense committee the extent of the ramifications. Asked about the Globus II's missile defense function, Rosjorde said it depended on which systems make use of the radar "and where it is located in relation to potential threats." He did not exclude that Globus II could be part of the NMD program but claimed "the US defense authorities have not made any mention in that direction." This was clearly more than fudging with the defense committee, which is supposed to deal with such programs. Rosjorde was obviously keeping the Norwegian Parliament in the dark—an instance of the application, in Norway, of administration politics typical of the Bush administration even before George W. Bush arrived at the White House.

On 6 May 1998 Defense Secretary Fjarvoll, who had only been in office since the previous November, told MPs that he did not know "the American name and address of the radar" although it had been tested in the US "for some years" and would be deployed at Vardo. He assured Parliament that Globus II was under "full Norwegian control" because it would be manned exclusively by Norwegian personnel and only they will have access to data in real time.[3] He claimed there was "no coupling" between Globus II and the USAF "in real time" and the radar could therefore not contribute to the NMD program: "This has neither been a Norwegian nor an American precondition for establishing the radar system in Norway", Fjarvoll claimed. He would neither confirm nor deny that Globus II—which he admitted was both an update of Globus I and new technology—was designed to track Russian intercontinental missiles launched from submarines in the Barents Sea or from Plesetsk, because it is part of an "intelligence mission which Norway needs." The defense secretary denied that Globus II would be technically upgraded to transfer data in real time to the US because to do so, it would have to be "equipped and dimensioned" for the task, and have a certain program

software: "This is not the case, it will not be prepared for direct transfer of data." He insisted that the radar is not linked on-line and none of the data collected would be sent out of Norway for analysis. Monitoring space junk—the official task of Globus II—is important to Norway, according to Fjarvoll, because "we are a top space nation. No one is better than Norway in space technology at the moment."

However, convincing the Russians of this has proved more difficult than the Norwegian DHC or Fjarvoll expected, even if they bothered to consider the consequences of upsetting Moscow by selling the idea that Norway needed a high-tech junk-monitoring radar system 65 kilometers from the Russian border. The Russian Defense Ministry's in-house magazine, *Kraznaya Zvezda*, (*The Red Star*) in an article on 28 May 1998, entitled "Do We Need This Globus II", accused Norway of making a less than helpful contribution "to the already difficult situation that has developed in Europe in connection with the NATO eastward expansion", which is unlikely to contribute to "mutual confidence and stability" in the northern region. In rather diplomatic language—compared to criticism of Western defense initiatives during the Cold War—the magazine expressed regret that the Norwegian DHC didn't seem to consider the fact "that the new tracking station in Vardo can be used to harm Russian security." Rather, it was in the Pentagon's interest that Globus II be deployed in Vardo to obtain data about Russian strategic ballistic missile launches from the Plesetsk test site, the Barents Sea and other oceans: "The tracking station will be used to form signature catalogues of the Russian intercontinental ballistic missiles early in their trajectory with the intention of choosing targets in the passive part of their flight. This is confirmed by the soundings rockets launch program at Svalbard and Andoya."

*Kraznaya Zvezda* also claimed that the deployment of Globus II was a possible violation of Article VI of the Anti-Ballistic Missile (ABM) treaty, which prohibits Washington and Moscow from deploying early warning strategic ballistic missile radar outside their national territory, and the transfer of AMB systems and component parts to other states. The Russian researcher Paval Podvig, a senior researcher at the Center for Arms Control, Moscow Institute of Physics and Technology, has pointed out that while Globus II has not been deployed "explicitly as an early warning radar" and is therefore not a "clear violation" of the ABM treaty, it can be used as an early warning radar and integrated into the Pentagon's NMD program. Podvig explained to *Bergens Tijdende* that although the system "is not yet an ABM radar as defined by the ABM treaty, it could become an ABM radar if tested for an ABM role." He also complained about how Washington and Oslo had behaved, saying that they "could at least have informed Russia about the Vardo deployment." Since then, the Bush administration has moved forward with ABM developments in Alaska, despite Russian protests and threats of another arms race.

The Russian ambassador to Norway, Julij Kvitsinkskij, was reluctant to be drawn into this rather esoteric debate on Globus II, explaining that there had been "low level contact" between embassy officials and Norwegian Defense Ministry representatives, and that "the answers to a list of questions"

sent to the ministry—after reports about the Vardo deployment had appeared in the Norwegian press—had been sent to Moscow for analysis. While Ambassador Kvitsinkskij was careful about saying anything which might damage the relationship between Norway and Russia, the Brookings Institute researcher, Stephen Schwartz, unfettered by political or diplomatic considerations, described the Vardo deployment as "quite provocative" and damaging to the "spirit" of the ABM treaty. He explained in *Bergens Tijdende* that if Russia were to deploy a similar system in Cuba "I have no doubt that the United States would raise serious questions about it. . . .The issue is not as clear-cut as the mid-1980s replacement of the old mechanical BMEWS (Ballistic Missile Early Warning System) radars at Thule (Greenland) and Fylingdales [located on the Yorkshire Moors, in the UK, the third and final site—with Thule and Clear in central Alaska—in the BMEWS chain, whose primary task was the detection of ballistic missiles launched from the Soviet Union towards the US] with new phased-array radars . . . Deployment of the Have Stare radar to Vardo for space-tracking or intelligence purposes would not violate the ABM treaty although these activities do have some potential for supporting the ABM systems." The fact that Globus II "will retain its original design features and their inherent potential to support other missions" demonstrates the difficulty of "demarcating" between what is permitted and what is illegal under the treaty.

The ABM Treaty permited the use of space-tracking radar anywhere, and there are no limits on these capabilities other than the ban on deploying "a base for national defense." The Globus II controversy appears to be "another case of looking for loopholes", according to Matthew Bunn, assistant director of the Science, Technology and Public Policy Program at the Kennedy School of Government, Harvard University, and the author of a 1990 study of the ABM Treaty and the various interpretations on what "compliance" actually means. Bunn believes that the language in the NMD documents could be used to question the legality of the Vardo deployment, but unless the Norwegian government becomes concerned, Washington "is certain to simply blow-off such arguments by citing the space-tracking exemption."

While the Pentagon had been quick to exploit the "grey areas" in the ABM Treaty, and with both Washington and Oslo displaying a lack of sensitivity to the compliance issues the deployment created with Moscow, the Russian Foreign Affairs Ministry waited until 18 April 2000 before issuing an official statement, which kick-started the debate on Globus II as work on the 43-meter-tall radar dome at the "classified" Vardo site neared completion. The Russian analysts had reached the conclusion that the US—with Norway's willing logistical and financial contribution to the project—had sited the renamed Have Stare radar at Vardo to monitor Russian ballistic missile tests, an exercise in deception banned under the 1972 ABM Treaty. The Foreign Affairs Ministry also stated that Moscow had received no explanation or clarification from Washington which would "dispel this concern" and added: "As a result of the situation evolving over that radar, Norway can become an accomplice to the violation and subversion of the ABM Treaty. Russia would not like developments to take this course." The Russian ministry referred to

"foreign experts" agreeing that the deployment of the Have Stare/Globus II system was more sinister than either Washington or Oslo cared to admit. These experts included FAS space policy director John Pike, who dismissed as "implausible" the official Pentagon explanation about the NASA monitoring space junk. In the April 2000 issue of the *Bulletin of the Atomic Scientists*, he stated: "One of the standard practices of creating a cover story for an intelligence operation is that the cover story is plausible and this cover story was not. This is the type of radar developed as part of the National Missile Defense (NMD) network, and I assume the reason they put it up there is to monitor Russian missile testing."

Up to this point in the debate, Washington had maintained that the NMD system was to be used to monitor missile threats to the US from "rogue states" such as Iraq, Iran and North Korea, and the possibility of a Russian threat was not mentioned—at least publicly. This was the explanation given by the British Ministry of Defence (MoD) after the Pentagon received permission to upgrade the radar site at Fylingdales in Yorkshire. The Russian Foreign Minister, Igor Ivanov, accused Washington of creating a situation which could lead to a "destructive domino effect for the existing system of disarmament agreements", a view shared by defense analysts in France and Germany, and underlined by US Department of Energy documents obtained following a court order by the Los Alamos Study Group (LASG) which confirmed that the Pentagon plans to develop "new nuclear options for emergent threats."[4] The nuclear stockpile upgrade has been described by LASG director, Greg Mello, as a "shocking disregard" by the US administration of its obligations under existing non-proliferation agreements, pointing out that if Washington cannot abide by the rules, "how can we expect other countries to do so."

Despite the fact that the threat from the Russian Bear has not been mentioned, it appears that even a decade after the ending of the Cold War, CIA and Pentagon hawks as well as senior officials in the various agencies which make up the US defense and intelligence community, have not been entirely convinced about the passive nature of the beast. For example, Russia was included in a 15-year threat assessment projection prepared for the National Intelligence Council, entitled "Foreign Missile Developments and the Ballistic Missile Threat to the United States Through 2015", dated September 1999, under the responsibility of Bob Walpole, of the National Intelligence Office for Strategic and Nuclear Programs. According to the report, North Korea could convert its Taepo Dong-I SLV (space launch vehicle) into an ICBM capable of carrying a light biological or chemical weapon payload. The weapon is described as inaccurate, which would make "hitting large urban targets improbable." The most significant threat is from the Taepo Dong-II, capable of carrying a several hundred kilo payload. An Iranian ICBM could deliver a similar payload "in the last half of the next decade". Russia is expected to maintain its nuclear arsenal "as its economy will allow", but well short of START 1 or 2 limitations. China, which tested its first mobile ICBM, the DF-31, with a range of 8,000 kilometers, in August 1999, will have "tens of missiles capable of targeting the United States, including a few tens of

more survivable land and sea-based mobile missiles with smaller nuclear warheads, in part influenced by US technology gained through espionage." This stockpile includes twenty CSS-4 ICBMs which could reach all targets in the US. Beijing is also developing road-mobile, self-propelled ICBMs which could pose a threat, and the JL-2 SLBM, which will "probably be used to target the US from launch areas near China."

Scientists and nuclear weapons specialists agree that US early warning radars, in general, have poor range resolution—only to 10 meters—which is not adequate to distinguish between hostile missiles and decoys. Globus II has the potential range resolution of 10 to 15 centimeters, making Vardo an "attractive site" for mid-course discrimination, according to defense commentator Alan Thomson, because "it lies under or near to the trajectories to major US cities from many of the current 'bad' countries like Iran, Iraq and maybe China. An easy way to see this is to get a world globe and stretch a string over it between possible launch sites and targets."

Thompson believes that the Vardo site could make Norway a target. Although Globus II may not be part of what's described as "the baseline NMD architecture", its technical capability and geographical location could be used in NMD if required. According to Thompson: "If a crucial NMD function like a mid-course discrimination radar is located in Norway, and Norway has no anti-ballistic missile defense, then that function is the logical target for the first missile. After that, the rest can go to the US."[5]

The Norse have been unexpectedly "hardheaded" about the issue. On 4 March 2000, Norwegian Justice Minister Odd Einar Eorum underlined this by claiming that "there is still a considerable Russian intelligence activity in Norway, and by that I mean all forms of intelligence" because of its membership in NATO. Norwegian Intelligence Service (NIS) analysts, working from SIGINT intercepts at NIS headquarters near Oslo, believe that the country's Arctic north and its NATO installations are of interest to Moscow. However, the minister shied away from explaining what Globus II was doing at Vardo . . .other than drawing Russian intelligence interest. Eorum's cabinet colleague, Defense Minister Elbjoerg Loewer, was just as disingenuous in her explanation the previous month to Norwegian lawmakers demanding an explanation for the deployment of Globus II. Loewer claimed that the radar tracks space junk, carries out research and "monitors Norwegian interests." She said it violated no treaties, but refused to elaborate on its operations. Such a lack of frankness, not to say dishonesty, can only be taken as proof that the truth is elsewhere, that "Star Wars" is still alive in Norway, and Globus II may be its "illegitimate" offspring.

Not true, claims NIS Vardo project leader, Tom Rykken. In a report, published on 6 June 2000 in *Bergens Tidende*, Rykken admitted that there were "two interest groups" in the USAF seeking to manage Globus II technology, an internal strategic stand-off which ran parallel to negotiations between Washington and Oslo prior to the deployment of the radar system at Vardo. Initially the USAF wanted to use Globus II as a "dedicated space surveillance sensor." However, in late 1996, while officials from Norway and the US were considering Vardo as a deployment site, a group within the USAF included

Have Stare/Globus II radar technology in its NMD architecture, called the "Minuteman Option", which involved three forward deployment sites—on the US east and west coasts, and in the western Pacific—linking X-Band radar systems to provide precision tracking and target discrimination. Vardo was not included in the original "Minuteman Option" proposal. When the BMDO claimed that Globus II could be used to support the NMD program, the original, planned and negotiated use of the Vardo site became lost in the confusion, "creating suspicion as to the US intentions with deploying the radar in Norway." Rykken claims that the NMD hawks within the USAF lost the fight to control the radar system: "All ties to missile defense were cut when we agreed to move the radar to Norway with space surveillance as a clearly defined mission. The two groups [within the USAF] also ran on independent tracks. Missile defense was never mentioned in the talks we had with our American partners."[6]

Unfortunately for Rykken, his attempt to explain away the "confusion" was dismissed as disingenuous and illogical. Dan Smith, the director of the Peace Research Institute of Oslo (PRIO), believes the USAF put pressure on the Norwegian Defense Ministry to use Globus II as part of the NMD program, despite claims that several such requests were rejected. "It would be logical", according to Smith, "for the Americans to do so if the radar has the technical possibility to become part of the missile defense system." The US is using the same arguments they used in the mid-1980s, according to the PRIO director, who claimed that Washington offered the system to all European states, including Russia. However, Smith noted, "any independent European observer would say that this missile defense system is the most unintelligent thing one can get started on."

Unintelligent though it may be, Norway, because of its geographical location, has played a front-line role in American SIGINT collection since the early 1950s. There are at least eleven intercept sites and nuclear detection stations which originally targeted the former Soviet Union and the Barents Sea, built by the United States but operated by Norwegian Military Intelligence personnel on behalf of the US National Security Agency (NSA) at Fort Meade, Maryland. The Vardo station was established in 1971, when the submarine-launched Soviet SS-N-8 missile became operational, to target the telemetry from Soviet SLBM tests in the Barents Sea, and intercept signals from Plesetsk, a major Soviet missile-testing center, and once the world's busiest space launch sites. From 1971 to 1973, activity at Plesetsk was also monitored at Orfordness, in East Anglia, in England. Codenamed "Cobra Mist" and described as an "over-the-horizon" radar tracking project, it cost more than $150 million to establish and maintain. It was "one of the most powerful, spectacular and large scale pieces of electronics ever seen in Britain", according to Duncan Campbell, in his formidable study of American military power in Britain, *The Unsinkable Aircraft Carrier*,[7] until funds were "abruptly withdrawn" on 29 June 1973 and 90 local staff were sacked on a day's notice.

In the late 1990s, the FAS Space Policy Project director, John Pike, pointed out that Vardo wasn't even a good location for tracking North Korean

rogue missiles—if that was the real intention behind the Globus II deployment. Nobody took his argument too seriously because North Korea, back in 1994, had made an agreement with President Bill Clinton to suspend its efforts to produce weapons-grade uranium, and dismantle its "offensive/defensive" nuclear program over a period of ten years. In return for closing down the reactor which was the source of fuel for its weapons project—and suspending construction of two larger reactors—the US, Japan and South Korea agreed to build two reactors—"light water" plants—to be used for non-military purposes.

All of this changed with the arrival of George W. Bush at the White House. In May 2001, the Pyongyang regime issued a memorandum accusing the Bush administration of breaking the 1994 agreement. According to its complaint, the first "peaceful" reactor was due to be completed by 2003, but US officials had indicated that the earliest possible completion date was 2008. In September 2002, the director of the Vienna-based United Nations International Atomic Energy Agency (IAEA), Mohamed El Baradei, suggested that the delivery of a light-water reactor might be delayed even longer because of North Korea's non-compliance with IAEA inspectors, who had only been allowed access to the nuclear reactor at Nyongbyon. On 3 October 2002, the assistant US secretary of state, Jim Kelly, armed with US intelligence data, traveled to the North Korean capital to confront senior officials of the Kim Jong-il administration with evidence that enriched uranium production had continued in North Korean reactors over the previous eight years. Without too much beating about the bush, as the Americans had expected, the North Koreans admitted that was the case. When Pyongyang, in the early 1990s, had concluded its inspections arrangements with the UN, it showed IAEA inspectors about 100 grams of weapons grade uranium, extracted by processing nuclear fuel rods. US officials believe that North Korea, since then, has produced enough plutonium for possibly two nuclear weapons. In Seoul, the capital of South Korea, about 55 kilometers from the demilitarized zone—not even a stone's throw away in missile technology terms—the Defense Ministry claims that the North has adopted an uranium enriching method "which does not need large scale facilities to develop nuclear weapons." FAS believes the Kim Jong-il regime is also pursuing a biological and chemical weapons program, and has long-range missiles capable of delivering such destruction.

So where does the Pyongyang admission take the Have Stare/Globus II space-junk versus NMD debate? To the USAF's Misawa Air Base in northern Japan, perhaps, which John Pike suggested was the best location for monitoring North Korea's missiles.

Misawa is the home of the USAF 35th Fighter Wing, which assumed the mission "to promote regional security in the Pacific by providing forward presence, deployable forces and quality mission support" in October 1994. It is also one of the National Security Agency's Pacific Rim sites, equipped with satellite communications intercept capability, which, according to FAS, includes "collecting against Russian Molniya, Raduga and Gorizont systems under project LADYLOVE at a facility six kilometers northwest of the main

airfield." Staffed and maintained by the Air Intelligence Agency's 301st Intelligence Squadron, the electronic equipment, worth in excess of $500 million, includes an AN/FLR-9 circularly disposed antenna array (CDAA) which is part of the Pentagon's world-wide, high-frequency direction finding system. The AN/FLR-9 consists of two rings of HF antennae. The inner ring, approximately 230 meters in diameter, monitors long-wave signals. The outer ring—260 meters in diameter—monitors shorter HF wavelengths, and the staff work in a control room in the center of the array, which is referred to as the "elephant cage" by the operators.

According to Frances Fitzgerald, in her excellent history of Ronald Reagan's Strategic Defense Initiative (SDI), *Way Out There In The Blue*,[8] more money has been spent on SDI than any other US military program, and produced far fewer results. The credit for the "mad national persistence in this endeavor" Fitzgerald believes, goes to "the Great Communicator" whose dream of a world made safe from missiles "became a kind of national bedside story." The problem for Norway is that George Bush Jr., at least, was still wide-awake and listening.. Bush has turned "ballistic missile defense"—which is still technologically flawed—into a political rallying call and major US defense industry moneymaker. With the Bush administration's abrogation of the ABM Treaty, and the eastward expansion of NATO, Russia has replied in kind by setting up a major defense radar station in Belarus pointing west With Norway now a front-line nuclear target for Russian missiles, its secret dealing with the Pentagon having guaranteed its insecure situation, the story of Have Stare/Globus II looks more and more like a precocious classic Bush administration scenario of secret imposition of US military policy.

# The Trumped-up Proof of Libyan Terrorism

On 21 December 1988, a PanAm Boeing flight from Europe to the US disintegrated over Lockerbie leaving 259 people dead. Following a punishing economic embargo and an international campaign to isolate it, Libya was finally forced to negotiate a trial in The Hague under Scottish law of two Libyan intelligence agents indicted for the terrorist act. The trial ended in a contested verdict: one suspect was exonerated and the other was sentenced to life imprisonment.

At the beginning of the investigation, suspicion was directed to small Palestinian groups as well as to Damascus and Tehran. On 19 September 1989, a UTA DC-10 had exploded in full flight over the Tenere part of the Sahara desert causing 170 deaths. Scientific analysis of the UTA flight had even determined that the technology used for the bomb matched that used by a Palestinian terrorist organization.

However, the summer of 1990 marked the onset of the first Gulf crisis. When Syria and Iran joined the American-led coalition against Iraq but Libya did not, the United States, followed by French Judge Jean-Louis Bruguière, decided to abandon their initial conclusions and concentrate on Libyan guilt. Thus, they joined together to incriminate Libya on the sole, extremely tenuous, testimony given in Brazzaville of Bernard Yanga, a Congolese attached to the services of that country.

According to Pierre Pean in *Manipulations Africaines,*[1] from the outset, those involved in the investigation realized how weak their case was, since it was based on the testimony of a single person (Bernard Yanga), which did not coincide with the only scientific proof available, which pointed to the Arab Organization of 15 May, and thus probably to the Popular Front for the Liberation of Palestine—General Command (PFLP-GC) of Ahmed Jibril.[2] Further scientific proof was necessary to substantiate the accusations made by the Congolese informer against Libya.

A special agent of the FBI and member of the prestigious "Explosives" unit, whose job it is to detect the "signature" on bombs and explosives used by terrorist groups, flew to the aid of Judge Bruguière. Tom Thurman had worked on all of the important American terrorist cases since he joined the police scientific laboratory in 1981. His love affair with bombs, explosives and armaments dated from his service in Korea, where he was in command of an armaments plant. However, he was not the type to spend his time

looking through a microscope—for which he was strongly criticized by his colleagues. One of them, Frederic Whitehurst, of the scientific analysis sector, even complained about Thurman in a memorandum to his superior, stating that Thurman, in a case being investigated at the same time as the Lockerbie case, was "fabricating evidence to prove the guilt of Roger Leroy Moody".[3] This type of behavior came to be proved in a number of cases, resulting in Thurman's suspension from the FBI in 1997.[4]

Thurman rushed to the scene of the crime and, like a bloodhound, started to sniff for evidence. Within two days of the explosion of the PanAm Boeing over Lockerbie, he was nosing around the debris of the plane, contacting the Scottish police and his CIA colleagues. The Americans found themselves facing this adrenalin-driven bulldozer envisioning all of the dramatic ramifications of his work. "I can't sleep", this new "Superman" confided, "We are the burrowers of the FBI, the men who dig up material details. We get extremely dirty, actually, filthy dirty."

Thurman's procedure was totally bereft of scientific considerations. He either formed an opinion, or adopted one suggested to him, and then tried to fit it into a scientific framework. Working closely with his CIA colleagues, on both the Lockerbie and the UTA DC-10 cases simultaneously, he appeared to "know" already that Tripoli was guilty on both counts, despite the accumulating proof against the PFLP-GC. That Libya might be a culprit of preference seems reasonable to conclude—American administrations had viewed Qadhafi with animosity for some time, not least because of his support for African American groups struggling for equality in the US, and in particular for Minister Louis Farrakhan of the Nation of Islam.

The CIA provided Thurman with files that, without a doubt, contain the Libyan signature. This was obtained from UTA DC-10 flight UI772 of Saturday, 10 March 1984, operating the connection Brazzaville-Bangui-N'Djamena-Paris, which exploded at 12h35 on the runway of the Chad airport. The explosion resulted in injuries to twenty-five persons (one of whom died several months later). This attack followed Qadhafi's challenge to the French demanding "if they were ready to become involved in a new war in Algeria or Chad". Qadhafi had decided to harass Paris until the three thousand men involved in the French armed forces' "Manta" operation against Libyan-backed forces in Chad were removed, and to prove to the French that, despite all of their soldiers, security was not guaranteed even 1500 kilometers from the "red line" in an area as sensitive as an airport. The French special services concluded that the Libyans were "most probably" responsible. The suitcase carrying the explosive device was probably loaded onto the plane in Bangui in the name of a fictional passenger, Said Youris (in reality a certain Al Masri, who was located in March 1985 in Cotonou, Benin, serving with a local but highly-active Libyan-backed popular movement in favor of Qadhafi). The French Direction Générale de la Sécurité (DGSE) transmitted its findings to the CIA.

The CIA, in addition, passed on to Thurman all of the information involving an attempted attack on the American Embassy in Togo. The security forces in Lome had discovered two suitcases full of "plastiques" and arrested nine persons.

Last, but not least, Tom Thurman was able to work on the CIA's "pet project" file, which served to support the Congolese military forces and put them on the trail of the Libyans. This included the 20 February 1988, arrest at the airport in Dakar, Senegal, of two Libyans, Mohammed Marouk, alias Mohammed Naydi, and Mansour Omran Saber, who were in possession of two MST-13 timers, apparently part of an order from Tripoli to a Swiss firm, Mebo AG, as well as some Semtex and 9 kilos of "plastique". The two men were freed after serving four months in prison.

After a full year and a half of sifting through the evidence, and time enough to have examined all pieces of evidence many times over, he suddenly acquitted himself magisterially—just as the Gulf Crisis began to brew—by "scientifically" declaring his discovery of the "signature" of Libya and the two Libyans, notwithstanding the fact that, up to that point, other investigators' evidence pointed to Syria via Ahmed Jibril's PFLP-GC. Thurman "discovered" a fragment, about the size of a fingernail, of a printed circuit from a timer which could have been at the origin of the explosion. In mid-June 1990, a committee of inquiry submitted a photograph of the fragment to Edwin Bollier, the owner of Mebo AG, for identification. He admitted that it could have been part of a shipment of timers he had sold to the Libyan secret services. He was not permitted, however, to examine the evidence itself. He saw only two fragments of the "famous" timer in September 1999—in Scotland, as part of the Hague-based Lockerbie trial. After examining them under a microscope, he and his lawyer concluded that they did not come from the timer sold to the Libyans, and further, that this timer had not been electrically connected, *i.e.*, that it had never been used. Even more significantly, Bollier concluded that it was not the one pictured in the photograph sent to him in 1990! In May 2000, the Scottish court asked him to identify a piece of the same timer—but this one was carbonized!

The Swiss manufacturer did not hesitate to clamor from the rooftops—more precisely, through the Internet[5] —that the fragments shown to him by the Scottish judge had been altered and that the evidence had been manipulated: "This [evidence] has been falsified by the FBI to sustain its theory of Libyan culpability. What I saw could not have come from Mebo."[6] If one can be objective about a man who has never been too "fussy" about his clients—it seems that he continued to sell timers to Libya after having learned that they were used in terrorist acts and also was a supplier to the Stasi, the East German secret service— it is most interesting to keep in mind the fact that Bollier has not substantially changed his original testimony when considering the history of a second timer involved in the explosion of the suitcase placed in the UTA DC-10.

Up to early 1990, Judge Bruguière was still working on the leads pointing to the PFLP-GC and Shi'ite connections, which appeared to involve Damascus and Tehran, when he received a Congolese report designating Libya as the culprit. This turnabout took place at the same time for the Lockerbie affair and the UTA DC-10 affair, and, from the beginning, there was evidence of the heavy hand of the United States. Like Judge Bruguière, the Americans were aware of the weakness of Bernard Yanga's testimony.

On the initiative of Judge Bruguière and Claude Calisti, an expert of the French Prefecture of Police Scientific Laboratory, Tom Thurman worked on photographs of all of the debris found over a radius of approximately fifty kilometers in the desert of Tenere, which were identified and placed in sealed No. 4 containers during the summer of 1991, along with a small section of the green printed circuit, about four centimeters square, carrying the marking "TY".

The American FBI sleuths, without forewarning the French Justice Department, followed the trail of the TY. "TY" is a trademark of Taryoun in Taiwan, the manufacturer of 120,000 of this type of circuit in 1998, of which 20,000 were sold to the German firm, Grandin, in Fribourg. The FBI then went through the list of Grandin's 350 customers until it came to what it considered an interesting buyer—Hans Peter Wust, a German who in November, 1988, had traveled to Libya, where he had met with someone named Issa El Shaham, who had asked him if he could furnish timers which operated on direct current of 9 to 12 volts, to illuminate aircraft runways at night in the desert. Upon his return to Germany, and supposedly for this Libyan order, Hans Peter Wust contacted the Steinmetz company asking that the batteries be changed to make them more powerful, which was done. Wust told the FBI that he delivered the ordered timers to Tripoli on 20 July 1989. The FBI peremptorily concluded from this information that since Libya had purchased timers with TY circuits from Grandin for its runways, it had therefore also bought the TY circuits that were used to arm the Samsonite suitcase on the UTA-DC10. This "possibility" was all that Tom Thurman needed to "discover" the scientific proof he was seeking of Libya's involvement in the Lockerbie and Tenere incidents.

Even before having so informed Judge Bruguière, the American machine was on the move to enlist London and Paris in its repression against Qadhafi, which resulted in an embargo against Libya. On 15 October 1991, Claude Calisti contacted Judge Bruguière immediately after receiving Tom Thurman's report in which the latter expressed great satisfaction with his exploit of having formal proof authenticating Yanga's testimony with scientific facts. "Formal proof of Libyan guilt" has been provided by the FBI, which, in utmost secrecy, worked on the photographs of the 4-centimeter integrated circuit used in the arming of the suitcase involved in the bombing, Jean-Marie Pontault publicized in the center-right weekly, *Le Point* and in his book.[7] While Pontault implied the proof resulted from a scientific-technical analysis of a piece of debris, in actuality it had come from a highly circumstantial comparison of lists of vendors, purchasers and their intermediaries, with the FBI designating a perpetrator of choice. "Racial" profiling at its finest. Neither Judge Bruguière nor Mr. Pontault stopped to consider why this "proof" had emerged so late in the case, more than two years after the attack, and at such an opportune moment.

Judge Bruguière's accusation adhered word-for-word to the FBI script without taking into consideration the protests and conclusions set forth by French experts. Tom Thurman's assertions, however, gave rise to two counterclaims—one by the 6th Central Headquarters of the Police Judiciary (DCPJ) and the Direction de la Surveillance du Territoire (DST) and one

undertaken by scientific laboratories of the Prefecture of Police (PP). An internal memorandum from the Minister of the Interior, dated 10 March 1991, is categorical: "The examination of the printed circuit fragment found in the debris of the DC10, which was possibly part of the timer which set off the explosion, has been completed. These tests, made in Taiwan and in Germany, however, do not establish that this fragment belonged to a batch of 101 timers ordered by the Libyan, El Shabami Issa." The conclusions of the Police are equally incontrovertible: "We cannot prove that our piece of circuit comes from the first batch ordered by the factory at Fribourg, or if the second batch was modified by Libya."

Judge Bruguière does not further elucidate on the counter-investigation carried out in 1993 by the Police under the leadership of Commissioner Claude Calisti, which took place after that undertaken by the FBI. Following Tom Thurman's report, the little piece of evidence—the "proof"—was removed from the No. 4 sealed container which held all of the debris, and placed into a special No. 4/4 evidence bag, and thoroughly examined from all sides. The first thing that came to the attention of Commissioner Calisti, who is considered to be one of the foremost experts on explosives in the world, was that the debris submitted by the FBI could certainly have come from a timer similar to that given to Judge Bruguière (the same type as those purchased by Tripoli) but in no way did that timer resemble the one which had actually caused the armed suitcase to explode. Commissioner Calisti and his collaborators found no traces of explosives. How could a time bomb causing such serious damage not show any trace, not even a molecule, of the chemical that set off the blast? The FBI tried to put the doubts of their French counterparts to rest by undertaking complicated demonstrations, trying to show that other zones near the bomb were also free of traces of the explosives and that the deformations of the piece of the integrated circuit were surely caused by the force of the blast .

To Calisti, this fragment of the timer absolutely did not constitute scientific proof of Libya's guilt. Calisti's conviction was based on the fact that he was thoroughly familiar with the "technology" of Palestinian terrorist, Abou Ibrahim: under no circumstances could the TY component have been integrated into the booby-trapped Samsonite. It was much too big. The police laboratory maintained its position. Despite his conviction, Calisti went over the debris of the sealed No. 4 container with a fine-toothed comb in an attempt to find another piece of the printed circuit that could have suffered the effects of the blast. This minutious research was also in vain. One is amazed at the similarity of the FBI "scientific" discoveries of proof in both the Lockerbie and Tenere cases. Among the thousands—the tens of thousands—of pieces of debris gathered at both catastrophe sites, in each instance only one fragment of the printed circuit was found, and—miracle of miracles—this one small fragment of the printed circuit could be traced to the Swiss firm, Mebo AG for Lockerbie, on the one hand, and to the Taiwanese firm, TY (Taryoun) for the UTA DC10 bombing in Tenere, on the other.

Despite rebuttal of his assertion by the DCPA, the DST and the PP laboratories, Judge Bruguière chose to believe Tom Thurman, the spurious

proof expert. The initial scientific proof in the Lockerbie case—the booby-trapped suitcase—seemed to involve Ahmed Jibril's Arab Organization of May 15—yet by seizing on a second exhibit, the timer, which was not conclusive, Judge Bruguière, incredibly, twisted the facts to connect the suitcase to Libya.

In the indictment, he explained that in September 1992, the DST was informed that the Libyans were in possession of two armed suitcases. According to the Libyans, these suitcases had been seized in the context of an attack by opposition forces in Libya. Using the DST as a buffer, the judge declared that this was a "maneuver by the Libyans" to point the French investigators in another direction. He proceeded to indict the Libyans.

One of the two Samsonite 200 suitcases on wheels did appear to resemble the one used in the DC10 explosion. "The Assistant Director of the DST, who had examined it in Tripoli," explained the Judge in his accusation brief, stated that the suitcase "had evidently been stored" somewhere without much precaution, as it was very dusty. There also were no indications that it carried an official seal. According to information received, it was said to have been seized in 1987 in Tripoli in the possession of a Libyan dissident linked to the Mugarief group, the main opposition movement to Colonel Qadhafi's regime. The person questioned by the Assistant Director of the DST was Abdallah Senoussi, the head of Libyan exterior affairs, who ended up by acceding to the insistent request of the French police, and producing the suitcases in question. This was done in an impromptu fashion in his office in Tripoli—an imprudent move that the Libyans had cause to later regret.

However, it was on Friday, 15 November 1991 and not September 1992 that Abdallah Senoussi spoke for the first time, in Tripoli, of the existence of this suitcase to intelligence expert, General Rondot, in charge of inquiries. Persuaded that he was providing decisive proof of his good faith, Senoussi brought forth a booby-trapped suitcase identical to that used to explode the UTA DC10. General Rondot took samples of the explosives it contained and took note of the explanation provided by a Libyan official of exterior affairs— "We got this suitcase from a Tunisian member of the Mugarief network. As you know, for a long time the Mugarief faction operated in Baghdad, where it assisted the Hissene Habre regime by providing arms recovered by Iraq after the war with Iran. As you are also aware, Mugarief was part of the Haftar force, which was set up and financed by the CIA in Chad, and subsequently disappeared into the wilderness, also with CIA connivance, shortly after the overthrow of Hissene Habre by Idriss Deby. I am sure you also know that the Mugarief is now installed in the United States."

Another DST mission traveled to Tripoli in April 1992 to—among other things—check the suitcases. On 24 September 1992, Judge Bruguière met secretly with the Libyan Judge Mursi in the French consulate in Geneva, examined the photographs of the suitcases, and retained them in his possession. Many more secret meetings were held before the suitcases arrived in France. However, what the Libyans considered as proof of their good faith was twisted by Judge Bruguière into important proof of their guilt. Taking the view that the Libyans always lie, Judge Bruguière adopted the

position that Libya possessed suitcases manufactured by Palestinian terrorist Abou Ibrahim and that the suitcases used to explode the UTA DC10 came from Tripoli.

However, in the indictment, one "detail" was overlooked: the system used in the suitcases provided by the Libyans was not, according to the FBI, the same as that used to explode the Samsonite suitcase loaded aboard the plane in Brazzaville. This "detail" served to reinforce the conclusions of the French experts under the direction of Commissioner Calisti. Thus, this served to further intensify the reasonable conclusion that the debris of the suitcase and the timer found in the desert at Tenere could in no way be interpreted as a Libyan "signature" of the attack.

Why would Judge Bruguière pursue a Libyan conviction so doggedly? Judge Bruguière was, first, a media hound who spent much of his time polishing his image and stage managing his court appearances and his travels. When he discovered that he could influence French foreign policy and that politicians were afraid of his clout, he undertook and perfected a powerful lobbying system whereby he could impose "his" truth. Judges may be the only professionals left who can read flattering articles about themselves in a now "merciless" press because, under the cover of confidential preliminary investigation, they have access to powerful "scoops". Woe to those who do not give quid pro quo. Judge Bruguière was one of the first to fully comprehend this advantage. The DC10 affair put him in the headlines. The editor of the weekly *Le Point* gave him the kind of coverage that must have hit him like a welcome bombshell of publicity:

> This judge is in the headlines of the *Point* because he represents all that we hold dear as against what we revile—love of justice versus obliging compromise, civic courage versus knee-jerk acquiescence; standing up for what is right versus bending to the reasons of State. He stands fast against terrorism, the war of cowards. He is against the passive investigation suggested to him by the usual "realists" for their own tranquility and that of a tired State.
>
> It is just that Judge Bruguière is one of the last knights in armor in the service of that upstanding old lady we call "democracy". A soldier in the service of justice. He is not a lily-livered pretender such as is in fashion these days. He has no sponsors, nothing to sell or publicize, except the ideal of what is right, the badge of honor of a civilized nation. I am aware that in this day and age this does not ingratiate one in the public eye. So much more reason to give him his due. . . .

This is not quite the truth. The Judge has always been closer to the Place Beauvais (where the Ministry of Interior [police] is located and the *Le Point* interview took place) than he has been to the Place Vendôme (where the Ministry of Justice is located), especially when a powerful right-wing

government was in power. He has remained close to Alain Marsaud since the latter removed his robes of the 14th Anti-terrorist sector to join Charles Pasqua in the Senate. His allegiance to the governing right-wing RPR fed his dream of someday occupying higher positions, such as Director of the DST, or of the police, because this "soldier of justice" has a "tough guy" side to him. Nothing had given him more pleasure than his masterminding—with General Rondot—of the kidnapping of Carlos in the Sudan in 1994. Man of law and order, and the right of the State, Judge Bruguière places himself at the head of the pack when it comes to defending certain rights. However, he has nothing but contempt for those he calls "bleeding hearts", the defenders of human rights, "who play the terrorists' game".

In 1981, the Court of Public Security, which presided over acts of terrorism, disappeared. The first attack involving "Action directe" was given to Judge Bruguière to handle. This was the turning point of his career. He forsook criminal matters to concentrate on terrorism. . . . In 1986, of an average 100 cases he handled, 80 were linked to terrorism. He became the uncontested expert on terrorism, which was traumatizing public opinion, with the result that the newspapers referred to Judge Bruguière as the 'Terrorist Hunter' and the 'scourge' of terrorists. . . .

His methods are sometimes regarded as too expeditious, giving him the reputation of being a different type of judge. He dispenses inquiry tribunals with dispatch, increasing the number of interrogations, summonses, detentions and political provocations. However, cases headlined in the press giving the impression of being already solved, collapse, or turn out to be badly prepared. In January 1999, the court exonerated Carlos of the 1994 attack on the DrugStore in Saint Germain des Près. When the Judge, with great pomposity and the connivance of right-wing Interior Minister, Jean-Louis Debré, hauled off the extensive Islamic network known as "Chalabi", with its 160 members, it led to a huge politico-legal conflict. Thirty-four of those arrested were set free by Judge Thiel, who had taken over the case. Of the 138 who were detained in the gymnasium at the jail at Fleury-Merogis, fifty-one were simply released after several months of preventive detention.

The application of justice in Paris under the heavy hand of Judge Bruguière is now subject to contestation. This kind of enforcement of justice is contrary to any concept of "democracy": this is the Judge's "pet project" and he has not changed his stance since 1986. He does not have to account to anyone. In his position—made to order for him—as first vice-president of the Paris Tribunal, he has reverted it to the status of the "Ancien Regime". Even the Accusation Chamber, which is meant to provide recourse to persons accused of terrorism, operates—according to the lawyers there—as a simple registration chamber of accusation. Since these dossiers are enormous and complicated, the judges go about their business without asking questions . . .

Soon after the US-led invasion of Iraq, Libya and the US (along with the UK) announced that they had come to an agreement on Lockerbie. Forced

by an oppressive regime of sanctions that had been maintained against it for over a decade, Libya finally agreed, in the summer of 2003, to pay $10 million for each of the 270 Lockerbie victims if all sanctions against it were lifted.

Most US families accepted a first payment of $4 million in September 2003 when the United Nations ended its sanctions, following difficult negotiations between France and Libya to obtain the same treatment for UTA DC-10 victims' families. The offer of a further payment of the remaining $6 million—$4 million for the end of some economic sanctions and $2 million when the United States took Libya off the list of nations supporting terrorism— expired on 22 July 2004. Relatives of 230 of the 270 Lockerbie victims signed a recent letter to President Bush, urging sanctions be lifted.[8]

Eventually, US sanctions against Libya were eased—somewhat. But rather than represent this as resulting from the compensation paid to Lockerbie families by Libya, the media portrayed Libya's exit from international isolation to the world as a victory for the Bush regime's war against WMD, as Qadhafi threw in the towel on his meager nuclear program.

France has always demanded equal treatment for all Lockerbie and UTA DC-10 victims. But there has been little public information concerning what this means for UTA families. The agreement, resulting from secret three-way negotiations, did not include France or the victims of the UTA DC-10 bombing since France had not joined Washington and London in invading Iraq.

# Secrecy Rights for Citizens: The Fight for Public Encryption

Before boarding a Paris-Miami flight and trying to blow it up by lighting explosives hidden in his shoes, British "shoe bomber" and Islamic fanatic, Richard Reid, had been "knocking around" Paris looking disheveled and aimless, a few specialists learned in 2002. In reality, he was being taken care of by an al-Qaeda logistic network in Paris that has since been rolled up and he was communicating with his al-Qaeda bosses by using cyber-cafés and encrypting his email messages sent out over the Internet. Almost no noise was made in the press about this particular use of public encryption despite the fact that the US government, and the FBI in particular, had been leading a worldwide battle against the right of the public to use encryption under the banner, "Terrorists will use it".

Well, a terrorist did use it and French and American intelligence had no difficulty finding out what Reid said using encrypted email. Indeed, Reid reportedly only used standard US-government-approved DES with a 30-some digit code key which didn't offer much resistance to US National Security Agency (NSA) code-breakers. But that's not a story receiving wide publicity in the US where a massive effort has been made since the mid-1990s to make sure the NSA, the CIA and the FBI "stayed ahead of the bad guys" and ahead of the concerned public.

In late 1994, public key encryption specialist, Philip Zimmermann, was still under investigation by the United States government for "illegal export of arms" because his Pretty Good Privacy (PGP) encryption system had been distributed outside the US.[1] PGP uses the RSA prime-factoring algorithm which is extremely difficult, if not impossible, to crack even for the American NSA. At the time, Mr. Zimmermann had distributed a message over the Internet saying that he was not "abandoning PGP users outside the US" and was working with the Massachusetts Institute of Technology (MIT) to "make PGP legally available throughout the world." Version 2.6.2 of PGP was already out in the States and was supposed to be compatible with the 2.6.1 version available in Europe from another public encryption specialist, Staale Schumacher, in Norway.[2] In public key encryption such as PGP, a part of the code key is publically available. It can only be used authentically when used in combination with the other secret part of the code key known only to the user.

J. Held made a contribution to the public effort by publishing *Top Secret Data Encryption Techniques*,[3] which provided not only a good

introduction to encryption, but also computer source codes in BASIC programing language for those who really wanted to get to work. Although largely dealing with mono-alphabetic substitution ("a" for "e", "h" for "d", etc.), there were two chapters on poly-alphabetic substitutions ("a" for "e" the first time in the text, "w" for "e" the second time, etc). Beyond that, encryption becomes a branch of higher mathematics and not really adapted for the general public.[4]

Almost a year later, in late 1995, the French "cyber cops" Delegation Interministerielle à la Securité des Systèmes d'Information (DISSI) formally modified encryption rules in France. With only a simple declaration by the provider, encryption systems could be used for protecting passwords, telephone numbers, credit card numbers and other signature-authentification means. Codes used for any other purpose were still to be submitted to the government for approval. The DISSI was examining cost-efficient means of setting up a public key escrow encryption system as recommended by the European Union, a policy not at all in line with what the US government was trying to force on the world.[5]

And if the US government was going to push a computer policy, then Microsoft and Bill Gates were going to make money on it. In early 1997, following a visit to Europe and in particular to the World Economic Forum in Davos, Switzerland, Microsoft boss, Bill Gates, claimed that information security specialists had apparently received an answer to a question that had been haunting them: the US NSA did not have an automated capacity to "sniff out" Internet messages encrypted with Zimmermann's Pretty Good Privacy (PGP). "Manually", NSA specialists reportedly could identify PGP-encrypted files, even when the identifying "header" (the address and other information at the beginning of an email) had been removed. However, Microsoft had an ongoing contract with the NSA to produce just such a "PGP Sniffer" program.[6]

By early 1997, things had already changed. At that time, the US government's attitude, particularly toward Europe and France, was less aggressive and conflictual. It was probably no coincidence that *Intelligence* editor, Olivier Schmidt, was invited at that time to speak at two international security and intelligence meetings, one in the US,[7] and one in Paris, France.[8] Floating around both meetings was a strange but unarticulated consensus that France and the United States were slowly moving toward a form of undeclared "cooperation"—some specialists called it "non-opposition"—on the question of public access to encryption. Both Stewart Baker, former lead counsel for the US NSA, and one of his French counterparts, acknowledged at these meetings that such an undeclared policy seemed to be evolving.[9]

During the 13-14 March, 1997, Western European Union (WEU) intelligence policy meeting in Paris, Schmidt advanced the following: Since early 1995, there had been a law in France stating that the government had the right to be able to understand any communications which take place on French soil. Less universal and more obscure versions of this law had been on the books for many years. For example, it has always been illegal to transmit coded telegrams in France. This "winner takes all" attitude on

eavesdropping—some simply call it "Big Brother"—is not tenable in a modern democracy, Schmidt indicated, pointing out that France had been condemned several times in the European Court for eavesdropping on its citizens, finally resulting in a European Union requirement that France change its laws defining what is, and is not, legal eavesdropping.

At the same time, France had set up a powerful eavesdropping oversight authority, the Commission Nationale de Contrôle des Interceptions de Sécurité (CNCIS), under Paul Bouchet, with the right to carry out surprise inspections of eavesdropping operations and demand on-the-spot justifications. The CNCIS had been instrumental in regulating the "wild west" private eavesdropping equipment market[10] and opening an investigation of wiretaps by officially "unknown" parties of leading public figures such as controversial lawyer, Jacques Verges (who had been contacted by family members to serve as lawyer for Saddam Hussein), left-wing politician, Alain Krivine, and former captain of the elite anti-terrorist GIGN, Paul Barril.[11] The operation, codenamed "Pêcherie" ("Fishing Expedition"), took place between 1987 and 1993 and did not seem to be part of the extensive eavesdropping program carried out by the services of former President François Mitterrand.[12] The CNCIS later obtained the declassification of secret eavesdropping documents to try to prove that Capt. Barril had leaked the above transcripts of wiretaps by the French presidency to the press. But Bouchet and the CNCIS were forced to respect the law, and Capt. Barril then won a libel trial against them for denouncing him in the press without proof.

It seemed that this combination of public accountability for official eavesdropping and government right to access to all communications was slowly making headway in the European Union. Enforcement efforts against drug trafficking, organized crime and international terrorism also provided powerful arguments for this policy. And, of course, in that framework, "Trusted Third Party" (TTP) public encryption systems (where you have to leave your code key in "escrow" with a non-government "trusted third party" that will only give it to the government when there is serious evidence of criminal behavior) were a natural choice—so natural a choice that initial French opposition to TTP as a "US National Security Agency (NSA) inspired Trojan horse" had disappeared over the preceding year.[13] Previously, France and many other nations believed the NSA had the means of spying on any national TTP and stealing the keys in its keeping.

Both the US—given the FBI's trouble in 1997 with its Digital Telephony law similar to the French encryption law—and the software industry were straining at the bit to produce and sell TTP abroad. They were more than happy to see the EU adopt the French policy. The US could immediately sell the necessary software to Europe, and then turn around to tell Americans, "Sorry, this is the quasi world standard, so you have to adopt it too." In fact, when the Clinton administration was building up momentum in 1996 to get its anti-terrorism legislation passed in Congress, it tried to get the Organization for Economic Cooperation and Development (OECD) to back its troubled "Clipper Chip" public encryption program. The OECD didn't, but an OECD commission meeting on 24 March 1997 in Paris on public encryption was

organized as if it were the next step in that mutually-advantageous direction. *Intelligence* stated at the time that "one can expect a low-key public announcement presenting this French policy as the 'wave of the future' solution for this extremely sensitive question."

At the same time, the public was also active.[14] On 21 July 1997, Mike Johnson made his revised and updated "Where to Get the Pretty Good Privacy Program (PGP) FAQ [Frequently Asked Questions]" available over the Internet. This was one of the more complete documents concerning the PGP public key encryption program.[15] The first batch of FAQs concerned availability (commercial, web, ftp, Compuserve, bbs), followed by a bibliography and a section on the touchy questions of "Is PGP Legal?", "What is Philip Zimmermann's Legal Status?", and "Can I Use Encryption Legally?". There was an extensive series of technical FAQs and an interesting section on "Where is PGP's Competition?" (nowhere in sight). The documents ended with an appropriate "How Do I Submit Information Correctly to This FAQ?"

Meanwhile "back at the ranch" in Washington, things weren't going so well. The public encryption battle heated up as a result of "coercive measures to impose widespread domestic adoption of government-approved key escrow encryption techniques."[16] In short, the "trusted third party" would have been the FBI. The pot boiled over on 3 September 1997 when FBI director, Louis J. Freeh, testified before the Senate Judiciary Subcommittee on Terrorism, Technology and Government Information, stating publicly for the first time and in no uncertain terms, that mandatory government-approved public encryption was the only acceptable solution.[17] The US TTP would be the FBI and no one else.

That "raw" statement was such bad press for the Clinton administration's planned encryption policy that the next day the administration's top official on encryption policy, Commerce Undersecretary William Reinsch, backed away from Freeh—the administration's top law enforcement official—by telling the press that "what he [Freeh] proposed was not the administration's policy." Freeh was "left to the wolves" while doing his duty. Reinsch explained that Freeh "has an obligation to tell the Congress what's in the interests of law enforcement, and he did that ... that doesn't mean he was speaking for everybody." To try to further calm things down, Vice President Al Gore told the press on 9 September that "the administration's position had not changed on encryption", apparently re-enforcing the view that Freeh was only speaking for the FBI. On 11 September, with the pot still boiling over, Congress "called time-out" to avoid a bloody showdown by taking two weeks to "think about it" and try to find a consensus approach.

Since public encryption was already "out of the bag" but law enforcement wanted it "back in the bag" and locked tight, there was little hope for a consensus. At best, lawmakers and law enforcement could try to diminish the eternal gap between laws and reality. However, this would not hide the fact that in relation to public use of encryption, the interests of the public are diametrically and permanently opposed to those of law enforcement. Since the ultimate goal of law enforcement—at least in democratic societies— is to defend the public, lawmakers would do well to have the public on their

side in the encryption battle rather than working against it, thereby making the task of law enforcement far more difficult or even impossible. A new cyber-age equivalent to Vietnam War era public courses on civil disobedience and draft dodging—free public courses on using PGP public key encryption on your computer and PGPphone for your telephone conversations—could have been the public response. That was not the Bureau's original intent.

If the US Congress wasn't going to "swallow the pill", Europe definitely would not. On 8 October 1997, the European Commission released a lengthy report claiming that the American approach to public encryption could threaten privacy, stifle the growth of electronic commerce, and simply be ineffective. The report was to become a major obstacle to the Clinton administration insistence that US-government-approved key escrow encryption policy be the only acceptable solution, insofar as US officials had acknowledged that their plan was viable only if other developed countries adopted similar systems. Earlier in 1997 in Paris, the US had failed to impose its plan at the OECD, and later made statements at odds with OECD recommendations concerning public encryption policy. Then the *Wall Street Journal* joined in and published a detailed list of objections to US "key recovery" and "key escrow" systems, such as on what basis could the FBI obtain someone's code key. But Europeans had to come up with better alternatives and, indeed, the European Commission remained vague about favorable alternatives to the American system. The October report did not forbid member countries from setting up national key-based systems. So the battle went on while the Internet continued to explode and people learned to use PGP.[18]

Then, in early 1998, the court joker jumped out with an incredible encryption claim. British GCHQ's little-known Communications & Electronic Security Group (CESG) released a report claiming that it had invented public key cryptography in 1970. According to certain specialists, the claim seemed legitimate and corresponded to rumors that had been circulated for some time. (On the other hand, the British had also claimed to have "cracked" the German Nazi Enigma encryption system when it was Polish military experts who started the work, and then continued it later in France with the French encryption services. When Germany invaded France, the entire team with its "know-how" moved to Britain where the work was finished.) But there was also the possibility that, in the later 1960s, under Admiral Bobby Inman, the US NSA knew about the technique. One specialist recently mentioned that National Security Action Memorandum 160, signed by President John F. Kennedy, was the basis for the invention, which was used for the command and control of US nuclear weapons. At least the Russians aren't claiming they invented it first.[19]

Another joker in the cards was the Clinton administration "Crypto Czar", David Aaron, US ambassador to the OECD in Paris from 1994 to 1997. Aaron worked with the administration trying to impose its public key system, but his irascible and undiplomatic nature didn't help Washington win any partners to its cause. State department telegrams released at that time to the American Electronic Privacy Information Center (EPIC) revealed the obstacles Aaron had encountered when aggressively pushing his case in

Western Europe. Even in Canada, there were misgivings. For example, Linda Watson, director of the export controls division of the Department of Foreign Affairs and International Trade (DFAIT), expressed "mild surprise" when US policy was outlined to her and was able to find reasons to avoid meeting with a US delegation. The economic officer at the US embassy in Ottawa then asked officials from the NSA, FBI and US Customs Service attached to the embassy to contact their Canadian counterparts to push the US policy. In a 19 December 1996 message to the State Department, Aaron reported a telephone conversation with Jon Tate, coordinator of security and intelligence for Canada's Privy Council Office. Tate had asked the US to delay implementing its new policy for six months to a year.

In Japan, authorities requested that Aaron's visit "be kept low-key". Japanese officials from the MITI, the post and telecommunications ministry, the justice ministry and even the National Police Agency asked questions which revealed strong doubts about US key escrow policy. When Aaron showed up in Australia, he ran into a wall: neither Attorney-General Dary Williams nor federal communications minister, Richard Alston, found time to meet him. Even Norman Reaburn, the deputy secretary of the Attorney General's department, and also chairman of the OECD cryptography exports committee, was unavailable to receive Aaron. In diplomatic terms, such snubs were tantamount to a no-confidence vote.

Italy and Holland also demonstrated their reservations, but France gave Aaron a more sympathetic hearing. However, he claimed he found total confusion among French industry and government sectors concerning public encryption. Citing the "balkanisation" of French industry on the encryption question, he declared in a 5 March 1997 telegram: "Executives from the sectors most closely concerned with encryption—telecoms, hardware and software manufacturers and Internet Service Providers—are simply not talking to each other." He also described complaints by the American Chamber of Commerce's telecoms committee concerning the French government's lack of transparency on encryption policy. After a 13 February 1996 meeting with officials from Oracle France, Aaron stated that they were worried about French efforts to restrict the import and distribution of US-made encryption (code keys with 56 bits or more) and would go through Ireland "if France attempted to place unreasonable restrictions on legitimate imports."

When Aaron was appointed Under-Secretary of Commerce for International Trade in September 1997, he ceased to be the Clinton administration "Crypto Czar" and the post disappeared with him. However, Washington's "crypto policy", and particularly that of the FBI, didn't seem to change that quickly. On 17 March, Robert S. Litt, principal associate deputy attorney general, told the Subcommittee on the Constitution of the Senate Judiciary Committee, "We are all looking at this point not to impose mandatory legislation [for law enforcement access to encrypted computer data and communications] and will work cooperatively with industry to find whatever solutions are available." When Wisconsin Democratic Senator, Russell D. Feingold, asked if Litt was representing the FBI position, Litt replied, "Yes, sir." This means the FBI had "temporarily" retreated from its aggressive stance

on encryption and was following the declared White House position. It did not mean "FBI Halts Its Push for Encryption Access Legislation", as the *New York Times* headlined the following day.

The strong lobbying effort by FBI Director Freeh for such legislation wasn't getting anywhere. It was earning more enemies all the time and was increasingly in open conflict with the White House's call for voluntary public key encryption. The FBI's new tactic was therefore to remove that political liability while looking for another strategy. Barry Smith, an FBI supervisory special agent in the FBI's Congressional Affairs office, who had lobbied hard to get a mandatory key recovery bill (where you would have to give your code key to the FBI) passed by the House Intelligence Committee the preceding year, stated that "if we can sit down with industry and reach a technical solution to law enforcement's public safety issues on a voluntary basis, we are happy to do that." This was not what he said in 1997 and could well not be what he would be saying a month later. The FBI was demanding the "ability to protect the public safety and defend our national security", but the public was not invited to discuss the meaning of "public safety" or "national security" which the FBI and the administration were defining by themselves.

At the time, *Intelligence* mentioned that many specialists were agreeing with Wayne Madsen of the Electronic Privacy Information Center (EPIC), who stated that he was skeptical that the FBI's "change" represented any real shift by the administration in the encryption debate. Indeed, Reuters simply described it as "FBI changes tactics in US encryption debate". The computer industry had long proposed to discuss the question with the US administration, which had refused. After all, Litt reportedly said the decision to change tactics was made after canvassing foreign governments and domestic business groups that opposed the measure.[20]

This change of FBI tactics followed the 4 March 1998 announcement by the well-financed and well-connected group, Americans for Computer Privacy, that it would launch a major campaign to educate the public about the need for unregulated strong encryption. It also indicated that the Clinton administration had agreed to work toward resolving problems of controls on encryption. But on 6 March, the telephone industry, the FBI and the Justice Department met behind closed doors and agreed to resume negotiations over implementation of the contested 1994 Communications Assistance to Law Enforcement Act (CALEA) requiring all digital telephone technology to be designed to facilitate wiretapping.

Even then, *Intelligence* noted that the Bureau's efforts could be swamped by the electronic commerce market and new technology. On 17 February 1998, the EU Committee of the American Chamber of Commerce reportedly gave conditional support for a Directive on electronic authentication, meaning strong encryption could be freely used for digital signatures in electronic commerce, a precondition for the growth of Internet commerce. Also on 17 March, MCI chief technology counsel, Tim D. Casey, testifying before a US Senate Judiciary subcommittee, called strong encryption essential to Internet privacy and vibrant electronic commerce, and urged encryption export decontrol and the rejection of restrictive "key-recovery" plans. On 19

March in San Francisco, Network Associates, the largest independent US maker of computer security software, said it would circumvent US export policies by allowing its Dutch subsidiary to begin selling an international version of Pretty Good Privacy (PGP), which did not provide a back door for law enforcement surveillance.

On 22 March, the press announced that Ronald Rivest, a leading computer scientist at the Massachusetts Institute of Technology, had recently posted a short technical paper on the Internet describing a new encryption approach that could circumvent government export policies limiting the foreign sale of encryption technology. The method would "chaff and winnow" digital information, instead of encrypting it, by breaking it into unencrypted packets that are then secretly identified as good information, or "wheat," and gibberish, or "chaff," in such a way that an eavesdropper cannot distinguish between the two.

On 25 March, EPIC revealed that William A. Reinsch, the Commerce Department's Under Secretary for Export Administration, had acknowledged in November 1996 that "escrowed" or "recoverable" encryption techniques pushed by the Clinton administration are "more costly and less efficient" than alternative methods the government was seeking to suppress. The concession was contained in a recently-released high-level document on encryption policy obtained by EPIC.

The FBI had been "swimming against the current" on public encryption for some time. But by late March 1998, it was literally being "swamped" by new technology and "drowned" by the electronic marketplace. Its only hope to "stay afloat" was to "work cooperatively with industry", but many considered it was too late, as the flood gates had been opened wide.

As the FBI and the Clinton administration floundered around for the rest of the year, things were moving in Europe, particularly in France under the Socialist government of Lionel Jospin which, on 19 January 1999, announced that France was suddenly reversing its long-term and traditionally restrictive policy toward the public use of encryption systems and allowing complete freedom of use of systems with key lengths up to and including 128 bits. At the time, only 40-bit keys were legal and they had to be deposited with a trusted third party ... of which there was only one recognized in all of France. Under the old French law, as mentioned above, the government had the right to understand any type of communication using public facilities, meaning post, telecommunications, semaphores, or what have you, although that law was seldom invoked publicly.[21]

The implication of the French decision went far beyond France itself. It was the first splash of a tidal change that was, in all likelihood, going to drown the restrictive international public encryption policy the US was still trying to impose on the world in the name of fighting crime, drugs and terrorism. France, which, before 11 September 2001, had probably suffered more deaths in the past few years from foreign terrorists than any other developed nation, "heard the players, questioned the experts and consulted its international partners" and explicitly decided that American high-tech eavesdropping and economic espionage was more detrimental to French interests than terrorists

using encrypted communications. The American menace was easily discernable in the opening lines of Mr. Jospin's statement concerning this tidal change in encryption policy: "With the development of electronic espionage instruments, cryptography appears as an essential instrument of privacy protection." No mention of crime, drugs or terrorists.

Since the EU had already imposed much stronger privacy protection laws than those in the US, had debated the threat posed by the NSA Echelon worldwide telecommunications surveillance system, and had resisted "falling in line behind the FBI" on public eavesdropping, experts clearly expected all EU countries to announce public encryption liberalization similar to that of France in the near future. Indeed, the developing EU strategy seemed to be to let the "uppity, snobbish Gallic French stand up to the Americans", something the French have always done with pride. Then, "once the rampart is breached", suddenly the other EU countries would follow suit in a movement that could only have been negotiated and organized beforehand. Specialists knew it was coming on drug policies, but very few anticipated that a French Socialist government would stand up so unexpectedly to French security and intelligence services (which imposed the 40-bit key limit, a record lower limit in Western countries) and to the US. But it had been done, the floodgates were open. *Intelligence* wrote: "Watch what's going to happen. . . ."[22]

The most obvious foreseen consequence was the development of a new EU public encryption policy to encourage "harmonization" (meaning 128-bit keys for everybody), "economic development" (meaning the production of EU encryption software more powerful than legally-exported US products) and "integration" (meaning 128-bit encryption can be legally used between all EU countries and not just inside each country). The latter was an inevitable consequence of the French decision, but it would take time and was likely to be resisted by all EU national intelligence services, with the French services probably fighting the hardest . . . and the Dutch the least. But the wave of the future was there and a lot of "securicrats" had already gotten their feet wet.

Soon they would be "all wet".

*Intelligence* was right. On 24 March 1999, the US House Judiciary Committee approved the Safety and Freedom through Encryption (SAFE) bill which substantially relaxed US export controls on powerful encryption software. On 31 March, powerful Senate Commerce Committee chairman, John McCain (R-Arizona), who once backed domestic controls on encryption, stated he planned to submit legislation to liberalize the export of the data-scrambling technology. About the same time, Barbara A. McNamara, deputy director of the NSA, testified before a House Judiciary subcommittee that the NSA would be "vulnerable" (less effective) due to the export of powerful encryption software, should the proposed SAFE Act become law.[23]

The following month, public encryption got another boost from Richard M. Smith, head of Phar Lap Software of Cambridge, Mass., when he showed that an obscure identifying code in Microsoft Office documents (the "globally unique identifier" or GUID) in the registration software for Windows 98 and in every document created with Microsoft Office, could help link the Melissa computer virus to a computer in New Jersey, which led to the arrest of a

suspect. In short, secret identifiers are hidden in "normal" Microsoft products and unencrypted messages. Smith had also tried out Anonymizer to see if it really protects the identity of those who use it on the Internet. He easily defeated several of the services offered and found flaws that could enable a web site operator to disable the privacy protections used by the services offering anonymity or trick the operator into passing along information that could be used to identify visitors to the site. The operators of the compromised anonymity services—Anonymizer.com (www.anonymizer.com), the Naval Research Laboratory's Onion Router (www.onion-router.net), the Lucent Personalized Web Assistant service (www.bell-labs.com/project/lpwa) and Aixs.Net (aixs.net)—were reportedly scrambling to patch the security holes while public encryption specialists were laughing at the new inadvertent publicity for their services.

There was also further technical progress in encryption for public use at RSA Data Security Inc. RSA announced on 14 April 1999 that it had been awarded a US patent on data encryption technology that improves the performance of smart cards and other small computing devices. The patent was for a technique dubbed "storage-efficient basis conversion" and was designed to ensure compatibility between two implementations of elliptic-curve cryptography (ECC), widely considered the "next big thing" in encryption. The existence of two common but conflicting numbering systems for ECC limited its usability and acceptance. Basis conversion resolved the incompatibility between the polynomial and normal bases for calculation and did so in a manner efficient enough to be handled within small or constrained computing appliances such as pagers, cell phones, or smart cards. Until early 1998, RSA—the largest company in the encryption field at the time and a de facto standards-setter—had generally downplayed the idea that ECC would displace the more established RSA methods of encoding and deciphering protected data.[24] Also on 14 April, *Wired* published a detailed and useful history of the development of public key cryptography. The six-page article was entitled, "The Open Secret". *Intelligence* stated that it should be considered required reading for anyone in information security.

In the spring, at the Eurocrypt '99 conference, well-known Israeli cryptographer, Adi Shamir, presented a new machine—Twinkle[25]—that could increase code-breaking factoring speed by a factor of 100 to 1,000. The device made it possible to factor 512-bit keys for RSA and other public key encryption systems. The best factoring algorithms all work on similar principles: a massive parallel search for linear equations with certain characteristics, known as the sieving step, generates a number of relations which are solved by a massive matrix operation that produces the prime factors. At that time, 200 computers had worked in parallel for about four weeks to find relations to help factor RSA-140, but the matrix operation had to be done on a single supercomputer. It took a large Cray about 100 hours and 810 Mbytes of memory to factor RSA-140. Shamir conceptualized a special hardware device that uses electro-optical techniques to sieve at speeds much faster than normal computers. According to well-known cryptographer, Bruce Schneier,[26] the basic idea was not new since a mechanical-optical machine, built by D.

H. Lehmer in the 1930s, did much the same thing at a much slower speed. The new machine had not officially been built and did not affect the work of the matrix step. Nonetheless the moral, according to Schneier, was that it is prudent to be conservative—all well-designed security products had gone beyond 512-bit keys years ago.[27]

Public access to powerful encryption continued to progress and then the issue reached the courts. On 6 May, the US Court of Appeals for the Ninth Circuit ruled that federal regulations that prohibit the dissemination of encryption source code violate the First Amendment. The court found that the regulations are unconstitutional prior restraint on speech because they "grant boundless discretion to government officials" and have "effectively chilled [cryptographers] from engaging in valuable scientific expression." The case was initiated by researcher Daniel Bernstein, who sought government permission to export source code he had written. The opinion was notable for its recognition of the threats to privacy citizens faced and the role of encryption in protecting information.[28]

In July, *Intelligence* announced that Rick Eason, of the University of Maine and Eiji Kawaguchi of the Kyushu Institute of Technology had developed a new form of steganography, which literally means "covered writing" and refers back to ancient Greek spies hiding messages beneath wax-covered boards. Eason and Kawaguchi's new coding algorithm was called a form of "digital fingerprinting": hiding encoded information inside imagery data to "tag" it and protect the copyright and prevent falsification. Several such systems had been developed and were at least in prototype format. However, there didn't seem to be any really "on the market" and there had been virtually no independent comparative testing of the different prototypes. Nonetheless, it was a developing field of encryption technology to watch.[29]

In September 1999, we announced that it had been a tough summer for Microsoft, with a major hack of its free Hotmail email service and a well-publicized accusation that it had installed a "back door" in its Windows software permitting eavesdropping by the NSA. On 15 August, in Santa Barbara, California, at the Crypto'99 Conference, Cryptonym's chief scientist, Canadian Andrew Fernandes, gave a "Rump Session" talk on Microsoft's NSAKEY. According to Fernandes, while investigating the security subsystems of Windows NT4, he discovered a "NSAKEY" in Win95/98/NT4 and Windows2000. Building on the work of Nicko van Someren (NCipher), and Adi Shamir (the "S" in RSA), Fernandes was investigating Microsoft's CryptoAPI architecture for security flaws, since CryptoAPI is the fundamental building block of cryptographic security in Windows.

In WindowsNT4 Service Pack 5, Microsoft reportedly "forgot" to remove the symbolic information identifying the security components. It appears that there are really two keys used by Windows: the first—KEY—belongs to Microsoft, and it allows them to securely load CryptoAPI services; the second—NSAKEY—belongs to the NSA, which means that in addition to its public security-related effort to be able to access encrypted messages, NSA can also securely load CryptoAPI services ... on your machine, and without your authorization, which is the conspiracy point of view.[30] The "incompetence is the

rule" point of view is that it permits NSA to securely load its own cryptographic systems . . . because it doesn't trust CryptoAPI. It also probably hinders the installation of any unauthorized—strong—encryption system.

Microsoft took the accusation seriously. On 3 September, it denied it had installed a secret backdoor in Windows software to allow the NSA to snoop on sensitive computer user data. The firm explained that it called its function an "NSA key" because that federal agency reviews technical details for the export of powerful data-scrambling software. "These are just used to ensure that we're compliant with US export regulations," according to Scott Culp, Microsoft's security manager for its Windows NT Server software.

Cryptography expert, Bruce Schneier, stated that Fernandes' claim "makes no sense" because a government agency as sophisticated as the NSA doesn't need Microsoft's help to unscramble sensitive computer information: "The NSA can already do that, and it has nothing to do with this [NSAKEY]."

It turns out that there is a flaw in the way the "crypto_verify" function is implemented, according to Fernandez. Because of the way the crypto verification occurs, users can easily eliminate or replace the NSA key from the operating system without modifying any of Microsoft's original components. Since the NSA key is easily replaced, it means that non-US companies are free to install "strong" crypto services into Windows, without Microsoft's or the NSA's approval. Thus NSA and Microsoft have effectively removed export control of "strong" crypto from Windows. Bravo! A demonstration program that replaces the NSA key was made available on Cryptonym's Web site at http://www.cryptonym.com

In November 1999, *Intelligence* announced that a new version of the freeware version of PGP had been released for both Mac and Windows. It was the 6.5.2a version and could be downloaded from http://web.mit.edu/network/pgp.html. The same issue of *Intelligence* noted that the Committee on Information Systems Trustworthiness (CIST) had been commissioned by NSA and the US Defense Advanced Research Projects Agency (DARPA) to study the effectiveness of the Common Criteria, a new set of information security standards established by NSA, the Canadian Communications Security Establishment (CSE) and the comsec agencies of Great Britain, France, Germany and the Netherlands. The CIST concluded that the standards are "largely fruitless" and "it is not clear it will work any better than previous criteria". So—back to the drawing board? . . . and not only for government spies.

The so-called hacker-proof encrypted digital movie format, DVD, was inadvertently cracked at that time.[31] While they were reverse engineering Windows DVD players, a group of programmers, looking for a way to play DVD movies on their Linux systems, stumbled on a method of decrypting the content scrambling system (CSS) used to encrypt DVD films. CSS can only be unscrambled using a 40-bit key which resides inside any hardware or software DVD player. Each manufacturer has its own unique key and each of the 400-odd possible keys is stamped onto a DVD disc. But the decryption key must first be encrypted to prevent the playback software from

being reverse engineered. During testing, the Linux programmers found one DVD player, XingDVD from Xing Technologies, a subsidiary of Real Networks, which hadn't encrypted their encryption key. The unencrypted key was then used by a group of three Norwegian hackers, known collectively as Masters of Reverse Engineering (MoRE), to create DeCSS, a tiny 60K utility that removes the encryption from DVD movies. There were soon freeware programs on the Internet that removed the copy protection on DVDs, allowing them to be played, edited, and copied without restriction. Information on the hack was posted at:

> http://www.wired.com/news/technology/0,1282,32263,00.html
> http://www.ntk.net/index.cgi?back=archive99/now1029.txt

Summary of the DVD encryption scheme was at:

http://crypto.gq.nu

DVD encryption wasn't the only technology to suffer that fall. On 7 December, reports claimed that two researchers, Alex Birykov and Adi Shamir of the Weizmann Institute in Israel, had cracked the A5/1 encryption scheme that protects communications made over cellphones using the GSM standard. The GSM protocol was employed in more than 215 million digital phones worldwide at the time, including those made by Pacific Bell and Omnipoint. Calling the researchers' claim "ridiculous," an Omnipoint executive stated, "What they're describing is an academic exercise that would never work in the real world. What's more, it doesn't take into account the fact that GSM calls shift frequency continually, so even if they broke into a call, a second later it would shift to another frequency, and they'd lose it." But US computer security expert, David Wagner, believed that the discovery was "a big deal" that put GSM calls "within the reach of corporate espionage".[32]

On 7 December, Finnish Sonera claimed it was the first non-US telecom operator to win the right to use the 168-bit US encryption system called 3DES, or Triple DES, and that it would launch services based on it in early 2000. Sonera said the US was moving to relax encryption export limits and 3DES could be used outside the US except in 12 countries. But by that time, Triple DES had already been cracked and was no longer considered a highly-secure encryption system.

Even if, in early 2000, it looked like the way was open for strong public encryption after the decision by the French government to permit it, and public and Congressional momentum in the United States, there were still "securicrats" that wanted to bridle public access to such programs and government officials willing to listen and act on their outdated arguments. In February 2000, a British Internet think-tank, the Foundation for Information Policy Research (FIPR), stated that British Home Secretary, Jack Straw, was resorting to "key escrow by intimidation". The FIPR was an independent non-profit organization registered as a private limited company in England and Wales under the 1985 Companies Act. The organization was established

to study the interaction between information technology and society, with special reference to the Internet, including the legal implications of public and private sector professional regulations and commercial codes of conduct in Britain and elsewhere, identifying IT issues affecting civil rights, freedom of expression, privacy, the accountability of public administration, social cohesion and access for all to the benefits of new technologies.[33]

The statement by Caspar Bowden, director of the FIPR, was a reaction to the Regulation of Investigatory Powers bill, which was published by the Home Office on 10 February. The legislation had the potential to criminalize—convict and imprison—Internet users who used encryption technology to protect their privacy and forgot or lost the encryption keys. It also required Internet Service Providers (ISPs) to maintain "reasonable interception capabilities", regulated the use of informers by the police, intelligence and security services, and had the legal authority to "compel decryption under complex interlocking schemes".

In 1999, the British Department of Trade and Industry (DTI) had deleted similar decryption powers from its E-Commerce Bill, due to become part of British law in October 2000, after DTI legal advisors convinced the man in charge, Minister Stephen Byers, that a law presuming an individual is guilty, if the person cannot prove their innocence, was incompatible with the European Convention on Human Rights (ECHR) and European Human Rights legislation. Mr. Bowden claimed that the "corpse of a law laid to rest . . . has been stitched back and jolted into life" by Mr. Straw, and believed a test case was inevitable—once the ECHR became part of British law—when tens of thousands of ordinary Internet users would start using inexpensive, off-the-shelf US encryption software "following the recent liberalisation of US export laws".

According to the FIPR—whose directors and trustees included Justice Peter Noorlander, Maurice Frankel from the Campaign for Freedom of Information, John Wadham, director of Liberty, Richard Clayton of Demon Internet, Andrew Graham, Acting Master of Balliol College, Oxford, and retired Ministry of Defence (MoD) senior executive, Brian Gladman—changes made in Mr. Straw's RIP bill on human rights issues "amount to window dressing" when compared to Part 3 of the draft E-Comms Bill (July 1999). Specifically, Clause 46 stated that authorities must have "reasonable grounds to believe" that a person is/was in possession of a key, where previously it had to "appear to the authorities" that the individual under suspicion had a key, a change which leaves unaffected "the presumption of guilt if reasonable grounds exist".

In Clause 49, included to deflate criticism surrounding "encryption e-mail out of the blue" (unsolicitated e-mail, where recipients were never in possession of a key), the prosecution would have to show that the person "has or has had" possession of the decryption key to prove non-compliance with a notice to decrypt. According to the FIPR, the "essential reverse-burden-of-proof" for some one who had lost or forgotten their key remained unchanged, and it was "logically impossible" for the defendant "to show this reliably".

While the British government fought a lost battle, back in the States, in light of the recent changes in export restrictions, the US Commerce

Department abandoned all claims that Prof. Daniel Bernstein was restricted from posting his Snuffle encryption source code on his web site. For several years, Bernstein had claimed the prevention was a Freedom of Speech infringement.[34] "We are still considering our options," Cindy Cohn, Bernstein's lawyer, stated, adding that the Commerce Department had failed to clear up some questions about the new rules.[35]

The battle was almost over. On 3 April, EPIC released "Cryptography and Liberty 2000—An International Survey of Encryption Policies", the third annual survey of encryption policy conducted by the Washington-based research organization. EPIC found that movement toward the relaxation of regulation of encryption technologies had largely succeeded. In the vast majority of countries, cryptography could be freely used, manufactured, and sold without restriction. Back in 1999, the Clinton administration and the FBI were still trying to "hold back the flood". When they failed, they began demanding more intrusive eavesdropping laws and technology imposed on Internet users.[36]

Unfortunately, public resistance to such measures was swept away in the aftermath of the 11 September 2001 attacks in New York City and Washington DC, but it is now returning due to the excesses of the Patriot Act and the Bush administration's anti-terrorism campaign.

# Pinochet Today,
# Kissinger Tomorrow?

No one was more surprised than Augusto Pinochet, the former Chilean military dictator, when Scotland Yard Special Branch officers arrested him on Friday night, 16 October 1998, at London Bridge hospital, on an Interpol "Red Notice" warrant issued at the request of Spanish investigative magistrate, Baltasar Garzon. Garzon wanted to question Pinochet about alleged atrocities committed against Spanish citizens and suspected acts of "genocide and terrorism" committed during the seventeen years that followed the overthrow of the democratically-elected government of Socialist President Salvador Allende in Santiago on 11 September 1973.

Judge Garzon and his colleague, Judge Manuel Garcia Castellon, had spent almost 12 months investigating complaints of brutality and torture against Pinochet and his regime. After several unsuccessful requests, Washington finally agreed in July 1998 to provide classified CIA, National Security Council (NSC), Defense Department and FBI documents to Castellon, who had launched an inquiry in 1997 into Operation Condor, an organized US-supported strategy of repression implemented by various South American dictatorships in the 1970s and 1980s.[1] Originally, the Spanish judges had only wanted to question Pinochet about human rights violations in Chile and Argentina. However, after being warned by the British Home Office that the "patient" was about to check out of the north London clinic, where he was recovering from minor back surgery, to return immediately to Santiago, the Interpol priority arrest warrant was issued.

Earlier that year, the former dictator had taken his seat in the Chilean Senate, which provided him with immunity from prosecution under the country's constitution. He had revised it before his carefully-negotiated handover of power in 1990 to ex-President Patricio Aylwin specifically for circumstances which he now faced—unfortunately on foreign soil. Much to his surprise, this friend and ally of British Prime Minister Margaret Thatcher during the Falkland War in 1982,[2] now had the distinction of becoming the first former head of state to be arrested in the United Kingdom while traveling on a diplomatic passport—a "violation of diplomatic immunity," according to an equally suprised Chilean President Eduardo Frei, who was attending the Ibero-American summit in Oporto, Portugal, when news of the arrest came through. Frei—in the name of the Chilean government—immediately filed a "formal protest" with the UK Foreign Office.

Many former Tory government ministers, including Foreign Secretary Malcolm Rifkind and Chancellor Norman Lamont, began to rally support for Pinochet's release. They claimed his arrest had been a political gesture on the part of the recently-elected Labour government, several of whose members, as students and Labour activists in the early 1970s, had protested against US involvement in the internal affairs of Chile and against well-documented human rights abuses by the Pinochet regime. However, the case against the 82-year-old general had been painstakingly compiled by the Spanish judges, who now had 40 days to draw up extradition warrants. According to Spanish Criminal Indictment documents lodged by Judge Garzon with Central Investigative Court No 5 at the National Court, Madrid:  on 11 September 1973, the Commander-in-Chief of the Chilean Army, Augusto Pinochet Ugarte, born in Valparaiso on 25 November 1915, with Chilean National Identity card number 1,128,923, put into action a plan to overthrow the "constitutional government of Chile and end the life of President Salvador Allende Gossens with a military coup."

General Pinochet was encouraged to seize power by the United States administration, specifically by Henry Kissinger, who chaired the National Security Council 40 Committee, by CIA Director Richard Helms, and by President Richard Nixon, who wanted US covert efforts to concentrate on inducing the Chilean armed forces to stage a military coup. Although $10 million was available  "to make the economy scream" according to Helms, both Nixon and Kissinger had made it clear to the CIA that the assassination of Allende "would not be unwelcome", according to US government documents; at least one NSC option paper discussed various ways this could be done. Efforts orchestrated by CIA operatives to involve the Chilean Army had been resisted by the former Commander-in-Chief, General Rene Schneider. This obstacle was removed when Schneider was murdered during a bungled abduction attempt in October 1970, part of a plot to prevent the democratically-chosen Allende from assuming the presidency. Shortly after Schneider's death, the CIA station in Santiago cabled Langley headquarters claiming "military plotters" had killed the general with "sterilized machine guns and bullets" supplied by the CIA, as declassified US government documents and particularly the Frank Church congressional investigation report would later reveal.

In 1998, for the 25th anniversary of the Pinochet coup, the French/ German cultural television channel, Arte, broadcast a documentary and interviewed surviving members of Allende's staff who were present in the Moneda Palace, as well as other close associates of the Socialist president. One cabinet member stated that Augusto Pinochet had been Allende's "trusted military adviser" until 11 September 1973. The fact that the commander-in-chief had sided with the coup meant, for Allende and his staff, that "all was lost" because Pinochet knew everything—the strengths and weaknesses of the Allende administration. This realization also prevented President Allende from calling for a popular uprising in support of the government, because it would only have degenerated into a massacre of civilians. The adviser interviewed by Arte also stated that Allende and his cabinet colleagues had

decided to hold a national referendum seeking popular support for government policies, with Allende offering to quit if the majority rejected his economic proposals. In a closed meeting with his advisers not long before the coup, Allende had proposed 11 September as the date to hold the referendum. However, Pinochet had advised the president that it was too soon and that the referendum should take place later in the month. Classified CIA and US State Department diplomatic cables exist which confirm that Pinochet informed both Kissinger and Nixon about the forthcoming referendum, and both called for a coup on or before 11 September, contradicting the claim that Washington "simply encouraged" the plotters, rather than ordering the coup. In late 1998, the former Secretary of State in the Clinton administration, Madeline Albright, stated that "regretfully" all State Department documents concerning the coup could not be declassified. This probably referred to the NSC/CIA "order to proceed" to Pinochet, whom we might describe with some accuracy as a "CIA mole" inside the Allende cabinet. However, on 13 November 2000, while the national and international press was focused on George W. Bush's efforts to secure the presidency in the Miami courts, and dispel allegations of ballot rigging, the National Security Archive (NSA) released over "16,000 secret US records" on the 17-year Pinochet dictatorship. Totaling more than 50,000 pages, the release included numerous controversial files containing documents which the CIA had refused to make publicly accessible until they were pressured by outgoing White House Democratic administration officials to do so.[3]

The Spanish criminal indictment against Augusto Pinochet included a detailed account of those abducted, tortured and killed during the first weeks of the coup. Beginning on 11 September 1973, Pinochet had ordered the arrest of nine senior advisers to President Allende, and fifteen members of the President's Security Guard. Among those taken from La Moneda[4] to Santiago's Tacna Regiment base, where they were tortured and shot, were Jaime Barrios Meza, managing director of the Chilean Central Bank; Edidio Huerta Corvalan, governor of the Moneda Palace; Arsensio Poupin Dissel, a lawyer and member of the Socialist Party's Central Committee; and Julio Moreno Pulgar, office boy and telegraphist. Members of the Socialist Party were detained at the 6th Police Station at 08h45, where their bodies were later found. Other detainees were taken to the Central Post Office where they "disappeared". The widespread repression, disappearances and murders were carried out on the orders of the ruling military junta[5] until 17 December 1974, when Pinochet was named President of the Republic.

In October 1973, according to the Spanish indictment, General Sergio Arellano Stark, acting on the direct orders of Pinochet, traveled to northern Chile to "unify criteria" for trials being carried out by military courts throughout the country. On 16 October, Gen. Arellano flew to Arica and ordered the local army commander, Lieutenant Colonel Ariostel Orrego, to execute fifteen detainees at Serena Prison. The following day, he ordered General Lagos Osorio to kill thirteen civilians detained in Copiapo. On 18 October, Arellano ordered the execution of fourteen people in Antofagasta Prison. They were taken in military vehicles to the "Quebrada El Way" and were murdered at

01h20. Their battered corpses were then dumped on the street in front of the morgue of Antofagasta Hospital.

The Nixon administration was fully aware of the executions carried out by the Chilean armed forces on the orders of Pinochet. A top secret memo from the US State Department to Secretary of State Henry Kissinger, dated 16 November 1973, confirmed that an "internal confidential report prepared for the junta put the number of executions for the period 11-30 September at 320"—three times greater than the publicly-admitted figure. The memo stated that the military junta justified the killings as "legal under martial law" and claimed "fear of civil war was an important factor in their decision to employ a heavy hand from the outset. Also present is a puritanical crusading spirit." According to Peter Kornbluh, an analyst with the US National Security Agency (NSA), this memo is one of "literally thousands of documents in the records of the CIA, the Pentagon, the State Department and elsewhere, that would literally prove Spain's case against General Pinochet."[6]

Despite his infirmity, General Augusto Pinochet arrived in Britain as the titular head of a high-level Chilean military mission. Throughout their visit, which began with an escort through normal Customs procedures to the VIP Hounslow Suite at Heathrow Airport, the Chileans were accompanied by a senior official from the British government's Defence Export Sales Organisation (DESO). Top of the mission's list of priorities was a visit to the Ministry of Defence Royal Ordnance plant at Warminster, in Wiltshire. Here, they were to review the progress of Project RAYO, a new, 160mm, multiple-launch system under joint development by Royal Ordnance and the Chilean defense contractor, FAMAE. Formerly a state-owned manufacturer of military equipment, Royal Ordnance had been taken over by the country's largest defense manufacturer, British Aerospace, which had been hoping to win all, or part of, a major fighter aircraft contract for which the Chileans were seeking tenders. Furthermore, according to Major Alan Sherman, head of the Defence Manufacturers Association, the Chilean delegation was also looking to buy "military engineering equipment, such as portable bridges and mine-clearance devices." On top of all these smaller contracts, the mission was expected to discuss the prospective purchase of two or three used British Type-22 frigates which had reached the end of their operational life with the Royal Navy. Two of Chile's top naval officers, Vice-Admiral Couioumdjian and Vice-Admiral Torres, were due in Britain the following month to negotiate the finer points of the sales contract.

When Pinochet was taken into custody in mid-October, the annoyance within the Chilean military establishment was made clear: the two naval officers cancelled their visit to the UK. Two Chilean army deals with other British companies—the purchase of 400 general-purpose machine guns (in addition to the 100 already sold) and a tank-training contract—were also shelved. The British MoD made its own position clear in a statement which expressed optimism that "both sides believe that a satisfactory resolution concerning General Pinochet will enable dialogue to be resumed."

Since the beginning of 1995, Pinochet had made at least three visits to the UK on military procurement business, and had been welcomed by

senior mandarins at the Foreign Office with all the pomp and ceremony reserved for a retired head of a friendly state. The first trip involved the signing of the RO/FAMAE contract in September 1995; the second visit, in October 1996, was to "review progress" on the project; the third visit was made in 1997 in connection with the multi-launch missile system, an indication of the importance the Chilean Defense Ministry attached to the RO/FAMAE deal, which also provided the defense forces with state-of-the-art MLMS technology. This extensive arms trade between Chile and the UK extended back to the 1982 Falklands/Malvinas conflict. Shortly after the Argentinean invasion of the disputed south Atlantic islands in April that year, the British ambassador in Santiago, Mark Heath, opened highly secret negotiations with the Chileans.[7] This back-channel diplomatic axis and an "intelligence cooperation agreement" between London and Santiago were two of the most sensitive subjects of the Falklands War. Under the deal, signed by both governments and initialed by Ambassador Heath and Augusto Pinochet, the British were granted access to all Chilean intelligence on the Argentinean armed forces, including the latest "order-of-battle" data. The agreement also provided for the use of the Punta Arenas base by British surveillance aircraft, and for the deployment of Special Air Service (SAS) and Special Boat Squadron (SBS) units.

After the deal was signed, several Canberra PR-9 aircraft especially equipped for high-level photo reconnaissance were dispatched from their headquarters at RAF Wyton. They landed at an airbase in the Caribbean state of Belize—until 1981 a British colony—where they were painted with false Chilean Air Force markings. From there they flew to Punta Arenas in the far south of Chile.[8] There, they spent the rest of the south Atlantic campaign providing photo reconnaissance and signals intelligence for the British military. The whole operation was supervised by a senior RAF intelligence officer, Group Captain David Edwards. After the war, the Canberra aircraft were sold to the Chileans at a knockdown price. Also, under the terms of the Heath/Pinochet deal, the Chileans were offered a squadron of Hawker Hunter jets and the complete (and very secretive) removal of all arms purchase controls, such as the requirement to apply for export licenses and to supply end-user certificates. At one point, this "gratitude" extended to nuclear items including enriched uranium and even a Magnox reactor. On the diplomatic front, the British government also promised to undermine human rights abuse investigations that the United Nations was expected to initiate into the conduct of the Chilean military junta after 11 September 1973. A British base in Antartica—Adelaide Island—was also signed over to Chilean authority.

As the military relationship between Chile and the UK blossomed during and after the Falklands War, so too did the intelligence relationship. In the early 1970s, the British Secret Intelligence Service, MI6, had reduced its presence in South America to just two stations in Rio de Janeiro and Buenos Aires. The last station head in Santiago before the Treasury-initiated overseas cutbacks took effect was David Spedding, who served as Second Secretary at the UK Embassy from 1972 to 1974, and later became MI6 Director from 1994 to 1999.[9] After the Falklands invasion, the MI6 Buenos Aires station

chief, Mark Heathcote, moved across the Rio Plata to Montevideo.[10] MI6 quickly reopened its Santiago station, and while Canberra PR-9s provided a steady stream of shared photgraphic reconnaissance and SIGINT material, British naval vessels used Chilean territorial waters to maintain surveillance on Argentina's southernmost naval and air force bases. When a British frigate, appropriately named HMS Brazen, ran aground in a channel between islands in the Tierra del Fuego in 1994 while handling such a clandestine reconnaissance task, it was the Chilean Navy that eventually freed the stricken vessel.

Of course, General Pinochet did not suffer the indignity of having to appear in court in person to answer the charges on the extradition warrants. His well-paid and extremely efficient legal team handled that "tasteless business" on his behalf. Within a week things were looking promising. On 21 October 1998, while the ailing octogenarian remained under police guard at the London clinic, Lord Chief Justice Lord Bingham, sitting at the High Court with Mr. Justice Richards and Mr. Justice Collins, quashed both Spanish provisional extradition warrants made at the request of Judge Garzon. They ruled that nothing invalidated the "principle" that one sovereign state "will not impede another in relation to its sovereign acts." He also added, "I would say for my part the applicant [Pinochet] is entitled to immunity as a foreign sovereign from the criminal and civil process of the English courts." The Crown Prosecution Service (CPS) was given leave to appeal the High Court decision to the House of Lords, while in a separate development the Attorney General, John Morris QC, refused to give his consent to applications from human rights groups for General Pinochet to be prosecuted in a British court for torture offences.

On 11 November, a 300-page formal request from the Spanish government for Pinochet's extradition landed on the desk of the Home Secretary, Jack Straw. The document accused Pinochet of genocide, torture and terrorism, and implicated the general in 3,178 murders or "disappearances" during his 17-year rule. There were also arrest warrants pending from French and Swiss authorities, which would come into effect if the Spanish warrant failed. The pressure on Straw to allow extradition hearings to begin increased a fortnight later when the Law Lords, by 3 votes to 2, unexpectedly ruled from the plush red leather benches of the House of Lords, that the former Chilean military dictator was not immune from prosecution for the savage acts committed in his name. General Pinochet followed the proceedings "live" on BBC television from Grovelands Priory Hospital, north London. The first two lords to speak—Lord Lloyd and Lord Slynn—confirmed the High Court ruling that Pinochet enjoyed "sovereign immunity." When Lord Steyn and Lord Hoffman (both originally South African) spoke against this, the crucial vote was left to 66-year-old Lord Nicholls, who ruled that no one, not even a head of state, could get away with certain abhorrent crimes: "International law has made plain that certain types of conduct, including torture and hostage-taking, are not acceptable conduct on the part of anyone."

With Santiago promising to fight extradition proceedings to the "bitter end", ex-PM Thatcher arguing that Pinochet should be sent home on

compassionate grounds, and Tory leader William Hague accusing the government of incompetence, Prime Minister Tony Blair, through his Downing Street office, issued a statement explaining that Straw's decision on whether to allow a full extradition hearing at Bow Street Magistrates' Court, or to send Pinochet back to Santiago, would be taken in a semi-judicial capacity, not a political one.

Whatever the options Straw may have been considering in late November, his decision was postponed following a ruling by a second panel of five law lords in December that the case for immunity against extradition to Spain would have to be reheard: Lord Hoffman, a member of the original panel which had voted in favor of extradition, had links to Amnesty International as an unpaid director of Amnesty International Charity Ltd., which funded research into educational and human rights projects involving ex-political prisoners and victims of repressive military regimes. Since his semi-retirement from power, Pinochet had become Chile's chief arms buyer, representing the armed forces, government agencies and private defense manufacturers involved in the country's multi-million dollar indigenous weapons industry—a role which might have negatively influenced a humanitarian such as Lord Hoffman to vote against immunity. Six months later, after twelve days deliberation, the Law Lords, under the supervision of Lord Browne-Wilkinson, voted for a second time in favor of Spain's extradition request. This led to Home Secretary Straw ordering a formal hearing on the issue.

Meanwhile, friends of the general rallied international support. Some former "comrades in intrigue" such as Henry Kissinger, however, were reluctant to become too involved and possibly draw attention to themselves and their own association with the Chilean coup and the resulting repression. Indeed, a devastating article, "The Case Against Henry Kissinger" by Christopher Hitchens, had already appeared in *Harper's Magazine*. A "Kissinger Watch" was set up on the Internet soon afterward and he was served with a summons during a trip to Paris. He reportedly has not participated in another important meeting in Western Europe to avoid the possibility of being served with another summons or perhaps even being arrested.

Margaret Thatcher argued that Pinochet's alleged crimes were committed in Chile, not in Spain, and therefore only the Chilean regime had the right to put him on trial. However, this argument is seriously undermined by the fact that details of Pinochet's links with European right-wing terrorists are disclosed in FBI files obtained by the NSA at George Washington University in Washington, DC. The files include letters written by Michael Vernon Townley, an expatriate American, born in Iowa, who became a naturalized Chilean citizen. Townley was employed by Pinochet's intelligence service, Departamento de Inteligencia Nacional (DINA), as a bomb-expert and assassin. DINA was headed by Colonel Manuel Contreras, who reported exclusively to and received direct orders from Pinochet, according to the US Defense Intelligence Agency (DIA). The letters were found by the FBI during its investigation of the 21 September 1976 assassination on Embassy Row in Washington, DC, of the former Chilean ambassador to the US, Orlando Letelier, and his 25-year-old American secretary, Ronnie Moffitt, by a Townley-made bomb planted beneath the driver's seat of the car.

Written between April and September 1976, the letters refer to a visit to Spain by General Pinochet in November 1975, shortly after the death of Spanish dictator, General Francisco Franco, to direct planned clandestine operations of "the Italians" and other groups of Fascist terrorists. These included elements of the French Organisation de l'Armée Secrète (OAS) who enjoyed "special privileges" under the Franco regime "while they engaged in assassinations and dirty tricks against the dictator's [Franco's] enemies all over the world." In 1974, after the initial purge of alleged enemies at home, Pinochet ordered DINA agents based at the Chilean Embassy in Madrid to gather intelligence on Chilean exiles in Europe. Operation Open Season began the following year, the third and most secret phase of Operation Condor, according to an FBI cable dated 28 October 1976 from an FBI official in Buenos Aires to Washington. It involved "the formation of special teams ... to travel anywhere in the world ... to carry out sanctions up to assassination." Townley's team included Mariana Ines Callejas and Virgilio Paz, co-founder of the Florida-based Cuban Nationalist Movement (CNM) and sub-contracted DINA assassins. In July 1975 the team, using rented cars, traveled throughout Europe, reporting on political exiles and the campaigns of solidarity organizations based in France, Belgium, the Netherlands, Luxembourg and Italy. They established contact and cultivated working relationships with extreme right-wing groups willing to kill on DINA's orders.

In September 1976, Townley and his associates traveled to Rome to meet Stefano Delle Chiaie ("Il Caccola"), coordinator of an international Fascist network known as the "Black Orchestra", and to plan the murder of Bernardo Leighton, exiled co-founder of the Chilean Christian Democratic Party (PCD). Rome was also the headquarters of the exiled Allende-associated Popular Unity Party (PPU). Leighton campaigned for a PCD/PPU alliance to restore democracy in Chile. He was also the editor of the exile magazine, *Chile-America*, and spoke frequently at anti-junta rallies throughout Europe.

The attempt to kill Leighton, who was accompanied by his wife, took place in Rome on 6 October 1975, and was carried out by Pierluigi Concuttelli, according to "pentito" Aldo Tisei. Prior to the operation, Virgilio Paz and Delle Chiaie had prepared a scenario designed to confuse the subsequent police investigation and "lead it away from DINA and the Italians [Paz and Della Chiaie]." On 13 October, another false trail was laid when the daily, *Diario de las Americas,* published a communiqué from an organization called "Cero" (the *nom-de-guerre* for CNM) which claimed responsibility for the attempted murder of Leighton and his wife.

On 4 November, a communiqué sent by Cero to the Miami offices of Associated Press claimed responsibility for the assassination of Cuban exile leader, Rolando Masferrer, five days earlier, accusing him of being an agent for G2, the Cuban intelligence service. This communiqué also referred to the failed attempt in Rome, claiming Leighton had been shot through the back of the head with a 9mm Baretta pistol, adding "we are informing you of this to contradict reports in the media and to identify them fully." Townley later told the FBI that the information used in the Cero communiqué had been channeled by "Il Caccola" to DINA headquarters in Santiago and from there to Virgilio

Paz in Miami. According to Aldo Tisei, DINA "reluctantly" paid 100 million lire to Delle Chiaie, despite the failed attempt to eliminate Leighton.

In a letter dated 26 April 1976 to Gustavo Etchpare, his DINA contact in Chile, Townley wrote about a man, code-named "Alfa", whom the FBI had identified as Delle Chiaie: "There were meetings between his Excellency [Pinochet] and the Italians in Spain after Franco died. Also, the Italians carried out numerous acts of military espionage against the Peruvians and Argentineans, not only in Europe but also in Peru and Argentina." Four months later, on 23 August, Townley wrote: "I haven't spoken about the Italians. I have no idea where they are, nor do I care to know. Alfa [Della Chiaie] got mixed [up] with various people to do business in Argentina. Some of them had very bad backgrounds who Argentine law enforcement agencies are seeking ... The problems with the Italians are serious...For your information, Pinochet had a meeting with Alfa in Spain some time back. Alfa can be much more of an embarrassment for the government in the long run than perhaps the Cubans."

Following criticism in the mid-1970s of human rights abuses in Chile by the British Labour government of PM Harold Wilson, Pinochet ordered Virgilio Paz to travel to Northern Ireland to take secret pictures of high-security prisons, including Long Kesh internment camp, about twenty miles from Belfast. MI5 agents based in the province, who were engaged in a "dirty war" against the Provisional IRA and clandestine psy-ops against PM Wilson and his Cabinet colleagues (the famous "Clockwork Orange" operation described in our previous book) "facilitated Paz's mission". They provided access to and copies of photographs of IRA prisoners taken from official files. FBI reports state the photographs of prisoners—taken after what the European Court would later condemn as "cruel and inhuman treatment"—"were to have been utilized by the Chilean government at the United Nations in order to discredit the British Government for its alleged violations of human rights." Paz successfully completed his task during a four-day visit to Ireland in July 1975. However, the photographs arrived too late to be used by the Chilean delegation at the UN. They subsequently appeared alongside an article criticizing Britain's human rights record in Northern Ireland in the pro-Pinochet, Spanish language Santiago daily, *El Mercurio*, a newspaper which had been used extensively by the CIA to encourage Pinochet's coup against Allende, and which was now in the forefront of the local media campaign to have "the liberator" returned to Chile.

Pinochet's supporters in the UK launched a publicity campaign which included a press-pack for "sympathetic media outlets" and a pamphlet called *The Real General Pinochet*, written by Robin Harris, personal assistant to Baroness Thatcher. The pamphlet described the exiled octogenarian—who had been granted bail and was now confined to a $25,000 per-month, eight-bedroom mansion in Wentworth, Surrey, where he was obliged to take exercise among the chestnut trees and conifers of the property's well-manicured gardens while the Law Lords reconsidered his claim for immunity from extradition following details of Lord Hoffman's links to Amnesty—as the victim of a "politically inspired kidnap" and the "closest thing Britain has to a political prisoner".

The PR campaign had a budget of $550,000, and was coordinated by British-based Chilean professor of law, Fernando Barros, whom opponents claim was a member of the secret Roman Catholic ultra-conservative organization, Opus Dei. It was managed by Bell Pottinger Consultants, a PR agency founded by Thatcher's former media adviser, Sir Tim Bell. A triumvirate of senior Roman Catholic clergy, including the Vatican's Secretary of State, Cardinal Angelo Sodano, Cardinal Media Estevez, and the Papal Nuncio in Santiago, Cardinal Piero Biggio, successfully persuaded Pope John Paul II to intervene on behalf of Augusto Pinochet, who never once expressed regret or remorse for the dead and disappeared during his 17-year rule.

Cardinal Sodano, a close friend of Pinochet, was the "architect" of the Vatican's relationship with the Chilean military junta since 11 September 1973. Described as "ferociously ambitious and traditionally conservative", Sodano was regarded as the second most powerful and influential figure in the Roman Catholic hierarchy. He served as papal nuncio in Santiago from 1977 to 1988 and organized the widely-publicized papal visit to Chile in 1987, which was seen as the Vatican's approval of Pinochet's brutal military regime, despite the jailing, torture and murder of many local priests. The visit went ahead despite opposition from local Catholics, including the Archbishop of Santiago, Cardinal Raul Silva Enriquez, who later provided information to the truth and reconciliation commission about the disappeared following the transition to civilian rule in 1990. Three years later Cardinal Sodano signed a telegram sent by the Pope to mark Pinochet's 50th wedding anniversary, which included a "pontifical autograph" and a "special apostolic blessing as a token of abundant divine graces." The power and international prestige of the Vatican had not been lost on the Chilean government.

Following Pinochet's arrest, the Chilean Under Secretary of State, Mariano Fernandez, had been dispatched to meet Angelo Sodano at Castel Gandolfo, near Rome, on 1 November. The Pope's intervention was confirmed by Foreign Office representative, Baroness Symons, in a written reply to the former Tory Chancellor, Lord Lamont. Although the British FO refused to disclose the nature of the plea, Lord Lamont stated that he was confident John Paul II wanted the general freed and returned home. Lord Lamont described the Pope as a man "who understands the importance of every individual human life, but he also understands the loss of freedom under Communism as it was threatened in South America. Having lived in Poland he understands what a Marxist dictatorship is all about. As a great Christian leader, he values human life and he understands what happened in Chile."

It took 16 minutes for Gaynor Houghton-Jones, the clerk at Bow Street Magistrates' Court in London, to read out, on 27 September 1999, the list of 35 charges of torture and conspiracy to torture against General Augusto Pinochet. The allegations were described as "some of the most serious ever to come before English criminal courts" by Alun Jones QC, acting for the Crown Prosecution Service (CPS). Jones told deputy chief metropolitan magistrate, Ronald Bartle, that the only question to be resolved was whether Spanish Judge Baltasar Garzon had the right to prosecute the 83-year-old dictator for crimes allegedly carried out by agents of DINA, or its successor,

the Center for National Information (CNI) between 7 December 1988 and 21 December 1989—crimes which occurred in Europe, thereby pertinent to certain objections raised earlier by Lord Bingham *et al* in the 21 October 1998 High Court ruling.

On the second day of the hearing, Jones accused the legal team representing General Pinochet of "shabby and underhand conduct" for suddenly revising their arguments against extradition, allowing the CPS, which was representing Spain, "insufficient time to consider its implications." He claimed the general's lawyers, Clive Nicholls QC and Julian Knowles, of trying to conduct an "ambush defence" by attempting to introduce evidence at the last minute to prove there was a political motive to Madrid's extradition request, based on testimony from carefully-selected legal authorities in the capital.

Replying to the 35 listed charges, Knowles claimed many were acts of "spontaneous brutality" carried out by local police and soldiers "similar to the conduct of the British Army in Northern Ireland." He said his client had never "aided, abetted, counseled or procured acts of torture" and that he was not "personally involved" with the human rights abuses, "none of which had taken place in the sitting-room of the presidential palace." Pinochet did not know the victims, he had not ordered torture, and he had no way of knowing that this would happen as a result of the "policies he had instituted," Knowles argued; "having a mere policy does not make you liable as a secondary for any act of torture committed in Chile by anyone, anywhere, at any time."

In his opening address Clive Nicholls claimed his client's hands were "tied behind his back" (under the circumstances a rather unfortunate euphemism, as this was the position in which many of the junta's deceased opponents had been found) because he was not entitled to answer specific charges under British extradition legislation. However, when Alun Jones pointed out that the general's evidence was admissible and invited Mr. Nicholls to call his client, the defense barrister declined the offer on behalf of his client.

On 29 September, in what legal observers regarded as a "desperate" bid, Mr. Nicholls introduced a motion for dismissal of torture charges concerning Wilson Fernando Valdebenito Juica, who died on 15 December 1989, because the victim had died immediately after a severe beating and electric shock treatment at the hands of the Chilean armed forces. Mr. Nicholls stated that "torture requires sustained, severe pain and suffering. If a person instantaneously dies they cannot have suffered severe pain and suffering." Alun Jones described the defense motion as "absurd", pointing out that the victim suffered serious burns to all parts of his body and his "immediate death followed a radical and really severe beating." Referring to defense assertions that the 35 torture charges—which resulted in three cases of murder and one case of suicide in custody—were "no worse than police brutality of the type that continues to be complained about in Chile, Spain and, to some extent, the UK", Jones pointed out that detaining people in tiny cells without food or water for several days was "not comparable" to the indiscipline of a couple of policemen on a Saturday night in Brighton.

On 8 October 1999, Magistrate Bartle ruled that Gen. Augusto Pinochet could be extradited to Spain on all 35 charges listed, including the

wide-ranging conspiracy to torture allegation, which allowed Judge Garzon to accuse the ex-dictator of using torture as an instrument of state policy. Mr. Bartle also stated that the families of the victims had suffered "mental torture". As Frederick H. Gareau has pointed out in *State Terrorism and the United States*,[11] it was a recognized policy decision to "disappear" people for the very effect of mental torture by preventing families from having the relief of closure. Such a ruling would permit the Spanish authorities to re-introduce the cases of 1,198 people taken into police and military custody, who had been tortured and "disappeared" by the regime.

General Pinochet was given 15 days in which to appeal against the ruling in the High Court. If this failed, his lawyers could take the case back to the House of Lords, a process which could take a further two years. In the end, however, the Home Secretary had the final decision, which included the option of releasing the "indicted detainee" on humanitarian grounds. After being in police custody and under rather splendid house arrest since September 1998, the ageing dictator now was well past the "imprison by date" rule under Spanish law, which specifies that no one over 75 years-of-age can be jailed. Extradition and a guilty verdict in Madrid would have meant a substantial fine, a freezing of all assets in foreign bank accounts and financial institutions accumulated by Pinochet during his period in power, and finally deportation, as a convicted torturer, to Chile.

The Pinochet affair was now becoming a diplomatic and legal nightmare for Great Britain, Chile and Spain—and no doubt, for many individuals in or formerly in high places who might well have feared similar fates. At the Foreign Office, senior analysts were advising Foreign Secretary Robin Cook that Britain's relations with several South American countries—which supported Chile's insistence that the "self-designated senator for life" should be returned to face possible trial in the country where his alleged crimes were committed—could be seriously affected. In Santiago, the center-left coalition government headed by President Eduardo Frei, amid rumors of the ageing senator's declining health, feared that Pinochet would die in custody in Britain, and be returned in a coffin to become a martyr for the right. Spanish Foreign Minister, Abel Matutes, told Robin Cook during a summit meeting in Rio de Janeiro of European and South American countries in June 1999, that despite Judge Garzon's "judicial independence and enthusiasm", the Spanish government would not allow Pinochet to enter Spain. In turn, Cook assured Matutes that his government would ensure that Pinochet did not die while under house-arrest in Britain. The Chilean Foreign Ministry was briefed by Madrid on the "latest thinking" in Britain.

In August, the Chilean ambassador to the Court of St James, Mario Artaza, who had refused to visit Pinochet's rented mansion in Surrey, and was reported to be "reduced almost to tears by having to defend a man he despised",[12] was replaced by Pablo Cabrera. Within days of arriving in Britain, Cabrera visited Pinochet and explained the latest strategy to secure his release: health matters and the consequences of his death in custody were the priorities of "Operation Return". He later told journalists that the man he had "found" at the mansion in Surrey had been unable to concentrate on what

was being explained for more than a few minutes, and had no idea why he was under arrest. Ambassador Cabrera's visit in September coincided with a secret meeting at the UN in New York, where the Chilean Foreign Minister, Juan Gabriel Valdes, made a formal request to Cook for Pinochet's return on humanitarian grounds. The request was passed to Straw at the Home Office. The following month, during formal committal proceedings at Bow Street Magistrates' Court, General Pinochet's locally-based doctor, Michael Loxton, told the court that apart from kidney problems, incontinence and diabetes, his patient had recently suffered two minor strokes and that to call him as a witness "would run the risk of him being very ill." The court was also told that, at one point, Pinochet's adviser had called in a priest to administer the last rites of the Catholic Church to a dying man.

In late November 1999, after several meetings with Chilean officials, the Home Office managed to persuade General Pinochet to undergo independent medical tests to be carried out on 5 January 2000 at Northwick Park hospital in west London by a three-man team headed by Sir John Grimlet Evans from the Radcliffe Infirmary in Oxford. After being told of the patient's medical history, including his inability to dress or shave, the team reached the medical conclusion that "further deterioration in both physical and mental condition is likely." After lunch, Dr. Maria Wyke, a consultant neuro-psychologist and fluent Spanish speaker based at Devonshire Hospital, London, carried out a series of psychological tests, including an IQ test, the "Wechsler Adult Intelligence Scale". The test produced a series of contradictory results: a vocabulary test suggested an IQ of 125; a numerical test (remembering a sequence of numbers in reverse) which suggested Pinochet was bordering on the subnormal; and a visual test, which involved completing a series from a collection of pictures, on which Pinochet scored 100. However, in crucial memory tests, he could only remember one detail from a short story he had been told after being asked to recall twenty, and was unable to understand the rules of a game in which he had to pair a list of Spanish words with a key word. After less than an hour, Dr Wyke concluded that Pinochet's short-term memory was seriously impaired, and that the test results were accurate because "his performance on both memory and intelligence tests declined only in relation to the difficulty of the task ... consistent across all tasks."[13]

The report on Pinochet's physical and mental capability was sent to Jack Straw the following morning. It stated that the former dictator was suffering from deteriorating brain damage, a condition which had convinced the medical team at Northwick Park that if he was extradited to Spain to stand trial "he would be unable to understand what was happening or to remember the offences he was accused of committing."[14] After consulting with the government's chief medical officer, Liam Donaldson, Straw announced, on 11 January 2000, that he was "minded" to halt extradition proceedings on medical grounds.

Pinochet's immediate departure was delayed, however, by the Belgium government, which had also requested extradition and now filed for a judicial review of Straw's decision not to release the medical report (the Home Office had reached an agreement with Pinochet's lawyers to keep the

report confidential, even from countries such as Belgium and Switzerland which wanted to extradite the former dictator). In the end, two High Court rulings, involving a panel of three judges, ordered that the medical report should be released "in confidence". Within hours of its being sent to Madrid, it appeared in full in three Spanish newspapers, leaked by the Spanish government which had refused to seek a judicial review of Straw's decision.

Straw's decision, announced six days before the Chilean general election, was supported by Robin Cook and senior Foreign Office officials who wanted to ensure that Britain would not be seen as responding to the demands of a new regime in Santiago. On 17 January, in an ironic and unexpected twist, the Chilean people elected, albeit by a small majority, Ricardo Lagos as the country's first Socialist president since Salvador Allende. Meanwhile, on the tarmac in Bermuda, a Chilean Air Force Boeing 707 equipped with mobile emergency medical facilities, was standing by, waiting to be given permission to land at RAF Waddington in Lincolnshire in the UK. Finally, on 2 March 2000, after 503 days in police custody and under house arrest in Surrey—during which his military and political career had been analyzed in detail in the international media, exposing a brutal background of unrestrained human-rights abuses—Pinochet left for Chile. The plane refueled at an RAF base on Ascension Island. However, instead of flying to the northern port of Iquique, the Boeing flew on to Santiago Airport, where Pinochet was met, at 10h40, by the Army Chief-of-Staff, General Ricardo Izurieta, military dignitaries, his immediate family and friends. While a military brass band played his favorite marches, the 84-year-old Pinochet, wearing a neatly cut blue suit and purple tie, smiled and waved to his supporters as he walked slowly with the aid of a white stick to a military helicopter. The helicopter was to take him to Santiago's military hospital where he was expected to remain for several days, undergoing tests to determine, according to Interior Minister Raul Troncoso, if he was fit to stand trial in Chile. This prediction, like many others over the previous 16 months, proved hopelessly inadequate. At 18h40, under a heavily armed military escort of honor which included helicopters, Senator Pinochet left the hospital for one of his private residences in the city. A series of blood and urine tests had confirmed that the "patient" was in good health, according to the hospital spokesman, Colonel Alejandro Campusano. Asked to explain the recovery, Pinochet's daughter Jaqueline told the local media that her father had boarded the plane in Great Britain a "destroyed" man. However, "bit by bit he recovered while he flew."

Update: On 27 August 2004, the United Nations noted that Chile's Supreme Court "yesterday voted to take away the immunity from prosecution that former Chilean dictator General Augusto Pinochet had been granted as a former president of the country." He may now, once again, face charges on human rights abuses, despite his legal team's assertions that he remains in poor health.

## Chapter Eight

# Losing a Spy Elite: The Chinook Crash and Operation Madronna

At 17h 42, on Friday, 2 June 1994, a Royal Air Force (RAF) Chinook Mk2 helicopter took off from RAF Aldergrove, outside Belfast. On board were a crew of four, and twenty-five key members of Britain's anti-terrorist and intelligence elite in Northern Ireland, en route, according to the Ministry of Defence (MoD), to a top secret security conference at Fort George, Inverness, in Scotland, in order to discuss the latest developments in the war against the Provisional IRA, and play a little golf. After clearing Aldergrove the Chinook's pilots, Flight Lieutenant Jonathan Tapper and Flight Lieutenant Richard Cook, should have programmed the flight path vectors—specific details of altitude and heading, given by the Operations Commander at Aldergrove in accordance with RAF Standard Operations Procedure—into the computerized automatic pilot, called the Mission Management System (MMS), which had been fitted by the helicopter's manufacturer, Boeing, at the company's plant in Philadelphia six weeks earlier.

Flight Zulu Delta 576 headed north/northeast, flying low over the coastal villages of Glenarm and Carnlough in County Antrim. At 17h 47, Flight ZD576 contacted Sinead Swift, the air traffic controller on duty at Aldergrove, to confirm its flight path and position and signed off by stating: "Approach F40 at zone boundary. VFR operational, good day." This suggests that when the aircraft left the airport control zone it was flying on "visual flight rules"—which meant that it had no obligation to stay in radio contact with air traffic control, nor would ATC try to contact the military flight, a necessary security precaution because there was no way of knowing who else might be listening. VFR also gives the pilot discretion as to the aircraft's altitude, and if the MSS was operational, the Chinook should have been flying at "at least 1000 meters, depending on the terrain", according to Mrs. Swift.[1] At 17h 55, David Murchie, the lighthouse keeper on the Mull of Kintyre—a former policeman, trainee pilot and helicopter enthusiast—heard the twin-engined Chinook approaching at "cruising speed" and assumed it was coming in to land at a helipad next to the lighthouse. The area was covered by a dense fog, with visibility down to twenty meters. Although Mr. Murchie was unable to see the helicopter, he had "formed the opinion that it wasn't flying at very high altitude" and was concerned that the pilot might not see two electricity

pylons close to the landing pad. He left the lighthouse and at approximately 17h 59, he heard a "dull thud followed by a whooshing sound". Within seconds there was total silence.[2] The dull thud was the sound of ZD576 crashing into the 428 meter-high Beinn na Lice, the worst disaster suffered by the RAF in thirty years. Apart from the pilots and RAF loadmasters Malcolm Graham Forbes and Sergeant Kevin Hardie, the victims included ten members of the Royal Ulster Constabulary (RUC) Special Branch, including Assistant Chief Constable Brian Fitzsimons, head of the SB (described by the RUC Chief Constable, Sir Hugh Annesley, as the "finest intelligence officer in Europe"), and three senior officers responsible for the management of covert operations; nine British Military Intelligence personnel, including Colonel Christopher Biles, Assistant Chief of Staff at British Army HQ, Thiepval Barracks, Lisburn, and several members of his immediate staff including three ranking lieutenant colonels of the Province Executive, the highest military intelligence and covert operations group attached to HQNI; six MI5 officers, including John Deverell, regarded as "Number 3" in the Security Service, and a close friend of MI5 Director General Stella Rimington, who was serving as MI5 Director and Coordinator of Intelligence (DCI) at the Northern Ireland Office (NIO), Belfast; and five colleagues seconded to the NIO's law and order division, a cover name for the NIO's MI5 base of operations.

The crash had effectively wiped out about 40 percent of the highest echelons in Britain's counterinsurgency war[3]—and unresolved questions surrounding it keep arising, even now in 2004.[4]

Charred human remains—some still wearing bright orange survival suits—hand luggage, golfing equipment and smoldering aircraft wreckage littered the south face of Beinn na Lice, known locally as the "Hill of Stone". The grass and heather were ablaze, and a strong wind, blowing across the face of the hill, carried a vast amount of paper files out over the sea. All twenty-nine victims died from multiple injuries, mostly to the head, chest and abdomen, according to Dr. Marjorie Black, a forensic pathologist.[5] The burning had occurred after they had died and most were identified from dental records. Neither of the pilots suffered from health problems which might have caused them to lose control, and tests for drugs and alcohol were also negative. Within hours of the military and intelligence authorities being notified of the crash, a blanket of secrecy, as impenetrable as the fog which covered the site, was thrown over the incident. A "Prohibited Air Space Warning", creating a no-fly zone for all civilian aircraft within 30 kilometers of the crash and up to a height of 6,000 meters, was issued by the Civil Aviation Authority to prevent news photographers getting close enough to take pictures. A 20-kilometer ground perimeter exclusion zone was also established, and Rear Admiral Charles Pulvertaft, chairman of the Standing Defence Advisory Committee, issued a "D Notice" to all national and regional newspaper editors, the broadcasting media and specialized publications, forbidding (on a voluntary basis) the publication of material on intelligence matters relating to the crash.

The secrecy imposed by the authorities led to several theories about the cause of the crash. There was speculation that the pilot, Flt. Lt. Cook, may have dropped below the cloudbase to get visual bearings, and was unable

to recover altitude in time to clear the hill of stone; that fire or multiple bird strikes had forced the Chinook to fly low over the sea, with fatal consequences when land loomed in the mist; that both radar altimeters could have been incorrectly calibrated at RAF Aldergrove, after the O/C's briefing, or failed after take-off; or that the aircraft's gears had failed, causing the front and rear rotor blades to collide, resulting in opposing torque forces which ripped the helicopter apart. Gearbox failure was blamed for the crash of a commercial Chinook off the Shetland Islands in November1986, in which 45 oil workers were killed. When seven servicemen were injured in two near fatal crashes on 27 February 1987 and 6 May 1988, it led to the grounding of the RAF's fleet of 33 Chinooks in 1989. An internal inquiry following these incidents recommended equipping the fleet with flight data and cockpit voice recorders. But ZD576 was not equipped with either because it was considered a security risk for aircraft operating in Northern Ireland, in case they should fall into the hands of the IRA which had already shot down several helicopters, using M60 heavy machine-gun fire, since the mid-1980s. On the other hand, British helicopters in Northern Ireland often have more protective armor than normal military helicopters. The British authorities also refused to allow American inspectors from Boeing Helicopter Division to visit the Kintyre site or inspect the recovered wreckage, which had led to media speculation about a mechanical fault causing the crash—a story that apparently originated from an unidentified RAF source.[6] However, within weeks the MoD agreed to provide Boeing customers worldwide with confirmation that there was no gearbox problem, thereby protecting the company's reputation and sales, and avoiding a legal challenge seeking access to the site and/or the recovered debris.

Within 24-hours of the crash, the MoD established a board of inquiry at RAF Benson. There were three members: Wing Commander Andrew Pulford, who was attached to the Army Directorate General Land Warfare HQ (who also had over 2000 flying hours on the Chinook Mk1 with both the RAF and the Australian Air Force), RAF Squadron Leader Gilday, and RAF Squadron Leader Cole, and five "in attendance", including two senior inspectors, Tony Cable and Rex Parkinson, from the civilian Air Accident Investiations Branch (AAIB), who provided technical assistance and advice. On 7 June, after the board of inquiry members had visited the crash site on three occasions, the inquiry president, Wing Commander Pulford, gave permission for the wreckage to be removed.

The board spent eight months examining the events leading up to the crash, taking evidence from civilians who witnessed the final flight of ZD576, and from RAF personnel with Chinook flying experience, checking the performance of the recently fitted technology, including the MSS "fly by computer" system, the FADEC engine control computer system (following a crew-reported problem during a briefing at Aldergrove with the paser-turbine-inlet-temperature of one of the engines) and the Racal Avionics RNS 252 SuperTANS navigational computer, which was installed in a console between the two pilots and processed tracking data from the GPS satellite system and the Doppler Velocity Sensor, which according to AAIB technical input "provides velocities of the aircraft with respect to the earth's surface by

transmitting signals from the aircraft and measuring the returns reflected from the surface." Before leaving Belfast, Flt. Lt. Tapper had complained that the SuperTANS was giving "unusual" GPS readings. A check was carried out, according to the RAF, and no fault was found. There was no maintainance log-entry to confirm that the FADEC complaint had been properly handled. It appears to have been taken for granted by the board of inquiry that the "lagging gauge" problem wasn't serious, and "was not a factor in the accident."

The final draft of the board of inquiry four-part report was handed to the RAF on 3 February 1995, and made public the following June. Part 1 contained the findings and conclusions, as well as the appended review of senior RAF officers, Air Chief Marshal Sir William Wratten and Air Vice-Marshall Day. The board "based its findings on logical argument derived from the limited evidence available" because there were no Accident Data or Cockpit Voice Recorders, survivors or eyewitnesses. However, "after careful consideration . . . the most probable cause of the accident was that the crew selected an inappropriate Rate of Climb to safely overfly the Mull of Kintyre."[7] While the board admitted being unable to positively determine the sequence of events leading up to the accident, it reached the conclusion that "although it is likely that Flt. Lt. Tapper made an error of judgment in the conduct of the attempted climb . . . it would be incorrect to criticize him for human failings based on the available evidence."[8] It was also agreed by the board members that "there were no human failings with respect to Flt. Lt. Cook."[9]

Even though there remained several unanswered questions, such as the purpose of a call (without a prefixed emergency code) made to Scottish Military Air Traffic Control at Prestwick five minutes before the crash, and the "small lateral displacements" to the right of the Chinook's expected flight path, according to recovered computer data, which may have led the crew to believe they were further west than was actually the case, in an area where the board noted "even a minor navigational inaccuracy could have been significant", it is likely that the report would have satisfied those directly involved, including the relatives of the victims, particularly the families of Tapper and Cook, the MoD, the RAF, and Boeing, whose senior executives, Madeleine Bush, the public relations manager in Philadelphia, and her colleague, Jack Satterfield, had been asked by the MoD not to comment on the crash or the inquiry's conclusions.

The appended review of the board's findings by Sir William Wratten and RAF AVM John Day, however, changed the likelihood of the Kintyre crash becoming simply another statistic in a growing list of Chinook accidents, both in the UK and the US. They issued a summary stating that "none of the possible factors and scenarios [considered by the board of inquiry] are so strong that they would prevent such an experienced crew from maintaining safe flight... that the actions of the crew were a direct cause of this crash"[10] and that Flt. Lt. Tapper and Flt. Lt. Cook were "negligent to a gross degree."[11]

In June 1995, the former Conservative Secretary of State, Malcolm Rifkind QC MP, told Parliament that "after an exhaustive inquiry into all the circumstances, the possibilities of major technical or structural failure, hostile action, or electro-magnetic interference with navigation, were eliminated as

possible causes. On all the evidence it was concluded that the cause of the accident was that the two pilots had wrongly continued to fly towards the Mull of Kintyre, below a safe altitude in unsuitable weather conditions. This constituted a failure in their duty, and regrettably therefore, it was concluded that both pilots had been negligent."[12] This astonishing conclusion is strongly contested to this day.

Contrary to the MoD/RAF board of inquiry findings, neither Jonathan Tapper nor Ricky Cook were to blame for the crash, according to a Scottish Fatal Accident Inquiry conducted by Strathclyde sheriff, Sir Stephen Young, at Paisley Court, in January 1996. During the course of the 18-day inquiry, it was disclosed the Flt. Lt. Cook told the duty operations officer in Belfast before the fatal flight that there were "some problems" with the newly introduced Full Authority Digital Engine Control (FADEC) system. It was also claimed that the crew, with RAF permission, had planned their flight to gain more experience at low-level flying, and may have been tempted to complete their journey quickly to avoid exceeding the limit for their flyng time that day. Helicopter crews in Northern Ireland are restricted to seven hours flying per day to avoid making mistakes caused by fatigue. According to an RAF squadron leader (not named for security reasons) who supervised Puma and Chinook operations at RAF Aldergrove, ZD576 had carried out several troop movements tasks on 2 June 1994 in Ulster, before the Scottish trip. He also explained that low-level flying with passengers was not "extraordinary", pointing out that the passengers were "military or military-related and would have routinely flown at low-level before." Asked why permission had been given for what could be described as a "training exercise" involving key members of the security forces' intelligence and counter-insurgency personnel, he told the court that "low-level flying was the safest option for the first leg of the journey across [the Sea of Moyle] to the Mull."[13]

RAF Wing Commander Donald Devine, in charge of military air traffic at the joint RAF/civilian control center at Prestwick, was unable to offer the inquiry an explanation as to why there had been no response when Flt. Lt. Tapper had called Scottish Military Air Traffic Control (SMATC) five minutes before the crash, saying: "Scottish military, good afternoon. This is Foxtrot Four Juliet Four Zero." All three military air traffic controllers on duty monitoring radio traffic that afternoon had their headsets on, and a technical investigation produced no reason why the message—which had only lasted several seconds, and was directed to Prestwick from two radio transmitters about 70 nautical miles from the Mull of Kintyre in the southwest Scottish border region, and on the Isle of Tiree—would not have reached their headsets. Although Prestwick acknowledged having a recording of the message, the lack of response indicates that something was amiss or that someone was lying. There was silence on both sides, indicating no conflicting signals traffic to prevent the duty controllers from hearing it. An air traffic control officer also confirmed that a small blip, seen on a radar screen at Prestwick after the unanswered call, could have been caused by a light aircraft, a flock of birds or something falling off the Chinook. Another senior RAF officer, from 230 Squadron, told the inquiry that the ill-fated Chinook's SuperTANS system

GPS had four receiver replacements within a six-day period from 3 to 9 May 1994, and stated that such persistent failure should have been investigated. Moreover, two engines had also been replaced less than a month before the aircraft arrived in Northern Ireland on 31 May.

The Scottish inquiry was the first public examination of the events surrounding the Chinook crash, and it left a number of questions unanswered, including who arranged the anti-terrorist conference in Scotland to which, strangely, neither the Secret Intelligence Service (MI6) nor its "military wing" the Special Air Service (SAS)—both of whom had a presence on the ground in Northern Ireland—were invited; who briefed the air crew and what flight path (specifically in respect to altitude and heading) they had been given; and who ordered 25 elite intelligence officers to travel together in a helicopter which Flt. Lt. Tapper had complained about "on a daily basis", according to a Special Forces commander tasked with converting standard helicopter pilots into "Special Forces flyers". This commander, who was not identified for security reasons and was not in Northern Ireland in June 1994 (he told Sheriff Young, "I was not in the UK, I don't think I can actually say where I was at the time") said that Flt. Lt. Tapper felt he had not had enough time to familiarize himself with the refitted Chinook during the four days it was based at RAF Aldergrove. Another unnamed RAF Chinook pilot suggested that the accident might have been caused by a "temporary 20 second control jam", and that the MoD/RAF official explanation—incorrect rate of climb—had been based on "speculation and conjecture." This witness also confirmed that Flt. Lt. Tapper was concerned that the Chinook Mk2 was "less capable" than the version it had replaced.

In his closing statement to the Scottish FAI, Mr. Peter Watson, the lawyer acting for Flt. Lt. Cook, said the MoD/RAF allegation of pilot negligence had been based on speculation because no data "black box" or CVR was available, despite recommendations following crashes in the 1980s that they should be fitted to all aircraft. He described the ZD576 crew as highly trained, highly motivated, careful and skilled, adding "that is evidence, not speculation", and he dismissed the theory that a rapid flight was planned to keep within permitted flying time. This was also the conclusion reached by Sir Stephen Young, who blamed the "mystery" on the lack of technical data available to crash investigators.

The lack of CVR and black-box evidence would be referred to in several subsequent reports critical of both the MoD/RAF accident inquiry procedures and the Wratten/Day review of the "open" verdict, when the Chinook mystery moved to the House of Commons. The human factor ensured that relatives of the pilots would be unlikely to let the matter drop, if only to salvage from the wreckage the reputations of both men who were familiar with the terrain—part of the RAF West Freugh training area for Special Forces and the SAS—over which they were flying.

In November 1997, the Defence Secretary, George Robertson (currently Secretary General of NATO), ruled out a new inquiry despite the disclosure of legal action taken by the MoD in the US against the Chinook's engine manufacturer, Textron-Lycoming, in 1989. This information was not made available to the official MoD/RAF inquiry (or at least not mentioned in

the inquiry's official report when it was published in 1996) or to the Scottish FAI. The American firm paid $3 million compensation to the MoD following an incident during ground testing of the refitted Chinook at Boeing's Wilmington-based plant in Philadelphia, when two independent FADEC sensors used to detect engine speed failed. This was interpreted by the computerized system as a loss of power which resulted in too much fuel being pumped to the two turbines which were, in fact, functioning normally at the time, and which almost destroyed the aircraft. Despite the relevance of this incident, the MoD withheld details from the AAIB (which was providing technical assistance to the MoD/RAF board of inquiry), including a highly significant detail: the fault code displayed by the FADEC computer after the Philadelphia incident was E5, the same code found on one of the computers among the debris on the Mull of Kintyre.

Four months later, the Armed Forces minister, Dr. John Reid, (currently serving as Northern Ireland Secretary of State), testifying before the House of Commons Defence Select Committee (DSC), told MPs that there was no evidence that a technical malfunction had cause the Chinook crash, and claimed that the 1989 US incident was the result of "inadequate testing methods rather than design flaws in the software." He denied that the MoD had sued Textron-Lycoming because of FADEC software failure, describing that version of events as "one of the misconceptions that has unfortunately been allowed to flourish." Dr. Reid also dismissed the "grave concerns" about the FADEC system expressed by RAF test pilots based at the MoD's Defence Evaluation and Research Agency (DERA) at Boscombe Downs in Wiltshire, despite the fact that, in October 1993, DERA advised the MoD that they could not recommend Controller Aircraft Release (CAR, air worthiness certification) for the Chinook Mk2 which, because of the extent of the upgrade, was designated a new type of aircraft within the UK fleet and had to undergo tests for a CAR before being returned to service. DERA withheld certification because of the "unquantifiable risk associated with the unverifiable nature of the FADEC software" and concluded that rewriting the software was essential. In order to meet the operational needs of the RAF, the use of the Chinook Mk2 had to be limited to 18,000 kilograms, 26.5 percent below the requirements specification, and thus restricting the payload capacity.

Dr. Reid's evidence serves as an example of what later proved to be the arrogance of senior MoD officials that characterized the search for the truth about the Chinook mystery since the day of the crash. The previous May, the specialized British magazine *Computer Weekly* had published a copy of the MoD's claim against the US company, which revealed that the MoD's case was based on the unreliability of the FADEC software—stating that the system was not airworthy, that the software was not properly documented, and that "almost total reliance on unproven software for engine and aircraft safety constituted a flawed design system." The report also included two previously unpublished memos from the MoD's assistant director of helicopter projects, Captain Brougham. The first, dated 29 April 1994 (a month before the fatal crash), urged senior RAF management responsible

for the Chinook refit to "understand and take full account" of the test pilots' concerns (regarding FADEC) to ensure "satisfaction of all safety case issues" in future negotiations with Boeing Helicopters and Textron-Lycoming. A second memo, dated 11 January 1995, refers to a series of problems with the refitted Chinook fleet, many of which were traced back to "software design and systems integration problems."

*Computer Weekly* also obtained RAF maintenance records for ZD576 which revealed that over an eight-week period, from March to the end of May 1995, there were six incidents involving the doomed helicopter. Five were FADEC related—including an "ENG FAIL" warning—while the sixth was the result of a vital part of the flight control assembly becoming loose. Dr. Reid also told the parliamentary DSC members that "as far as I'm aware" there had only been one accident prior to the Kintyre crash involving the RAF's fleet of 33 Chinooks. In fact, between 1984 and June 1994 there were nine serious accidents, none of which were crew-related. In the US, there had been 116 serious accidents—seven of them fatal—involving the US Army's 466-strong Chinook CH-47 fleet, according to the annual reports released by the Alabama-based US Army Safety Center (USASC) which are on file at MoD HQ, Whitehall, as a reference source for briefing government ministers.

While there is no evidence to suggest that Dr. Reid personally deliberately misled MPs (which would be a serious breach of parliamentary procedure, and could cost the minister his portfolio), his testimony suggests that he had been deliberately misled by MoD officials during a series of briefings prior to his appearance before the DSC, and that his boss, Defence Secretary Robertson, had also been deliberately misinformed on several occasions since taking charge of the defence ministry following Labour's general election victory in May 1996.

In May 1998, the Defence Select Committee produced its report which concluded that there was "no compelling evidence" to support claims that the crash of ZD576 "pointed to fundamental flaws" in the design of the Chinook Mk2 or its components. The report, which was described as a "great success for the MoD",[14] also accepted that the failure of Boscombe Down to approve the FADEC software was a "management failure" and the absence of approval "raises no safety-critical questions." There was also no evidence, according to the committee MPs, to suggest that RAF safety procedures had subjected personnel to unnecessary risk. However, a "careful reappraisal of policy on the transport of key personnel" was recommended.[15]

Whatever comfort the MoD mandarins—who had knowingly withheld information from the SFAI, a parliamentary inquiry, and government ministers—may have taken from the "success" of the DSC report, was short-lived. When the Public Accounts Committee (PAC), the government's financial watchdog, examined the "acceptance into service" of the Chinook Mk2, the product of a program to upgrade 32 Chinook Mk1 helicopters, undertaken by Boeing under a contract worth £143 million, placed by the MoD in 1990, its case study raised issues relating to the processes of RAF boards of inquiry, and to the MoD's capability to "act as an intelligent customer when accepting equipment that incorporates and relies on complex software systems."[16] The PAC

expressed concern at the fact that after six years in development and three years in production, problems with FADEC software were not detected until the Chinook Mk2 was delivered for flight trials at the end of the procurement process. At the time of the crash in June 1994, ZD576 was experiencing repeated and unexplained technical difficulties caused by the FADEC software. The absence of cockpit voice and accident data recorders meant that the technical data recovered from the wreckage was incomplete, and does not, according to the PAC, "conclusively rule out a technical malfunction as a potential cause of the crash." It was therefore impossible for the RAF inquiry to conclude that the pilots had been grossly negligent, a finding which, under accident inquiry procedures, requires that there be "no doubt whatsoever."[17] The PAC called on the MoD to "recognise and be guided by the decision" of the properly constituted Scottish Court under Sheriff Sir Stephen Young, and "appreciate the superior standing [of the SFAI] to its own domestic procedures." In what we might regard as a direct reference to the unelected MoD mandarins who—unlike in the US political process—remain to stalk the corridors of power in Whitehall no matter who runs the country, the PAC described the MoD's preference for the results of their own procedures as "unwarrantable arrogance", and recommended that the "unsustainable finding of gross negligence" should be set aside. In the case of ZD576, two senior RAF reviewing officers, Wratten and Day, disagreed with the findings of the investigating officers. Such procedure should be revised, according to the PAC, to ensure that "those officers who control the findings... should not be those who also have the management and command responsibility for the aircraft and personnel involved."

The MoD's ability to act as a "truly intelligent customer" in accepting and operating complex computer software and in investigating faults and accidents was undermined by its having to heavily rely on the expertise of the FADEC manufacturers, particularly in the analysis of software performance. During the trials of the Chinook Mk2 at Boscombe Down, the MoD had employed an independent expert software, engineering and testing company, EDU-SCICON, to verify the FADEC software. The company found the software to be defective and divided the anomalies into four categories, with "category 1" anomalies being the most significant. EDU-SCICON explained to the MoD that well-developed software should contain "none or very few category 1 anomalies", and a small number of category 2 anomalies in the whole system. However, by the time they had tested 18 percent of the software, "EDU-SCICON had found 21 Category 1 and 154 Category 2 anomalies".[18] The company could not complete their evaluation of the software after reaching 18 percent because of the density of the anomalies; however, their work provided the basis for Boscombe Down to recommend to the MoD that the FADEC software was "unverifiable" and should be rewritten before an independent assurance on its performance could be given. MoD mandarins' refusal to act on EDU-SCICON results is a flagrant example of their entrenched and powerful position, and their disregard for the human consequences of their decision.

Responding to the EDU-SCICON and DERA concerns, Textron-Lycoming claimed that the Static Code Analysis (SCA) testing procedure

was inappropriate, because the FADEC software had been designed to a different testing philosophy, and that SCA was bound to show faults, "but that finding such faults did not show anything about the quality of the software". The PAC described Textron-Lycoming's response as "wholly spurious", pointing out the MoD regarded SCA as a recognized and approved method of testing safety critical software. The Chinook FADEC contract specified the international standard RTCA DO 178A airborne systems software, requiring that the software should be "traceable, testable, maintainable, and understandable to persons other than the operators."[19] The FADEC software code, if it had been well written, should have been "amenable to independent verification regardless of the approach that the assessor chooses to use." The SCA assessment reflected the "poor build quality" of the software rather than the poor choice of testing methodology.

When asked about the technical status of the FADEC software, the MoD claimed it was not flight safety critical. The PAC contemptuously dismissed this response by describing the ministry as being "in a minority of one in holding this view." On this issue (apart from several others), the PAC described the MoD's judgment as "flawed", pointing out that Boeing Helicopters, "prime contractor and design authority" for the Chinook, itself considered FADEC and the software as a flight safety critical system.[20] Textron-Lycoming designed, manufactured and qualified FADEC as flight safety critical, "building into it layers of redundancy through the inclusion of a primary and revisionary system" within the software for each engine.[21] Furthermore, the MoD had been willing to pay the extra costs of building redundancy into the FADEC system, to the extent proposed by Textron-Lycoming, to protect the aircraft against "control systems malfunctions", implying that when the fleet refit contract was agreed in 1990, the MoD "also regarded the system as critical to safe flight."[22] The MoD estimated the probability of total FADEC failure as "infinitesimal" because of the software design, but was unable to quantify the probability of failure.[23] This should have been possible in order to indicate whether FADEC "meets the parameters of a safety critical system." The PAC was bemused by the MoD's wish to "reduce to infinitesimal" the risk of a failure "unless the system was critical to safe flight and the consequences of failure so undesirable as to be catastrophic in certain circumstances."

The MoD's definition of flight safety critical seemed to mean what the MoD wanted it to mean—which was different from that of Boeing Helicopters, Textron-Lycoming and the Pentagon—and, more than mere incompetence, indicated senior MoD officials' overbearing desire to "get systems on-line" despite human concerns. The MoD claimed that a software system was flight safety critical if failure would be catastrophic, in contrast to a more widely used definition, according to the PAC, that "a system is safety critical if a failure could cause catastrophe."[24] The MoD's definition risked certain systems being underestimated and could lead to "potentially inadequate risk management and mitigation in design and testing", and the PAC recommended that the MoD adopt the more widely held definition to include situations "where system failure could, rather than just would, be catastrophic."

The PAC's detailed and succinctly argued case study has been described as "one of the most damning attacks made on the integrity of a Whitehall department."[25] Although highly technical, reading through the report it is easy to see how the PAC became progressively more exasperated and impatient with the prevarications of the MoD. Time and time again the phrase "we do not understand..." is used, the most relevant, especially for the families of Jonathan Tapper and Ricky Cook, when referring to the absence of definite evidence—the black boxes—and to how the RAF and the MoD could have "no doubt whatsoever" that crew negligence caused ZD576 to crash. The PAC report was welcomed by a coalition of MPs and peers in the House of Lords, including Sir Malcolm Rifkind, the Tory defence secretary at the time of the crash, who are continuing to campaign for the RAF/MoD verdict— described by the Tory chairman of the PAC, David Davis MP, as "a major miscarriage of national justice"—to be set aside.

Up to the present time, the MoD has paid out more than £13 million to the families of 27 of the 29 victims of the Chinook crash, the largest MoD payment arising from a single incident, making it, in terms of financial compensation, the most expensive crash in RAF history. The compensation followed the MoD's rejection, in September 1998, of a dossier of evidence sent to the Armed Forces minister, Dr. John Reid, by MPs and the families of the victims, seeking to reverse the official verdict of gross negligence against Jonathan Tapper and Ricky Cook, and clear the names of "two first class pilots." The file includes a statement from RAF test pilot, Squadron Leader Robert Burke, who believes a "control jam"—which is caused by part of the flight control system becoming detached and an engine "runaway" due to failure of the refitted Chinook FADEC computer software—is the most likely explanation for the fatal crash. The former senior RAF officer also claimed that while serving in the armed forces he had been "ordered not to discuss the crash with anyone."

Dr. Reid rejected the dossier, describing the contents as the "recycling of old theories." He also rejected calls for a fresh inquiry while ordering an accelerated rate of compensation in what could be regarded as a determined effort by the Labour administration to draw a line through the most sensitive and controversial post-World War II military crash. Under the terms of the compensation—ranging in payouts from £605,117 to £709,032 —the MoD, which had already admitted liability under a "duty of care", could no longer be held liable for further damages by any family that accepted the compensation package. Payments to the Tapper and Cook families, reduced by the MoD because of the pilots' alleged culpability, were rejected by the relatives. Michael Tapper continued the campaign to clear his son's name, and discovered that Freedom of Information (FOI) legislation cannot be used to reverse a decision by the MoD not to release two "confidential" technical reports on the airworthiness of the Chinook Mk2. It was left to junior defence minister John Speller to refuse Mr. Tapper a copy of a full-scale assessment report on the crash of a similar upgraded RAF Chinook which had been carried out by the MoD Air Research Centre (ARC) at Boscombe Down before the aircraft went into service in Northern Ireland, claiming it was "policy

advice." Mr. Speller also refused to release a report on a US Chinook Mk2, claiming it had been "supplied in confidence" by the US Department of Defense. However, the report is available under US FOI legislation and reveals that a US Army Chinook rolled over during a training exercise and flew upside down for a considerable period before the pilots regained control. The incident was blamed on the aircraft's FADEC software.

Both the official RAF and Scottish FAI inquiries into the Chinook accident—and an accident is what we are dealing with here, there was no Provisional IRA involvement in this incident—and the parliamentary select committee reports which re-examined and re-interpreted evidence, reaching a different conclusion in some cases to the official explanation, have concentrated on the FADEC software or other technical possibilities for the cause of the crash. While being able to identify a technical malfunction would clear the names and reputations of Jonathan Tapper and Ricky Cook, the focus on the software has distracted attention from several fundamental questions in the whole affair—and raises the possibility that what critics regard as an offical MoD cover-up concerning the cause of the crash, is in itself intended to divert attention from and thereby cover up yet another even more important question: what were 40 percent of Britain's anti-terrorist intelligence elite in Northern Ireland doing in the sky over Scotland in the first place—at that particular time and on that particular day?

The MoD has consistently maintained that flight ZD576 was headed for Fort George near Inverness, which raises this question: why were the authorities at Fort George not informed? It is logical to assume that such a high-level two-day conference would be held in a secure environment and require tight security. Fort George is the headquarters of the Royal Scots Regiment, it is listed as a national monument, promoted as a tourist attraction in the Highlands, and is crowded with visitors during the holiday season, as well as containing married quarters for soldiers where people may enter and leave without security clearance. The second in command at Fort George, Major Brian De La Haye, was reported to have told a colleague that he was "flabbergasted to learn" that a security conference was planned that weekend, precisely because Fort George is not considered a secure and remote location,[26] while a local newspaper claimed that neither the Inverness police nor air-traffic control staff at the regional airport were expecting delegates on a military flight from Belfast that evening.[27]

One possible explanation why the Scottish military and civilian authorities were surprised to learn of the conference was that no such conference was scheduled for this venue. It had been mentioned simply because the MoD needed a destination following the crash, other than the base where flight ZD576 was actually due to land. The exclusion zone around the Mull of Kintyre was not only to prevent journalists photographing tangled wreckage; it was also to prevent identification of the Chinook's real destination: a secret MI5 base codenamed QMAC, located apart from the main buildings at the RAF Macrihanish base, on the tip of the sparsely populated Kintyre peninsula, about 18 minutes flying time from Belfast. During the Cold War, RAF Macrihanish housed US Navy NSW2—also known as SEALs—and

unmarked, black USAF C-130 Hercules, used for secret transatlantic military communications operations, codenamed Combat Talon. There are also Special Air Service (SAS) and Special Boat Squadron (SBS) training facilities. With overnight accommodations at the Officers Mess, it was considered an ideal location for security and intelligence conferences dealing with the Irish conflict. On at least one previous occasion, it had been used by MI5 and RUC Special Branch to discuss the shoot-to-kill investigation being carried out by John Stalker, deputy chief constable of Greater Manchester Police. When Mr. Stalker and his team of detectives came close to uncovering the links between MI5, the RUC Special Branch and the RUC E4A units that were responsible for the deaths of several unarmed persons in Northern Ireland in close surveillance operations, he was removed from the inquiry and suspended from duty amid false allegations of corruption. Ironically, most of the RUC Special Branch officers who were responsible for trying to discredit Mr. Stalker and eventually ending his career as a police officer, were passengers on flight ZD576 and perished near where they plotted against him.

Sources close to the MoD have claimed that the weekend conference was called to consider the security forces' response to a Provisional IRA cease-fire proposal, put forward during secret back-channel discussions between senior MI6 officer, Charles Oatley, and Sinn Fein representative, Martin McGuinness, the former deputy O/C of the Provos in Derry. There had been media speculation for several months about the possibility of an IRA "cessation of hostilities", which was eventually declared two months after the Chinook crash. However, the explanation given by the MoD—that the "cream of Ulster's intelligence community" were packed into a "faulty Chinook" whose safety-critical software had a "dense history of significant problems" according to *Computer Weekly*, in order to formulate a response to the possibility of an end to an undeclared and debilitating war—was actually as far from the truth as could be imagined—the opposite end of the scale, in fact.

Those who died on the Scottish hillside had not flown low and hard across the Sea of Moyle to discuss peace but to consider a "military solution" to the conflict, outlined in a joint MI5/RUC Special Branch plan to impose "selective internment" on both sides of the Irish border.[28] The Dublin government would have been fully briefed on the plan, codenamed Operation Madronna, if it had been accepted by the QMAC "war council". A rehearsal for Madronna "administrative detention" of alleged Provo activists and the Sinn Fein leadership had already been carried out on 19 April with a series of pre-dawn raids on 41 premises across Ulster, on the British mainland and in the Irish Republic following a 13-month investigation coordinated by the RUC C13 unit, headed by Det. Supt. Ian Wilson, and involving over 1,200 police officers from the RUC and Irish Garda Special Branch, Scotland Yard SO13 anti-terrorist personnel, Metropolitan Police CID and MI5, supported by British and Irish army units.

The RUC later claimed that the operation was designed to "set the Provos back years". However, like Operation Crystal, a prototype RUC/Garda swoop carried out in 1992,[29] the 19 April Madronna rehearsal was not a complete success because many of those targeted had been forewarned

and were "not at home" when the forces of law and order arrived with the dawn chorus. Nonetheless, at the end of May, a week before the Chinook crash, RUC Special Branch chief, Brian Fitzsimons and his operations section commander, Chief Supt. Phil Davidson, traveled to Dublin from RUC HQ at Knock, in East Belfast, to discuss the finer points and possibilities of Madronna with Assistant Garda Commissioner Ned O'Dea and Chief Supt. Noel Conroy. It is reasonable to assume that this secret meeting suggests that the cross-border internment initiative was likely to be approved by the joint security chiefs meeting on Kintyre the following month. This might also explain why no MI6 or SAS representatives were included, according to relevant sources on the crash.

Although the Provos were aware of the implications for the war effort, and the disruptive consequences of Madronna for the organization from sources within the security forces on both sides of the border, there is no evidence to suggest that the Chinook was sabotaged. A report in the Republican Movement's Dublin-based weekly newspaper two months later stated: "It is clear by this stage, despite much wishful thinking, that the IRA was not responsible for the Chinook helicopter crash." *An Phoblacht/Republican News* further claimed the aircraft's MMS had been disrupted by one of the passenger's answering a mobile phone,[30] a story which had first appeared in the center-right British newspaper, the *Sunday Express*, on 31 July 1994, and which sources in Dublin later claimed was actually planted by the IRA—the Republicans' version of the British psy-ops tactic of "placing a story and bringing it home."

As previously stated, between 1984 and 1994 there were nine serious accidents involving RAF Chinooks, none of which were blamed on pilot error. During the same period, according to the USASC there were 116 accidents— seven of which proved fatal—involving military Chinooks, only one of which was blamed on a FADEC computer system malfunction. In the majority of cases in both countries, the cause of the accident is unknown. The only certainty is that they cannot be blamed on the pilots, and, in the Mull of Kintyre crash, the legal battle to clear the pilots' names has moved to the House of Lords and continues to this day.

Nonetheless, only a minority of crashes can be blamed on FADEC.[31] If the logic behind the decision of retired Sir William Wratten and the deputy chief of the Defence Staff, Sir John Day, to blame Tapper and Cook for the crash of ZD576 is applied to the UK and US Chinook crash statistics, then the majority of accidents in both fleets were caused by pilot error because technical failure was ruled out. If this were the case, it would raise serious questions about Chinook pilot training and competence on both sides of the Atlantic and would rightly be dismissed as too much of a bizarre coincidence to merit serious consideration.

Had flight ZD576 been fitted with flight data and cockpit voice recorders, the cause of the crash would have been resolved within weeks, and the questions being asked would have related to why a high-level security conference was necessary, and what was the agenda of the two-day Scottish gathering of the best and the brightest of the intelligence services in Northern

Ireland—also described by a republican source in Belfast as "the most ruthless body of men ever to die at one time" in the history of the Irish conflict.[32]

Such an unsympathetic response may seem harsh to an outsider, but it underlines the depth of feeling within the republican community which had witnessed a demand for equality and basic civil rights in the late 1960s develop into a bitter military conflict to which the British government had responded by employing all the counterinsurgency techniques at its disposal, including inhuman and degrading treatment of detainees at RUC holding centers; internment without trial; the use of uncorroborated informer testimony to ensure convictions in non-jury, single judge courts; shoot-to-kill operations and (documented) collusion between the RUC Special Branch and British Military Intelligence with loyalist assassination squads. Many of those who died on the wind-swept, fog-bound slopes of Beinn na Lice were in the forefront of the "dirty war" in which state-sponsored terror accounted for the deaths of more than ten percent of the estimated 3,550 victims of the conflict.

# The Sinking of the *Kursk* and "Retired" US Navy Spy Edmond Pope

On the morning of 4 December 2001, President Vladimir Putin flew north from Moscow to the White Sea port of Severodvinsk, near the Dvina delta. The Russian leader was accompanied by a larger than usual detachment of personal security personnel. The most important business on the day's agenda was to launch the new, nuclear-powered, cruise missile submarine, the *Gepard*, built at the Sevmash shipyard, the same facility where the ill-fated *Kursk* had been refitted in 1998. On 12 August 2000 the *Kursk,* then the country's most modern, well-equipped and best-run ship exploded and sank in the Barents Sea. All 118 crew members taking part in the largest Russian Northern Fleet naval exercise for over a decade were lost.

Commissioned in 1995, the *Kursk* was a Typhoon class, type 949A nuclear-powered vessel, one of the world's largest submarines, approximately 185 meters long, 25 meters wide and weighing an estimated 14,000 tons. The naval exercises involved test firing new weaponry and mock attacks on Western submarines and surface vessels. Prior to taking part, the *Kursk* was armed at Murmansk with cruise missiles and torpedoes, including the Chelomey Granit missile, NATO code-named SS-N-19 Shipwreck, which can carry a 1500 pound conventional or nuclear warhead, and has a range of at least 425 kilometers, and the Veder missile, NATO code-named SS-N-16A Stallion, which has a liquid-fuel rocket engine and is capable of delivering, at supersonic speed, a lightweight anti-submarine torpedo armed with a conventional 200 pound or a mini-nuclear warhead which can track and destroy a target at a depth of up to 500 meters. The *Kursk* was also carrying the 500kph "Shkval" (Squall) torpedo, designed and developed in the mid-1970s by the Sergo Ordzhonikidze Aviation Institute in Moscow. The Shkval is a rocket-propelled torpedo, 8.25 meters long, 533mm in diameter, with a range of 12 kilometers and capable of engaging targets at depths of 400 meters. The weapon has a "porous second skin" through which a constant flow of gas reduces drag due to water friction by 40 percent, allowing it to travel at least three times as fast as its NATO equivalent, the Royal Navy's "Spearfish". The Russian weapon made its public debut in a series of drawings presented at the Abu Dhabi IDEX'95 arms exhibition. Immediately, it caused a major

headache for Western navies and military intelligence because there was no defense against such a weapon, which could easily sink an aircraft carrier before a radar operator could warn the captain. Since then, both John Castano, based at the US Naval Undersea Warfare Center, and Mark Galeotti, at Keale University, England, have been working on the problem of defense against the Shkval, so far without a great deal of success, although "some progress is being made", according to a former Royal Navy submarine specialist.

On 12 August 2000, at precisely 08h28:27 the hydro-acoustics and seismic monitoring systems on board the US Navy's spy ship, the *USS Loyal,* recorded a "massive blast" on board the *Kursk.* At 08h30:42 a second explosion, twice as powerful as the first, according to US naval analysts, registered shock waves at seismic stations thousands of kilometers away, including Norway's Norsar seismological observatory. When the smoke and spray cleared, the *Kursk*, which was operating at periscope depth—the level at which a submarine usually fires its torpedoes—had disappeared, rapidly sinking 125 meters to the bottom of the Barents Sea.

Both West and East—including President Putin—initially accepted that there were three credible scenarios for the incident. The first was that the *Kursk* was preparing to test-fire of one of the new missiles when the weapon's rocket-fuelled engine blew up, breaching the specially designed, isolated double hull. When the *Kursk* sank and hit the bottom, several torpedo warheads exploded, flooding the entire ship. The second scenario is that the Northern Fleet's flagship, the missile launching cruiser *Peter The Great*, test-fired an anti-submarine missile which hit and destroyed the *Kursk.* The third is that a collision caused the first explosion, sinking the stationary submarine and causing a series of secondary explosions when it hit the bottom.

There is general agreement that one of the *Kursk's* tasks was to test-fire at least one of the Russian Navy's new weapons systems, either the Squall, the Stallion or the Shipwreck, for the benefit of two high-ranking, civilian submarine weapons experts on board the *Kursk.* Their presence was confirmed by the governor of the region, Alexander Rutskoi, while French military intelligence floated the rumour—within days of the sinking—that there were also Chinese military officials on board to witness the trials. According to the first scenario, when the *Kursk* was about to launch a new weapon after receiving final radio orders to begin the test program, the propellant or the rocket motor of the weapon exploded and sank the ship. However, some analysts have argued that during a weapon-firing exercise from the forward first compartment, all other compartments are usually sealed off to avoid catastrophic flooding due to a possible misfire and explosion.

Moreover, the *Kursk's* double hull, constructed from especially resistant honeycombed non-ferrous composites, made the vessel virtually indestructible to even a heavy torpedo explosion, and certainly resistant to a relatively small 100 kilogram TNT blast. So the first explosion, either inside the second pressure hull, between the two pressure hulls, or "outside" both pressure hulls and inside the outer cowling, could not have caused the immediate and catastrophic flooding that sent the *Kursk* to the bottom. The

outer hull contained the ship's stores as well as weapons. With five separate pressure compartments, the *Kursk* was designed to absorb a lot of energy before the inner hull fractured. However, US Navy weapons specialists and intelligence analysts, having examined the physical and seismic evidence, believe that the first explosion was powerful enough to leaving a gaping hole on the starboard side of the vessel, from the bow to the conning tower, causing the *Kursk* to sink within a couple of minutes. The second recorded explosion was actually a series of nearly simultaneous detonations, and was equivalent to five tons of TNT. In support of this theory, US intelligence analysts have referred to claims made by Vladimir Gundarov, described as a "Russian submarine specialist", writing in a Russian military newspaper, that the *Kursk* had been refitted in 1998 with "potentially dangerous" torpedo-launching technology which used gas produced by liquid fuel ignition to fire the torpedo, against the advice of several senior naval officers. The fuel used was described as an unstable "dual purpose, liquid monopropellant" with a "low flash point and impact resistance" unless a chemical stabilizer is added. It appears that the only advantage the refitted technology had over the original silver battery/ rocket fuel ignition system was that it was "cheaper to make."

According to the second scenario, the *Kursk* was hit by an anti-submarine Shipwreck missile, fired by *Peter The Great*. However, even though naval exercises are meant to be as realistic as possible, it is highly unlikely that a fully-armed torpedo would have been used. If it was a "paint-ball" dummy torpedo, it might have caused a small explosion, but nothing nearly as powerful as that registered by *USS Loyal* and, because of *the Kursk's* construction, it would not have caused catastrophic flooding and the destruction of the vessel.

The third theory is that the *Kursk*, at periscope depth, was hit by another vessel, which ripped open at least two compartments before the other compartments could be sealed off. The problem with this scenario is that it doesn't seem possible that the *Kursk* was rammed from the side, because the hull was breached lengthways, from the bow to the conning tower. Taking into account the *Kursk's* size and speed, it would be extremely difficult for a surface vessel to have rammed the submarine from behind, except by surprise. If there was a collision, it was probably frontal, which raises the question of how such an incident could take place during naval maneuvers when every military service in the world with an interest in Russian naval warfare capabilities was keeping tabs on what was going on, with the latest technology at their disposal? Whether such a frontal collision was intentional or unintentional, it must have happened rather suddenly, otherwise the *Kursk* and other Northern Fleet ships would have tried to avoid it, even if the exercises were being conducted under radio silence, which is often done (there reportedly was no radio distress message sent out by the Kursk). If a Russian vessel rammed the *Kursk*, there is no reason why Western intelligence would not have leaked the story to the press. Even the most hard line, right-wing publications—some of whom are still fighting the Cold War—would have to have seen no mileage in a "Russian Blunder Sinks Sub" story—a highly unlikely possibility.

The other possibility, put forward by Russian defense officials and certain Western analysts, was that the *Kursk* was suddenly rammed by a Western vessel, and that this was such a violent encounter that it caused the seismic and sonar activity registered by several different sensors. If the *Kursk* was at periscope depth when the incident took place, and possibly with the periscope active, then radio contact should have been possible. Why, then, did the *Kursk* maintain radio silence, not call for help and not try to explain what had happened?

Western vessels shadowing the Russian Northern Fleet during the Barent Sea trials were, by definition, "intelligence platforms"—spy ships equipped with state-of-the-art monitoring and surveillance technology. They are highly-valued and seriously protected assets. The flotilla observing the Russian "war games"—including the *USS Loyal*, and two US Los Angeles class attack submarines, the *USS Memphis* and the *USS Toledo*—should not have been closer than 100 kilometers in normal circumstances. However, the *Kursk*, with its special "stealth" coating on its hull, was considered a very "quiet" vessel with a very low magnetic and sonar signature because of its non-ferrous composites. It is not unthinkable that, in the perpetual East versus West "hide and seek" underwater warfare exercises (in which US subs "tailing" Russian subs have actually "bumped" Russian vessels, without causing serious damage—except to Russian egos—on several occasions), the *Kursk* was actually ordered to silently sneak up on a Western spy ship—something which also has happened previously during NATO and Russian fleet exercises. Within days of the incident, the press mentioned the possibility that an American or a British submarine, either intentionally or by accident, had collided with and sunk the *Kursk*, if the Russian vessel had been running silently and "playing tag." However, when asked about this possibility, Russian Defense Minister Igor Sergevev pointed out that the *Kursk*, because of its size and construction, would have "unquestionably prevailed" over a smaller NATO adversary. This didn't explain why, as the *Norway Post* reported, a large number of Russian planes combed the Norwegian coast as far down as Moere in search of NATO submarines, during the first 48-hours following the *Kursk* tragedy.

The two candidates for the fatal collision are the *USS Memphis* and the *USS Toledo*. On 26 September 2000, the Russian magazine *Versiya* published a Russian spy satellite photograph taken on 19 August—one week after the *Kursk* sank—of what was described as a "Los Angeles class submarine" docked in Haakonsvern, Norway, supposedly for emergency repairs. The photograph conveniently fit in with Admiral Vladimir Kuroedov's assertion that the *Kursk* sank after being in an accidental collision with a foreign nuclear submarine. On 9 November, Deputy Prime Minister Ilya Klebanov, who had taken personal charge of the government commission investigating the sinking, stated that the *Kursk's* log had been found by divers in the fourth compartment but the document was "unreadable" and contained "nothing related to the accident"—although how he knew this if the log couldn't be read wasn't explained. Later that day, the chief of the Russian General Staff, Anatoli Kvashnin, issued a statement in which he repeated earlier demands that Russian naval specialists and accident investigators be allowed to inspect

NATO submarines which had been part of the fleet shadowing the Barent Sea exercises. The following day, 10 November, officers from the Federalnaia Sluzhba Bezopasnosti (FSB), the federal security service, visited the offices of *Versiya* to investigate how the satellite photo had been obtained. They questioned the magazine's investigations department editor, Dmitry Filimonov, for several hours, and according to the newspaper, *Obshaya Gazeta*, continued their inquiries into a possible breach of national security, eventually arresting an unidentified officer from the Satellite Reconnaissance Department of the SVR Main Intelligence Department. On 15 November, reflecting how sensitive the *Kursk* affair had become, a statement by the Northern Fleet spokesman, Vladimir Navrotskii, confirmed that the Russian Navy was using depth charges and grenades in the Barents Sea, near where the submarine sank, in order to keep foreign divers and submersibles out of the area. The "small explosions" were recorded by Norsar, and followed reports that senior Russian naval officials had expressed concern that "foreign navies" might try to gather intelligence about the *Kursk*.

On 3 April 2000, just over four months before the *Kursk* tragedy, a 53-year-old retired US Naval Intelligence officer, Edmond Dean Pope, was arrested in Moscow by FSB agents while attempting to procure "classified scientific data" relating to ballistic missiles and high-speed torpedoes used by Russia's submarine fleet from Professor Anatolii Babkin, a senior member of the rocket engineering department at Bauman Moscow State Technical College. In a statement released shortly after Pope's detention, the FSB said it had confiscated "technical drawings of various equipment, recordings of his [Pope's] conversations with Russian citizens relating to their work in the Russian defence industry, and receipts for American dollars received by them." On 7 April, while Pope was locked up in Moscow's top-security Lefortovo Prison on espionage charges which carried a 20-year sentence if proved, the US Embassy in Moscow released Pope's name—something the FSB had not done. This was taken as an indication that Washington was prepared to "cover" Pope rather than allow the former spy to spend too much time behind bars.

Edmond Pope, a native of Grant's Pass, Oregon, retired from the US Navy in March 1994 after a 27-year career which included stints with the Naval Intelligence Command and the Defense Intelligence Agency, according to the Pentagon. He immediately joined Pennsylvania State University's Applied Research Laboratory, where he worked as a foreign technological assistant until February 1997. He was responsible for arranging collaboration between research universities and organizations, many of which were in the former Soviet Union. The executive officer of Penn State's Naval Reserve Officer Training Corps, Dave Willis, said he had talked to Pope in early April, two days before Pope's departure for Russia. Pope had mentioned his forthcoming trip to Russia "for business reasons" and did not seem worried about it. Although Willis had known Pope both professionally and socially for a number of years, he told the press that he did not know what kind of business Pope conducted in Russia, and he had not heard of Pope's CERF Technologies International—a company specializing in assessing and buying foreign naval equipment that he had founded after leaving Penn State—until

the news of his friend's arrest and detention: "I didn't have a clear picture of what he was doing in Russia. I thought he was an entrepreneurial kind of guy doing some dealings in Russia." On the day of Pope's arrest, the FSB also detained Professor Daniel Kiely, the head of Penn State's Energy, Science and Power Systems Division, a facility which designs and develops torpedoes for the US Navy. The 68-year-old Dr. Kiely, who had joined Pope in Moscow to offer technical advice, was questioned by the FSB for several hours, then quietly released on "humanitarian grounds" and allowed to return to the US.

On 20 April, the FSB revealed that Pope was trying to obtain classified information about the Shkval torpedo, particularly technical data relating to the thin layer of gas which covers the missile and is produced by a high-pressure stream of bubbles from its nose and skin, allowing it to travel at extremely high speeds, for which there is "no Western equivalent", according to a 1995 report in *Jane's Intelligence Review*. The information Pope was seeking had a strategic military application, which made his mission to Moscow, without diplomatic cover, extremely dangerous, given the importance of the data.

On 18 October, Edmond Pope's non-jury trial began behind closed doors at Moscow City Court before Judge Nina Barkova. It was immediately adjourned for 48 hours to allow Pope's lawyer, Pavel Astakhov, to draw up requirements for a medical test for his client. Since his detention almost seven months earlier, Pope, who suffers from a rare form of bone cancer, had been examined only once by a doctor called in by the FSB, who deemed him fit to stand trial. Mr. Astakhov asked for an American doctor to conduct the tests, and for an "impartial translator" to replace the individual provided by FSB. Mr. Astakov also asked that Professor Anatolii Babkin, who was alleged to have handed over the classified information to Mr. Pope, be called as a witness. This request was rejected by Judge Barkova—a decision which led some intelligence analysts to surmise that the FSB suspected Pope of being an American agent, while others believed Prof. Babkin might have been "turned" by the FSB, which would explained why he had been called as the chief prosecution witness, after charges against him were "suspended" for health reasons

Pope pleaded not guilty to the charges of espionage outlined in the 28-page indictment. Astakhov acknowledged that his client did try to purchase information on the Shkval torpedo, but argued that espionage can only be proved in Russia if it is demonstrated beyond reasonable doubt that the accused knew the information he was buying was secret. Pope claimed that the information he was looking for had already been sold abroad and published in open sources. His lawyer told the court that his client had stressed that the condition for his working in Russia was that no classified materials would be included in the publications he was collecting. Pope had started collecting information in Russia in 1996, "in a more open time", but since then the atmosphere had sharply changed: "The doors that had been open to the closed enterprises, the closed scientific institutions and the educational establishments all of a sudden slammed shut, like a mouse trap, and he [Pope] was caught in that mouse trap, still unable to understand what he is accused of and feeling certain that all the materials are not secret."

Astakhov described the prosecutor's case as "based on speculation, incorrect conclusions and blatant falsification". It was sufficient, however, for Judge Barkova to find Edmond Pope guilty as charged, and on 6 December 2000, after a six-week closed hearing, he was sentenced to the maximum 20-years in prison, becoming the first US citizen to be convicted of spying in Russia for 40 years. The sentence included the confiscation of money seized when he was arrested while trying to purchase information from Professor Babkin, a sum which went some small way towards the 7bn rubles—$250 million—in damages to the Russian defense industry, which the prosecution had also demanded. The trial and the verdict were immediately condemned in Washington by President Clinton's national security advisor, who described the outgoing White House administration as being "deeply disappointed". However, General Alexander Zdanovich, on behalf of the FSB, told journalists that the bureau was "satisfied" with the result, and warned that "Russia has its secrets, we will do our best to protect them."

A plea for clemency on health grounds entered by Pope's wife, Cheri, who had sat with him in the caged defendant's box—a traditional feature of Russian courtrooms—was rejected. She had visited Lefortovo Prison prior to sentencing, and had drafted a letter to President Putin, pointing out that her husband had been allowed to sit during court hearings—rather than stand as is required in Russia—because he had suffered from sharp attacks of pain, and had trouble taking notes and speaking properly. Pope also wrote to the Russian president, stating: "I'm writing to request that I be released from prison to return to my family in Pennsylvania and receive health care. I am not well. I need immediate medical care." The US Embassy also confirmed that President Clinton had asked Mr. Putin to release the accused spy because of his failing health, but the Russian leader had responded by saying the trial should run its course. The Pennsylvanian Republican Congressman, John Peterson, who had travelled to Moscow for the conclusion of the trial, publicly warned that US-Russian relations would "suffer greatly" if Mr. Pope's health deteriorated while he was incarcerated in Lefortovo.

Vladimir Putin had spent 16 years in the KGB, later becoming head of the FSB, prime minister, and finally succeeding Boris Yeltsin as president. He won the election on a hard-line anti-Chechen policy following four bomb attacks in Moscow and the southern city of Volgodonsk in September 1999, which deliberately targeted residential buildings, killing more than 300 people. The attacks were blamed on Chechen "terrorists". However, on the evidence left by a fifth, unexploded device, the anti-personnel bombs may have been planted by old KGB/FSB "hands" in order to provide "their presidential candidate" with a high profile, and a populist policy. Up to that point, Vladimir Putin had been a faceless St Petersburg bureaucrat. After Yeltsin announced he was supporting Putin's taking charge of the world's second nuclear super-power, the Russian media, according to Matt Ivens, editor of the *Moscow Times,* was convinced that there was "no way this guy could win an election unless something really extraordinary is going to happen." The bombing provided the former spymaster with the opportunity to raise his political profile, and, according to London-based *Observer* journalist, John Sweeney, Putin

began "working with the grain of Russian racism." He immediately accused the Chechens of being responsible for the bombings and declared: "These who have done this don't deserve to be called animals. They are worse—they are mad beasts and they should be treated as such." The tanks rolled into the Caucasus, the FSB took charge of the second Chechen War in less than a decade, thousands of innocent people died, hundreds of thousands became refugees, the capital Grozny was reduced to rubble, and Vladimir Putin's opinion poll rating rose to almost 70 percent.

On 14 December 2000, a few hours after it became clear that George W. Bush would be the new American president, the Kremlin announced that President Putin, while visiting Cuba, had pardoned Edmond Pope, after a presidential commission had recommended clemency shortly after Pope was sentenced. The decree stated: "Being guided by the principles of humanity, taking into account the health condition of the convict and his personal appeal, and based on the high level of relations between the Russian Federation and the United States of America, I order the pardon of Pope, Edmond, Dean."

With a stroke of the pen, Vladimir Putin had become George W. Bush's new best friend, and shortly before noon, the plane carrying the convicted spy left Moscow for the USAF base in Frankfurt, Germany. In a brief comment to the media before he left the Russian capital, Mr. Pope said: "On the one hand, I am glad; on the other hand, I am sad all this happened. I did not want to harm Russian-US relations." An FSB spokesman told journalists that as he was leaving Lefortovo, Mr. Pope had thanked staff for maintaining prison conditions to an international standard. The statement was not supported by Mr. Pope's appearance: he had lost two teeth, and almost 12 kilos, as a result of the poor prison diet. According to a source quoted in the London-based *Guardian* newspaper, Pope had complained on several occasions that his "five cellmates had often eaten all his food and occasionally also ate his supply of tablets." However, when he arrived in Germany a few hours after leaving Moscow, he was described as "elated". He was welcomed by USAF personnel waving American flags. Wearing a "traditional" blue hospital smock, Pope told reporters from the balcony of the base hospital: "It's great to be back in the real world. It's great. I feel good." After undergoing several health checks, Edmond Pope, the ex-naval intelligence officer, who failed to obtain the secrets of the Shkval, flew home to the relative obscurity of the academic, intelligence and high-tech business community in Pennsylvania, after the customary debriefing by the CIA and officials from the Office of Naval Intelligence (ONI).

One of the unexplained aspects of the Pope affair is the question of who the former covert naval IT specialist—through his "private company" CERF Tech. Int.—was working for. The search for data on the Shkval wasn't a solo project—there was a "customer" lined up for what Pope might obtain from academic and defense specialist sources in Russia. This explains why, as his laywer argued, Pope had imposed the condition that "no classified material" should be included in what he was asked to collate. He took the job, so obviously he had received the assurance. The question is, from whom? The Russians likely found out—or they wouldn't have released him. But they weren't letting on what they knew.

There was at least one bizarre attempt to answer the question. In an article, published on 4 January 2001 in the *Washington Post,* journalist John Mintz claimed that the US was a junior partner in the affair, which was run by—Canada! Neither Mintz nor any other journalist bothered to ask the obvious follow-up questions of what Canada would do with a Shkval—other than sell it to the US—or why Canada wanted the Skhval so badly that it would go to the trouble of deceiving an ex-US naval intelligence specialist to try and obtain information which he would not be advised was secret.

Some analysts have described the Shkval as an "erratic unguided torpedo"—an "aim, shoot and pray device" to be used against a very large target in a fairly confined space. Such as a Nimitz-class aircraft carrier or a cruise-missile carrying submarine. The US has plenty . . . Canada has none. So the conclusion to the "spin" in the *Washinton Post* report is that if Canada was involved at all, it was acting as a "cut out" for other Western services, most likely the ONI and British naval intelligence, in order to develop some form of deterrent. The list of places in the world where the Shkval could effectively be used is topped by the Taiwan Straits. Being able to take "pot shots" with Shkvals at US carriers and submarines from mainland China would make an invasion of Taiwan almost possible . . .and who, within the various divisions of NATO's Western intelligence agencies, would claim that Beijing doesn't know the secrets of the Shkval. The French, at least, think they do.

Meanwhile President Putin turned his attention to the sinking of the *Kursk,* aware that with a defense budget of $7.5 billion for 2001, the Russian Navy would have to be downsized—with the focus on a smaller, more efficient and better maintained nuclear submarine fleet. According to Alexander Pikayev, a defense analyst at the Carnegie Center in Moscow, Mr. Putin realized after the *Kursk* tragedy that "the challenges Russia faces are from the desert and the mountains of central Asia and the Caucasus, and not from the sea." On his desk were plans, drawn up a year earlier by the Navy's senior officers, for a massive and costly expansion of the fleet, including more vessels on permanent patrol, at least a dozen new aircraft carriers, and naval exercises in "Western waters" including the Mediterranean, where the *Kursk* was due to visit after the Baring Sea maneuvers, escorting a Russian flotilla in a show of Russian sea power.

On Saturday, 1 December 2001, within hours of Russian Prosecutor-General, Vladimir Oustinov, providing Putin with a draft copy of his report into the *Kursk* tragedy— which, according to the *Kommersant* newspaper, blamed the naval hierarchy for sending the *Kursk* to sea with a complete and fully-armed complement of weapons—the Russian president sacked Admiral Vyacheslav Popov, who had publicly supported the theory that a collision with a NATO vessel had been responsible for the sinking of the *Kursk,* and the Northern Fleet's chief of staff, Vice-Admiral Mikhail Motsak, as well as nine other admirals and three senior captains. Most of those on the president's "hit list" were regarded as anti-Western, and unhappy with Putin's overtures to NATO which, in turn, reduced the need for a large Russian naval fleet. Defense analysts compared the purge to former president Mikhail Gorbachev's opportunist sacking of senior military hardliners who had criticized his *glasnost*

policy after 19-year-old West German, Matthias Rust, crossed the Finnish border on 28 May 1985, and flew undetected for almost 1000 kilometers through Soviet airspace before landing his single-engine Cessna in Red Square, Moscow, under the noses of the highly-embarrassed defense chiefs.

Strangely, there is an absence of satellite imagery, at least in the public domain, of the *Kursk* tragedy, an "empty file" which has puzzled independent intelligence analysts. It is logical to assume that the surveillance resources of the US National Reconnaissance Office (NRO) in Washington DC, which can provide the Pentagon, the Defense Intelligence Agency (DIA), the ONI and NATO with a 24-hour view of every "hostile" military adventure, were deployed to "eyeball" the Russian Northern Fleet exercises in the Baring Sea. So either the US has the photos and is not releasing them (i) for security reasons; (ii) not to embarrass President Putin, who was quick to repatriate Pope, and apparently received nothing in return—a very atypical Russian gesture; or (iii) a NATO vessel did fatally damage the *Kursk*, evidence of which could severely damage Mr. Putin's presidency, and Moscow's relationship with NATO and Washington.

The bodies of 94 of the 118 crew who sailed on the *Kursk* have been recovered. Although on 9 January 2002, Vladimir Oustinov informed relatives of the victims that he "felt sure" the causes of the sinking of the pride of the Russian submarine fleet would be known by the end of the year, as with other affairs of this nature, there may be a political price to pay for the truth.

# "Bloody Sunday":
# The Search for the Truth Continues

A six-year inquiry into the Bloody Sunday shootings in Londonderry in 1972 has finally proved in 2004 that none of the civil rights protesters killed were armed. But in so doing, it has raised more significant questions than that which it resolved. In examining the event—an anti-internment march organized by the local civil rights association in Derry, during which fourteen unarmed civilians were shot dead and twenty-eight were seriously wounded by members of the British Army's Ist Battalion, Parachute Regiment—the SavilleTribunal still failed to answer these questions: who shot the victims, who commanded those who shot them, who designed and implemented the plan which led to their shooting? Had what was essentially a policing operation by the military gone badly wrong, or had unarmed protesters been deliberately shot down in the exercise of a preconceived plan? What might have been the intent of such a plan?

The opening statement to the Saville Tribunal by counsel at the Guildhall in Derry City, Northern Ireland, had been the longest in British legal history, concluding on 28 June 2000, when Christopher Clarke QC, ended his 40-day review of the written evidence. Mr. Clarke described the tribunal as "free-standing and independent", claiming it had "amassed and will consider more evidence about Bloody Sunday, in written and oral form, than any other body."

Classified threat assessments concerning the safety of serving and former British soldiers who had been directly involved in the operation, returning to Derry some 28 years after the event to give evidence, were submitted by the British Security Service, MI5, and the Royal Ulster Constabulary (RUC). After being told that the soldiers' legal representatives would be seeking a change of venue, copies of the threat assessments had been requested by Mike Mansfield QC, on behalf of the lawyers acting for the relatives of the dead and wounded, because it was "essential to know on what grounds their arguments were based."

After several weeks, MI5 produced a three-paragraph memo, described by Mr. Mansfield as "quite astonishing" and an "insult to the intelligence of those who read it." The Security Service simply stated that despite a Provisional IRA ceasefire, which had been in force since July 1997, all soldiers were considered "legitimate targets" by militant republican organizations:

In the case of soldiers and ex-soldiers involved in the events of Bloody Sunday, we assess that their actions at the time would make them stand out from the generality of soldiers and make them more attractive targets, if a successful attack could be carried out. However, if the hearings at which soldiers and ex-soldiers appear are held on the mainland, the terrorist groups will be deprived of the ease of operation which they enjoy on their home ground in Northern Ireland . . . In consequence, the generally more difficult operating conditions on the mainland are likely to give rise to the perception that a successful terrorist attack would be harder to achieve.[1]

The RUC assessment noted that the "Continuity IRA" and the "Real IRA"—republican splinter groups which had broken away from the Provisionals—were not on cease-fire and had "the potential to carry out an attack" on soldiers giving evidence at the Guildhall. However, while there was "no special intelligence" indicating a specific threat in Derry, the "presence of a large emotive crowd could make it difficult for the police to ensure the safety of protesters and soldiers attending the inquiry without segregation.

The extraordinary lengths to which the British Conservative government went to cover up events on Bloody Sunday, in order to protect ministers who took specific decisions regarding the deployment of troops, and the "arrest operation" carried out by the Paras, were referred to by Clarke, and extended to altering a passage in *Hansard,* the official record of daily proceedings in the Houses of Parliament.[2]

If the British political and military establishment believed that selective memory loss would provide some form of safeguard against accepting responsibility for what had taken place in Derry City three decades earlier, they had failed to take into account the tenacity of the relatives of the victims, and campaigners like Don Mullen, who had dismissed the first 39-page official report published in April 1972 as a "whitewash" long ago. The late Lord Widgery, a Senior Grand Warden of the English Freemason Brotherhood and a former Army officer, had arrived in Derry in an Army helicopter and stayed in Army quarters during the course of his brief inquiry.[3] He had sat passively while soldiers gave evidence that they had been fired upon, and Tory ministers claimed that "all or most of the victims were gunmen or nail-bombers"—despite the fact that no weapons or bombs were found at the scene of the killings; that there was no forensic evidence to support the allegations; that none of the soldiers were injured by bombs or bullets; and that none of the thousands of photographs and over 40 hours of "live" footage filmed by local and international journalists and television crews (who had traveled to Derry to cover the banned march as the "war" escalated, following the introduction of internment the previous August) showed guns or bombs being used by any of the victims. Lord Widgery concluded that the actions of some of the paratroopers had "bordered on recklessness" and that while none of the victims were actually armed when they were shot dead, there was "strong suspicion" that some had earlier fired guns or handled bombs. The relatives of those who died—and who had regarded the appointment of a

Lord Chief Justice, the most senior member of the British judiciary, ten weeks earlier, as a sign of respect and of how seriously the deaths of British citizens in a British city (albeit in the "troublesome" six counties of Ulster) at the hands of members of the British Army were regarded by the British government—accused Lord Widgery of producing a report designed to blame the dead and injured, and defend the actions of the soldiers.

In 1997, allegations of an official cover-up extending all the way to the highest level within the Ministry of Defence (MoD) and the British Cabinet, were supported by a book, *Eyewitness Bloody Sunday*, edited by Don Mullen, which quoted from official Home Office files released by the Public Record Office in Kew, south London. One memo records a meeting between Lord Widgery and a senior Home Office official which included a hand-written note stating: " LCJ will pile up the case against the deceased . . . but will conclude that he cannot find with certainty that any . . . was a gunman." Another document, the classified minutes of a "Confidential Downing Street Cabinet Briefing", reminds Lord Widgery that Britain was fighting "not only a military war but a propaganda war in Northern Ireland." In a third document, the Home Office rates the performance of senior army officers in this manner: "Brigadier MacLennan loyally covered up for his subordinates, but Colonel Wilford's activities surely need some explaining." Lieutenant Colonel Derek Wilford was the O/C commanding the Paras in Derry that afternoon. He was awarded the Order of the British Empire (OBE) in the 1973 Queen's honors list for exceptional military service in Northern Ireland, a gesture which added insult to injury, underlining the lack of respect for those who had been the victims of the soldiers under his command.[4]

Mullen's book also contained transcripts of RUC and Army radio communications which have no reference to soldiers coming under attack by gunmen or nail-bombers but, more significantly, suggested that soldiers deployed on the city walls, high above the route of the anti-internment demonstration, had opened fire on the marchers. Extracts from the log of the 8th Infantry Brigade, the Royal Anglian Regiment, show that at least two "hits" were registered by soldiers on the walls. Dr. Raymond Maclean, a local doctor who had served as a medical officer in the Royal Air Force (RAF) and who had taken part in the march, treated the wounded and attended eleven of the post-mortem examinations, claimed that three of the victims were killed by shots fired downward at a 45 degree angle.[5] An independent ballistic expert, Robert Breglio, who spent 25 years with the New York Police Department (NYPD), concluded that Michael McDaid, John Young, and William Nash were likely to have been hit "by a single marksman using a telescopic sight operating from a height." According to Mullen, Lord Widgery confined his inquiry to the 108 shots fired by the Paras at ground level as they entered the Bogside, and ignored the role of the soldiers stationed on the walls, as well as the actions of the RUC and the evidence of independent police observers. He also ignored all but 15 of 500 witness statements taken by the Northern Ireland Civil Rights Association (NICRA) shortly after the killings. These were actually found in a plastic bin-liner at a community center in the city in 1996—some 24 years later!

On 29 January 1998 British Prime Minister Tony Blair announced in the House of Commons that the newly-elected Labour government had ordered a second judicial inquiry into the events on Bloody Sunday. Some critics, particularly within the military and conservative ranks, described his announcement as a damage-limitation exercise and a concession to Sinn Fein, the political wing of the Irish Republican Movement. It was made an hour before the Irish government published a 178-page critique in Dublin of the Widgery Tribunal. The purpose of the Widgery Tribunal, according to the Irish government's publication, was not to establish the truth "but to exculpate the actions of the British Army."

The grounds for these suspicions are many and obvious, and might naturally result from the "highly-constrained terms of reference" of the tribunal itself, the speed with which the proceedings were concluded, the nature of the proceedings and the "manifold failures to consider the evidence either fairly or comprehensively." However, the most damning feature of the Widgery Report was that it "failed to hold any individual or agency accountable for the deaths of thirteen innocent people." This was a point also made by Derry journalist Eamonn McCann, who stated that the killings in cold blood of thirteen unarmed anti-internment demonstrators had been witnessed by dozens of people, some of whom had told Widgery what had happened, and that nonetheless the Lord Chief Justice had concluded "that all the killings were entirely justified and that not one of the killers or their commanders had any liability under the law."[6]

The Irish report, which was generally ignored in the UK and international media (except for a brief mention of its existence) concludes:

> In the wake of Bloody Sunday, a clear chasm rapidly emerged between the versions put forward by the authorities and the many accounts offered by civilian eyewitnesses. The Army offered that its soldiers had come under a sustained gun and nail-bomb attack and lists were circulated by the authorities citing the weapons allegedly found on the victims. The civilian eye-witnesses attested to a largely peaceful event, albeit with some stone-throwing on the fringes, the absence of IRA gun-fire, nail-bombs or petrol-bombs, and the sudden arrival at speed of British soldiers who opened fire immediately on debussing, shooting into the backs of fleeing civilians. Rather than resolve how such a stark, not to say startling contrast could exist between the British Army's version of events and that of the many civilian eyewitnesses, the Widgery Report opted, contrary to what many at the time believed was the weight of the evidence, for the version put forward by those who were implicated in the deaths and injuries, particularly the soldiers of 1 Para.

> The new material which recently emerged provided a fresh platform on which to mount a reconsideration of the events of Bloody Sunday and the Widgery Report. It reinforced the original

doubts about the completeness of the official version of events, particularly through the strong evidence that shots were fired into the Bogside by the British Army from the vicinity of Derry's walls. It provided fresh grounds for the belief the members of 1 Para willfully shot and killed unarmed civilians. It suggested that the approach and conduct of the Widgery Inquiry was informed by ulterior political motivation from its inception. It demonstrated that the Widgery Inquiry was inherently flawed by the failure to reveal or acknowledge that the testimony of implicated soldiers had been altered in successive statements by the Military Police, Treasury Solicitors and the Inquiry itself. Furthermore, it suggested an increasingly detailed—though obviously incomplete—picture of what happened on Bloody Sunday which was radically different from that offered by Lord Widgery.

The new material offered little on why Bloody Sunday occurred: the answer to that question undoubtedly lies in large part in official British archives and the memory of those involved on the British side. The material emerged from many different sources, including published contemporary eyewitness accounts, recent releases from official British archives and academic analysis of them, and ongoing investigative reports by the [mainly Irish] press and media. To draw these strands together, the Government decided to assess the new material and focus in particular on what significance could be attached to it vis-a-vis the Widgery Report. To do this effectively required a detailed analysis of the Widgery Report in which virtually every paragraph was considered afresh in light of the new material.

As is evident from the foregoing assessment, it can be concluded that the Widgery Report was fundamentally flawed. It was incomplete in terms of its description of the events of the day and in terms of how these events were apparently shaped by the prior intentions and decisions of the [British] authorities. It was a startlingly inaccurate and partisan version of events, dramatically at odds with the experiences and observations of civilian eyewitnesses. It failed to provide a credible explanation of the actions of the British Army, particularly of 1 Para and of the other units in and around Derry. It was inherently and apparently willfully flawed, selective and unbalanced in its handling of the evidence at hand at the time. It effectively rejected the many hundreds of civilian testimonies submitted to it and opted instead for the unreliable accounts proffered by the implicated soldiers. Contrary to the weight of evidence and even its own findings, it exculpated the individual soldiers who used lethal force and thereby exonerated those who were responsible for their deployment and actions. Above all it was unjust to the victims of Bloody Sunday and to those who participated in the anti-internment march that day in suggesting they had handled firearms or nail-bombs, or were in

the company of those who did. It made misleading judgements about how victims met their deaths. The tenacity with which these suggestions were pursued, often on flimsy or downright implausible grounds, is in marked contrast to the many points where significant and obvious questions about the soldiers' behaviour, arising from the Report's own narrative, are evaded or glossed over.

There have been many atrocities in Northern Ireland since Bloody Sunday. Other innocent victims have suffered grievously at various hands. The victims of Bloody Sunday met their fate at the hands of those whose duty it was to respect as well as uphold the rule of law. However, what sets this case apart from other tragedies which might rival it in bloodshed, is not the identity of those killing or killed, or even the horrendous circumstances of the day, it is rather that the victims of Bloody Sunday suffered a second injustice, this time at the hands of Lord Widgery, the pivotal trustee of the rule of law, who sought to taint them with responsibility for their own deaths in order to exonerate even at that great moral cost, those he found it inexpedient to blame.

The new material fatally undermines and discredits the Widgery Report. A debt of justice is owed to the victims and the relatives to set it unambiguously aside as the official version of events. It must be replaced by a clear and truthful account of events on that day, so that its poisonous legacy can be set aside and the wounds left by it can begin to be healed. Given the status and currency which was accorded to the Widgery Report, the most appropriate and convincing redress would be a new report, based on a new independent inquiry. The terms and powers of any new inquiry would need to be such as to inspire widespread public confidence and that it would have access to all the relevant official material and otherwise enjoy full official support and cooperation, that it would operate independently, that it would investigate thoroughly and comprehensively, and would genuinely and impartially seek to establish what happened on Bloody Sunday, why it happened and those who must bear the responsi-bility for it.[7]

Because of the limited availability of the Irish government's analysis, the general public, both in Britain and abroad, who rely on their local media for such information, has never fully appreciated the depth of bitterness which Bloody Sunday and the Widgery "whitewash" still generate on both sides of the Irish border. The new material referred to in the report—supported by declassified files made available at the Public Record Office—also included an eyewitness statement, published in October 1997 by the Derry-based Policy Research Institute (PRI). It was given by Chris Owen, one of eight students and staff of Magee College, Derry, who were standing directly beneath an Army pill-box on the historic, 17th century city walls. According to Owen, he heard the first shots being fired and saw people running in all directions.

He said there was no doubt "the pill-box above us fired" at least two shots, and that he could see "absolutely no [IRA] rooftop snipers at all." Acoustic evidence also supported Owen's statement.

A tape made by BBC radio journalist David Capper, held at the National Film and Television Archive (NFTA) in London, recorded the first shots fired as a 10-ton British Army Saracen armored personnel carrier, with a 12-man compliment including crew and a turret-mounted Browning machine gun, entered the Bogside. Capper gave evidence to the Widgery Tribunal, but the tape was not heard. The recording is an optical sound negative tape according to the NFTA, and audio engineers believe that an acoustic scientific analysis of the tape should confirm that the first shots fired were from standard Army issue weapons.

Dr. Raymond McClean also mentions hearing "ominous sharp cracks" coming from the upper William Street area "towards the back of the march"—different to the sound of rubber bullets being used at the William Street perimeter—and being called to treat a teenager and a middle-aged man, both of whom had been shot in the upper thighs, approximately 15 minutes "before I heard the sound of several gunshots in the vicinity, coming in rapid succession . . . from the Glenfada Park direction."[8]

Although the judicial inquiry headed by Lord Saville has the authority to subpoena witnesses and grant immunity from prosecution, it is essentially a homicide investigation, and if those who died are innocent victims—as British PMs Tony Blair and his Tory predecessor John Major have admitted in parliamentary statements—then those who fired the fatal shots, the officers who ordered them to do so, and those who briefed the soldiers prior to the operation, are either guilty of murder or of culpable manslaughter as a result of multiple errors of judgment. Of the hundreds of people in the vicinity of Rossville Street and Glenfada Park in the Bogside, where the majority of the killings took place, and who may have witnessed potentially-relevant details, Lord Widgery heard evidence from only thirty, as well as twenty-one press and television journalists and photographers, and seven Catholic priests, compared to forty-eight soldiers and RUC officers. Widgery concluded that 108 rounds had been fired by the Paras—who claimed to have only fired at "identified gunmen and nail-bombers"—but added "twenty more rounds were fired by the Army in Londonderry that afternoon but not by 1 Para and not in the area with which the tribunal was primarily concerned." This reference took on a greater significance in relation to the new material referred to by the Irish government, concerning the shots considered irrelevant by Widgery—those fired by units of the 8th Infantry Brigade from the city walls, and from an observation post on the roof of the Embassy Ballroom in the city center, about 300 yards from the Bogside. Audio tape footage of Army communications between the units on the walls and operational headquarters confirm several shots were fired, and the trajectory of a single, high-velocity round penetrated a metal stanchion on the side of the nine-storey high residential Rossville Flats, indicating that at least one shot had been fired from the ballroom observation post (OP).

The Provisional IRA[9] had indicated that it would have no military presence in the Bogside while the anti-internment march was taking place, according to the former head of the RUC in Derry, Chief Superintendent Frank Lagan, who passed the "no threat" intelligence analysis to General Robert Ford, Commander of Land Forces (Northern Ireland) and to Brigadier A.P. Maclellan, Commander 8th Infantry Brigade, as well as to the RUC Chief Constable Graham Shillington, at Brooklyn HQ Belfast. Lord Widgery noted that "the final decision which was taken by higher authority after General Ford and the Chief Constable had been consulted, was to allow the march to begin but to contain it within the general area of the Bogside and Creggan Estate so as to prevent rioting in the city centre and damage to commercial premises and shops." The Commander of 1 Para, Lt. Col. Derek Wilford, had told Widgery that he, at least, was unaware of the Derry RUC report.

Don Mullen, however, claims that senior military officers knew the IRA would not be in the Bogside area and produced a "plan within a plan" to draw the IRA out of the sprawling Creggan Estate by deliberately wounding two civilians shortly after the march started, a teenager called Damian Donaghy and a middle-aged man, John Johnston, who later died of his injuries. These were the two casualties treated by Dr. McClean, who described Johnston's injuries as a "gunshot wound over his upper inner right thigh, and a peculiar jagged wound over his left shoulder region, which I thought could possible have been caused by a ricochet."[10] Other evidence which wasn't fully considered, or was covered-up or ignored completely, included film footage taken by an Army helicopter which policed the march and shows the rapid deployment of I Para, the fleeing crowds and the shooting which followed. As in all murder investigations, the "best evidence" is the damage done to the victims, yet Widgery failed to take testimony from all of the injured. Only seven of the twenty-four people wounded were asked to explain the circumstances in which they were shot.

What happened on Bloody Sunday was not the result of a policing operation by the military which went badly wrong, but a pre-planned confrontation in which civilian casualties were an integral part of the British Army's counter-insurgency strategy, according to a 10-page unpublished article by former *Sunday Times* journalists Murray Sayle and Derek Humphrey. Their article was based on "one hundred pieces of evidence", including contemporaneous eyewitness accounts, taped interviews and indirect contact with the IRA. It had been missing for 26 years from public record but was later found in the archive of the National Council for Civil Liberties (NCCL). The article claims that the former Conservative Prime Minister, Edward Heath, and the late Unionist leader, Brian Faulkner, accepted a Military Intelligence briefing which stated that the IRA in Belfast was beaten and a "decisive blow" in Derry would "finish them off." The planned operation was based on Brigadier Frank Kitson's counter-insurgency strategy.

Kitson was a veteran of British colonial campaigns in Kenya. Malaya, Oman and Cyprus. His widely-known published theories concern the political control of populations, psychological warfare, and the integrated use of special units and the intelligence services. In 1970, less than a year after the British Army had been deployed on the streets of Northern Ireland in what would

eventually become Europe's longest 20th century conflict, Kitson commanded the 39th Brigade in Belfast. He established a pseudo gang, the Mobile Reconnaissance Force (MRF) based at Palace Barracks, in the unionist-dominated east of the city, which consisted of Military Intelligence personnel and "turned" members of the Official IRA. The MRF was responsible for a number of drive-by shootings of civilians in nationalist areas, which were intended to provoke both the Provisional IRA and the Officials into an open confrontation with the British Army. According to Sayle and Humphrey, Kitson's strategy was "based on the military principle that the way to bring your enemy to battle is to attack something that, for prestige reasons, he will have to defend, so that he will then be annihilated by superior strength. The civil rights march, the Parachute Regiment planners believed, was just such an objective which the IRA would have to defend or lose its popular support in the Bogside—either way the IRA would be finished."

Based on eyewitness accounts, the article outlined how British Army Saracen APCs took up rehearsed blocking positions along Rossville Street, next to Rossville Flats. Paratroopers wearing combat, not anti-riot, gear, jumped out and dropped into standard British Army firing positions clearly selected in advance for the purpose of the operation . . . this was a pre-planned operation, parachutists specialise in them. They seldom have what are called "encounter battles" when two groups just run into each other. Paras have a plan which they initiate the moment they hit the ground, jumping either from aircraft or in this case, from "Pigs" (Humber APCs).

The article suggested that the civilian victims of Bloody Sunday were not shot "in the mistaken belief that they were armed members of the IRA" but were "acceptable casualties" in an operation which failed disastrously because both the Official and Provisional IRA refused to be drawn into an armed confrontation with the Paras, leaving the British government to explain why front-line assault troops were deployed in Derry to "police" a demonstration which ended in the deaths of 14 unarmed civilians.

The decision not to publish the article by the two "Insight" journalists was not taken by the *Sunday Times* editor Harold Evans, who had established the "Insight" team of investigative journalists, but by Bruce Page and Ron Hall, former Insight editors at the newspaper, because they believed that the conclusion reached was not substantiated by the evidence produced by the reporters. A warning from Lord Widgery to Evans that publication of the article before he [Widgery] had produced his report could constitute contempt for the tribunal, may also have influenced the decision to "spike" the article.

In reaching his conclusion that the victims of Bloody Sunday had either handled weapons or explosives, or had closely supported IRA gunmen and bombers, Lord Widgery had relied on the testimony of the soldiers—without even considering, for a brief moment, the possibility that their versions were deliberately concocted to defend what was essentially a shoot-to-kill operation—and evidence from Dr. John Martin, the principle scientific officer with the Northern Ireland Office's Department of Industrial and Forensic Science, who carried out paraffin swab tests on the hands of the victims and concluded that lead deposits indicated that they had either fired a gun, handled

one or stood close to someone using a firearm. However, in one of several independent reports into the scientific and forensic evidence considered by Widgery which were commissioned by Lord Saville, Dr. Martin concedes that the "positive tests" carried out in 1972 could have been the result of "contamination from other sources such as motor exhausts, which at the time were not fully evaluated."

A second report, compiled by forensic scientists Dick Shepherd and Kevin O'Callaghan, suggests that James Wray, who died in the enclosed courtyard space called Glenfada Park, had been shot twice in the back from a distance of less than a meter while lying on the ground, a conclusion which "merits a murder prosecution", according to family solicitor, Paddy McDermott, The same report also concludes that Bernard McGuigan, the father of six children, had been shot in the back of the head by a dum-dum bullet, a standard issue round shaved to fragment on impact and banned under the Geneva Convention. This conclusion was supported by the massive amount of damage done to McGuigan's skull, observed by Dr. McClean who was present at the post-mortem examination carried out on 31 January 1972 at Altnagelvin Hospital, Derry.[11]   The independent analysts, who had been commissioned by the Saville Tribunal, described the forensic and ballistic evidence accepted by Widgery as "worthless."

The Institute of Sound and Vibration Research (ISVR) in London also produced a report into the sounds of Bloody Sunday which confirmed that the sharp, repetitive beat of a Sioux helicopter blade, known as "blade slap", was similar to the rate of fire of some submachine guns, and it was therefore possible for an observer on the ground "to mistake a brief period of helicopter blade slap for the firing of a submachine gun at a moderate distance." The armor-plated, two-seater, petrol-driven Sioux helicopter was the type used by British Army observers over the Creggan and Bogside areas to monitor the civil rights march. According to the ISVR study, the "blade slap frequency" occurs during transit maneuvers, step turns, shallow descents and "with the flare approaching a hover." Under certain conditions, with some helicopters, "continuous blade slap can occur in level flight." For the listener on the ground, the peak sound pressures from the Sioux blade slap, at a height of 300 to 600 meters, "were between 0.6 Pascals and 1.4 Pascals." By contrast, a submachine gun "would need to be a few hundred meters away from the peak pressures to be this low, or else shielded by buildings."

While admitting the possibility of blade slap being mistaken for gunfire, the report states that the "sound of individual blade slap impulses is subjectively lower in pitch than nearby gunfire and the character of the blade slap often changes perceptively from slap to slap whereas the repeated shots in a burst of submachine gun fire are more uniform." The report concludes that under conditions such as those in Derry, where a helicopter or submachine gun would be clearly audible above any background noise, "their sounds would be sufficiently distinctive that the likelihood of confusion would be small." However, taking into account that the repetitive rate of blade slap is similar to the rate of firing of some submachine guns, "it might be possible

under some conditions for an observer on the ground to mistake a brief period of helicopter blade slap for the firing of a submachine gun at a moderate distance."[12]

From a totally unexpected source, the Saville inquiry received a tape recording of telephone conversations which took place between journalists and senior British Army officers. Made from RUC Headquarters, Victoria Place, Derry, on 30 January 1972, the tape described the killings of the anti-internment demonstrators by members of 1 Para several hours earlier. The tape was released by the Irish police force, the Garda Siochana in County Donegal, where it had been "discovered" in storage after 27 years. The recording had been made by the Provisional IRA, who had monitored RUC communications. Several extracts had been played on 15 September 1974 at a Sinn Fein press conference in Dublin attended by relatives of the 14 people killed. The former president of Sinn Fein, Mr. Ruairi O'Bradaigh,[13] said the tape had not been made public earlier because the phone-tapping operation was of such military value to the Provos that the Republican leadership had decided to keep it a secret, although everything possible had been done to put "the relevant information" into the public domain without compromising the covert operation. The tape was seized in late 1974 by the Irish police during a series of raids in Donegal on the homes of republican activists and sympathizers, and had been held since then at Donegal Garda Division HQ. For years, senior Garda officers had denied the existence of the tape until they were approached by local Sinn Fein counselor, Jim Ferry, and Eamon MacDermott, a reporter from the *Derry Journal,* and threatened with legal action unless the tape was returned to the person from whom it had been confiscated. According to Sinn Fein, this incident was one of several which confirmed that there had always been a "certain amount of collusion" between Donegal Garda Division and the RUC in Derry, apart from the official force-to-force cooperation that developed over the next twenty-three years.

Max Hastings, the former editor of the *Daily Telegraph*—a London-based newspaper that has been critical of the Saville Tribunal—is heard on the tape asking about the number of casualties. He confirmed that "the conversation involving me is authentic because I was making a documentary for the BBC in Belfast at the time." The Irish national broadcasting organization, RTE, also confirmed that Paddy Clancy, who was working for the *Daily Telegraph* in the early 1970s, is another of the journalists who is heard on the tape seeking information about the Bogside shootings. The most disturbing parts of the recording are the remarks of an unidentified British Army officer, including a comment that the O/C Land Forces, Gen. Ford, had gloated over the civilian deaths. Speaking with a military colleague, the officer called "Alan" is heard to say:

> "The whole thing is in chaos. I think it has gone badly wrong in the Rossville [Bogside] area. The doctor's just been up at the hospital and they're pulling stiffs out there as fast as they can get them out."
> "There's nothing wrong with that, Alan."

"Well, there is because they're the wrong people. There's between nine and fifteen killed by the Parachute Regiment. There are old women, children, fuck knows what, and they are still going up there. I mean the Pigs are just full of bodies. There's a three-tonner up there [a reference to an armor-plated Humber APC] with bodies in it . . . stiffs all over the place . . . The padre's a bit upset. He's going off to see the commander about ill-treatment."

"General Ford?"

"He was lapping it up."

"Who was?"

"Ford"

"Was he?"

"Yeah, he said it was the best thing he had seen for a long time"

"Well done, First Para."

Interviewed later that Sunday evening on the BBC, General Ford claimed that the paratroopers "did not fire until they were fired upon and my information at the moment is that [the Paras] fired three rounds altogether after they'd had something between ten and twenty [rounds] fired at them." He also claimed that the thirteen dead civilians "may not have been killed by our soldiers." Ford's behavior during the course of the afternoon, however, had been observed by Brian Cashinella, a reporter with *The Times* of London, who heard the Land Forces O/C shout "go on, the Para, go and get them." In an article two days later, Cashinella wrote:

I found the reaction of the paratroopers to this situation interesting. They seemed to relish their work, and their eagerness manifested itself, to me, mainly in their shouting, cursing and ribald language. Most of them seemed to regard the Bogsiders and people who took part in the parade as legitimate targets. [14]

The journalist Simon Winchester of *The Guardian* also witnessed the Paras at work up close, as the post-demonstration speeches were beginning in the Bogside. In an article published the following day he wrote:

. . . four or five armoured cars appeared in William Street and raced into the Rossville Street square, and several thousand people began to run away . . . Paratroopers piled out of their vehicles. Many ran forward to make arrests, but others rushed to the street corners. It was these men, perhaps twenty in all, who opened fire with their rifles. I saw three men fall to the ground. One was still obviously alive, with blood pumping from his leg. The others, both apparently in their teens, seemed dead.

The meeting at Free Derry Corner broke up in hysteria as thousands of people either ran or dived for the ground.

Army snipers could be seen firing continuously towards the central Bogside streets and at one stage a lone Army sniper on a street corner fired two shots at me as I peered around a corner.

Then people could be seen moving forward in Fahan Street, their hands above their heads. One man was carrying a white handkerchief. Gunfire was directed even at them and they fled or fell to the ground. . . .

Weeping men and women in the Bogside spent the next half hour . . . pushing bodies of dead and injured into cars and driving them to hospital. I saw seven such cars drive away with some of the bleeding bodies on the back seats, inert and lifeless.[15]

Derry was a "turkey shoot" approved by the British Prime Minister Edward Heath and the Northern Ireland unionist leader Brian Faulkner, according to Lord Gifford QC, representing the family of James Wray, who had been "finished off" at close range while lying wounded in Glenfada Park. The operation was planned at the highest military level and carried out by a regiment which had been "brutalised by previous campaigns in Oman" and had been "authorised by their superiors" to shoot to kill. Lord Gifford made his uncompromising statement to the Saville Tribunal on 22 November 2000, relying on a memo, entitled "The Situation in Londonderry as of 7 January 1972" from General Ford to the former British Army GOC and Director of Operations in Northern Ireland, Sir Harry Tuzo.[16] In his "memcomm", General Ford wrote:

Against the DYH [Derry Young Hooligans] the Army in Londonderry is . . . virtually incapable. This incapacity undermines our ability to deal with the bombers and gunmen and threatens what is left of law and order on the west bank of the River Foyle [where the nationalist areas of Creggan and Bogside, as well as Derry city-center is located]. Attempts to close with the DYH bring the troops into the killing zone of the snipers. As I understand it, the commander of a body of troops called out to restore law and order has a duty to use minimum force but he also has a duty to restore law and order. We have fulfilled the first duty but are failing in the second. I am coming to the conclusion that the minimum force necessary to achieve the restoration of law and order is to shoot selected ringleaders amongst the DYH, after clear warnings have been issued. I believe we would be justified in using 7.62mm but in view of the devastating effects of this weapon and the dangers of rounds killing more than one person, I believe we must consider issuing rifles adapted to fire .22 inch ammunition to sufficient members of the unit dealing with this problem to enable ringleaders to be engaged with the less lethal ammunition.

If this course is implemented, as I believe it may have to be, we would have to accept the possibility that .22 rounds may be

lethal. In other words we would be reverting to the methods of internal security found successful on many occasions overseas, but would merely be trying to minimise the lethal effects by using the .22 round.

Another confidential analysis by Lt. Col. Harry Dalzell-Payne, written on 27 January, three days before the anti-internment march, suggested that the MoD "should try and anticipate some of the problems we may face on Monday, 31 January 1972, if events on Sunday prove our worse fears." This document strongly supported the deployment of the Parachute Regiment to police the march, but warned that senior officers should be aware that military force will lead to "accusations of brutality and ill-treatment of non-violent demonstrators." The MoD responded to the killings in Derry within 24 hours by releasing to the international media, through the government's news agency, the British Information Service, a copy of the "operational briefing" allegedly given to senior officers by Col. Dalzell-Payne. The document was described as a "ludicrous catalogue of invented detail."[17] The briefing listed a series of incidents intended to demonstrate that "all the army shooting was at identified targets in return of fire under the terms of the Yellow Card, which lays down when fire may be returned."[18] These included killing two and hitting four gunmen who had opened fire, and killing two and hitting seven nail-bombers and a petrol-bomber. The MoD also claimed that the Royal Anglian Regiment had hit two gunmen, and that four of the thirteen dead were on the Army's wanted list of known terrorists.

The Paras, however, were not the original choice of senior officers based at Thiepval Barracks Army HQNI, for operational duties in Derry, according to a written statement from a former soldier, identified only as INQ1952, who claimed that his unit, the Royal Fusiliers, was ordered to shoot and kill at least seven people even if there was no justifiable reason to do so. The ex-Fusilier's account submitted to the Tribunal in mid-June 2001, states:

> We were told that these orders came from Downing Street . . . our section would be taken to a place and when called we would clear the street. If the demonstration looked like it was going to pass off peacefully, we would be sent in to shoot and kill a number of people in order to disperse the crowd. Lieutenant INQ2084 and Sergeant INQ2148 said that, with all the soldiers out there, the IRA would be tempted to shoot at us and would therefore give us an excuse to disperse the crowd. However, if the organisers managed to convince the IRA that it would be in their best interests to stay away, we were to shoot up seven civilians.

The ex-Fusilier claims that he was picked by Lt. INQ2084 to do the shooting:

> I think the officers were taking advantage of me because they knew I would not disobey an order. I was trusted to do the

job and was expendable. I argued with Sgt. INQ2148 that once I started shooting, people would be running all over the place. What if a woman or child ran in front or what if a bullet went through the target and then hit a woman and child, what then? "Tough on you", he replied, with a grin on his face. On January 29, just before I went to bed, the section was called together and told we were stood down and that the Paras had been brought in to do the job. We were told that it was because the latest intelligence received by Downing Street [the British PM's residence in London] was that the march was going to be much bigger than originally thought.

Once the announcement that a second official inquiry into the part played by the British Army on Bloody Sunday was made by Tony Blair, the MoD began a low-intensity campaign of damage limitation. This included encouraging the lawyers representing the ex-soldiers called to give evidence to seek anonymity, to argue against traveling to Derry, and to look for assurances against prosecution for what had taken place in the city that chilly afternoon in 1972. A number of classified MoD documents—said to identify Military Intelligence informers and their handlers, as well as an "on-going assessment of IRA membership, military structure, armaments and strategy" in Derry in the early 1970s—were supplied to the Tribunal with several heavily-redacted sections. Counsel for the MoD, Philip Havers QC, claimed the copies of the uncensored original documents should only be seen by the members of the inquiry panel, because "wider disclosure" would have "grave consequences" for the informers. The MoD set about obtaining "gagging orders" under Public Interest Immunity (PII) provisions, while claiming that disclosure might deter potential informers, a situation that senior MI analysts claimed "could seriously damage national security."

It wasn't long before the "smart monkeys" at MI5 realized that the Widgery Report—which had served its purpose by shielding the Whitehall political and military establishment from responsibility for the deaths of 14 unarmed civilians for more than 25 years—was no longer worth the paper it was written on. A little disinformation was required. However, the attempt by the Security Service to point the finger of suspicion at Sinn Fein MP Martin McGuinness, the current Minister for Education in the Northern Ireland Assembly, backfired badly and raises the question of MI5's credibility in providing evidence to judicial tribunals of this nature. The claim that Martin McGuinness, who has admitted being second-in-command of the Provisional IRA in Derry in 1972, fired the first shot which "precipitated" the fatal events, was made in debriefing notes by an alleged Provisional informer, codename "Infliction", in several intelligence cables sent from the British Embassy in The Hague, Holland, to MI5's former Curzon Street HQ in London more than 17 years ago. The first report, dated April 1984, reads:

INFLICTION: Debriefing. Below are a number of separate items of intelligence reported by INFLICTION for dissemination as you see

fit [name deleted]. Martin McGuinness . . . has admitted to INFLICTION that he had personally fired the first shot (from a Thompson machine gun on "single shot") from the Rossville Flats in Bogside that precipitated the "Bloody Sunday" episode.

This claim is repeated almost word for word in a second "Out Telegram, Classification: Secret Addressee Only" dated 15 May 1984. The document is headed "In London AO" for the attention of the RUC and Army HQNI and describes the informer as a "leading member of the Provisional IRA, who no longer has access to the organisation". A third document is dated 17 May 1984, and headed "Secret/Delicate Source/Limited Distribution. Title: PIRA: Martin McGuinness. Routine to Security Service ZEN/HQNI . . . NIO . . . for liaison staff representative . . . ZEN/Chancery, Dublin. This report is being circulate under separate arrangements in RUC HQ, Knock and NIO(B) . . . Clearance must be obtained if you wish to discuss it with anyone else." The report repeats the allegations made in the two previous telegrams, but adds a "desk comment" which reads: "At the time of Bloody Sunday, 30 January 1972, McGuinness was a senior member, if not O/C, of Londonderry PIRA. Although we have no collateral [*sic*] for the above report there is intelligence that McGuinness was actively involved in PIRA attacks in the city shortly after Bloody Sunday."

What MI5 hoped might be considered "collateral intelligence" came from the archives of the *Sunday Times*. This anonymously-written report refers to an alleged statement made by Ivan Cooper, a prominent civil rights activist and former SDLP representative,[19] which claimed that McGuinness was with two men, George McEvoy and Joe McCallion, in a house in William Street, shortly before the demonstration began. "Their plan was to fire through the door at soldiers whom IC [Ivan Cooper] says were occupying some of the houses on the other side of W St. The troops moved in and the trio were trapped. IC says that MM panicked and thought he was going to be caught. McE said to dismantle the Thompsons and put them up their jerseys. They did and ran off with the crowd." Cooper, a former Minister for Community Relations in the 1974 failed Northern Ireland power-sharing executive, rejected the *Sunday Times* report, describing it as a "poisonous and disturbing account which smacks of a British security forces operation." Christopher Clarke, counsel for the Tribunal, also warned that the document, which had been dormant in the *Sunday Times* archive for almost 30 years and never published—despite that newspaper's continuous attempts (notwithstanding the ceasefire and IRA decommissioning) to discredit and vilify McGuinness—should be treated "with caution", saying it would have to be explained by Mr. Cooper, by the reporters who filed the report, and by the Sinn Fein MP, who has confirmed that he "welcomed the opportunity" to give evidence later in the year. Counsel for the MoD and the ex-servicemen would have undoubtedly relished the opportunity to question him about his role in the Provisional IRA in the early 1970s—something about which he had never previously spoken. This was precisely the reason why the MI5 "raw intelligence" and *Sunday Times* archive materials were introduced in the first place, and will probably have little or no bearing on the search for the truth about Bloody Sunday.

The uncorroborated MI5 allegations in the cable traffic from Holland were repeated in a censored briefing document submitted to the Tribunal in December 2000, during a hearing into the admissibility of PII certificates signed by former Home Secretary Jack Straw, and Defence Secretary Geoff Hoon. The PIIs seek to establish that "full disclosure of the contents of Security Service documents could cause real harm" to the work of the agency. However, if MI5 thought that the PIIs would prevent close examination of the material—which also claims that Infliction believed the matter of who fired the first shot was "the one thing that bothers McGuinness" and seems to be "on his conscience"—the agency failed to reckon with former MI5 agent David Shayler, who left MI5 in 1997, and who had access to classified information about MI5's informer. Writing in *The Observer* on 14 January 2001, Shayler states that Infliction was widely-known in intelligence circles in London as a "bullshitter". The former agent says he came across Infliction while working in MI5's counter-IRA T8 Branch during research into an IRA supporter, identified as Leonard McMullin who, Infliction had claimed, "had influence within the higher echelons of the IRA." Despite his seemingly being such an important target, Shayler could find "no other significant intelligence traces of the man [McMullin]". When he raised the matter with other T8 Branch officers, including the "agent handling section", he was told that Infliction's information could not be trusted.

The former Provo had been recruited because he seemed to have "particularly good access" to the IRA Northern Command. Initially his information had been taken seriously until a conflict arose between his reporting and that of other MI5 sources. According to Shayler, "Infliction was supposed to be the reliable source and MI5 went with his version, only to be made to look stupid." The Security Service immediately "terminated" Infliction (ceased using him as an agent) and labeled the intelligence he had provided about the Provisional IRA as coming from a source "whose reliability is being assessed." When Shayler inquired about the result of the reassessment, he was told by a T8 Branch colleague that Infliction had "conned" many MI5 officers "who had since scaled the management ladder in the service" and who are now anxious "to avoid spending the rest of their careers in maintenance or document audit." Shayler believes the MI5 managers who are aware of Infliction's unreliable reporting "haven't attempted to resolve the issue, and have stuck together to ensure that no one was blamed for the Infliction fiasco." He also raises the possibility that they have allowed themselves to "become involved in a state conspiracy to mislead the Bloody Sunday inquiry" because if they break ranks it could "jeopardise their livelihood, security and, possibly, liberty" because they could face prosecution under the Official Secrets Act.

Both David Shayler, and his partner Annie Machon, also a former MI5 colleague who left the agency five years ago, have submitted written statements to the Saville inquiry, and have indicated they are willing, if called, to travel to Derry to give evidence. A former soldier, once a member of the British Army's Force Research Unit (FRU), who handled military intelligence agents in Derry in the 1980s, has also been in touch with lawyers acting for the families of the victims. This witness claims to have had access to, and to

have read, classified military reports gathered around the time of Bloody Sunday, which show that Military Intelligence believed that the Provisional IRA did not intend to open fire during the civil rights march, and that there was no record of Martin McGuinness having done so. He also stated that the "intelligence grading" on the Infliction source report he had seen—an indication of its reliability—had been blacked out.

In the Fall of 2002, the inquiry moved to London, taking evidence at Methodist Central Hall, Westminster, from ex-servicemen and serving soldiers, including General Sir Michael Jackson, the current chief of staff of British forces deployed in Iraq. In Derry, over 30 years ago, he was a junior officer, an adjutant in charge of administration with the Paras, and described the carnage on the streets of the Bogside as a "first rate operation."[20] The intervening three decades hasn't changed his opinion, and that remains the perception of many of the Army officers involved and the Paras who opened fire, although Major General Peter Welsh, who was a lieutenant colonel commanding the 2nd Battalion, the Royal Green Jackets, and Britain's longest serving commander in Ulster, Colonel Roy Jackson, both criticized the use of paratroopers—whom Col. Jackson described as "shock troops." However, the former commander of the elite 22 SAS Regiment, General Sir Michael Rose, repeated the allegation that a member of the IRA had opened fire first with a Thompson machine gun. He claimed he had been briefed that the IRA might use the march as a cover to attack the Army, but had not been told about any large-scale arrest operation involving the Paras. When Michael Mansfield QC pointed out that the IRA had never used civil rights marches in this way, General Rose replied: "On this occasion, they chose to fire. I know." (*ibid.*)

The Widgery Tribunal was a 10-week sprint compared to the current "marathon", which is expected to produce its definitive report in spring 2005, at least five years after Prime Minister Blair announced that one of the MoD's worse nightmares had become a reality. This is why the MoD has been less than fully cooperative—for example, supplying only the names of 3,300 soldiers "who might have been deployed" in Derry, and no further details. So far, the Saville Tribunal has traced approximately 1,500, of which between 300 and 400 are expected to give evidence via video link from the British mainland, following a Court of Appeal decision, handed down by the Master of the Rolls, Lord Phillips, that the soldiers' human rights would not be protected if they were ordered to attend hearings at the Guildhall in Derry.

The inquiry's statistics are impressive: four years of hearings, involving 918 witnesses and statements from 1,800 individuals in Derry and London, included 427 days of oral testimony. Statements have also been taken from 627 soldiers, 90 journalists and photographers, 53 RUC officers, 32 former members of Republican paramilitary organizations, 23 politicians, 13 clergymen, and several British intelligence agents who testified anonymously. Documentary evidence exceeds 62,000 pages (119 volumes) including the 39-page whitewash produced by Lord Chief Justice Widgery, which limited references to certain victims to a single paragraph. There are 5,000

photographs (8 volumes) and over 40 hours (55 tapes) of VTR material, including 8mm and 16mm film footage shot by national and international news organizations, and 29 audio tapes, including "live" radio recordings. Lord Saville also commissioned independent reports into "pathology and ballistics, firearms and explosives residue, acoustic evidence and injuries". All individuals and agencies summoned to testify or submit documentation, have been asked by the Tribunal to provide written assurances that they have passed over everything of relevance, which is something else that the MoD has refused to do. Hundreds of civilian witnesses, including relatives of the dead and injured, doctors, first-aid personnel, priests, journalists, and citizens of the city who opposed the selective use of internment without trial, and the ill-treatment suffered by the detainees at the hands of RUC Special Branch and Military Intelligence interrogation specialists, have already taken the stand and given oral evidence. Later in 2003, it was the turn of the military witnesses, and individuals such as former Derry IRA deputy O/C Martin McGuinness, and former MI5 agent David Shayler, who—in a curious irony—found themselves "on the same side" in refuting MI5's attempts to undermine the slow progress towards "finding the truth rather than establishing facts."

The Saville inquiry, if it is allowed to proceed without further interference, has the potential to become a milestone in British legal history because of the manner in which it has gone about its business. However, intermittent intervention by English courts may continue, with high-powered, well-paid MoD lawyers ready to use every trick in the book to challenge decisions taken by Lord Savile and his colleagues during the course of the inquiry over the next 12 to 18 months Another tactic is to lodge a series of legal objections to specific points in the report with the High Court in London, which could delay publication of the final draft. The relatives of those who died, in particular, are apprehensive at such a possibility. Following the December 2001 Appeal Court ruling, their feelings were summed-up by Michael McKinney, whose 26-year-old brother, William, was one of the fourteen victims of the ill-conceived and ruthless military operation: "Again we feel an inferior court has overruled an international inquiry. Here you have a system [which is] starting to protect its own."[21]

In March 2004, the final witness—the former O/C of the Provional IRA in Derry, identified as PIRA 24—completed his testimony, confirming that the Provos had moved all their weapons from the Bogside to prevent a confrontation with the British Army. The inquiry's proceedings were selectively reported in the UK media. However, those British politicians, in particular Tory members of parliament who regularly criticized the cost involved—estimated at approximately $350 million—and claimed there was "apathy and a general lack of interest" in what had taken place in Derry, might reflect on the fact that when the Saville Tribunal ended, the inquiry's official web site had recorded more than 9 million hits.

# New Europe's Old Belgium: Murder, "Passive Corruption" and the Pink Ballet

It is probably fair to say the Belgium is no more crazy than other developed Western countries where power and greed have contributed to an "acceptable level" of corruption. What makes Belgium unique is the quality—in terms of intrigue and ruthlessness—of its scandals.

Belgium is a divided kingdom, divided between the French-speaking Walloon region and the Flemish-speaking Flanders region centered around the city of Antwerp, where approximately sixty percent of the population live. This ethnic and linguistic rivalry has often led to political instability at the national and local levels. The ethnic division has resulted in several Walloon and Flemish political parties—liberal, socialist, and social democrat—each with similar programs but unable to unite their ethnic counterparts into a single national political force because of cultural and linguistic barriers. Unworkable national coalition governments and bad legislation have often been the result.

Appointments and promotions within all state institutions and agencies in Belgium, from a junior local-council clerk to ministerial office, are based on card-carrying, political patronage. This back-scratching arrangement was a critical factor in the lack of cooperation in the 1980s and 1990s among the Belgian police forces: the Gemeentepolitie (uniformed community police), the Gerechtelijke Politie (the plain-clothes judicial branch which investigated organized crime, drug trafficking and terrorism) and the Rijkswacht, (the former military police force which became the responsibility of the Ministry of Justice and the Ministry of the Interior in January 1992 after demilitarization the previous July). Within the domestic security service, the Sûreté d'État, the lack of proper oversight and a cult of secrecy led to hardcore corruption, with some senior officers linked to right-wing political parties which, less than two decades ago, were suspected of actively facilitating the return of a non-democratic agenda which bordered on Fascism.

Such is the domestic climate of the host country of the European Union and NATO, both of which are headquartered in Belgium. But for the most part, EU and NATO business commands the attention of the foreign media while the affairs of the Belgians—with the exception of the Dutroux child-sex killings in the mid-1990s—are ignored outside the country.[1]

## THE MURDER OF ANDRÉ COOLS

The ancient industrial city of Liege is located about eighty-five kilometers southeast of Brussels on the A3 motorway. Because of the level of unsolved crime—a series of corruption scandals and the assassination of a senior politician since the mid-1970s—this former capital of the 1000-year-old principality has often been referred to in the media as "Palermo-on-the-Maas." In the early hours of 18 July 1991, André Cools was shot dead in Liege, in the car park near the apartment of his mistress, Marie-Hélène Joiret. It was a cold-blooded, professional killing; nobody believed it was linked to Cools' private life. In fact some reports immediately claimed it had been carried out by a Marseilles assassin, acting on orders from a powerful political figure "as hard as André."

André Cools was a leading Socialist Party politician, one of the most influential in the post-war years. His party controlled Liege, the cultural center of the Walloon region, and the only city in Belgium where the French national holiday, Bastille Day, is still celebrated. The Socialist Party (PS) with almost 40 percent of the vote, dominates the region, and Liege dominates the PS. First elected to parliament in 1958, Cools controlled the city for almost thirty years. He served as minister for finance in 1968 and later as minister for economic affairs in 1971, and as one of the many vice-premiers. According to colleagues, his political career was one "in which he made as many enemies as friends."

Cools' murder received widespread coverage in the Belgian media. A common element in many of the reports was the lack of surprise that old scores could be settled in such a manner in Belgium, regarded internationally as the "soul of the new Europe." Because of this perception, most members of the European Parliament from abroad, and foreign media hacks were hardly aware of the incident. Most seldom bother to leave Brussels, and when they do, it's not to visit run-down cities like Liege, while André Cools, in the 1980s and early 1990s, did not frequent the exclusive 12-nation European cocktail-reception circuit.

Many Belgians believe their country is as institutionally corrupt as (for example) Italy, where the political system is perceived to be dominated by powerful figures linked to organized crime bosses, but without the presence of pan-European institutions such as the EU and NATO to distract the attention of foreign correspondents. The role of the Italian Mafia, the terror of the Red Brigades and the nihilistic savagery of the neo-fascist "Black Orchestra" network, have been well-documented, but nothing similar has occurred in relation to Belgium. After all: Belgium is small, Belgium is boring, nothing ever happens in Belgium . . . and nothing could be further from the truth.

For over a decade prior to the "incident in Liege", the citizens of Belgium had been subjected to a barrage of stories of political corruption, sex networks involving the rich and (locally) famous, drug trafficking, murder and an alleged, extreme right-wing attempt to promote a coup d'état, linked to the murderous rampage of the Nijvel Gang between 13 March 1982 and 9 November 1985, in which 28 people died. The Cools assassination appeared to be part to this lethal rage and endemic corruption. Everyone seemed to

have a piece of the puzzle but nobody knew the complete picture. As for the police forces and the Sûreté, what they knew, they weren't sharing.

Finally, in February 1993, following the arrest of a prominent business-man, George Cywie, chief executive of the electronics firm, MCA-Tronix, the Belgian authorities announced a "significant breakthrough" in the 17-month Cools homicide investigation. Cywie had accused retired Belgian Army officer, Colonel Jean Dubois, of accepting illegal payments following a decision, announced by the Ministry of Defense, to purchase 18 reconnaissance and 28 anti-tank helicopters from the Italian company, Agusta. When questioned by investigating magistrate, Veronique Ancia, Cywie's statement corroborated allegations of secret payoffs and serious corruption made by former SP minister, Alain van der Biest. Cywie was the official trade representative in Belgium for Agusta, and played a major part in securing the contract—worth approximately $350 million—for the Milan-based company in the face of stiff competition from the French manufacturer, Aerospatiale, and the German firm, MBK. The decision to buy Italian was taken by Guy Coeme, the SP defense minister in the coalition government. Shortly after it was announced, the Liege branch of the SP allegedly received a secret $5.5 million "political donation", via the Italian Socialist Party and what has been described as an international network of Socialist associations.

Magistrate Ancia pursued her investigation on the assumption that André Cools had become aware of the payment, and that his threat to name SP colleagues involved led to his death. This scenario provided a motive for the murder, something which had been noticably lacking in the homicide inquiry up to that point. Now there was even an Italian connection. Since the beginning of another investigation in Italy involving Agusta, which had been part of the state-owned multinational Efim until mid-1992, Magistrate Ancia had been given access to confidential pre-trial documentation seized by the Italian authorities. These included a confidential fax from Agusta's Brussels-based representative, Ricardo Baldini, to the company's head office in Milan which identified Senator Guy Mathot, the chief minister of the Walloon regional assembly, as the "key figure" within the Socialist Party to "take care of business" and mentions a "commission" of approximately 2.5 percent on the $350 million helicopter deal. This allegation was supported by Agusta executive Jacques Cardon, who told investigating magistrates that he had seem Guy Mathot accept a "serious amount of money" to replenish the SP's coffers. Phillipe Moureaux, a friend of André Cools, also claimed that Mathot had interceded directly on behalf of Agusta with Defense Minister Coeme, while a former girlfriend, Elaine Van Vreckom, stated that Mathot's "commis-sion" was a villa and site in the southern French resort of Saint Raphael, reportedly worth $250,000.

Another Belgian politician named in files confiscated in Italy was Senator Guy Spitaels, a former finance minister and interior minister in the Walloon regional assembly, who was linked to Mauro Giallombardo, a senior advisor to the former Italian Socialist Prime Minister, Bettino Craxi. Described as Craxi's "portaborse" (bagman) in the Socialist International, between 1987 and 1989 Giallombardo had been the chief Italian Socialist Party (PSI)

spokesman at EU level, and general secretary of the Federation of European Socialist Parties.

Giallombardo also controlled two Luxembourg-based "shell companies", Merchant Europa and Merchant International Holdings, which the PSI used to launder funds and repay favors. Described as a key figure in the Socialists' "international slush-fund", he took flight before the Italian magistrate, Antonio Di Pietro, or his Belgian colleague, Veronica Ancia, had an opportunity to question him. After 18 months "on the run", he surrendered to the Italian police on 13 July 1993, two days after the Belgian Senate's judicial committee began hearings to consider the suspension of parliamentary immunity, requested by Ancia, for Mathot and Spitaels, while a parliamentary commission considered the case against Guy Coeme. All three had resigned earlier in the month, with Coeme blaming a "politically-orchestrated media witch hunt" for his decision. The Belgian press had no sympathy for the "Three Guys." The most critical was La Dernière Heure, which ridiculed the "fall of three little Socialist marquises" and called for an Italian-style "uno puro mano" anti-corruption campaign.

Guy Spitaels denied all the allegations made against him, claiming Agusta executives met several senior Belgian politicians, including defense minister Coeme, economic affairs minister Willy Claes, and transport minister Jean-Luc Dehaene, while he denied having met Agusta president Roberto d'Alessandro. This was contradicted by Agusta director Cortesi, and the firm's agent, Georges Cywie, who said that both men had at least one meeting to review the helicopter contract when d'Alessandro visited Brussels in June 1988. The Italians, it seems, went right to the wire to secure the order. On 23 November 1988, Agusta senior vice-president, E. Cucrra, wrote to Willy Claes offering a $125 million investment opportunity for Belgium companies in the development of a new Agusta helicopter, the A-129 Utility, if the government agreed to purchase the A-109. Two days later the cabinet formally approved negotiations with Agusta. On 8 December, Minister Coeme decided in favor of the Italian company.

The case against Coeme involved two official documents: a well-researched technical report from the General Defense Staff, dated 6 June 1988, and signed by General Andre Jacobs, which recommended the purchase of Aerospatiale's Ecureuil because of suitability, and low operational and maintenance costs; and a detailed statement released by the Defense Procurement Office on 16 November 1988. Considering the allegations against Guy Coeme—that the minister falsified the technical evaluation analysis in order that Agusta would secure the contract—several members of the parliamentary judicial commission asked Magistrate Ancia to disclose the identity of an anonymous, highly-placed "deep throat" apparently linked to claims that following Coeme's decision, five million dollars was lodged in five accounts of then unknown ownership at British branches of CommerzBank du Luxembourg SA, and Duits CommerzBank AG at Austin Court in the City of London.

The Agusta affair had cost three senior politicians their jobs, but had it cost André Cools his life? Cools, a former finance and economic affairs minister, had been succeeded by Guy Spitaels as chairman of the Liege SP,

but he remained a powerful and influential figure in the economic development of Wallonia. In the early 1990s, the region had 40 percent of the population, but accounted for only 26 percent of the Gross National Product, while Flanders, with 60 percent of the population, accounted for 74 percent of the GNP, of which 10 percent annually was used to prop up the overburdened Walloon welfare system. At the time of his death, Cools was senior executive with a company called Meusinvest, which was financially involved in expansion plans for the Liege airport at Bierset. The project, which would have provided a welcome economic boost for the region, with the potential for future investment, was under the supervision of the Societé de l'Aerodrome de Bierset, and the chairman of SAB was André Cools.

There is a passage in Magistrate Ancia's file from an anonymous source which reads: "A meeting had been called by André Cools for September 3, 1991, with the intention of replacing Spitaels as chairman of the PS by Mr. Moureaux." A second notation reads: "It is unthinkable that an arrangement could be made for the PS to receive funds without the cooperation, in the criminal sense of the world, of the chairman [Spitaels] of this party." Another "well-informed person" told Ancia that Cools met economics minister, Willy Claes, on 7 December 1988, the evening before Agusta secured the contract, and expressed his concern that the Italians would fail to honor their investment promises. This meeting was also noted in Cools' personal agenda which the magistrate had confiscated in the course of her investigation. It was no secret among the Socialist rank-and-file in Liege that Cools had also become suspicious of his political "dauphin", Mathot, after an earlier, unsuccessful attempt to oust Spitaels.

This failure took its toll on Cools' influence within the PS, and shortly afterwards he was "eased out" of discussions between the PS and Agusta. Cools believed he had been double-crossed by the Three Guys, financially and politically, and he wasn't present at the official opening of Agusta's European Distribution Centre at Liege Airport, in June 1991, where Guy Coeme, and another Walloon minister, Alain van der Biest, were joined by Georges Cwyie, Agusta vice-president Michele Feratoli, and newly appointed EDC chief executive, Corlaita. At some stage during that summer, Cools reportedly planned a second attempt to replace Spitaels with his friend Moureaux, and expose the treachery of his former comrades. To some extent it was a case of the "pot calling the kettle black." Yet within a month, the old Socialist warrior, who had come to epitomize the "gut politics" of the region, lay dead in an empty urban car-park.

One of the problems for magistrates in Belgium investigating politically sensitive cases such as the Cools/Agusta affair is the accusation of political bias. The appearance of bias is almost inevitable due to the way the judicial system is structured, and the political patronage involved in the appointment of magistrates (and indeed all other public sector employees). Magistrate Veronica Ancia is a member of the Christian Peoples' Party (CVP), the main political opponents of the PS in Wallonia. This led to persistent allegations from PS politicians that Ancia had used the homicide investigation to discredit the PS, particularly Alain van der Biest and Guy Mathot. In fact, the unproven

allegation that Mathot had sanctioned the murder of Cools was made by Richard Taxquet, the former driver and private secretary to Van der Biest. However, the source of the allegation, according to *Le Soir Illustré* and *La Libre Belgique* and which was repeated by local Liege gangster, Domenico Castellino, when questioned by Ancia, was Van der Biest, who told Taxquet and he in turn told Castellino. This was part of the Sicilian connection, which, by autumn 1996, led to an international arrest warrant being issued for two professional Tunisian assassins, Abdelmajid El Almi and Abdeljeld Ben Brahim.

The Tunisian assassins were hired while living in Agrigento, Sicily, in mid-1991, by a local Mafia member, Calogero Todaro, and paid approximately $12,000 to eliminate Cools. Neither were aware of the true identity of their victim—they were told that their target was "an important drug dealer" who had caused serious business problems for a local Mafia clan. They were identified from passport details noted by a diligent Italian customs official on duty at a routine vehicle check-point on the French/Italian border on 18 July 1991, as the two men were returning to Sicily in a car driven by Domenico Castellino. The "hit" was coordinated by Carlo Todarello, who also claimed that Mathot sanctioned the contract. In the absence of an extradition treaty between Belgium and Tunisia, both the accused, who pleaded guilty, were tried before local magistrates in Tunis in June 1998 (two years after the gun used in the killing was fished out of the Ourthe canal in Liege). They were each sentenced to twenty years imprisonment. The case against the remaining suspects in the Cools conspiracy—including former government minister and PS colleague Alain van der Biest, his former secretary Richard Taxquet, and Silvio De Benedictis, Pino Di Mauro, Iachino Contrino and Mauro De Santis, was due to begin in 2003, allowing time for defence lawyers to answer the charges, which are contained in over 10,000 pages of documentation, compiled by investigating Veronique Ancia.

However, on 18 March 2002, Alain van der Biest was found dead at the family home in Grace-Hollogne. He had apparently committed suicide, according to official reports, having taken a lethal cocktail of prescription drugs mixed with alcohol. In a farewell letter to his wife, van der Biest denied being involved in the murder of Andre Cools, stating tht his "crusade" to prove his innocence was finally over.

Despite the untimely death of the chief suspect, the case against his co-accused on charges of 'complicity in the crime of murder' went ahead. In January 2004, both Taxquet and Di Mauro were sentenced to 20 years in prison, and the remaining defendants who had facilitated the assassination by providing logistical support for the convicted Tunisian gunmen, received prison sentences ranging from five to twenty years.

## THE NIJVEL GANG ATROCITIES AND THE PINK BALLET

The assassination of André Cools once again focused attention on old scandals such as those mentioned above, which involve the complicity of elements of the state intelligence and security service, the Sûreté d' État, and the venal nature of the political greed. It went back as far as the Pinon

affair, a sordid tale of sex and drugs involving some of the most prominent people in the country, who were deeply involved in the vengeful politics of the 1980s, when psychiatrist Dr. Andre Pinon hired a private detective, Bob Louvigny, in 1980, to investigate his estranged wife's social life, pending divorce proceedings. Louvigney discovered that Josianne Jeaniau was part of a vice network which involved the sexual abuse of minors. Drugs were freely available at orgies held at a Brussels nightclub, "La Jonathan", at the Parc Savoy Hotel, and at a suburban golf club. Implicated were senior police and military officers, politicians, businessmen, a banker, law officers and possibly two circuit court judges. Break-ins followed at Dr. Pinon's home, and at the Etterbeck Psychiatric Clinic where he worked. Both premises were ransacked but nothing of value was taken. Dr. Pinon believed the "plumbers" were looking for audio and video cassettes containing details of the vice ring, including corroborative statements and other testimony. The Rijkswacht began an inquiry, and File 3891007.79 soon contained statements from many of the network's clients, as well as hardcore visual material. By late1980, the investigation was beginning to create panic among the political elite in Wallonia. Pinon spoke to Jean-Claude Garot, editor of the Brussels-based weekly magazine, *Pour* about the affair. On 5 July 1981, days before a detailed report was due to be published, the editorial offices of Pour were gutted in an arson attack carried out by Jean van Engeland, a member of the extreme right-wing Front de la Jeunesse, and a friend of the enigmatic Paul Latinus, a nuclear engineer and founder of the Fascist organisation, Westland New Post (WNP).

Then came the evil days between March 1982 and September 1985, when the Nijvel Gang carried out a series of bloody atrocities in the guise of several armed robberies, leaving 28 people dead and dozens seriously injured. Leon Finne, a 55-year-old branch manager with the Copine Bank in Brussels, was one of those who died. Finne had been deliberately targeted, according to witnesses. After Finne had been hit twice in a supermarket carpark, one of the attackers, wearing a carnival mask, pumped nine rounds into his lower back. It later emerged, during an official inquiry into banditry, that the Nijvel Gang was a highly-trained 12-man commando, which included former Gendarmerie and army personnel. It was originally assumed that their task was to encourage widespread panic among the general public—what the media referred to as a "strategy of tension"—in order to provoke an outcry for greater powers for the police and military to tackle the rampant crime wave, including the use of curfew and martial law, if necessary. This in turn had the prospect of eventually paving the way for a hard line regime of the extreme right. The commission of inquiry learned of this in 1989 from a senior Rijkswacht officer, Lt. Col. Herman Vernaillen, who claimed that Leon Finne was one of his informers. The banker was also an important informant for the Brussels Judicial Police, and was a well-known figure among right-wing activists with links to a former Belgium prime minister, Paul Vanden Boeynants. He was also involved in financing the pedophile vice network, now referred to in the media as the "Pink Ballet".

Within the Belgian security forces, the evidence appeared to implicate two small cliques—Group G (Gendarmerie) and Group M (Militaire)—in the

conspiracy. Another armed gang with links to the Rijkswacht—the Cellules Communistes Combattentes (CCC), also known as the Fighting Communist Cells—suddenly emerged on the scene in November 1985, carried out several bombings and shootings, then "disappeared" as a source of terror the following month, with the arrest of four members in Namen. The commission on banditry also heard about Westland New Post (WNP), the collection of neo-Nazi thugs led by Paul Latinus, who had links to police and military officers. Latinus was found dead in the apartment of his girlfriend in April 1984. His death was officially described as "suicide"; however, the cable with which he allegedly hanged himself was only capable of holding 40 kilograms, while Latinus weighted 60 kgs. At the time of his death, Latinus had been trying to interest journalists in material from the "Pink Ballet" file, claiming he had obtained a copy of the original from sources within the Sûreté. Following his untimely but convenient death, media speculation credited WNP with the strategic task—within the "strategy of tension" scenario—of discrediting the Sûreté in order to undermine any investigation of the Rijkswacht, ignoring the connection with the "Pink Ballet".

Not so, stated Belgian journalist Hugo Gijsels, however. Giisels claimed the mindless brutality of the Nijvel Gang was not perpetrated to destabilize the State, but to eliminate several key witnesses involved in the "Pink Ballet" network. It included several senior politicians, such as Paul Vanden Boeynants and Guy Mathot, as well as Rijkswacht General Beaurir.[2] During at least one sex and drugs orgy at the Parc Savoy Hotel in Brussels, the building was guarded by several Rijkswacht officers, acting on the orders of Gen. Beaurir.

Elise Dewit, whose name was found in an address book belonging to Paul Latinus, was another victim of the Nijvel Gang linked to the "Pink Ballet" network. Similar to the banker, Leon Finne, Dewit, too, was shot dead during a robbery—at the Colruyt supermarket in Halle on 17 September 1983, alongside her partner Jacques Fourez, a 49-year-old businessman, who rented apartments in Brussels. Fourez, regarded as one of the organizers of the "Pink Ballet", often visited a restaurant frequented regularly by police officers and some seriously dangerous criminals. The restaurant, Aux Trois Canards, near the cloister of Notre Dame de Fichermont, was owned and managed by Jacques Van Camp. On Saturday, 2 October 1983, shortly after 01h.05, Van Camp was ordered into the adjoining car park by two armed men wearing carnival masks, who shot him several times in the neck, using a 7.65mm pistol allegedly stolen from a Rijkswacht officer in Nijvel two weeks earlier.

Elise Dewit worked for a notary called Deferre, who had come into possession of a videotape showing "Pink Ballet" clients having sex with minors, which had been made in order to blackmail some of the prominent (and wealthy) individuals involved. Several copies of the tape existed, as well as photocopies of files of the political group CEPIC in which the "Pink Ballet" is mentioned and a justice official, Jean Depretre who handled juvenile cases for the Public Prosecutor's Office in Brussels, while procuring children to be abused by the pedophile network. Some of this material was passed to Paul Latinus, who may have tried to use it to manipulate both politicians and police.

This was a level of terror far beyond the imagination of most people, including Belgians and Italians. The political cognoscenti found a "strategy of tension" and the possibility of a Fascist coup easier to accept than that the wanton slaughter of the Nijvel Gang might have been perpetrated simply to eliminate those who witnessed the warped and perverted life-style of men like Vanden Boeynants and Albert, the future king of all the Belgians.[3] However, because of the divided nature of Belgian society, there is a déjà vu quality about many of the political and sexual scandals, as if the eddies in a sea of corruption simply come around and around again.

## THE DASSAULT AFFAIR

Consider the Dassault affair, which broke upon the political scene in May 1996 when the Brussels-based corporate lawyer, Alfons-Hendrik Peulinckx and the Socialist Party MP, Luc Wallyn, were formally indicted on charges of "passive corruption" by Liege magistrate, Prignon. This followed a decision taken by the Swiss financial authorities the previous month to allow Belgian detectives access to bank accounts in Lausanne opened by Puelinckx. The accounts provided evidence of illegal payments estimated at $5 million from the French company, Dassault Electronique, to the PS. The payments took place in 1989 after the company had secured a multi-million dollar order to refit the Belgian Royal Air Force's American-built F-16 fighters with French electronic warfare systems.

This web of deceit began to unravel on 8 March 1995, when the former chief of staff of the BRAF, Lieutenant General Jacques Lefebvre, was found dead in Room 22 on the second floor of the Mayfair Hotel in Brussels. His death was reported to be a suicide. Lt. Gen. Lefebvre was 64 years-old when he died. He had served as Chief of Staff under former defense minister Paul Vanden Boeynants, strongly supported the French military industries on defense procurement issues—particularly Dassault Electronique—and had advised against the purchase of American F-16 fighters for the BRAF in 1975. Lefebvre had been questioned, and was due to be questioned further, by Liege magistrate, Veronique Ancia, in connection with the Belgian defense contract for the 46 Agusta helicopters.

However, when questioned about Lefebvre's death, Alfons-Hendrik Puelinckx claimed it had more to do with the Serge Dassault scandal and the secret financing of the Catholic PSC party than with the Agusta affair. Peulincks had worked for Serge Dassault, the owner of Dassault Electronique, for many years, and was no stranger to corporate intrigue, bribery and corrupt practices, which have been the modus operandi of the European defense industries for decades. When it was disclosed that he was cooperating with the Belgium authorities, Puelinckx received a call from another high-profile lawyer, Emile Verbruggen, acting for Serge Dassault and the former PS minister, Guy Spitaels, who was interested in what had been said about his clients in letters left behind by Lefebvre, which Puelinckx claimed to have seen. The lawyer allegedly told Puelinckx that Serge Dassault was particularly worried about the discovery of payments to the Catholic PSC, despite the fact that, as far as the public

was concerned, at this stage the official investigation was focused only on "commissions" to the PS and not on the PSC or other coalition partners. The Dassault payments had reportedly been passed to the PSC through Lefebvre. Later, Puelinckx would claim that Verbruggen had suggested that it would be better for him (Puelinckx) if he were to change his statement, and "remove the name of Serge Dassault" from his testimony.

At another meeting on 12 May 1996, Verbruggen told Peulinckx it would be in his "best interests" to cooperate with the French industrialists, and repeated his previous request that Peulinckx retract his original statement implicating Dassault. He told Peulinckx to take sole responsibility for the PSC payments, since he was already under investigation with regard to illegal payments to the PS. If Puelinckx agreed, "life would be a cushy affair" after a slightly longer prison sentence. Puelinckx thought about the offer for almost two years, while the investigation into the links between Dassault and the Belgian political establishment continued.

Faced with the possibility of being "hung out to dry" by others implicated in the Dassault affair, Puelinckx at last decided to tell the authorities everything, including details of his meetings with Verbruggen. He provided the Union de Banques Suisse account number—8.38695 UBS Lausanne—that had been registered to Jacques Lefebvre since 1984 and had been used for off-the-record "commissions" since then. He couldn't, however, verify that the 1989 $5 million PSC payment had passed through this account.

Serge Dassault made a secret two-day trip to Brussels in May 1998, in which he presented the authorities with a signed affidavit stating that Peulinckx was responsible for all payments to the PS. He claimed that Puelinckx had stolen "millions of francs" from his 87-year-old mother, who died in 1995 after the scandal broke, as did the Dassault family banker, Pierre de Boccard, who managed two secret accounts in her name, codenamed "Sophie" and "Mirabelle". Dassault claimed De Boccard had conspired with Puelinckx to extort money from Madame Dassault, some of which they kept, and some of which they paid to Belgian politicians to "cover up their dirty dealings." When confronted by statements from two of his own senior executives which contradicted his testimony, Serge Dassault simply asserted that both men were wrong. He claimed that the Puelinckx/De Boccard conspiracy was hatched on the Côte d'Azur, where both men had villas close to each other. Both men had Riviera villas, but several kilometers apart, and among hundreds of other wealthy residents of the region—not exactly the type of proof that would stand up in court.

Apart from Pierre de Boccard, who was a senior executive at Credit Suisse when he unexpectedly died after being hospitalized during the Dassault investigation, and the troubled Jacques Lefebvre, whose purported suicide had removed a key witness, another important person became unavailable in the course of the inquiry: Maom Kassab Bachi, who had access to the UBS Lausanne account, was involved in a fatal accident on 22 May 1998 while leaving Geneva. There was no official investigation to determine what had happened, but an unofficial account of the accident stated that he was en route to Fribourg when a car, coming in the opposite

direction, crossed over the road and landed on top of Bachi's vehicle, killing him instantly.

In December 1998, following a 16-week trial regarded as a judicial indictment of the country's political establishment, a 15-man panel of judges sitting at the Cour de Cassation in Brussels ruled that the former defense minister, Guy Coeme, and the former deputy prime minister, Guy Spitaels (who was described by the state prosecutor, Elaine Liekendael, as the "Mephistophelean puppeteer" at the center of the corruption scandals) were guilty of "passive corruption". Each received a two-year suspended sentence. Also sitting in the dock alongside the ex-ministers was Serge Dassault, who was found guilty of "active corruption", and also received a suspended two-year sentence. The judges made no distinction between the "active" offer and the "passive" acceptance of illegal kick-backs in relation to government contracts. Seven others, including Luc Wallyn, the former general secretary of the Flemish Socialist Party (SP), and François Pirot, the former treasurer of the Walloon PS, also received suspended jail sentences at the end of the process.

## NATO SECRETARY-GENERAL WILLY CLAES

The defendant with the highest profile was the former NATO General Secretary, Willy Claes, who was given a three-year suspended sentence and banned from holding public office for five years on charges of passive corruption in relation to the defense contracts awarded while he served as minister for economic affairs in the Belgian government in the late 1980s. During the course of the trial, Willy Claes was asked to explain two payments into his personal bank account of $60,000 and $125,000 deposited in 1988 and 1992. In his first statement, he claimed his wife had saved the money from her housekeeping allowance since the early 1970s, and had kept it in a drawer. When it was pointed out to him that bank records showed that most of the bank notes were printed in 1988, he changed his story and claimed the money was part of the Socialist Party's election funds, which he was holding for "safe keeping." After prosecution witness, Roberto Baldini, testified that Claes had met secretly with Agusta's former chief executive, Raffaello Teti, at the Department of Economic Affairs in Brussels on 8 January 1989, during which the A109 helicopter contract and Agusta's "commission" was discussed, the president of the Cours de Cassation panel concluded that on the basis of Baldini's evidence, "it is not excluded that prior to awarding the contract he [Claes] gave his assent to his chief cabinet aide to accept Agusta's offer." The contract had been signed the previous month between representa-tives of the Italian company and Defense Minister Guy Coeme.

The Belgian Justice Ministry's investigation of Willy Claes began in the early 1990s after Raffaello Teti fled to Brazil to avoid being indicted on corruption charges in Italy. His role in the Belgian affair began to be examined after his successor at Agusta told Belgian detectives investigating the murder of André Cools that he was surprised at the speed with which the A109 helicopter contract with the Belgian Defense Ministry was secured once Teti became directly involved, "following years of long drawn-out negotiations between Agusta executives and defense officials which failed to produce a

result." Teti was arrested in Rio de Janeiro on 18 October 1995, after an international warrant for alleged fraud and corruption was issued by Liege magistrate, Veronique Ancia. While the extradition request was being processed, the Belgian authorities obtained a copy of a video-tape made in mid-1989 at a local ground-breaking ceremony for a factory on an industrial site at Lummen, in Limburg. The tape revealed Willy Claes mentioning his meeting with Raffaello Teti the previous January to discuss the defense contract and taking personal responsibility for securing the Italian inward investment in Lummen—part of his electoral constituency—which was a significant element in the Agusta deal.

By the time Teti was taken into custody by the Brazilian police, Willy Claes had become the "Pinocchio" of Belgian politics, as well as an embarrassment to some of the world's most powerful political and military leaders. After serving as Belgium's foreign affairs minister for several years, he had managed to get himself appointed secretary general of NATO, the most powerful military alliance in history, having convinced NATO ambassadors in October 1994 that he was as "clean as the driven snow." In 1995, he set off on a goodwill tour of NATO countries, and was photographed on 8 March at the White House in Washington, grinning like a Cheshire cat in the company of President Bill Clinton—even as, in Brussels, the body of Jacques Lefebvre was being driven in an ambulance from the underground car-park of the hotel where he had died. Clinton actually looked uncomfortable in the official White House photograph, like a man wondering just how corrupt Claes really was. American State Department sources in Brussels, as well as the CIA officials who stalk the corridors of NATO HQ, had no doubt briefed the Clinton administration about the ongoing Agusta/Dassault investigation and the NATO chief's "total ignorance" defense against mounting press speculation, which was beginning to label him either a liar or a fool.

On 7 April, within weeks of his homecoming, the Belgian Parliament voted by a substantial majority, to suspend Claes' diplomatic immunity and allow the Supreme Court to question him. Continuing to protest his innocence and ignorance, Claes resigned as NATO boss in October 1995, shortly after Teti's arrest in Rio. When the former Agusta chief executive arrived in Belgium the following year, he was taken directly to Lantin Prison in Liege, before being transferred to a secure unit at the local hospital to receive treatment for severe tuberculosis, which he had contracted during his seven month stay in a Rio jail. Along with his French counterpart, Serge Dassault, the former Italian arms manufacturer was charged with "active corruption". He never made it to the Cour de Cassation, dying of a heart attack in August 1998, a week before the trial opened, and taking "at least some of the secrets" to the grave with him.

Willy Claes presented himself as a "Dreyfus" figure, the victim of the greed and corruption of others. The only major Belgian scandal to receive any degree of sustained coverage in the international media over the past two decades has been the abduction, rape and murder of four young girls in the mid-1990s by electrician Marc Dutroux. The Dutroux investigation was characterized by police incompetence that actually led directly to the deaths of two of his eight-year-old victims who starved to death in specially built

cages in the basement of his house while Dutroux was serving a short prison sentence for theft. Neighbors had rung the local police when the girls were heard screaming for help, but Dutroux convinced the officers who called to investigate that it must have been children playing on the street that had caused the problem. As details of the pedophile killings emerged, the failures of the police and the judicial system brought hundreds of thousands of people—led by relatives of the victims—onto the streets of Brussels and other Belgian cities. In late 1997, the permanent oversight committee of the police produced a report on how the investigation had been handled and stated that "no police official who participated in the [Dutroux] inquiry was able to present a working agenda or log book showing what they did and at what date". In fact, one of the most surprising instances of complete incompetence was the first interrogation of Dutroux, which the five officials present claim took place on a different date.

There is no end in sight to the incompetence, which at times borders on the bizarre. During an unauthorized interview given to a journalist from the Flemish commercial television station VTM, broadcast on 21 January 2002, Dutroux claimed that he had procured young girls for a pedophile network with which he maintained regular contact, but the authorities "don't want to look into it". He reiterated this claim during his 2004 trial but no proof was given and the accusations were dismissed as further falsehoods by Dutroux. How did VTM manage to get this interview? A journalist working on the program, Telefacts, accompanied Flemish VLD Senator Jean-Marie Dedecker, a regular prison visitor who had an appointment to see Dutroux, telling the guards at Aarlen Prison that he was the senator's chauffeur. He smuggled in an audio cassette recorder to record Dutroux complaining of having to "live like an animal" since 1996, and being "really at the end of my tether".

The Minister for Justice, Marc Verwilghen, believed that Dutroux's claim that "a network with all kinds of criminal activities really does exist" was simply an attempt to postpone his trial. The editor of Telefacts has acknowledged that Dutroux's allegations "could be a trick to force an investigation". Nonetheless, the families of his victims, aged between eight and eighteen years old, have long maintained the existence of such a pedophile network, and claim that its activities were covered up because senior politicians and policemen were part of it.

The long-awaited trial of Dutroux began on 1 March 2004 and lasted 15 weeks. Dutroux maintained throughout that he had been part of a wider child abuse network with links to powerful politicians and prominent public figures. However, co-defendant Michel Nihoul, a Belgian businessman whom Dutroux claimed was involved in the network, was acquitted of all but drug-related charges. And Sabine Dardenne, one of Dutroux's victims, told the court she never saw anyone other than Dutroux during the 79 days she spent chained to a bed and abused repeatedly.

Which brings us back to the social deprivation of the Borinage, where the Dutch painter Vincent van Gogh gave Bible lectures in miners' cottages in the 1870s, and where, as he observed, "there are no pictures"—back to the perverse world of the "Pink Ballet" and the bleak environs of Liege.

# Chapter Twelve

# Bull's "Supercannon" and Moyle's "Suicide"

In March 1990, several months before Saddam Hussein invaded Kuwait following the collapse of the Jeddah talks, two murders were committed in Brussels and Santiago, which were linked by the Iraqi dictator's unbridled ambition to dominate the Arab world by military power. Fourteen years later both crimes remain unsolved. Nobody was detained for questioning in either case, the usual suspects have not been "helping the police with their inquiries"—an indication, when there's no use of the tired old homicide investigation clichés to reassure the general public, that those who committed the acts of violence have either slipped back into the intelligence communities from which they emerged, or have been "terminated with extreme prejudice" so that they cannot reveal details of their crimes

The first man to die was Canadian Dr Gerald Vincent Bull, described by John Pike, a ballistics and missile expert, at that time with the Federation of American Scientists, as "the greatest artillery genius of his generation".[1] Born at North Bay, Ontario, in 1928, Gerry Bull was a scientific prodigy. He enrolled at the University of Toronto in 1944, at fifteen years-of-age, the youngest of twenty-two students taking a four-year honors course in aeronautics under Professor Thomas Loudon, an internationally known aeronautical engineer. After he graduated with a Batchelor of Applied Science degree, he started his Ph.D. in September 1948 on the shock-wave speed measurements and aerodynamic characteristics of supersonic wind tunnels, which he completed shortly after his twenty-third birthday.

In the 1950s, Bull joined the Canadian Armaments Research and Development Establishment (CARDE) and was immediately assigned to a top-secret project, codenamed "Velvet Glove", which involved the development of an air-to-air missile capable of deterring a Soviet nuclear bomber strike. The project was eventually scrapped and millions of dollars wasted, after it was confirmed by Canadian military intelligence sources that the Soviets had developed bombers fast enough to outpace the missile. Bull remained with CARDE, however, becoming head of the Aerophysics Division, and establishing an international reputation in ballistics with a missile nosecone design capable of withstanding atmospheric re-entry. In April 1961, Bull left CARDE to become professor of engineering science at McGill University in Montreal, where he worked on a High Altitude Research Project (HARP), in partnership with the Canadian government and the Pentagon, to prove that

large artillery pieces could be used to launch satellites into space. In the mid-1960s, Gerry Bull set up the Space Research Institute (SRI), a non-profit scientific organization at Highwater, Quebec, with a private artillery test-bed where horizontal firings could be carried out involving a 400mm naval gun, nicknamed Betsy, which eventually evolved into an artillery piece with a 36 meter barrel and a 424mm bore. In July 1965, at an SRI test site in Barbados, the supergun fired one of Bull's Marlet series of projectiles (a 168cm, 212kg finned shell capable of carrying radio equipment and scientific instruments in its nose-cone) to a world record altitude of 150 kilometers. In 1968, Dr Bull won the prestigious McCurdy Award for outstanding scientific achievement. Within months, however, the Canadian government withdrew funding from HARP, and the Pentagon, having developed a big-gun research and test facility site at Yuma, Arizona, also decided that Bull's project could no longer be supported financially.

In the late 1960s, Gerry Bull transferred his business/base to Europe, setting up the Space Research Corporation, a subsidiary of SRI, at Uccle, a suburb of Brussels, to market "base-bleed" munitions, a technique which could boost the range of most conventional artillery pieces by as much as 50 percent.[2] In 1972, Dr Bull was made an honorary American citizen under a special Act of Congress, which provided security clearance allowing him to participate in top-secret US military projects. Three years later, a retired Brussels-based US Air Force officer, Colonel John Frost, an arms dealer acting on behalf of the Israeli government, ordered 15,000 extended range, full bore (ERFB) 155mm shells from SRC. Col. Frost also worked on clandestine arms deals for the CIA, and when the South African regime expressed concern about the Angolan MPLA's use of Cuban forces armed with 122mm Soviet missiles to Lt. Col. John Clancey, a Marine officer on assignment for the CIA in Pretoria, Clancey put senior South African Armscor officials, T. Denys Zeederberg and Piet Smit, in touch with Frost, who introduced them to Bull's company. SRC sold ERFBs to South Africa in breach of an international arms embargo, a deal which included a radar tracking system sent from Canada to Cementation Engineering in Johannesburg in September and October 1976, which was closely monitored by the British foreign intelligence service MI6, and 14,800 howitzer 155mm shell casings, shipped in May 1977 from Saint John, New Brunswick, via Antigua, to Cape Town.

SRC's involvement in arming South Africa was exposed in a joint BBC "Panorama"/CBC "Fifth Estate" investigation in autumn 1978. On 25 March 1980 Gerry Bull and Rodgers Gregory (a former US Army officer who handled US operations for SRC) pleaded guilty before US District Judge James S. Holden to joint charges of exporting howitzer shell forgings, two 155mm artillery barrels, and a radar tracking system to South Africa. They were each sentenced to one year in jail with six months suspended, to be served at the minimum security Allenwood Prison Camp in Montgomery, Pennsylvania. In 1982, Bull learned that he had been betrayed by the CIA's John Frost, who was a shareholder in SRC, and had kept Langley HQ and the Office of Munitions Control fully informed of the South African deal. Frost also testified at US Congressional hearings on US/SA relations.[3]

Following his release, Gerry Bull moved to Brussels, although his family remained in Montreal. His only business lead was the People's Republic of China. He contacted London-based businessman, Michael Chang, who had been asked by the Chinese Communist regime to investigate the possibilities of buying a new ordnance system, following five years of artillery clashes, from 1964 to 1969, with the Soviets along the northern border.

After meeting Chinese officials in Beijing in April 1981, Bull agreed to sell his GC-45 system. This initially involved the purchase of two 155mm howitzers, manufactured by Voest Alpine of Austria, which had bought the technology from SRC in 1978 for a one-time payment of $2 million. The guns were shipped to Manchuria, and test-fired by veteran Chinese artillery teams at a remote site near the disputed border. In spring 1984, the North China Industries Corporation (NORICO), a procurement agency acting on behalf of Beijing, signed a three-year contract with SRC worth $25 million which involved a towed 155mm supergun, designated MF-45, with a 40 kilometer base-bleed range, and a 30 kilometer standard munitions range. The deal also involved factory layouts and blueprints for manufacturing every part of the gun, and production plans for ERFB base-bleed shells. By the mid-1980s, Dr Bull was spending at least three months per year in China, at remote top-secret test sites and as a guest lecturer at Nanjing. The Chinese regime also established a research facility for SRC at the University of Xi An, a business and academic relationship which was closely monitored by the CIA and MI6, using American and British embassy-based officials in Beijing.

In January 1988, Bull was invited by Amer al-Saadi, deputy head of the Ministry of Industry and Military Industrialization (MIMI) to visit Baghdad and meet his boss, Hussein Kamil al-Majid. Bull told the Iraqi minister he could build a high-altitude, long-range cannon for Saddam Hussein for as little as $10 million, based on the original HARP design. Bull decided to form another company, Advanced Technology Institute (ATI), separate from SRC, to handle the proposed deal, designated Project Babylon. ATI was located above the Bolivian Embassy in Brussels, several kilometers across the city from SRC's offices. Dr Christopher Cowley, a British-born metallurgist, was the engineer in charge of the project. Alexander Pappas, vice president of SRC who had worked with Bull since HARP, was a special consultant for the project. Poudreries Réunies de Belgique (PRB), one of the largest manufacturers of military explosives in Europe, which had a 39 percent stake in SRC, would supply the explosives needed to operate the cannon. Satisfied with these arrangements, Kamil al-Majid, on behalf of the Baghdad regime, signed a contract with Dr Bull for two self-propelled howitzers with 155mm and 210mm guns, enhanced ammunition and a ballistics training course for Iraqi military personnel.

Project Babylon was generally referred to in the media as a "supergun" program, with the obvious implication that, given the range of the massive artillery piece, it could be used as a weapon to target Israel. It was presumed that Saddam Hussein, given the opportunity and the equipment, would not have hesitated to launch a missile assault on the Jewish state. However, there is evidence that Gerald Bull was perhaps more interested in the

possibility of launching satellites. While tests on prototype 155mm and 210mm cannons, which had been completed by late March 1989, were being carried out on a site near the village of Bir Ugla, northwest of Mosul, in Iraq, Bull was planning a larger version of his Martlet series—with Marlet IV, using a three-stage, automatically-timed booster system, capable of taking a satellite payload into fractional orbit at an altitude of 2,000 kilometers. In order to achieve this, it was necessary to keep the Iraqis onside. Saddam Hussein's interest could only be maintained if the military possibilities were emphasized—despite the "prestige of putting something in orbit"—as Bull constantly reminded Dr al-Saadi.[4]

Gerry Bull spent Christmas, 1989, with his family in Montreal. He returned to Brussels for the New Year, and traveled to Iraq to inspect delivery of the barrel sections of Project Babylon at a site in the Jabal Makhul mountain range, north of Baghdad. The following month, Bull returned via Brussels to Canada, then flew with his wife, Mimi, to the Mardi Gras in New Orleans. He returned to Belgium via Washington, where he stopped off to "meet some guys," according to his wife,[5] and London, where he met Michael Chang to discuss the possibility of a new contract with Beijing. Bull also told Chang that while he was in Washington, one of his Pentagon contacts had introduced him to a "young guy" who knew a "great deal about his background", including his links with the South African regime, and who seemed to be warning him to be extremely careful, suggesting that at one time there was a plan to kill him.[6]

On 22 March 1990, Gerry Bull arrived early at the offices of SRC on Rue de Stalle, where he had a 10h00 scheduled meeting with Christopher Gumbley, the former chief executive of Astra Holdings, a pyrotechnics and munitions company which had taken over PRB for an estimated $60 million the previous September. Gumbley had been sacked in a boardroom coup six days earlier, and was convinced that the giant Belgian group, Société Générale de Belgique, which owned PRB, had defrauded Astra by claiming its explosives subsidiary was a profitable company when it was, in fact, in serious financial difficulties. Gumbley planned to sue PRB officials through the Belgian courts, and wanted help and advice from Gerry Bull. The meeting lasted throughout the day.

At approximately 19h15, Bull asked Monique Jamine, SRC office manager, to drive him home to his apartment on Avenue François Folie. The journey took approximately 15 minutes. She watched as he climbed out of the Renault station wagon into the cold, damp Brussels evening and entered the apartment block where he lived at number 20, a self-contained modern unit on the sixth floor. Bull ascended by the elevator, which automatically switched on the hallway light on the floor when the doors opened. As he inserted a key into the door of his flat, an assassin, who had been hiding in an alcove near the elevator, stepped up behind him. Using a silenced Colt 7.65 pistol, he shot Bull five times, in approximately seven seconds, from less than a meter away. The first shot entered the rear of Bull's skull, shattered his brain and exited through his forehead. The next three shots hit him in the neck and spine. The last shot was also to the head. This was a professional

"execution" with no "playing around" to have the victim bleed to death or feel pain as in organized crime killings.

Bull's body was found by Hélène Grégoire, with whom he had an appointment. She arrived at the apartment several minutes after the assassin left, and called the emergency cardiac arrest service, convinced that Dr Bull had suffered a heart attack. The first police officer on the scene was a member of the Brussels narcotics squad who, suspicious of the fact that Bull was carrying $20,000, believed he was the victim of a drug-related murder. At 21h00, officers from the Sûreté de l'État, the security service attached to the Ministry of Justice, arrived. They briefly questioned Hélène Grégoire, took one look at the victim's wounds, considered the circumstances of the killing and were immediately convinced that it was a "political" assassination carried out by professionals. The killer had used the stairs to the ground floor and left the building by the rear exit, passing through the gardens to be picked up by a waiting car.

Despite the nature of his work, and his business relationship with some of the world's most unpopular regimes, Gerry Bull took very few safety precautions. His home phone number was ex-directory, and a company name, Giltaur, was taped over his name on the letterbox of the Avenue François Folie apartment, which was fitted with a high security lock at street level. The efficiency of the execution, as well as SRC's contract with the Iraqi regime, pointed to a Mossad connection, a theory promoted by several Western intelligence services, including MI6. Through Dr Saadi, the Iraqi intelligence agency, the Mukhabarat, informed the Bull family that Mossad was involved, but would not have acted without consulting the CIA because Dr Bull was an American citizen. This was also the opinion of an Austrian intelligence officer, who also claimed that the task had been discussed at several meetings between US and Israeli intelligence agents, at least one of which had taken place in Frankfurt in late 1989[7] (this officer may have been the source of the warning passed to Dr Bull in Washington, the previous February). Within the CIA there was a general understanding that Mossad had given the order to eliminate Dr Bull, as a warning to other Western defense scientists not to sell their expertise to Saddam Hussein.

Dr Chris Cowley claims the operation had been planned since the previous November, when two "Israeli businessmen" rented an apartment on the same floor as Dr Bull, paying six months rent in advance and lodging a bank bond with the property company which owned the building. The apartment was never occupied, false names and banking details had been used, but the exercise in deception had provided a key to the building, allowing the shooter to enter and wait in the shadows on the sixth floor for Dr Bull to arrive.[8] If it was a Mossad operation, at least three other persons would have been part of the hit team: one assigned to watch the SRC office, in radio contact with a second person in or near Dr Bull's apartment who kept the assassin informed of Dr Bull's movements, while the third accomplice waited in the getaway car. Apart from the security of the hit-team, an important consideration was that Gerry Bull should be alone when the murder was committed. Those involved left Belgium within hours. One of the "businessmen" may have taken

an El-Al flight later that evening,[9] while the murder weapon was either disposed of, or taken out of the country by diplomatic bag.

Despite the proven success rate of Mossad in such operations, the Belgian police carried out a thorough investigation, led by magistrate Christian de Valkeneer. It failed to generate enough evidence to prove an Israeli connection, however, and the case was shelved after two years. In testimony before the British House of Commons Trade and Industry Committee on 15 January 1992, Dr Cowley repeated his allegations that Dr Bull had been murdered by Mossad, with prior knowledge of both the CIA and MI6. Dr Cowley, who had met representatives of Walter Sommers Ltd., and Sheffield Forgemasters in Great Britain on 17 April 1988 to inquire about building a prototype of the supergun, told the members of parliament that the huge 350mm pipe sections manufactured by British firms could not have been assembled into a weapon, but would have been used to launch small satellites. He claimed that Saudi Arabia was interested in the project, and had agreed to allow test-fired projectiles to land in uninhabited areas of its northern deserts bordering Iraq. Furthermore, as early as 1988, both MI6 and the CIA had been briefed on Project Babylon by Dr Bull, according to Cowley, a claim supported by Belgian government sources, and by associates of Dr Bull, who believe that PM Margaret Thatcher and her senior Cabinet officials were also told of the Iraqi/SRC project in May 1988. Dr Cowley also stated that representatives of the Ministry of Defence (MoD) and the Defence Sales Division of the Midland Bank, with MI5 (the domestic security service) and MI6 connections, were in Baghdad when Dr Bull conducted negotiations with MIMI officials, while scale models of the "launcher" and a smaller version, called Baby Babylon, were on public display at the Baghdad International Trade Fair in May 1989.

The investigation into what was now being occasionally referred to as the "mysterious death" of Gerald Bull remained dormant for six years until magistrate Christian de Valkeneer reopened the case in April 1998 after receiving information, on Astra Defence Systems Ltd. letterhead, of a secret visit to Belgium between March 19 and March 21 1990, of a three man team from the British MoD Special Forces Staff, which deals exclusively with Military Intelligence and the Special Air Service (SAS). The team visited PRB factories and laboratories to examine research, development and production capabilities of "special operations equipment". The MoD delegation included Colonel Ian Jack, SHAPE liaison officer with British Special Forces, and MoD senior Tactical Support officials Terry Hardy and Michael Blane.

The team was accompanied by Stephan Kock, a non-executive director of Astra Holdings PLC, who had links with both MI5 and MI6, and who had been responsible for Chris Gumbley's sacking from Astra—a matter Bull had discussed with Gumbley shortly before being murdered. Kock was visibly active in several areas of Astra's business, particularly its investment portfolio, and between September 1987 and March 1990 he supplied MI6 with confidential commercial information about Astra's investment strategy. His work as a "support agent" for MI6, confirmed in government documents submitted to the High Court in London in February 1998, formed a crucial

part of a case in which the Department of Trade and Industry (DTI) sought to have four of Astra's directors, including chairman Gerald James, disqualified as company officials for alleged malpractice and mismanagement. According to James, when he and fellow director Chris Gumbley informed the British intelligence and security services, in October 1989, of links between PRB and Gerald Bull, and supplied MI5 with documents outlining the part played by the Canadian ballistics expect in developing a supergun for Saddam Hussein, both MI6 and MI5 were "already extremely well informed" about Project Babylon. Gerald James was another Astra executive fired by Kock in March 1990 after he publicly disclosed that PRB was exporting munitions to Iraq.

Following a four-year DTI inquiry into how Astra had been managed (which excluded the role played by Stephan Kock who was considered "less responsible" for the collapse of the company) and despite the advice of inspectors that no charges should be brought against Gerald James, the DTI commenced disqualification proceedings and listed 35 charges of business incompetence. The attempt to have James disqualified from holding a company directorship failed when the High Court dismissed the charges and ordered the DTI to pay the former Astra executive's legal costs. James believes that Astra was exploited by MI6 which wanted to use the company and its overseas connections as a conduit for UN sanction-busting arms deals, and that the DTI's decision to prosecute was to undermine his credibility as a witness in the arms-to-Iraq scandal. The scandal erupted eleven days before Dr Bull's death when supergun components were found by HM Customs at Teeside Docks in the north of England, sparking an investigation which would eventually lead to the Scott Inquiry ordered by Prime Minister John Major on 10 November 1992. The inquiry followed the collapse of the trial of three directors of the Coventry-based Matrix Churchill company, accused of exporting dual-use machine tools to Iraq in January 1988, February 1989, and November 1989— despite the fact that the British government's "Working Group on Iraqi Procurement", set up on the personal instructions of Margaret Thatcher, confirmed in a classified report, dated 23 June 1989, that ministers had already been aware that the end-user for the Matrix Churchill order was the Iraqi missile program.[10]

Gerald James was convinced that Stephan Kock was a "spy" planted by Her Majesty's Secret Intelligence Service on the board of Astra to "run down the company." He also claimed to have seen documents, from either the CIA or the US State Department, stating that Mr Kock, in the company of alleged MI6 agent Roger Holdness, had been "shadowed" at the Hotel Carrera in Santiago between 26 March and 2 April 1990.[11] The dates are significant because it was in room 406 at the Hotel Carrera that the body of British journalist Jonathan Moyle was found on 31 March 1990. Moyle's body was found by a chambermaid. He was naked, hanging from a clothes-rail in a closed, built-in warbrobe, with his head in a pillowcase. He was also wearing a towel over two pairs of underpants covered by a polythene bag, in order to prevent the smell of bodily fluids drawing attention to the body.

Jonathan Moyle was a graduate of Aberystwyth University in Wales, where he had obtained a first-class honors degree in international politics

and strategic studies in 1983, which was followed by fourteen months research at the British Ministry of Defence (MoD) for his MA thesis, "Air Attack on Britain"—although the MoD claims to have no record of his employment.[12] Moyle trained as a Royal Air Force helicopter pilot at RAF Cranwell, but left the service to concentrate on journalism. In 1988 he was appointed editor of the specialist publication, *Defence Helicopter World*. [13] He arrived in the Chilean capital, Santiago, two days after Dr Gerald Bull was murdered in Brussels. While his official assignment was to cover FIDAE, an international aerospace fair organized by the Chilean Air Force, he had told friends before leaving Britain that he was also interested in the part played by British companies (particularly Marconi Defence Systems whose Warford-based subsidiary, Marconi Underwater Systems, had one of the largest computing facilities devoted to underwater technology outside the United States) involved with Cardoen Industries in supplying sophisticated avionics and mine technology to Saddam Hussein. MUS was heavily involved in the development of the NATO naval mine, "Stonefish", and with the approval of the British government, Marconi had opened discussions with Cardoen Industries. Only hours prior to his death, Moyle is believed to have met with a British Naval Intelligence officer to discuss a BNI internal report into the relationship between the two companies and the implications for the "Stonefish" project.[14]

Cardoen Industries was set up in 1977 by a US-educated Chilean engineer, Carlos Cardoen, who made millions of dollars in profits during the Iraq-Iran war selling a Chilean version of the US cluster bomb, the CB-500. He sold it to Baghdad for $7,500, undercutting (by two-thirds) the "Beluga" bomb, manufactured by the French company, Matra, which was Iraq's main supplier. In 1984—at the height of the slaughter which had developed into a war of attrition—Cardoen Industries made 18 deliveries to Iraq of the CB-500 (including fuses supplied by the Pennsylvania-based International Signals Corporation) using specially provided Iraqi Airways Boeing 747 cargo planes. The deal earned Cardoen Industries approximately $500 million.[15] In 1987, the Chilean company was contracted to build a cluster bomb factory in Iraq— on a site designated Saad 38—at Taji military complex, and a production line for pyrotechnic fuses which could also be adapted for fuel-air explosive warheads. Carbide-tipped precision machine tools were supplied by the Michigan-based company, GTE Valenite, while the British involvement included equipment from BSA Machine Tools based in Birmingham, and lathes from Matrix Churchill.[16] By 1990, when an inquisitive Jonathan Moyle arrived in Santiago, at least 95 percent of Cardoen Industries' business was being conducted with Iraq.

Shortly after Moyle's body was found, the naval and military attaches, and the first secretary (generally regarded as an MI6 posting) at the British Embassy in Santiago, left Chile. With key witness unavailable, the brief inquiry conducted by local SICAR *carabineros* concluded that the journalist had committed suicide. On 31 May 1990, during a British Embassy reception for the Archbishop of Canterbury, who was visiting Chile, MI6 circulated a rumor (repeated in London to journalists the same day) that Jonathan Moyle

had died in an "auto-erotic accident". However, on 10 September 1990, Judge Alejandro Solis, who coordinated the original investigation into the case, ruled that bloodstains found at the foot of the bed in room 406 and a large dose of Bromacepam and Diazepam tranquilizers in the victim's stomach, were "sufficient grounds" to suggest that Moyle had been murdered and then hanged to make the death look like suicide. Judge Solis also stated that there were no suspects, nor could his officials determine the motive for the crime. He complained that his efforts to identify Moyle's killers, whom he described as "merchants of death [working for] a foreign intelligence agency", had been obstructed by the unwillingness of the British authorities to cooperate.

Speaking on BBC Radio 4 "World At One" news program shortly after the Solis report, Jonathan's father, Anthony Moyle, described his son as a "very level headed fellow" who was soon to be married. He realized his son had been murdered when he heard he had been found "with a pillow case pulled down tightly over his head and shoulders, and that he was suspended by a shirt . . . where the rail was 5 foot 5 inches and he was 5 foot 8 inches [tall], and the fact that the door opened outwards, and you can't hang yourself and close the door behind you." He also stated that the affair had been "covered up" by MI6, a claim pursued by the former Labour MP (and current Lord Mayor of London) Ken Livingstone, who told MPs in the House of Commons on 27 November 1990 that Jonathan Moyle had been injected in the heel by a lethal substance, possibly sodium cyanide, after being drugged. Under parliamentary privilege (which allows MPs to make statements without fear of libel action), Livingstone also claimed that there was an "authorized British cover-up" involving the Foreign and Commonwealth Office (FCO) and staff at the British Embassy in Santiago. He cited "overwhelming circumstantial evidence" linking the prime minister's son, Mark Thatcher, to Chilean arms dealer Carlos Cardoen, who consistently claimed that his Middle East weapons sales were known and "verified" to British and US military attaches based in Santiago who regularly visited his production facilities.

After two adjournments, a British inquest into the death of Jonathan Moyle was held at Exmouth Magistrates Court on 27 February 1998 under coroner Richard van Oppen, and a verdict of "unlawful killing"—*i.e.* murder—was returned. Tony Moyle expressed his satisfaction with the verdict while accepting the fact that it would be unlikely that those who murdered his son would ever be found, because the "professional hitmen who did the job" had probably disappeared. The inquest coincided with the publication of *Operation Valkyrie* by journalist Wensley Clark, who claimed that Jonathan Moyle had been operating as a "freelance agent" on behalf of MI6 as part of a covert mission, codenamed Operation Valkyrie, to help gather intelligence on the activities of the Iraqi arms procurement network in Chile. At the time of his death, Moyle had discovered an attempt by Baghdad to purchase at least 100 civilian Bell helicopters which had been converted into military aircraft by Cardoen Industries without the knowledge or involvement of the US Bell manufacturer—a deal worth about $650 million, which would have been in breach of the UN international arms embargo imposed during the eight-year

Iraq-Iran war. Clark also claimed that Moyle's killers were hired by a senior executive of Cardoen Industries who had since died of cancer.[17]

Moyle is said to have interviewed Carlos Cardoen and his chief of public relations the night before he died—a meeting denied by both men. However, what made the helicopter sale so sensitive to the principals involved—Cardoen Industries, the British FCO and Saddam Hussein—was the fact that the converted Bell helicopters had been adapted to carry a British electronic guidance system known as HELIOS, which could be used with the US-manufactured TOW anti-tank missile, which had been used with devastating effect by Iran (who had bought 10,000 to 12,000 in 1986 from the US at a cost of $10,000 each) against Iraqi armor during the 1981 to 1987 war.

According to author and journalist Stephan Dorril, any investigation of Carlos Cardoen also "posed a threat" to the newly-elected Chilean president, Patricio Aylwin, whose election campaign had received a donation of $3 million from the Chilean arms dealer. Aylwin was making a "conscious effort" in the post-Pinochet period, to rehabilitate his country with the West, an effort supported by the British FCO, who wanted to "cover up everything that might cause embarrassment" to London.[18] To coincide with the Moyle inquest and the publication of Clark's book, MI6 leaked a report that claimed that Iraqi agents were trying to purchase advanced helicopter crop-sprayers "as a delivery system for nerve gas and anthrax weapons".[19] The leak was probably intended to distract attention from the HELIOS sale-and-adaptation hypothesis by raising the specter of biological warfare—a little piece of mischief making on the part of MI6 to influence a public used to images of US crop-spraying but not the end result of "smart ordnance". That would come to television screens for the first time during Operation Desert Storm in 1991 after Saddam Hussein had used his UK and US manufactured arsenal, Revolutionary Guards, and conscripted infantry to cross the border into Kuwait.

To summarize: the official paperwork has been carefully filed away, homicide detectives have been reassigned to other duties, and investigating magistrates have focused on more immediate affairs, and we are left with two 14-year-old unsolved murders. A common denominator in both cases is the active interest taken by the intelligence services of at least three nations, each with a ruthless degree of expertise in "executive action" options.

Mossad, whose assassins have stalked the world since the early 1950s, hunting down fugitive Nazis, Palestinian militants, and those considered a threat to the security of the Jewish state, was always going to be top of the suspect list for the murder of Dr Gerald Bull. When European diplomats suggested that Mossad was involved—an allegation based on little more than Bull's links with Iraq and the efficiency of the kill—Israel left the charge unanswered.[20] Unofficial sources in Tel Aviv suggested that Saddam Hussein had ordered the Iraqi General Intelligence Department—Da'irat al-Mukhabarat al-'Amah—to eliminate the Canadian scientist after discovering that Bull had betrayed Project Babylon to MI6. Adding credibility to this theory is the claim that Israel was convinced that the "supercannon" was not a military threat (at least no more so than the Scud missiles which reached Israel

using conventional launchers in 1991) and was content to see Saddam waste his resources on "pie in the sky" rather than a more feasible military option. At the time of Bull's death, the former hawkish Defense Minister (and current Israeli Prime Minister), Ariel Sharon, stated in a BBC Television "Panorama" current affairs program in June 1990 that Israel had known about Babylon for more than a year.

Mossad was not involved in the murder of Jonathan Moyle. In fact, the agency may have been discreetly helping the journalist with his inquiries through several "cut outs"—a "firewall strategy" designed to protect the source of classified information by having it pass through successive intermediaries.

The Mukhabarat, or locally hired assassins working for Cardoen Industries, are the obvious suspects. Because of the nature of the covert arms trade—particularly the "gray areas" where trust among principals and clients simply doesn't exist—Mukhabarat agents were based in Santiago making sure that Carlos Cardoen was fulfilling his end of the deal with Baghdad. Moyle appeared to be well informed about the converted Bell helicopter deal, Stonefish and HELIOS, a package that included a range of military hardware and state-of-the art technology. The deal was being threatened by the journalist's inquiries.

MI6 turned up in both cities shortly before both Bull and Moyle died, and had a motive to kill on each occasion. Gerry Bull was fully aware—through contacts in the UK like Astra executive Chris Gumbley, and from MIMI sources in Baghdad—that Mrs Thatcher's Conservative administration had been illegally providing dual-use equipment and precision tools to Iraq in breach of its own export guidelines and a UN arms embargo. But Dr Bull was a realist, and while some commentators have suggested that he was killed by the SAS (on the orders of MI6) to prevent him using the information to help Chris Gumbley who was preparing a legal challenge against the British government, drawing attention to the sale of UK arms to Iraq would also have drawn media and the parliamentary opposition Labour Party's attention to Project Babylon and his own business relationship with the Baghdad military regime. Financially, this was the last thing SRC could afford to have happen in 1990. The Iraqis had never been overly enthusiastic about paying their bills until projects were completed and every nut and bolt was accounted for. For the SRC, an end to Project Babylon because of public and political pressure, would have meant ruin for the company because there was, literally, nothing else in the pipeline.

In the case of Jonathan Moyle, the British "D Notice" system—formal letters of request not to publish, circulated confidentially by the MoD to national and regional newspapers, radio and television editors, and to the editors of periodicals concerned with defense, covering reports on "naval, military and air matters the publication of which would be prejudicial to the national interest"—may have played a role. Although D Notices have no legal force, they serve as a warning that items may be protected under the Official Secrets Act.[21] In the late 1980s, approximately 950 people were on the D Notice circulation list, including the former editor of *Defence Helicopter World*,

Jonathan Moyle. Since the 1990s, successive Tory and Labour government ministers have successfully used Britain's libel laws, courts injunctions and Public Interest Immunity certificates (referred to in the trade as "gagging orders") to suppress details of crimes, including murder, carried out by UK Special Forces in Northern Ireland, Gibraltar and the US. Jonathan Moyle would have had nowhere to go with his story on the illegal evasion of the UN embargo. On the other hand, if, in fact, he was part of Operation Valkyrie, then it is logical to assume that MI6 would not have ordered the death of "one of their own."

The evidence—both circumstantial and forensic—suggests that locally-based assassins hired by Cardoen Industries were not involved. Contract killers are usually swift and efficient, anxious to get the job done as quickly as possible and leave the scene without having to tidy-up a killing zone. The manner of Moyle's death suggests he may have been questioned while drugged by professionally-trained operatives capable of knowing if the victim is being truthful and evaluating the "raw intelligence"—part of every spy's basic training, and something outside the expertise of hired thugs. Cleaning up room 406, hiding the corpse in the wardrobe and taking precautions to prevent detection from body odor for as long as possible, suggests that Moyle's killers needed time to get where they were going—to leave the country, not just the Hotel Carrera.

Having read most of the information in the public domain, and being familiar with the tradecraft of the clandestine services, it is our opinion that the murders were committed by rival Middle East intelligence agencies. By Mossad in the case of Dr Bull, as a warning to all Western scientists, technicians, aerospace engineers, and defense industry executives involved in the arming of Iraq, on the basis that if you can't kill them all, kill the one with the highest profile to create the most fear; by the Iraqi Mukhabarat in the case of Jonathan Moyle, to prevent exposure of the UK/Chile/Iraq arms procurement network, which ironically would probably not have been exposed because it was not in Britain's interests to permit this to be done. Whatever Moyle discovered as an MI6 "contract agent" would have been regarded as classified information under the Official Secrets Act.

Both murders are likely to remain unsolved, because apart from the families of the victims, it is sadly not in the interests of any of the nations directly or indirectly involved (and this includes Belgium and the United States) to identify, prosecute or seek the extradition of those responsible.

# The FBI's Wen Ho Lee Scandal: Much Ado About Something Chinese

The FBI had its eye on Los Alamos nuclear weapons scientist Wen Ho Lee for some time before the scandal resulting from his wrongful imprisonment got the Bureau into deep trouble. Managers at the Los Alamos National Laboratory had wanted to examine Lee's computer as early as 1996—so the Senate Energy Committee was told on 5 May 1999—but were warned away by Justice Department lawyers who feared such a search would taint information for any future use in court. In early 1999, Sen. Pete Domenici (R-NM) put the spurs to an FBI campaign against Lee by pointing out at least four "missed opportunities" by federal authorities to halt actions by Wen Ho Lee. When the FBI searched Lee's office computer in April, it asserted that more than 1,000 secret files of computer codes on nuclear weapons had been deleted after being improperly transferred from a highly secure computer system. Another Republican senator, Don Nickles (R-Okla.) stoked the alarm by revealing that such bumbling between government agencies had included the loss of Lee's security clearance review file at the Department of Energy (DoE) headquarters in the late 1980s. The message to the Bureau was clear: the FBI better do something or else ...[1]

The Chinese espionage issue heated up on 10 May 1999 when the press reported that Peter Lee, a scientist working on a classified Pentagon project in 1997, had reportedly provided China with secrets about advanced radar technology being developed to track submarines. Federal prosecutors in Los Angeles wanted to charge Peter Lee with espionage but were unable to do so, in part because Navy officials would not permit testimony about the technology in open court. Instead, Peter Lee ended up pleading guilty to filing a false statement about his 1997 trip to China and to divulging classified laser data to Chinese scientists during an earlier trip to China in 1985.

On 11 May 1999, press reports claimed that China had obtained important details of several classified US nuclear warheads—everything from the weight and accuracy to sketches of the re-entry vehicles—more than ten years ago. A 1988 Chinese military document, obtained by the CIA in 1995, was key to current investigations into admitted security breaches at US security installations. But the classified material didn't contain sufficient information necessary for Beijing to copy or construct US-style nuclear weapons since knowing the dimensions and the size doesn't tell you how to

build a nuclear weapon. The same day, Secretary of Energy Bill Richardson stated that he was consolidating Energy Department security operations under a "security czar" who would report directly to him. Richardson also extended a moratorium on wholesale declassification of old Cold War documents to prevent accidental disclosure of nuclear weapons secrets. A real "security scare"—well nourished by the press—was under way and being fanned by Congressional Republicans. The FBI likely felt it had received "carte blanche" to get someone. Someone—anyone—Chinese. . . .

At the time, the House select committee, chaired by Rep. Christopher Cox (R-Calif.), published a three-volume report concluding that China had stolen design information on every type of nuclear warhead in the US ballistic missile arsenal. On 14 May, the press quoted from the secret Congressional report before its official release (indicating an intentional press leak from the Cox panel itself) stating that China had obtained sensitive information about seven major weapons in the US nuclear arsenal through aggressive spying over the past two decades. Then, the next day, a wave of reactions started to spread in the press with reports mentioning that at Los Alamos "the line between classified and unclassified material gets crossed every day." Scientists who study the integrity of America's nuclear stockpile, may also be involved in medical research on brain waves, and satellites meant to identify illegal underground nuclear tests can also be used to study lightning storms. As many as half of all new recruits hired at Los Alamos come from foreign countries and the free exchange of ideas among some of the world's greatest thinkers was considered a necessary part of the scientific process ... but not for right-wing Republicans and the FBI. Other articles mentioned that China doesn't need to use spies anymore to obtain precise details and sketches of America's most modern thermonuclear weapons, ballistic missiles and re-entry vehicles. According to one press report, "These days, anyone armed with an Internet account or a library card can get some of the same military secrets that China is accused of stealing from the Los Alamos National Laboratory." In fact, China gave an impressive press conference and showed how it could be done.

Then the FBI acknowledged that at least two Los Alamos scientists, other than Wen Ho Lee, had committed similar alleged computer breaches that the Bureau was investigating. The Energy Department stated that the security clearances of the two had been suspended, but ruled out the possibility that the scientists were involved in espionage.

On 23 May, Notra Trulock, head of intelligence and security at the Department of Energy, and one of the main witnesses for Congressman Chris Cox's contested report on DoE security, claimed he was told at one point not to pass the information on to Congress because it could be used to attack the White House's policy on China (which is exactly what Congressional Republicans were trying to do: attack the Democrats and the Clinton administration). Turlock's testimony thus suggested that the White House had been told about Chinese espionage much earlier than it had acknowledged, an accusation that Republicans had been trying to push forward since the beginning of the Wen Ho Lee affair.

On 23 May, a Clinton administration ally, Democratic Sen. Robert Torricelli, stated that Attorney-General Janet Reno's job should be on the line over the Justice Department's failure to actively pursue suspected Chinese spying in US nuclear energy labs. The Republican chairman of the Senate intelligence committee, Richard Shelby (R.-Ala.), also said Reno should lose her job in light of the Cox report. Asian-American employees in the nuclear weapons laboratories started protesting against snide remarks, ambiguous warnings and other forms of work place discrimination that indicated a real threat of "ethnic profiling".

On 25 May, a declassified version of the Cox report was released, calling the loss of US nuclear secrets "one of worst failures" in US history, but tempering this clear exaggeration by noting that, more than ten year later, China had not deployed any weaponry incorporating the stolen technology. The White House quickly replied that the damage had been done during Republican administrations. The House select committee on Chinese espionage activities against US nuclear facilities, consisting of five Republicans and four Democrats, confirmed that the primary focus of Chinese espionage was the weapons research labs of Los Alamos and Sandia in New Mexico, and Lawrence Livermore in California. Though the Cox report confirmed, in qualified terms, much of what is mentioned above, media analysis seemed to continue with the wave of reactions. "What is not clear is whether the lapses, bungling and downright negligence of three US administrations makes a kiloton's worth of difference in the world balance of power", claimed one newspaper. According to another, "it is a first-rate spy story. Trouble is, no one is sure what it means."

Finally, serious doubts about the Cox report and the entire affair started to surface in the press. In the winter of 1995, a Chinese spy had walked into the CIA's arms in Taiwan, carrying a suitcase crammed with secret documents that provided the real basis of the entire affair. But the CIA eventually decided that the man was under the control of Chinese intelligence, sent to deliver a message whose meaning no one has been able to translate ... not even the Cox report or anti-Clinton Republicans. Reportedly, the only valuable paper in the suitcase contained evidence that China had obtained secret information on seven advanced US nuclear weapons. Earlier that year, three scientists at the Los Alamos National Laboratory, analyzing three years' worth of data from Chinese nuclear tests, had voiced similar suspicions, thus starting the investigation that resulted in the Cox report.

Now the press was listening to experts who downplayed China's spying and claims that the loss of US nuclear secrets to China represented, at worst, a marginal threat to national security. China had yet to field a weapon a decade after it allegedly stole design information from US nuclear weapons labs, and some of the information Beijing's spies collected was now declassified. Even conservative former secretary of state, Henry Kissinger, publicly cautioned against overreacting and told senators that even with stolen US nuclear secrets, it would take China fifteen years to develop the capacity to manufacture weapons. Many specialists believed that even if China did have the information and knowledge, it was incapable of manufacturing such

arms without going through a long, costly and slow development period at a time when China clearly had other issues on its mind and priorities elsewhere.

A well-argued critical evaluation of the whole affair, "Chinese Espionage in Perspective", was made available by the Federation of American Scientists at <http://www.fas.org/sgp>. The three-volume 872-page Cox report was posted at <http://www.house.gov/coxreport/>. An interesting comparison with a country that "got away with it" was available through an article, "Israel's Economic Espionage in the United States," appearing in the *Journal of Palestine Studies*.[2] According to many specialists, a "Cox report" on Israeli spying on US military technology would produce far more concrete "facts" than the China case.

On 7 December 1999, the FBI announced, once again, that it had intensified deliberations about whether to prosecute Wen Ho Lee on charges of mishandling highly classified atomic data.[3] No mention of spying for China was made this time and, again, a decision on whether to charge Lee was "expected within days".[4] That announcement followed a 4 December meeting at the White House attended by the administration's top security, law enforcement and energy officials, and as we added in *Intelligence*: " ... but nothing happened, again."

Not exactly—not until 10 December when Lee was arrested at his home in New Mexico and a 59-count indictment was announced against him for compromising US national security by moving nuclear secrets from secure computers to ten portable computer tapes. Note that neither espionage nor China were mentioned, only "unlawfully gathering and retaining defense secrets with the intent to secure an advantage to a foreign nation." Seven of the ten tapes remained unaccounted for, according to the indictment.

There were serious doubts concerning possible Chinese involvement in the case. China rarely recruits master spies, according to Paul D. Moore, a 20-year US intelligence veteran and specialist on China's major intelligence service, the Ministry of State Security. Moore and other experts believe that China methodically sifts information from open sources and combines it with many small leaks of secret information. According to Ralph McGehee, former CIA officer and a leading CIA dissident, a Chinese manual details how Beijing gathers technology and weapons secrets from the United States. The revelations concerning their methodology can be found in a 361-page book, *Sources and Methods of Obtaining National Defense Science and Technical Intelligence*, originally published in 1991, which was never classified. It outlines strategies for gathering both open and secret military technologies, and how the US is the prime focus of those efforts. The authors teach intelligence at the China National Defense Science and Technology Information Center (DSTIC) in Beijing which coordinates intelligence among various branches of China's military.

This Chinese strategy would not point toward Lee and its further pursuit would not be hindered by the new FBI "witch hunt" or by the Energy Department's new heavy-handed polygraph security policy whose regulations were announced three days after Lee's arrest. The policy was causing serious trouble with lab researchers and even in the political arena. A senator for

California, Diane Feinstein, opened a rift with the University of California— which runs the three nuclear weapons labs—by reportedly complaining in a closed-door meeting that the university is lax in oversight of Los Alamos and Livermore.

On 15 December, five Stanford University experts from the Center for International Security and Cooperation issued a harsh, detailed 95-page report stating that the Cox Panel Congressional Report on Chinese espionage released the year before contained significant factual errors, "inflammatory" language and "unwarranted" conclusions.

After Lee's arrest, FBI agent Robert A. Messemer was quick to testify that Lee misled coworkers about transferring classified data from secure computer systems, claiming that Lee convinced a colleague to teach him how to download secret information. But one of Lee's colleagues, Chris Mechels, countered by testifying that Lee's copying of computer files had in fact taken place in 1993 and 1994 when the national laboratory was making a chaotic transition between computer networks and scientists were worried they might lose valuable data. Nonetheless, Messemer's testimony was enough to get US District Court Judge, James A. Parker, to refuse bail for Lee.

Not long afterward, the press reported that FBI agents misled Lee into believing that he had failed a polygraph test during a lengthy 7 March 1999 interrogation concerning passing nuclear weapons secrets to China. The interrogation took place the day before Lee was fired from his job for violating security rules. The interrogation was reportedly highly adversarial and ended only after Lee repeatedly asked to leave. It's standard operating procedure for police and FBI agents to mislead suspects during preliminary questioning since judges accept such evidence as long as the suspect is not under arrest. Lee did not admit to any espionage under the aggressive FBI interrogation.

Within a week, Lee had filed a civil suit against the FBI alleging unlawful leaks by the Bureau and the departments of Justice and Energy— another "standard" procedure intended to make the suspect panic and accept the FBI's story. But Lee was represented by some exceedingly heavy-weight lawyers who knew their way around courtrooms and Washington. The Lee family's lead attorney was Brian A. Sun, a former federal prosecutor from O'Neill, Lysaght & Sun in Santa Monica, California. Sun represented Johnny Chung, the former Democratic Party fund-raiser who pleaded guilty to bank and tax fraud related to Chinese campaign contributions to the Democrats. Sun's co-counsel included two high-profile partners, Thomas C. Green and Mark D. Hopson, at the Washington office of Sidley & Austin, a major Chicago-based firm with more than 800 attorneys worldwide.

At the time, it looked as if Walter Pincus of the *Washington Post* was the only one who had come across a coherent explanation of the Lee case. The Taiwan-born scientist may well have been innocent of espionage for mainland China, but perhaps not for his homeland which, in the past, had delved into nuclear arms research as an ultimate means of keeping Beijing at bay. According to Pincus, US officials were investigating the possibility that

Lee copied nuclear secrets to help his native Taiwan, an accusation the former Energy Department security chief, Notra Trulock, would cite in *Code Name Kindred Spirit*, his 2003 book on Lee. In the spring of 1998, Lee had traveled to Taiwan to work for several weeks as a consultant at the Chung Shan Institute of Science and Technology, a top-secret, military-run facility devoted to nuclear research and missile development. In December 1998, Lee returned to Taiwan for three weeks, delivering a speech at Chung Shan and again consulting with scientists there. During that visit, according to court testimony by a Los Alamos official, Lee dialed up the main computer at the national laboratory and used his password to gain access to the classified nuclear files he had previously downloaded. It would be helpful to know if the FBI thought to interrogate Lee as aggressively on possible ties to Taiwan as it did concerning possible ties to Communist China.

It didn't take long for the Lee case to divide the Senate.[5] By March 2000, Neil Gallagher, head of the FBI National Security Division, was reportedly under investigation by the General Accounting Office for possibly withholding documents in the Wen Ho Lee case from Congress the previous year, according to Sen. Charles E. Grassley (R-Iowa). Grassley disclosed the GAO probe and faulted the FBI for failing to inform Congress throughout much of 1999 that its agents had concluded Lee was not the prime suspect in an espionage probe at Los Alamos National Laboratory. The investigation involved leaked W-88 warhead secrets to China. Grassley's comments came as a conservative Republican senator, Arlen Specter (R-Pa.), released his own report on the Lee case. In contrast to Grassley, Specter played down the FBI's role and focused instead on the Clinton administration Justice Department's failure to approve a secret search warrant for Lee's office. In short, the Clinton administration was "soft on security"...

In May 2000, it was revealed that the computer files at the heart of the case against Wen Ho Lee were given higher security classifications in 1999 only after Lee was fired in the midst of the politically-inspired crackdown at the weapons laboratory. At the time Lee downloaded the files onto his computer, they were not classified but designated "protect as restricted data" (PARD) which the FBI had reluctantly conceded was a low security level. Lee's lawyers stated that "the indictment is deceptive" and definitely took the case out of the category of stolen "crown jewels", "worse than the Rosenbergs" and "change the strategic balance" as conservative Republican "securicrats" have claimed. It started to look more and more like the FBI had cheated.[6]

No one who had been reading *Intelligence* in late 2000 was surprised to learn that the FBI case against Lee was falling apart. We had been following Lee for some time.[7] On 15 June 1999, *Science at its Best. Security at its Worst. A Report on Security Problems at the US Department of Energy*, a 57-page report on the US Energy Department and its nuclear weapons laboratories, was released by the Foreign Intelligence Advisory Board (FIAB) which concluded that the Energy Department was incapable of reforming itself. The FIAB's major unanswered question about the Los Alamos spy case is: why did the FBI and the DOE's chief spy hunter, Notra Trulock,

focus virtually all their energy on Lee, without hard evidence that classified warhead data supposedly obtained by China *came* from Lee or anyone else at the fabled home of the atom bomb.[8]

On 5 July 2000, attorneys representing Lee filed their long-awaited selective prosecution motion, arguing that Lee was singled out for investigation as a possible spy and ultimately charged in December 1999 because he was of Chinese origin. Two days later, federal prosecutors concluded that Lee was trying to boost his job prospects with research institutes in Europe and Asia when he allegedly copied a virtual archive of nuclear weapon secrets. Conservative journalist, Bill Gertz, replied a few days later in the *Washington Times* with a headline, "China Boosts Spy Presence in US, CIA, FBI Report", but this scare tactic didn't keep the Justice Department from admitting that it had no case against Wen Ho Lee.

In a surprising twist, on 24 July, the press announced that Lee's wife, Sylvia Lee, supplied information about Chinese scientists to a CIA officer when she was a secretary at Los Alamos in the 1980s. In short, she was a *CIA* agent.

On 17 August 2000, Robert Vrooman, a former chief of counter-intelligence at the DOE Los Alamos National Laboratory, stated that he did not believe China obtained any top-secret data on US nuclear warheads from any DOE laboratories and further claimed that the Department of Energy's national laboratories had found out far more about China's nuclear weapons than they ever lost to foreign spies. Vrooman had retired as counter-intelligence chief at Los Alamos in March 1998, and been stripped of a consultant's contract in September at the recommendation of Energy Secretary, Bill Richardson, for having failed to remove Lee from his job inside Los Alamos's top-secret X Division in 1997 after Lee came under suspicion for espionage. Vrooman stated that he deserved a medal, not scorn. He added that investigators targeted Lee as an espionage suspect largely because he is a Chinese-American. According to Vrooman, "This case was screwed up because there was nothing there—it was built on thin air."

On 22 August, the press announced that the Justice Department Internal Security chief, John Dion, had advised against prosecuting Lee because investigators did not have the evidence to convict him of stealing secrets for China. On 23 August, Notra Trulock, the DOE intelligence officer who first raised concerns about Chinese espionage at Los Alamos and virtually got the FBI "witch hunt" going, resigned, citing a DOE inspector general report which failed to back his allegations against Lee as the reason for his resignation. Trulock had come under mounting pressure as two government reports and a growing number of intelligence and security officials sharply criticized him for singling out Lee as the government's prime espionage suspect.[9] It sounded like there were some highly placed "slow learners" at the DOE, Justice and the FBI.

On 1 August, in a substantial embarrassment to the FBI and the Justice Department, Lee won a procedural victory when Judge James A. Parker ruled that much of the classified information Lee was accused of improperly downloading was relevant to his defense. On 16 August, Harold

Agnew, a former director of Los Alamos, and an instrumental defense witness, called testimony against Lee by Sandia Laboratory director, Paul Robinson, "a bunch of bull". On 24 August, the court ordered the pretrial release of Lee and proposed the required conditions for bail and release. By this time, Lee had already been held—in solitary confinement—for eight months. But the case was far from won: on 31 August, in a cautious and balanced opinion, Judge Parker was obliged to explain why he decided to grant bail to Lee, a decision that was subsequently stayed by the Federal Appeals Court in Denver.

In October 2000, *Intelligence* headlined, "Lee 'Case' Becomes the Lee 'Affair'.[10] It occupied a lot of space in the major press. The *Christian Science Monitor* of 12 September headlined, "The lessons of the fizzled Wen Ho Lee spy case". On 11 September, the press had reported that "Suspected Spy Wen Ho Lee Goes Free—Jailed Scientist Strikes Plea Bargain". While the *New York Times* editorial board called for an independent review of the prosecution to determine if racial profiling or other unfair tactics were used by the FBI and other government agencies, the *Times* had helped cultivate the false impression that Lee had transferred secret computer codes for nuclear design to China, and editorialized that those codes could "serve, in effect, as a physics blueprint for warhead design", which is a hotly contested assertion. A critical dissection of the *Times* handling of the case appeared online in the November 1999 "Brills Content".[11] Timothy Noah, writing in the online magazine *Slate*, posed the question: "Why Won't the 'New York Times' Apologize to Wen Ho Lee?"[12] In releasing Lee, Judge James Parker stated: "I do not know the real reasons why the Executive Branch has done all of this."[13]

FBI Director Louis Freeh was not embarrassed as the "case" turned into an "affair", stating that he defended the Bureau's conduct. He did not deign to mention the false testimony presented by FBI Agent Messemer which was posted at http://www.fas.org/irp/ops/ci/whl_freeh.html. Attorney General Janet Reno was also "not embarrassed", stating that "I think Dr. Lee had the opportunity from the beginning to resolve this matter, and he chose not to."[14] The Defense and Energy Departments set up a Joint Policy Group to examine the classification of the most sensitive nuclear weapons design secrets. The Group's 28 August 2000 charter was posted by Steven Aftergood at the Federation of American Scientists (FAS) website,[15] which has consistently provided public information on the case/affair.

In the *Washington Post,*[16] Kenneth Bass examined the so-called "crown jewel secrets" Wen Ho Lee was charged with mishandling, which had subsequently been shown to have not been classified at all until after the case began (nuclear scientists had testified the info was innocuous, not very useful, and widely available on the Internet—as Chinese officials demonstrated publicly, to no avail). *Post* intelligence specialist, Vernon Loeb, wrote, "Political pressure, I believe, distorted decision-making in this case from the beginning."[17] But Jeffrey H. Smith, former general counsel of the CIA, didn't seem to agree and offered an ominous warning which the *New York Times* saw fit to print, that "espionage cases often involve our most important secrets, and the true story may never be known."[18]

On 18 September, reinforcing the fact that partisan politics had been a major part of the "affair" from the beginning, Republican Senator Charles Grassley (R-Iowa) sought to use it as an occasion for Clinton-bashing, stating: "This is the latest instance of President Clinton failing to take responsibility", more "Clinton soft on security" talk.[19] Grassley also demanded that acting Defense Inspector General, Donald Mancuso, not be confirmed by the Senate as IG and asked whether there was a "double standard" at work.[20]

On 22 September, the Senate Judiciary Committee announced that it would hold two hearings on the Wen Ho Lee case the following week. On 26 September, the full committee was to hear FBI chief Freeh, Assistant Attorney General, James Robinson, of the Justice Department Criminal Division, and US Attorney Norman Bay. On 27 September, Sen. Arlen Specter's Subcommittee on Administrative Oversight was to hold its own hearing. On 26 September, government witnesses, including Reno and Freeh defended their conduct of the Wen Ho Lee investigation and prosecution at a joint hearing of the Senate Judiciary Committee and the Senate Intelligence Committee. The Lee defense team was not represented at the hearing and those absent—even when not invited—are, of course, presumed guilty.[21]

The same day, without acknowledging a single error of fact or apologizing to anyone, the *New York Times* admitted that its coverage of the Wen Ho Lee case contained "flaws."[22] But on 27 September, the *New York Times* partly criticized and mostly congratulated itself for the way it covered the Lee-Los Alamos espionage case over the past two years,[23] while the *Washington Post* chose to quote the claims of Neal Lane, director of the White House Office of Science and Technology Policy, the president's chief science adviser, that the Clinton administration and Congress "have overshot the mark" in their reaction to security problems at Los Alamos and other national laboratories.[24] That didn't stop the "steam-roller" disciplinary rules and paranoia put in place at Los Alamos during the Lee affair: later, in an unrelated case, following the disappearance and reappearance of hard drives containing nuclear secrets, three review panels recommended punishment of several employees.[25] "The type of severity or magnitude (of the punishment) has not been determined yet", according to laboratory spokesman, James Rickman.[26]

On 3 October, a Senate Judiciary Subcommittee heard testimony from witnesses arguing whether or not the files downloaded by Wen Ho Lee were the "crown jewels" of the US nuclear weapons program. According to Steven Aftergood at the Federation of American Scientists, under the skillful questioning of Senator Arlen Specter, the two conflicting views converged somewhat, but not completely. Weapons designer emeritus, John Richter, acknowledged that the weapons design parameters downloaded by Wen Ho Lee, unlike the computer "source codes", were indeed sensitive and properly classified. Los Alamos Associate Director, Stephen Younger, acknowledged that to build a bomb, far more would be required than the information contained in the downloaded files, and that the files were not classified at the highest level. But there the matter stood.

Former Los Alamos counterintelligence chief, Robert Vrooman, and former DOE Intelligence Director, Notra Trulock, each provided vivid testimony

in this unusually interesting hearing. According to Vrooman, the FBI prematurely focused on Wen Ho Lee as a possible spy when the original investigation had identified 12 possible sources, including a number of Caucasians: the FBI had concentrated on Lee from the outset. Vrooman also accused Secretary of Energy, Bill Richardson, of leaking Lee's name to the press. Vrooman also clashed with Trulock over accusations of racial profiling. The hearing received testimony from defense witness, Robert Young,[27] who admitted that he inaccurately assessed the amount and sensitivity of the information downloaded by Lee. The witnesses' prepared statements were made available on the Federation of American Scientists website.[28]

On 12 October, in a lengthy colloquy concerning the "Investigation and Treatment of Wen Ho Lee" on the House floor, Rep. Patsy Mink stated that: "My reason for rising here tonight is that we believe that there was a serious mistake made by the government in the way that they dealt with Dr. Wen Ho Lee", referring to the government's failure to acknowledge wrongdoing in its conduct of the case and the sense of injustice that continues to fester, particularly among Asian Americans. The same day, Senator Pete Domenici noted, in a press release, that in its mad pursuit of a misconceived ideal of "security", Congress quietly imposed broad new polygraph testing require-ments on Energy Department employees and contractors. Subtle changes adopted in the conference on the defense authorization bill would require polygraph tests on an additional 5,000 persons in the nuclear weapons labs, an increase from the current level of around 800.

On 16 October, the *Washington Post*'s Vernon Loeb quoted a former FBI expert in Chinese counterintelligence, Paul D. Moore, who has long been skeptical of the Bureau's Kindred Spirit spy case, doubting whether the FBI would ever catch a Chinese mole at Los Alamos or anywhere else in nuclear weapons research. But after listening to FBI Director, Louis J. Freeh, describe Wen Ho Lee's "history" with the FBI to Congress a few weeks ago, Moore had to admit that the former Los Alamos physicist could scarcely have done more to trigger the suspicion of counterintelligence investigators. According to Freeh and Attorney General Janet Reno, the government's "paramount concern" in the Wen Ho Lee case was to determine what happened to the missing tapes containing the nuclear weapons information Lee downloaded. If this were true, it is therefore incongruous that over a month had passed since Wen Ho Lee was set free, with an apology from the judge, and yet the government had repeatedly deferred the opportunity to resolve its "paramount concern" by debriefing Lee. This was, of course, *after* he had spent eight months in solitary confinement! On 17 October, that debriefing finally began.[29]

Under his plea agreement, Lee could be interrogated under oath by the FBI for ten days over a 21-day period. The interrogation, which could again include the use of a polygraph, could cover any topic of interest to the FBI.[30] If it was found that Lee had not told the truth during the questioning, the plea agreement could be overturned and the 58 indictments that had been set aside could be reinstated. The *American Journalism Review* reported

at the time that the *New York Times* uncritically "embraced the outlook of investigators in its breathless coverage of the Wen Ho Lee case. As a result, the nation's premier news organization tarnished not only the scientist but also its own reputation." Unfortunately, the *Review* didn't get into the fallout from the FBI's "breathless" pursuit of Lee.

On 6 November, the *Washington Post* reported that the FBI revealed information on two serious cases of espionage at national weapons laboratories dating from the 1970's and 1980's. The cases ran parallel with the Wen Ho Lee case but were never made public or brought to trial. The men involved were fired but the cases were not closed. Lee had become entangled in one of the cases when he was heard talking on the telephone to one of the suspects. The other case, dealing with nuclear submarines and their noise reduction, was an outgrowth of the famous 1980s Walker family spy ring at the Pentagon. According to several specialists, the publication of this information appeared to be an effort to demonstrate the seriousness of the problem of espionage against US military technology and the preferred method of dealing with such cases—meaning, keeping them out of the hands of partisan politicians and the media, which obviously didn't happen in the Lee case.[31]

On 11 December 2000, the FBI crime laboratory announced it was examining more than ten computer tapes recovered from a New Mexico landfill, and a government official said that, judging by their "outside appearance," they could be the classified cassettes that Lee claims to have thrown into the trash. A FBI source familiar with the case stated in November that Lee said he disposed of the pocket-sized computer tapes, containing the downloaded nuclear secrets, in a dumpster inside the top-secret X Division fence in January 1999.[32] If so, the 50-acre New Mexico dump is where they should have ended up.[33]

On 24 December, the press reported that Lee told the FBI that he was a paid consultant in the late 1980s and early 1990s to a Taiwanese businessman who later helped arrange for him to spend four weeks at Taiwan's leading military research center, according to sources close to the investigation. The FBI stated Lee may have accumulated nuclear weapon secrets with the intention of assisting his homeland.[34]

In September 2001, *Intelligence* mentioned that the FBI was far from dropping the Lee case or admitting it was a fiasco.[35] That summer's media activity confirmed that analysis.[36]

And it goes on and on, right up until now with the publication of books and continuation of court cases for damages, defamation and apologies which may never be made.

# Terrorists' Networks and Traffic Analysis Before and After September 11

## THE DIFFICULTY OF DEFINING "TERRORISTS"

Despite worldwide backing for the US government's "anti-terrorist" campaign against the individuals and organizations responsible for the 11 September 2001 attacks in New York City and Washington, the United Nations has to date been unable to come up with a definition of "terrorism". The head of Reuters news service even went as far as to explicitly discourage the use of the term "terrorist" in Reuters press releases following the 11 September attacks. Indeed, the governments of Israel, South Africa, Angola and Zimbabwe—to name only a few—have been run by individuals and parties that were once widely described as "terrorists" until they came to power. A resume of the issues was recently provided by Seumas Milne,[1] who stated that: "The transformation from terrorist to respected statesman has become a cliché of the international politics of the past 50 years, now being replayed in Northern Ireland."

When both sides target individuals for assassination in Western Europe's longest modern war between MI5 and the IRA, it's difficult to call one use "anti-terrorist" and the other "terrorist". Insofar as the same methods may be used by one large company against another, by one intelligence service against another, or by states against internal or external groups, it seems more appropriate to avoid value-laden terms such as "illegal" and "illicit" and to use instead the term "adversary"—a term to be used in this paper, though it is hardly to be hoped that states worldwide would permit the adoption of such a value-free label.

Nonetheless, developments since the 11 September attacks have indicated a direction of possible progress. Western Europe reportedly developed the first "modern" definition of terrorism in the 1980s as "violence to obtain political objectives". Thus, while it might be readily agreed that the Red Brigades in Italy and ETA in Spain were "terrorists", the United States could not condone such a definition which could seriously hinder its foreign policy, particularly in Israel and Palestine where the Israeli government applies an official assassination policy against Palestinian leaders.

Following the 11 September attacks, a consensus seems to be developing around the use of the term "terrorism" to describe "violence to obtain political objectives and involving attacks against citizens of foreign countries not directly involved in a conflict".[2] Also, this definition focuses the problem of clarification on the term "directly involved in a conflict", but makes it clear that the 11 September attacks were "terrorism". However, it leaves open the question of whether or not killing civilians in a theater of combat without proof of their support of adversaries—such as US forces have done in the Iraqi cities of Fallujah and Najaf—is also "terrorism".

Conducting research on "adversaries", a term now including political or commercial rivals, can take many forms. Even when limiting the field to empirical data-based methods, there are still numerous possibilities even though this tends to eliminate almost all the "methods" employed by political, commercial and other organizations that are intended more for sale as commercial products than as tools for scientific research. By limiting the field even further to "structural" methods used in scientific research, there are still many candidates. Here, two are presented: 1) the village survey method developed by CIA officer, Ralph W. McGehee, and 2) traffic analysis or communication link analysis, whose first formalization seems to have been in a US Army World War II manual, *Fundamentals of Traffic Analysis (Radio-Telegraph)*.

## THE VILLAGE SURVEY METHOD DEVELOPED BY THE CIA'S MCGEHEE

Ralph McGehee, a CIA officer and former Notre Dame football star, arrived in Bangkok, Thailand, in September 1965 to fight Communist rebels.[3] He soon found out that the CIA data on the rebels was not only unreliable but, in many cases, false. This reflects a similar discovery concerning official data on "terrorists" on the US "No Fly" list which recently kept Senator Edward Kennedy from boarding a plane in Washington, DC, to fly back to Boston. McGehee decided to "go into the field" and develop what he called the "village survey" method, which is simply a form of the classic village monograph method in anthropology. McGehee and his district survey team would interview village members and note family and community relationships. Cross-checking was all that was needed in many cases to obtain confessions of Communist Party membership or even arms training.

By returning later to the same villages, redoing another survey and cross-checking data with the previous survey, McGehee often obtained a complete description of the local or even district structure of the Communist Party and its various associated organizations. By surveying 30 Thai villages, he was able to extrapolate results to all of Thailand, and that's where things went wrong. He found more Communists in one province than the CIA officially recognized for all of Thailand. Using available information, the method indicated that if applied to Vietnam, the threat posed by the adversaries would have been catastrophic: "the surveys would have shown there that the Communists could not be defeated."[4] The CIA's response was to award McGehee its highest service medal and keep his results from being known by anyone

outside a very small circle of CIA officials including William E. Colby—then CIA Far East division chief and McGehee's more-or-less direct superior—until he became head of the CIA during the Vietnam "police action".

## THE EARLY HISTORY OF TRAFFIC ANALYSIS

As defined during World War II in a US Army technical manual,[5] "traffic analysis" was "that branch of cryptology which concerns the study of the external characteristics of signal communications and related materials for the purpose of obtaining information about the organization and operation of a communication system." Although traffic analysis probably existed in other forms since the use of electronic battlefield communication systems, this is the first mention of the term and the first formal presentation that has been found. It is a "filing card" technology system, meaning that its data analysis methods—mostly manual cross-checking—were no different from those McGehee was using in Thailand in the late 1960s before computers were widely available.

One should note, in the above definition, the use of the term "external characteristics", which clearly implies that the structure of communications, and not their content, is the object of study. In its most precise and limited definition, traffic analysis, or "metering", consists of a form of network analysis of many telephone calls (or other forms of contact or communication) to determine who calls whom, in what order, for how long, and at what time. Such analysis does not involve listening in on conversations and is therefore not legally "wiretapping" under most nations' laws. Indeed, since privacy law does not even mention the existence of traffic analysis (or pen registers) in most countries, it can legally be done by law enforcement agencies, intelligence services, private companies or anyone else who can obtain the necessary "metering" information. Properly done, with good data, and with unaware adversaries not employing counter-measures, traffic analysis can determine "ring leaders", "gate keepers", "messengers", "outliers", and other types of network members and their roles.

## "CIVILIAN" USE OF TRAFFIC ANALYSIS AFTER WORLD WAR II

US military policy in Latin America evolved as the Cold War settled in and moved from sending in the US Marines to CIA-developed "counter-insurgency", and traffic analysis reportedly found new life in tracking Eastern diplomats—and potential spies—in Washington, DC, and New York City. In such developments, the British are either not far behind or are even working directly with the US, which seems to be the case for traffic analysis. The first detailed publicly-available information on the non-wartime use of traffic analysis was in Northern Ireland against the Provisional IRA as part of a system called Movement Analysis, developed by the British MI5 internal security service (also known as the Security Service but preferring the acronym "MI5" [Military Intelligence 5] to that of "SS"). This information surfaced in January 1989, in London, when MI5 asked the Speaker Office of the House of

Commons to withdraw the name of Hal G. T. P. Doyne Ditmas from a question by Labour MP, Chris Mullin. The reason was that MI5 feared Irish subversives would discover that Mr. Ditmas "made a significant contribution to the efforts of British intelligence in Ireland", according to the Dublin newspaper, *The Phoenix*, on 13 January, by developing and applying movement analysis, reportedly used initially in North America against Eastern block diplomats, against the IRA both in Northern Ireland and in Great Britain.

A methodology then attributed to Terry Guernsey, the head of the Royal Canadian Mounted Police, or "Mounties" (Canada's internal security service), movement analysis reportedly consists of a data collection system and a statistical analysis system to determine who holds what position and what are their functions. Data is systematically collected on times, durations, days of the week, places and individuals visited, type of visits, car license plates, and trajectories by car, foot, or public transportation. First, by simple cross-tabulation, and then by more sophisticated statistical methods, such as automatic classification analysis, typological analysis, and factor analysis, specific "types" of behavior can be precisely defined, along with the "outliers" who do not fit easily into the specified types. These types and outliers can then be examined in detail to see if they represent profiles characteristic of intelligence activity: in short, who is acting suspiciously and like a spy, and who is not. Secondly, structural analysis to determine the relationship between the different individuals analyzed can be done using the various social network analysis statistical methods such as traffic analysis. These determine who are the leaders of groups, the "gate keepers" between different groups, the peripheral members, and the central members.

When MI5 decided to computerize its operations in Northern Ireland in the mid-1970s, it took several years. When completed, it was Mr. Ditmas who installed the movements analysis system that covered all Catholic ghetto areas where the IRA operates. Called Operation Vengeful, it used British soldiers both for routine information collection and for "census" calls on virtually every Catholic household. This aspect closely resembles McGehee's village survey work, but in a "domestic" and much more hostile environment.

## PUBLIC COUNTER-MEASURES: TRAFFIC ANALYSIS "BITES BACK"

In Northern Ireland, MI5 discovered not only that the IRA knew about the method, but that it had actually developed its own version and used it against British intelligence. Reportedly IRA traffic analysis discovered that all Royal Ulster Constabulary (RUC) agents and informants were paid the same day every month and would line up at a certain number of automatic teller machines to draw out their cash, thus permitting the IRA to identify a major part of MI5's secret anti-IRA assets, according to Irish press reports at the time.

The next time traffic analysis entered the public domain, it was because of a 19 July 1992 theft of confidential documents in a Scottish police station. The subsequent publication of these documents in the newspapers, *Sun* and *Scotland on Sunday*, revealed that the Scottish police

had carried out widespread traffic analysis of telephones used by 78 persons and organizations. The publication also resulted in the arrest and detention of two journalists that fall. The press reports clearly referred to the use of traffic analysis or "metering". It seems like poetic justice that some of those who were "metered"—journalists—were those that exposed the method . . . and were put in jail for their contribution to public knowledge.

In early 1994, the first publicly available "counter-measure" was described in press reports. To defeat traffic analysis, a caller needs to protect, at a minimum, his or her identity and to limit the duration of the telephone call. This impedes establishing a link between the caller and a targeted number under surveillance or being eavesdropped. If the caller is already under surveillance or being eavesdropped, this "first-generation" system, the "Stopper", does not work. But the minimum requirements of anonymous caller identity (a caller not under surveillance) and indeterminate call duration were reportedly met by the Stopper, which was a secure switching scheme provided by a Washington and Beverly Hills-based privacy lawyer, William Dwyer II. It also kept a caller's unlisted number secure from caller ID systems. By telephoning first to 1-900-stopper (786-7737) at what was then a $1.95 per minute rate, the caller received a dial tone to make a touch-tone call anywhere in Northern America. For $3.95 per minute and an initial call to 1-900 call 888 (225-5888), it was possible to telephone anywhere in the world without revealing your number. Other security features included multiple outgoing calls, which prevented identifying a call by the time of day and its duration, and the possibility of using Cylink voice encryptors between the caller and Stopper. Such options interest intelligence agents much more than the general public. Nonetheless, US and Canadian officials declared the system legal. It closely resembles current widely-used "Kall Back" systems.

Traditionally, a new director of the Belgian Sûreté d'Etat internal security service gives a press conference concerning the service's priorities. It's a sort of an initiation ceremony and the late 1994 appointment of Bart Van Lijsebeth as Sûreté chief was no exception to this rule. A new priority for Mr. Van Lijsebeth was the Belgian extreme right and local religious sects. This axis was probably determined largely by that year's political events including investigations of the Sûreté's shady ties with the neo-Nazi Westland New Post group and with the Brabant massacres.[7] Van Lijsebeth also stated he would like to have more personnel and legalize telephone eavesdropping. Because "wiretaps" were still illegal, the Sûreté was reportedly getting around the problem by telephone traffic analysis, "a form of network analysis to find 'gate-keepers' and 'core' persons by analyzing who calls whom at what time and for how long. Since this information does not constitute 'tapping', the Sûreté can resort to it without oversight".[5] Mr. Van Lijsebeth seems to be the only public official to have gone on record stating that traffic analysis was a way of getting around the law on wiretapping.

## TRAFFIC ANALYSIS IN THE 1990S

With such information available in the public domain, it couldn't have

been long before the then proud and powerful software industry put traffic analysis tools on the market to replace file-card cross-tabulations and the user-unfriendly "homegrown" programs that were being used by law enforcement agencies, intelligence services, private companies and assorted "adversaries". In spring 1996, Alta Analytics of Columbus, Ohio, well-known for graphical data analysis, announced a "product development and joint marketing agreement" with a major on-line data service, Lexis-Nexis, concerning a link analysis "data mining" program, Netmap. An *Intelligence* review of the program[6] noted that "information specialists probably didn't notice that Netmap's 'credentials' include being 'widely used in intelligence and law enforcement'. Link analysis is part of a larger category of scientific tools called social network analysis and can be applied to all forms of relationships: financial, organizational, command, hierarchical 'pecking orders', telephone conversations, emotional support, counseling and advice."

Up until then, the type of network or link analysis programs available to the general public (outside the social network scientific community) had been mostly "graphical", meaning new and more beautiful ways of presenting data in full color to decision-makers. What Alta had done with Netmap was to adapt certain scientific tools for intelligence work, and for public data mining. The US Defense Intelligence Agency (DIA) Office of National Drug Control Policy had "plugged" Netmap into its new Emerald drug interdiction coordination computer network, and other intelligence services could clearly profit from Netmap applications, according to Alta Analytics, which also recommended Netmap for assisting "in the intelligence production cycle to detect and expose financial crimes and money laundering activities."

Schematically, the program laid out analytical "units" (persons, bank accounts, companies) on the perimeter of a circle and traced lines between the "units", representing a "link" or tie. The darker or thicker the line, the greater the tie (more financial transactions, more telephone calls). This particular graphic technique had already been around in network analysis since the late 1970s and early 1980s, and was used as a starting point of cognitive mapping techniques developed in France at the Ecole des Mines de Paris. Whereas network analysis and cognitive mapping usually go from this basis into multivariate analysis—and therefore lose the general public and most intelligence professionals—Netmap makes it simpler by sticking to univariate (single variable) analysis and successively "cleaning up" the circle diagram (although Netmap does have certain multivariate capabilities). Thus, a circle of 4,003 telephone calls between 1,103 numbers was reduced to 45 "units" (telephone numbers) with more than 20 calls, then to three numbers with 40 or more calls.

If sequence of calls is introduced, then Netmap can help map out the "command hierarchy" of telephone calls (which is not necessarily pyramidal as the general public is usually led to believe) and furnish valuable information on who to "wiretap" or arrest. This is exactly what the US Army was doing in World War II on bristol cards when it was doing traffic analysis: identifying the adversaries' "command hierarchy" . . . before bombing it. More recently, uses of traffic analysis results have often not led to more subtle outcomes. In

classic intelligence and law enforcement work, traffic analysis can usually be done without a warrant since conversations are "counted", not "listened to". When several Netmap-like circles (one for telephone calls, one for "work together", one for "leisure time together") are overlaid, one on top of another, or analyzed at the same time (multivariate analysis), the often complex structure of an adversary's network becomes much more clear. What is done with this information is, of course, something else, as we will see below.

## GOOD GUYS AND BAD GUYS USE HIGH-TECH

The crooks "pulled a fast one" just as the cops were catching up with them—technologically speaking—by using still newer technology that easily defeated Netmap and similar traffic analysis methods: cell phones. As portable or mobile telephones became widely available, they also became widely stolen. Crime bosses would buy a half dozen at a cheap price, use one after another for a few days—it depends on how dangerous your "business" is—and then "recycle" them by either putting them back on the black market or running over them with their car. Dropping them out of a car window on a busy freeway is also considered "cool" ... and probably bothers the police technicians who are trying to follow the location of the cell phone.

In Great Britain, cell phone technology also brought new developments for the "good guys" when, in 1997, it was reported that under the British Interception of Communications Act 1985, the British police were not obliged to seek a warrant to eavesdrop on private conversations made by the then 4 million users of mobile telephones. This interpretation of the eavesdropping law was a direct result of advances in signal technology. The mobile telephone is made up of two items: a base unit, which is part and property of the public telephone network; and a handset, which is regarded as a stand-alone private system using radio waves to transmit instead of a land line. British legislation, as then drafted, allowed the police or other government agents to use signal intelligence equipment to intercept conversations "broadcasted" by private systems without having to seek legal permission to do so. This interpretation was underlined at the time by a Law Lords ruling in the case of a drug dealer, convicted on signal intercepts, which confirmed that "the interception by the police of telephone conversations on a cordless telephone is not subject to the Interception of Communications Act 1985 and evidence at a criminal trial of such conversations is not rendered inadmissible."[8] So who needs traffic analysis when you can listen directly to the conversation and, moreover, record the physical location of the callers? A question for future research is whether or not British crooks went back to land lines when this information became available.

Cell phone location information, although not directly related to traffic analysis, is very closely associated with it. It doesn't seem to be covered by privacy legislation in any country. On the contrary, again in Great Britain, its use by authorities has been clearly stated. Mobile telephone location information can be used to trace a caller's physical presence years afterward by

employing technology reportedly used for the first time in 1997 in a British murder trial and in a British Winchester football match-fixing trial. In the former case, the police used computer records to track the accused's journey from work to the murder scene and back again, even though no calls were made or received. William Ostrom of Cellnet, one of Britain's four largest mobile phone providers, stated that the stored data was used for billing purposes, but it was also used to check for "unusual use" and possible theft of a telephone. He claimed: "We can tell where any one of our mobile phones was, as long as it was switched on, for any time and date in the past two years. It's exactly the same for all four mobile networks in Britain, which deal with nearly seven million users. . . . We are helping the police with three cases at the moment."[9] Vodafone admitted that similar data is stored, but another British mobile phone provider, Orange, refused to comment. Orange now belongs to France Telecom but it is possible that British cops have kept Orange's old location information. Another future research project would be to find out what happened to privacy data, and particularly cell phone location information, following takeovers by telecommunication companies from different countries.

When activated, mobile telephones, even when not receiving or sending a call, emit a signal so that base units know where it is and which apparatus it is, so that a call to or from it can be quickly routed. This signal serves as a miniature tracking system unknown to the user, and reveals the whereabouts of the apparatus at any given time. The electronic signal data, pinpointing the device's location, are stored in service provider computers for several months and, in Great Britain, up to two years. "Smart" mobile phone users often think they have "outsmarted" the system by simply turning off their unit, but most, if not all, units can be turned on remotely with the appropriate high-tech equipment at the disposal of official intelligence services. The only "foolproof" counter-measure is to take the battery out of the mobile unit or put the unit in a "tempested" farad cage, if you have one. Members of the general public usually do not.

## BIG TIME INTELLIGENCE CALLS ON TRAFFIC ANALYSIS

The "big time" came to traffic analysis—and all forms of social network analysis—in March 1998 when the American Association of Artificial Intelligence (AAAI) launched its "Call for Papers" for its 23-25 October 1998 symposium on Artificial Intelligence and Link Analysis in Orlando, Florida. The AAAI recognized—as we have mentioned above—that "computer-based link or network analysis is increasingly used in law enforcement investigations, fraud detection, telecommunications network analysis, pharmaceuticals research, epidemiology, and many other specialized applications. Much of the current software for link analysis is little more than a graphical display tool, but many advanced applications of link analysis involve thousands of objects and links as well as a rich array of possible data models which are nearly impossible to construct manually." In short, formal network analysis was necessary, and, as the symposium organizers stressed, "the focus of the symposium is new technologies, not capabilities and applications embodied

in current software." Little wonder that the organizers included William Mills, of the CIA Office of Research and Development (R&D), and Raphael Wong, of the US Treasury Department FinCEN, financial "cops" specialized in money laundering pattern recognition.[10]

At the same time, in addition to law enforcement and intelligence, network analysis made its entry on the Internet when UCLA sociology graduate student, Marc Smith, used his program, Netscan, to analyze USENET topic groups for patterns of interaction such as how many posts were made to a newsgroup during a given time period, how many different people made those posts, and how many of those posts were cross-posted to other newsgroups—more-or-less traffic analysis applied to USENET activity. Netscan produced simple bar graphs and numbers, and could help generate hypotheses about the social dynamics in the newsgroups and what kinds of experiences each group offers its participants. Although Netscan did not actually do multivariate network analysis, it could easily function as the "front-end" of more advanced systems, and Smith intended to develop that aspect.

It also appears that network analysis and associated pattern recognition methods defeated one of the "new pretenders" at the time: neural network analysis. According to an early 1998 study by InfoGlide Corporation, of Austin, Texas, "neural nets are essentially obsolete for fraud detection" when compared to pattern recognition, although this result may be dependent on the specific methods tested.[11] Usually, neural networks are "trained" by multivariate pattern recognition and network analysis methods before functioning independently. If the objects of analysis suddenly undergo a significant change, such as a new form of fraud, the neural net must be "retrained" by the multivariate methods before it can function again correctly. Since some criminals are not stupid, they often come up with new types of fraud that initially avoid detection by existing systems. Thus, back to traffic analysis.

In early 1998, two of Ireland's top universities, Trinity College, Dublin, and Queen's University, Belfast, obtained European Commission funding to establish a "transfer technology node" to promote the application of supercomputer technology into commercial and industrial projects such as data mining in the financial sector and simulation of network designs for the telecommunications industry. *Intelligence* disingenuously commented: "Previous major computer programs in Ireland included MI5 'traffic analysis' of IRA suspects' movements and telephone calls, and IRA analysis of automatic teller withdrawals to identify RUC [Royal Ulster Constabulary] agents and informants. The current project appears to be the EU contribution to 'peaceful' use of computer technology."[12]

## THE FBI, THE NEW KGB, PRIVACY INTERNATIONAL & NEW YORK CITY

In late July 1998 the Russian FSB internal security service (the successor of the Soviet KGB chief "domestic" directorate) announced that under its Project SORM (System of Operative Intelligence Actions or System for Ensuring Investigative Activity, depending on translations), it planned to

monitor the Internet in Russia, in real time, for every email message and Web page sent or received. All Internet service providers (ISPs) in Russia would have to install an eavesdropping device on their servers and to build a high-speed data link to the FSB's Internet control room. The US firm, Cisco, probably found a market for its "Private Doorbell" surveillance-friendly encryption system. According to the Swedish publication, *Svenska Dagbladet*, the FSB had developed three levels of control: full statistical traffic analysis (listing all outgoing and incoming telephone conversations), and control of a communication area through network analysis monitoring by a station covering the area. The importance of the project could be judged by the man in charge: FSB deputy director, Aleksandr Bespalov.[13]

In fall 1998, the British group, Privacy International, awarded its annual Big Brother "Name and Shame" privacy invader titles. The product winner that year was WatCall software, produced by Harlequin Ltd., for telephone record "traffic analysis" "which avoids the legal requirements needed for phone tapping."

In May 1999, the administration of President Bill Clinton, through the International Law Enforcement Telecommunications Seminar (ILETS), an umbrella organization set up by the FBI in 1992 which includes security and law enforcement agencies from 20 Western countries, was pressuring EU members to force European ISPs to provide "interception interfaces" for all future digital communications to allow police and spies to monitor an individual's web activity, check newsgroup membership and intercept email. Caspar Bowden, director of the London-based Foundation for Information Policy Research (FIPR), stated at the time that the data-taps probably infringe on the European Convention on Human Rights (ECHR). Mr. Bowden claimed that even if Internet users encrypt their email, sophisticated analysis programs—such as communications traffic analysis—can reveal a great deal to the trained professional about an individual's usage and his or her network of personal contacts. Thus, traffic analysis could be used even to counter encryption-based public privacy in communications.[14] This seems to be one of the uses of traffic analysis by the worldwide Echelon electronic communications eavesdropping system directed by the US National Security Agency (NSA) and the cornerstone of the secret UK/USA security agreement.[15]

On 6 July 1999, in a unanimous opinion, the New York Court of Appeals marked a significant shift in wiretapping jurisprudence and gave traffic analysis by law enforcement a real "shot in the arm" by deciding that police may install pen registers—devices that monitor numbers dialed from a telephone line—without obtaining a warrant based on probable cause. "Reasonable suspicion" is now sufficient for pen register surveillance to be initiated. At least, pen register surveillance is now mentioned in law and can be discussed in court. Few countries are even that far down the road to protecting privacy. Indeed, we made a request to Privacy International concerning information on the legality of traffic analysis and pen registers in Western countries. Privacy International, which keeps tabs on privacy legislation in most developed countries, gave us a polite reply that our question would make a good but difficult project for future research.

# Now You See Them, Now You Don't: Executive Outcomes and Sandline International*

Business owners all over the world have learned the lesson: the cops are never there when you need them. Therefore, if you want security, you pay a price. The South African company, Executive Outcomes, offered the ultimate in private security: hire your own army.[1] Executive Outcomes' high-caliber forces turned the tide in Angola and Sierra Leone,[2] and brought stability where chaos reigned. But their services came with a price: these warriors were equally adept at securing profits by draining the client state's mineral resources.

## COLONIALISM'S OLD SOLDIERS NEVER DIE: THEY GO ON TO FIGHTING FOR PROFIT

Executive Outcomes (EO) was by no means unique—the African continent, in its present state of anarchy, is a playground for dozens of shady mercenary companies, risk analysts, security consultant firms, and military trainers. Small and unstable governments lack money, but they do have natural resources. So they hire private guns and, in order to pay them, they cut them in on the resources. These mercenary armies, which currently frequently include East European adventurers, have no strings attached. They will fight for any party, and they remain loyal as long as the money keeps coming. But EO was different in its background and professionalism. It was, by all accounts, the best in the business, claiming to work only for established governments. In its day, it had serious competition from only one other firm, the US entry in this exclusive market: Washington-based Military Professional Resources Incorporated (MPRI).[3] With the Bush administration's invasion of Iraq, however, the field is now full of them, including Dyncorp, CACI, Titan and

---

*The first special report on Executive Outcomes was published in *Intelligence* on 10 March 1997 and a second—on Executive Outcomes and Sandline—was published in *Intelligence* on 22 June 1998. This chapter draws on and abridges these reports.

several others, some of which have been directly implicated in the torture of Iraqi prisoners.

Many of EO's hundreds of soldiers were former members of the 32nd Battalion of the South African Defence Force (SADF), the name for the South African military under the Apartheid regime. The armed forces under the present democratic government are referred to as the South African National Defence Force (SANDF). The 32nd was the so-called "Buffalo" Battalion. Operating mostly in Namibia and on Angolan soil against MPLA government troops which were backed up by Cuban forces, it was composed largely of Portuguese-speaking Angolans and became South Africa's most highly-decorated unit since the Second World War. Other EO personnel have similar backgrounds: from the Reconnaissance Commandos (Reccies), the Parachute Brigade (Parabats), and the paramilitary "Koevoet", or "Crowbar" police unit. Together, they were South Africa's experts in regional destabilization during the Apartheid era. Initially, 70 to 85 percent of EO's fighting forces were black Angolans and Namibians, while most of the officers were white South Africans, with the recent addition of Eastern Europeans, often from former Yugoslavia.

EO claimed it recruited only seasoned veterans who had served in the SADF or the South African police, although some of the aircrews and maintenance personnel were, by necessity, of foreign origin, due to EO use of a lot of Warsaw Pact aviation equipment. This background ensured common training and combat experience. EO promised excellent financial benefits and full life insurance. Salaries went as high as US$13,000 per month for a pilot, while a captain in EO still earned three times as much as his counterpart in the SANDF. Depending on skills, the average EO "instructor" could expect to earn US$2,000-5,000 a month. Standard contracts ran for one year. In "times of peace" many EO employees found temporary work in companies related to EO.

EO's origins are reflected in the career of its founder and managing director, Luther Eeben Barlow, 40 years old at the time. Born in Rhodesia, he moved to a farm in Waterberg, Nylstroom, South Africa, at the age of six and became a naturalized citizen. He joined the army at the age of 18 and began to study African politics and international affairs through correspondence courses at UNISA in 1986. He held the rank of lieutenant colonel in the SADF and, in 1982, became the second in command of 32 Battalion. In 1983, he transferred to the Directorate of Covert Collection (DCC), where he was involved in espionage operations. In the late 1980s, he moved to the Civil Cooperation Bureau (CCB) hit squad, where in 1989 he became head of the European section "6". The CCB was a covert part of South African military intelligence structures designed to collect intelligence abroad, to devise sanction-evading mechanisms and to spread disinformation. In his capacity as the CCB's point man in Europe, Barlow may have been involved in several assassinations of regime opponents in exile, although he himself has vehemently denied this.

Among his more mundane tasks with CCB was the setting up of front companies in Cyprus, Great Britain, and a half dozen other European

countries, an experience that would serve him well in his later entrepreneurial career. Barlow says he left the military in 1989 and launched Executive Outcomes. Other sources claim Executive Outcomes itself was just another military intelligence front of the CCB until it was disbanded by President F. W. de Klerk in 1991. Barlow then operated as a traveling salesman, offering specialist security services and espionage gadgets throughout the African continent. During this period, he began organizing groups of former military men with a view to employing them as security forces outside South Africa.

## ANGOLA: FIGHTING FOR CORPORATIONS

Barlow's name began to appear in the international press. In March 1993, for example, he was mentioned as head of Executive Outcomes in the British *Guardian* when he had to confirm that three white South African mercenaries who were wounded while working in Angola as "security consultants," had been employed by his company. The men turned out to be part of a shadowy, hundred-strong force. At the time, observers assumed they were mercenaries fighting with the UNITA rebel forces. But in fact EO had just won its first Angolan contract with two oil companies, Gulf-Chevron and Ranger Oil, which had hired the company to protect their installations. According to Barlow, he was then approached by Anthony Buckingham, the head of a company called Heritage Oil & Gas, in October 1992 to protect his commercial assets in Angola. Barlow agreed, and in January 1993, Buckingham and his colleague, Simon Mann, commissioned Barlow to recruit a force of South African veterans to drive the UNITA rebels from the Soyo oil industry region. Barlow and his partner, Lafras Luitingh (a former major in the 5th Reconnaissance Regiment, who had also worked with Barlow in the CCB hit squad), assembled a small force of fewer than a hundred men and succeeded in their mission, though Soyo was recaptured by UNITA after the South Africans left.

## ANGOLA: FIGHTING FOR THE MPLA GOVERNMENT

Executive Outcomes' performance impressed the Angolan MPLA government. It awarded EO a US$40 million contract in July 1993, partly in the form of oil concessions. Anticipating future ANC rule in South Africa, Barlow then approached the ANC through his Umkhonto we Sizwe contacts and proposed that they tolerate the EO activities in Angola. For the ANC, it must have seemed a reasonable suggestion as EO would recruit and occupy people whom the ANC feared as a potentially destabilizing factor for South Africa's future.

Executive Outcomes established a firm reputation in the Angola campaign. Under a further contract of US$95 million in 1994, and additional month-to-month contracts ending in January 1996, an estimated 500 EO personnel were flown in. They trained the Forces Armadas Angolanos (FAA), supplied logistics and communication support, and also became directly involved in combat missions. Eeben Barlow's men rebuilt the FAA's 16th

Brigade, which had been virtually wiped out by SADF in 1988, into an effective fighting force against UNITA. In their supervising role, EO personnel were present at all levels in the FAA from platoon to command center. A top EO official, quoted in the press, conceded that "We have to be there to assist in operational plans and help command and control. If the operation backfires, we get the blame. We have to stand behind the client. You can't have command and control at the tactical level when you're sitting in Luanda hundreds of miles away." This hands-on approach took its toll: some twenty EO personnel died in Angola from combat, training, and health-related problems.

EO's active combat involvement was most visible in the air. The firm's own pilots flew combat sorties in Mi-17 Hip-H helicopters and a Mi-24 Hind helicopter gunship, as well as in MiG-23 Flogger jet fighters. Most of the military equipment was purchased and supplied by the contracting government, often on EO specifications. EO itself only brought in specialized items such as secure communications, interception and navigation equipment.

Building on their intimate knowledge of UNITA's weaknesses and the terrain, very probably through operations conducted earlier on behalf of apartheid South Africa's army, which had supported UNITA, the EO operatives soon managed to deal a devastating blow to the rebel forces, driving them from the diamond mining areas of Cafunfo, once again from the oil installations at Soyo, and from most major towns and cities, including their Central Highlands stronghold of Huambo. During the campaign, many hundreds of UNITA members lost their lives, not least because they were confronted with the deployment of sophisticated and ruthless anti-personnel weapons such as cluster bombs and Fuel-Air Explosives (FAE), nicknamed "the poor man's atom bomb". FAEs break open upon hitting the ground, create a mist of flammable liquid, and, upon ignition, deliver a tremendous blast with enough pressure to destroy any equipment in a large area and kill all living beings within a square-kilometer.

Realizing that his forces faced annihilation on the battlefield, UNITA leader, Jonas Savimbi, was forced to make major concessions, which resulted in the signing of a peace accord (the Lusaka protocols) in November 1994. In 1995, the actual demobilization of both rebel and government forces remained problematic, but in January 1996 the last three hundred South African "military advisors" formally left the country.

The Angolan government was under heavy pressure from the US government at the time. In December 1995, President Bill Clinton threatened to withhold US financial aid if Executive Outcomes' "mercenaries" remained in the country. EO's position was partly taken over by another "military consultancy company", Military Professional Resources, Inc. (MPRI).[4] Based in Alexandria, Virginia, near the Pentagon, MPRI had been set up by retired US generals, led by Ret. Lt. Gen. Harry E. Soyster, former director of the Defense Intelligence Agency (DIA), and manned by former employees of the US military and the CIA. MPRI's acquisition of the Angolan contract was due to the mediation of Herman Cohen, advisor to the former US undersecretary for African Affairs. The US government's moral aversion to mercenaries did not extend to MPRI.

It seems reasonable to conclude that politico-economic considerations played a more significant role in US actions than altruism. While EO had provided the Marxist-oriented Angolan MPLA government with professional (nonpolitical) military services irrespective of that government's political orientations, its replacement by an American Pentagon-oriented mercenary force represented more than just another instance of a profitable service contract being secured for a US firm through intervention by US officials. In the mid-1970s the US, through the CIA, had tried to overthrow the MPLA government with its puppet "liberation movement", the FNLA, and later with the UNITA, which had originally been set up by the CIA. The new US-mediated contract may have effectively limited the ability of the Angolan government to enforce its policies in any manner contrary to American interests by removing its access to a reliable military force, thereby removing the need for any further American impetus toward regime change. That EO may have generated lucrative business ventures in tandem with its mercenary activities (see below) would not necessarily have interfered with its responding as requested to the policy intentions of the Luanda government.

## NEXT STOP: SIERRA LEONE

Executive Outcomes' success in Angola won headlines in *Newsweek* and other international media. African heads of state quickly picked up the vibes. In 1995 in the troubled state of Sierra Leone on Africa's west coast, military ruler, Captain Valentine Strasser, was easily convinced that EO was the only instrument that could save his government. It had lost control of most of the country and was beleaguered by rebel forces which had come within 30 kilometers of the capital, Freetown.

The trouble in Sierra Leone had begun in March 1991, when the Revolutionary United Front (RUF) launched an offensive from neighboring Liberia to overthrow the Sierra Leonean government led by President Joseph Momoh. Although Momoh was subsequently ousted in a coup led by Captain Strasser in April 1992, the RUF continued its insurrection against Strasser's National Provisional Ruling Council (NPRC). The civil war would last at least five years, during which an estimated 1.2 million of Sierra Leone's pre-war population of nearly 4.5 million would be displaced by fighting, with some 800,000 in need of emergency food and assistance. In addition, over 300,000 inhabitants fled the country as refugees. Nearly 15,000 people were killed in the conflict. The NPRC reacted to the insurgency by boosting the armed forces from approximately 3,000 to 16,000 troops between 1991 and 1994. However, morale remained low—likely an indicator of the unpopularity of the Strasser regime, and its Momoh predecessor—and military effectiveness was negligible.

The Heritage Oil & Gas company, which first brought EO into Angola, and the Branch Energy mining firm, which turned out also to have been founded by Anthony Buckingham, managed to convince President Strasser to bring in Executive Outcomes. Buckingham agreed to bankroll EO's operation in Sierra Leone in exchange for future mining revenues.[5] Khareen

Pech, a South African journalist who has written extensively about Executive Outcomes, said EO's cost for supporting the roughly 500-man fighting force in Sierra Leone was over US$1.5 million a month, and its bill to the government probably more than twice that.[6] With the Angola experience behind it, EO's performance in the unfamiliar region turned out to be even more impressive than in southern Africa. Under the command of former SADF Colonel Andy Brown, it mounted a full-scale counterinsurgency campaign.

The amenities had improved. This time, there was more than just one Mi-24 gunship. EO itself purchased several Mi-17 transport helicopters for operations in Sierra Leone, as well as two Boeing 727s as supply planes, bought for US$550,000 each from American Airlines. EO pilots flew the now familiar MiG-23 jet fighter-bombers, and a squadron of Swiss Pilatus training planes were converted to fire air-to-ground rockets. EO's involvement in actual combat operations was also less disguised: journalists had no difficulty locating EO personnel around Freetown's bars and nightclubs who would openly boast that they were fighting on the front line. Military observers estimated that EO-led forces in the Sierra Leone conflict killed between 400 and 600 "rebels". EO's losses remained limited to only two South Africans who were killed in an ambush, plus about one dozen wounded in action.

In January 1996 dictator Strasser was deposed in turn by his deputy, Brigadier-General Julius Maada Bio, in a bloodless palace coup which, according to several local sources, was masterminded by Executive Outcomes. Representatives of the NPRC and the RUF negotiated a deal involving presidential elections for a civilian government. In March 1996 Alhaji Ahmad Tejan Kabbah was elected president of Sierra Leone in the first free elections since 1967. Six months later, in September 1996, the government came under pressure from the International Monetary Fund to cut public spending, and was forced to negotiate a reduction in the amount it paid EO. Finance Minister Thiamu Bangura told reporters that the government owed the company US$18.5 million in back pay, but that an agreement had been reached to cut down the monthly payments to EO from US$1,225,000 to below $1 million. In February 1997, the last planeload of Executive Outcomes personnel officially left Sierra Leone. Some EO personnel remained in the country in various capacities, notably to provide security to a number of mining companies, for which purpose EO had established a civilian company called Lifeguard.

Journalists in Sierra Leone reported that in areas such as the diamond-rich eastern district of Kono, many people were not happy to see the South Africans go. They had little confidence in government forces and feared that the relative calm would soon be disturbed again by rebel violence. Reporters were approached by tribal chiefs and foreign entrepreneurs, and also by people in the streets who expressed their eagerness to see the South Africans return again to guarantee their security, even at the cost of millions of dollars a month. A worried senior military officer explained that there had been rebel attacks on more than ten villages in the southeast and north of the country since the 30 November 1996 peace accord was signed between President Tejan Kabbah and Alfred Foday Sankoh, the leader of the

RUF. The situation remained far from stable. In late 2000, former South African military intelligence officer, Johan van Zyl, who had worked for Lifeguard in Sierra Leone, accused the company of supplying rebels with arms at the same time Lifeguard was under contract to Branch Energy to protect its diamond mining operations in Sierre Leone.[7]

## PAPUA NEW GUINEA: NIGHTLY TOUCHDOWNS IN BOUGAINVILLE

Well-hidden from most international press services, the small island of Bougainville, situated in the Solomon Sea northeast of Australia, has presented the Papua New Guinea (PNG) government with a crisis it has been unable to resolve. Papua New Guinea achieved independence from Australia in 1975 and enjoyed relative calm and prosperity. The Bougainville conflict began in late 1988 when the island population rose to protest the exploitation of the island's copper and gold mines, for which the locals saw few returns. The government's violent and stubborn handling of the crisis led to an escalation, and in 1989, to a state of emergency. Successive PNG governments have employed diverse strategies to deal with the Bougainville Revolutionary Army (BRA) insurgents. While the Bougainville secessionists have been treated as a band of criminals, the army has never managed to suppress them.

In September 1996 the insurgents took five soldiers hostage, confronting the government with an acute and embarrassing dilemma. Leading figures began to lobby for an unconventional and vigorous "solution" and suggested hiring the, by now, notorious South African Executive Outcomes group. That summer, the Australian press had already hinted at a possible EO involvement in Bougainville. Confronted by ABC radio on 4 August with the question of whether his company would be interested in getting a contract on Bougainville, EO spokesman Nick Van Der Bergh replied that if they got an invitation from the government or a private mining company, they "would surely be glad to go in and have a chat with these guys."

On 23 February 1997 the first Australian press report of actual EO presence on the island appeared. The *Weekend Australian* newspaper, quoting senior PNG government officials and independent sources, reported that the cabinet had approved the hiring of Sandline International, a subsidiary of the British-registered company, Executive Outcomes, to plan and execute a "surgical strike" against hard-line rebel leaders in central Bougainville. Initially, the PNG government refused to talk about any mercenary presence. PNG Prime Minister Sir Julius Chan would only say that the Defence Force needed to be upgraded consistently and had previously been given special squad training by United States paratroopers. The Australian press pursued the matter, stating that, during the past two weeks, up to 150 mercenaries had been flown to Wewak in two Russian military cargo aircraft flying under the flag of Bulgarian Air Sofia, and were now in training. A photo of an Air Sofia plane at Nadzab airport near Lae (PNG) later appeared in the Australian press.

On 24 February Prime Minister Chan admitted to hiring between 30 to 40 private military personnel from a reputed private security company and

explained that some of the advisers would go to Bougainville with the soldiers they were training. He told the press that the twelve-month contract and the purchase of various "equipment" would, together, cost more than US$30 million, and assured them that the advisors would certainly not be involved on the front line. Later, Mr. Chan told Australian reporters that the government had been trying to recruit a group for the past 18 months. Executive Outcomes itself then confirmed it had been sub-contracted to train security forces as part of a strategy for a lasting solution to the Bougainville situation. Clearly, a developing-country government did not want to come straight out and state it had hired foreign military specialists to solve its internal problems, a solution that smacked of colonialism.

Critics described the government's move as a desperate political gamble to seek a quick fix to the civil war before the national election in June, which would, to the contrary, form a serious threat to the peace process. Probably to disguise the involvement of EO, leaks appeared in the press suggesting that the deputy prime minister, Chris Haiveta, had approached the chairman of a company called North Fly Highway Development Company Pty. Ltd. In January 1997 a company he referred to as "Roadco", had been nominated as "the vehicle by which the government's program of implementa-tion will be coordinated and financed." The government's ongoing effort to disguise the insertion of EO into the conflict reflected their desire to avoid "technical complications" if the World Bank and the International Monetary Fund found out that certain loans were being used for something that was not part of the agreed conditions in the structural adjustment program. Indicative of this, Haiveta's leaked letter to North Fly gave instructions for a subsidiary ledger to be created to account for all monies received and expenditures incurred for the specific assignment. Journalists soon discovered that the North Fly Highway Development Company did not legally exist, since it was deregistered in March 1996.

It is widely assumed that the US$30 million needed to finance what was in fact a "Sandline" (*i.e.*, Executive Outcomes) operation was to be drawn from the Orogen Minerals company, a state-backed resource development company that went on the Stock Exchange in 1996. Reacting to these revelations, a constitutional lawyer at the University of Papua New Guinea commented that since parliament had been kept uninformed, the Chan/Haiveta government had probably breached the criminal code and the national constitution, which forbade the raising of unauthorized forces.

Human rights activists, meanwhile, pointed out the PNG Defence Force's bad human rights record. Amnesty International reported an increase in unlawful killings and disappearances, asserting that, in the last year, the PNG Defence Force and the government-backed paramilitary were responsible for the unlawful killing or disappearance of 44 people on Bougainville, while their opponents, the Bougainville Revolutionary Army, had committed at least 36 arbitrary killings since 1993. The human rights group said the PNG Defence Force refused to hold its soldiers responsible for their actions, thus creating a cycle of impunity.

The Australian foreign minister, Alexander Downer, expressed his opposition to any use of foreign soldiers in the Bougainville conflict. He rejected claims by the PNG government that Australia had been told about the plan to hire mercenaries, and warned that the A$320 million-a-year bilateral aid program would be at risk if it was confirmed that the Chan government was employing mercenaries. The British government also made plain its disagreement with the plan, and added that British citizens recruited as mercenaries could be referred to prosecuting authorities if any evidence came to light. IMF official, Stanley Fisher, appeared on Australian television to say that loans to PNG might have to be reviewed in light of the mercenary-use allegations.

Off the record, Australian defense officials said they became aware of the PNG government's plan two weeks before the news broke in the *Weekend Australian* newspaper through radio messages intercepted from PNG territory. Australia's top intelligence analysis body, the Office of National Assessments, had provided a report to Prime Minister John Howard confirming that an advance party of more than 30 mercenaries had landed in PNG—60 mercenaries, according to *Asia Online*.[8] The cabinet prepared a range of preventive measures, including winding back the $11.8 million ($US9.0 million) defense cooperation program, but then decided that a public outcry over the plans would discourage both the mercenaries and the PNG government from proceeding with the operation, making Australian sanctions unnecessary. *Intelligence* sources suggested that the PNG government's move followed resentment over Australia's refusal to provide electronic intelligence to back an operation to capture or kill rebel leaders by using satellite technology to pinpoint the source of BRA radio broadcasts.

In spite of the criticism at home and the threats made by the Australian government and others, the PNG government refused to back down. On 26 February, the *National* newspaper at Port Moresby (PNG) wrote that a high-level PNG delegation led by Defence Force Commander, Brigadier-General Jerry Singirok, was in Singapore for the purchase of two helicopter gunships with the help of military consultancy firm, Sandline International. Defence Minister Mathias Ijape also confirmed that Sandline International personnel had been training at the Urimo training ground on the outskirts of Wewak town in East Sepik province since they arrived in late January.

The PNG government's recalcitrance did not remain unchallenged. In the first week of March, PNG Prime Minister, Sir Julius Chan, came under further pressure when Australian press sources revealed that he and members of his family were major shareholders in a security company run by two Australians, who were accused of hiring and arming Australian police and former anti-terrorist soldiers to work in Papua New Guinea to deal with hostage incidents and other security problems.

## HAVE GUN—WILL TRAVEL

Press reports indicate that Executive Outcomes built up contacts over the previous decade in many countries, mainly in Africa, thus explaining

the frequent sightings of white South African "advisors" in many African capitals. EO advisers were reported in Kenya, where they are believed to have formed a partnership with Raymond Moi, a son of President Daniel Arap Moi. The company is said to have provided personnel to protect Canadian oil interests in the Sudan (the Canadian mining company was since forced out by a determined public campaign in Canada which marshaled surprising support throughout the country, due in no small part to its facilitation by the Canadian media, which was very moved by the possibility of human rights abuse in Islamic Sudan). Executive Outcomes itself remained most discrete about its possible clients, and solid evidence of EO military activities elsewhere in Africa remained hard to find. According to one press report, the company had served approximately twelve countries, about 70 percent of which were African. EO operatives present during the campaign in Sierra Leone were spotted in Zaire, although Barlow strongly denied sending men to join a mercenary force helping the Zairian army against rebels in the east. He explained on Voice of America that his company trained the Angolan armed forces, while "for years, Zaire was offering safe haven to UNITA itself, as well as providing them with training camps. That could be the thinking why Zairian authorities have not yet entered into any debate with us, or even made any approach toward us." He further elaborated that a number of mercenary outfits had (wrongfully) claimed to be part of Executive Outcomes, and that they had been reported to the proper authorities (which would presumably have been South Africa's Brand Forgeries Bureau).

In the increasingly volatile "have gun—will travel" environment, it seems quite possible that people who once worked for EO would later surface in another war and under another logo. In early January 1997 the French press reported that hundreds of European mercenaries were massing in eastern Zaire to mount a counter-offensive against Rwandan-backed rebels. *Le Monde* wrote about a so-called "White Legion" of between 200 and 300 mercenaries who were recruited in part by Colonel Alain Le Carro, former head of the presidential guard under the late Francois Mitterrand. The French Defense Ministry described the mercenary force as a "private initiative" without government backing. Again according to *Le Monde*, a former French gendarme by the name of Robert Montoya was said to be supervising logistics for the operation. Mr. Montoya was identified as EO's intermediary in Togo, where he headed the company "Service & Security" and worked as an adviser to President Eyadema.

By the end of January, the senior foreign editor of the Paris daily, *Libération*, Steven Smith, reported that he had witnessed the arrival of about 280 mercenaries at Kisangani airport in Zaire. Among the men were sixteen Frenchmen, two Belgians, a number of Russians, Serbs, Croats, Poles and one Italian. Smith said the mercenaries had a small air force at their disposal made up of several jet fighters, plus at least four Mi-24 Hind gunships and a half-dozen Puma and Gazelle helicopters. The Belgian daily, *Le Soir*, published an interview with Christian Tavernier—the man believed to be leading the mercenaries—who claimed that his men were involved in a training and logistics operation in support of the Zairian army.

Some months earlier, in September 1996, the South African Foreign Affairs Minister, Alfred Nzo, publicly stated that he had information on EO support of an insurrection in Burundi. *Soldiers of Fortune* magazine reported in its October 1996 issue that EO had been involved in fighting in Uganda since at least 1995, when one of its senior directors died in an air crash "while reconnoitering front-line areas near the Sudanese border." There were also other reported sightings of white South Africans in the area, believed to be involved in training the Burundian Hutu guerrilla "Force for the Defence of Democracy".

From the above portrait of Executive Outcomes and its activities, it's possible some Westerners might perceive the organization as a real-world variety of International Rescue with no strings attached: a powerful and bold NGO dedicated to bringing peace and stability for a price. This is, indeed, the image that the PR-sensitive spokespersons of EO were anxious to present to outsiders: that EO's South African past may be a trifle shady, but in this post-Cold War era, old sensitivities need to be put aside for new challenges to be taken on. In a number of interviews in popular magazines, EO operators were portrayed as tough and cocky but sensible characters who are genuinely moved by the gratefulness of the population in the areas they "liberated". They were portrayed as providing comfort and aid to civilians in need, and attention was drawn to their having flown child soldiers back to their home villages where they could take up their lives again. This, no doubt, is part of the truth. But as soldiers for hire, it remains the case that their insertion into conflict areas is based on a client's willingness and ability to pay, rather than on the rectitude or legality of their causes.

## A LABYRINTH OF MILITARY-CORPORATE LINKAGES

The hub in the wheel of Executive Outcomes was a holding company called Strategic Resources Corporation (Pty.) Ltd. (SRC), which appeared to be the umbrella structure covering dozens of separate corporations with ever-changing names. Barlow, Luitingh and Nicolaas Palm (EO's financial manager in 1994) were board members of SRC. The holding had a number of hi-tech companies among its subsidiaries, such as Advanced System Communications (supplying telephone networks, radio and satellite systems), Applied Electronic Services (counter-intelligence equipment), Aquanova (applied hydrogeologic and geophysical research) and Bridge International (civil engineering, agrarian consultancy and humanitarian aid). Other subsidiaries, such as OPM Support Systems (consultancy on investments, tax and juridical matters), Trans Africa Logistics (import-export and transport arrangements), and Ibis Air provide auxiliary services to SRC and EO companies. Ibis Air International is registered in the Bahamas and has its main office on Guernsey, with branches in Johannesburg, London, Malta, Luanda and Freetown.

Strategic Resources Corporation also had a base in Lynnwood, Pretoria. Bank documents dated March 1995 and obtained by journalist Khareen Pech show SRC South Africa to be the holding corporation for a string of companies including the Saracen security company, Falconer

Systems, a provider of logistical supplies to "United Nations-related organizations," and (once again) Bridge International, specializing in construction and engineering. Press reports also mention yet another holding, "Crossed Swords", on which no further information is available. Faithful to the lessons learned while setting up front companies in the 1980s for the pro-apartheid military, Barlow changed his corporate structure so often that a French intelligence source had to admit to a journalist: "We simply cannot keep up with them." Documents circulating in government circles tallied about fifty companies associated with SRC since its founding, and the company was said to have built contacts in at least 34 mainly African countries.

Some surprising convergences occurred at 535 King's Road in Chelsea, London SW 10. Here, journalists located the offices of the Heritage Oil & Gas company, DiamondWorks, Ibis Air International, and Sandline International. A list of company and staff names, dated September 1994, further included Executive Outcomes Ltd, Branch International Ltd., Branch Mining Ltd. and Capricorn Systems Ltd. The key resident at 535 King's Road is Anthony Buckingham, chief executive of Heritage Oil & Gas, which was originally a British company, but is now incorporated in the Bahamas. Buckingham is also a director of the publishing company, Fourth Estate, in which the *Guardian* newspaper holds fifty percent of the shares. Other directors and staff operating from the King's Road offices include Simon Mann, Sir David Steel, and the South African director of Ibis Air, Crause Steyl. Branch International is believed to be the holding corporation for a string of subsidiary companies involved in the gold, diamonds and oil businesses. Sir David Steel was a former Liberal Party leader who is said to maintain close business and private relations with Buckingham. Capricorn Systems is believed to be a descendant of the Capricorn Society, which was established in Rhodesia shortly after the Second World War by the founder of the Rhodesian Special Air Service (SAS), Sir David Stirling, who passed away in 1990. Capricorn Air was the owner of the two Beechcraft King Air light aircraft which EO initially used in the Angolan operation to maintain logistical contacts with its South African base near Johannesburg. This outfit later grew into Ibis Air, also operating from Johannesburg airport.

In interviews, Barlow maintained that there were no direct ties between Executive Outcomes and Buckingham's business empire. He specifically denied any links between EO and Branch Energy (BE), registered in the Isle of Man, and claimed that all relations with Branch Mining were severed in late 1995. He told reporters he made his first contact with Buckingham in October 1992, when Buckingham approached him as manager of Heritage Oil & Gas, seeking to protect the company's commercial assets in Angola. Buckingham, in turn, has been at pains to deny any "corporate link" between his businesses and Executive Outcomes. However, a top secret British intelligence document circulating among journalists in London, of which the authenticity has not been verified, notes that "Executive Outcomes was registered in the UK on September 1993 by Anthony (Tony) Buckingham, a British businessman, and Simon Mann, a former British officer." Buckingham is actually also a veteran of the Special Air Service (SAS), and Mann is a

former troop commander in 22 SAS regiment with a solid intelligence expertise. Both reputedly maintained close connections to the British Secret Intelligence Service (MI6).

In January 1997 Canadian researchers dug up a connection between Executive Outcomes, the Branch group, and Buckingham. The Vancouver-based mining company, DiamondWorks Ltd., publicly acknowledged that its largest shareholder, Anthony Buckingham, acted as an intermediary for Executive Outcomes. In a prospectus filed with Canadian securities regulators, Mr. Buckingham was described as providing introductions for Executive Outcomes to governments and advising these governments on their commercial relations with the group. EO's activities in Sierra Leone were coordinated by Branch Energy, with security operations run by EO and commercial elements run by a South African, Alan Paterson. According to DiamondWorks' due diligence filing, Mr. Paterson was the "Regional Manager, West Africa" in Sierra Leone for Branch, which DiamondWorks took over. Former EO senior officer, J. C. Erasmus, became Branch's "Angola Manager".

The close connections between BE and EO were obvious to observers in Sierra Leone. On 7 July 1996, for example, journalist Khareen Pech noted in a *Sunday Independent* article that everybody in Freetown reportedly knew that the contracts with Branch Energy and Executive Outcomes had been closed by the same people. Soon after the rebel forces were driven out of the Kono diamond mining region, Branch Energy negotiated substantive concessions in which EO had a major stake. In August 1996 the Canadian mining company, Carson Gold, bought BE's assets in Angola and Sierra Leone for US$50 million. In October, the company was renamed DiamondWorks Ltd, and former BE senior executive, Michael Grunberg, became one of its directors. Mr. Grunberg immediately signed a contract with the Lifeguard security company to protect its assets. Lifeguard was a sister company of EO. Mr. Grunberg, too, had offices at 535 King's Road.

As in Sierra Leone, EO kept a strategic presence and lucrative interests in Angola. Although EO officially left the country in January 1996, press reports speak of stay-behind activities through SRC subsidiaries such as Saracen International security and OPM, which worked on the privatization of Luanda's airport. Mr. Hennie Blaauw, former SADF operative, expert in military intelligence and part of EO's nucleus, was with Branch Energy Angola, which held highly profitable prospecting rights at that time. In January 1996 EO's spokesman Nico Palm confirmed that while EO itself had completely withdrawn from the country, some "business units" remained in Angola.

The Branch group's activities do not remain limited to the former battlefields of Angola and Sierra Leone. In December 1996 the Sierra Leonean newspaper, the *Statesman*, wrote about BE, which had earlier signed an US$80 million diamond deal with the government in Freetown. The paper explained that while BE had sold its diamond interests to DiamondWorks, it was now suspected of smuggling gold from Uganda. The smuggling was allegedly carried out by large aircraft that used BE's Ugandan airstrip at night. As a result, a Ugandan parliamentary committee had requested a government investigation into BE.

Buckingham appeared to have substantial interests in Uganda. According to *Business Day* newspaper of 17 January 1997, Buckingham's Kampala Branch Energy had a joint venture with Uganda for the exploitation of gold reserves at the Kidepo National Park. Major-General Caleb Akandwanaho, alias Salim Saleh, a half-brother of Ugandan President Yoweri Museveni, was said to own 25 percent of the shares. *Business Day* referred to intelligence sources that said Mr. Saleh was supplying weapons to Rwanda and Burundi. According to the newspaper, he also supplied Branch Energy and Mining and two SRC partners with import licenses for technical and military hardware. Mr. Saleh was said to hold 45 percent of the shares in one of these partners, Saracen Uganda.

## THE IMPLICATIONS OF MERCENARY AND RESOURCE CORPORATIONS' INTERPENETRATION

Even after pulling all the strings together, the exact business relationship between the Executive Outcomes group and the Branch group remains somewhat obscure. Branch got EO into Angola and Sierra Leone, and, to all accounts, paid EO's bills in the latter country since the government was always short of cash. It can also be assumed that the people behind EO held a substantial amount of shares in Branch group companies. One recent press report asserted that EO held a 60 percent interest in Branch Energy Angola during the Angola campaign. The position of Buckingham, and the relevance in this context of his presumed British intelligence contacts, could be crucial to the understanding of exactly who controls Executive Outcomes and its strategic affiliates.

Most of the press coverage of Executive Outcomes was understandably focused on the military aspect. Yet, to understand its full significance and economic ramifications, one only had to look at the business deals that went on behind the closed doors of the 535 King's Road offices. Unfortunately, accessing such information would require a full-blown infiltration job of which few intelligence services, let alone investigating journalists, would be capable. In this context, people of Eeben Barlow's caliber can be trusted to be formidable adversaries.

In 1995 British Ministry of Defence (MoD) officials warned their government that the mining companies and mercenary armies controlled by businessman Anthony "Tony" Buckingham were likely to create havoc in Africa. Their blunt prediction was contained in an intelligence memorandum prepared by the Defence Intelligence staff. The memorandum (file number DI (ROW) / Hd A3 /12) examined the activities of Executive Outcomes, ostensibly created by special forces veterans of the former South African apartheid regime's army based in Pretoria, and shows that prior to that, a British company called Executive Outcomes was first registered on 7 September 1993 at Alton, Hants., by the very wealthy Tony Buckingham and a former Rhodesian SAS intelligence officer, Simon Mann, currently Lieutenant Colonel Tim Spicer's deputy chief executive at Sandline International.

Sandline and Executive Outcomes have always publicly maintained that they were rival companies, locked in friendly competition to provide soldiers of fortune for established pro-British governments who needed a little extra help to overcome anti-democratic domestic rebels. In reality, there were not one, but two companies called Executive Outcomes. One was domiciled in luxurious offices in Pretoria, whose directors are Lafras Luitingh and Nico Palm, who each own 50 percent of the shares.[9] The Andrew report, which investigated the companies on behalf of the government of Papua New Guinea, added that the directors and only shareholders of the British Executive Outcomes, which is registered in Hampshire, are Mr. and Mrs. Eeben Barlow. The daily work of all three companies appeared to serve the business interests of Buckingham, whose other interests were described above. According to the Andrew report: "There is a strong inference that Sandline Holdings Limited may be something of a joint venture between the interests of Mr. Buckingham and the interests of Mr. Barlow and Executive Outcomes. The information provided by Sandline Holdings that they are entirely separate from Executive Outcomes cannot be correct, but the exact nature of their relationship seems clouded behind a web of interlocking companies whose ownership is difficult to trace".

On 24 April the National Investigation Service of HM Customs—the intelligence arm of which is charged with combating the illegal export of arms—raided an undisclosed address in Guernsey, according to the *Observer* (10 May 1998). This followed similar raids on Sandline's business premises and on its chief executive's home and current residence, which occurred on 3 April. Spicer's boss, Tony Buckingham, is named as chairman and chief executive of Plaza 107, a British military consultancy (registration number 2941555) which recommended Sandline and Lt. Col. Spicer to the government of Papua New Guinea (PNG) to put down a revolt on the island of Bougainville. Buckingham and Spicer met PNG's top military men in Cairns, Australia, in April 1996, to set up the deal, which was brokered by Rupert McCowan of the Jardine Fleming bank. In January 1997 Plaza 107 director, Michael Grunberg, drew up a contract, according to the Andrew Commission's report. As part of his fee for the job, Buckingham hoped to gain control of the fabulously rich Panguna copper mine for his company, Branch Energy, which shared premises with Sandline at 535 Kings Road, Chelsea. Sandline's part in the abortive deal may have earned the company $22.5 million, but it ended in fiasco with Spicer's imprisonment for illegal arms possession and the company's expulsion from the country.

Buckingham, who had previously dismissed suggestions that he was an active mercenary as "fantasy", was the authorized signatory of a Sandline Holdings bank account into which the PNG government paid $18 million, according to Alex Renton, writing in the *Evening Standard* (8 August 1997). The other signatories on the Hong Kong account (n. 600774426, Hong Kong and Shanghai Bank, 1, Queens Road, Central, Hong Kong) were Simon Mann of Sandline and the two South Africans, Luitingh and Barlow, the former a principal shareholder in the Pretorian Executive Outcomes, the latter in its British shadow company.

While Buckingham was negotiating military intervention by Sandline on the other side of the world, the MoD's analysts were worrying about his activities in Africa. They were particularly concerned about a decision by President Tejan Kabbah—restored to power in March after the coup orchestrated by Lt. Col. Spicer—to hand control of Sierra Leone's Monkey Mountain at Koidu, site of the world's richest diamond mine, to Executive Outcomes. The MoD's analysts noted that Buckingham's mining company, Branch Energy, had hired Alan Patterson, formerly head of De Beers' operations in Sierra Leone, to exploit the mine. Branch Energy has since put the day-to-day running of the mine, in which Buckingham has invested £6 million, in the hands of another company which he controls, DiamondWorks.[10]

DiamondWorks shareholder Rakesh Saxena[11] promised Spicer $10 million for his countercoup provided President Kabbah promised to look after his diamond interests in Sierra Leone once he had been restored to power. According to Sandline's lawyers, the City of London law firm, S. J. Berwin, the deal had been approved by the British government. Such approval sat uneasily with Foreign Secretary Robin Cook's proclaimed commitment to an ethical foreign policy.[12] On the other hand, such approval fitted perfectly with the Foreign Office's mission statement as laid down by Lord Palmerston in 1848, a policy which Whitehall's mandarins have followed ever since: "We have no eternal allies and we have no perpetual enemies. Our interests are eternal and perpetual, and those interests it is our duty to follow." The MoD's watchers warned the British government in 1995 as follows:

> Executive Outcomes will dominate the security situation and may also control the bulk of the revenue-producing assets of Sierra Leone . . . There is a real danger that senior Executive Outcomes figures will become key power brokers, distorting attempts to return the country to some form of accountability... Their indifference to the social development of the country could easily foster rebellion, perhaps furthered by dissident groups outside the country... Executive Outcomes' widespread activities are a cause for concern . . . It appears that the company and its associates are able to barter their services for a large share of the employing nation's natural resources and commodities . . . On the present showing, Executive Outcomes will become ever richer and more potent, capable of exercising real power, often to the extent of keeping military regimes in being. If it continues to expand at its present rate, its influence in sub-Saharan Africa could become crucial.

The analysts' dire predictions were submitted to representatives of MI6, MI5, Defence Intelligence and GCHQ in the Joint Intelligence Organisation (JIO), based in the Cabinet Office. JIO functions as a clearing house which regularly collates dozens of such reports from all British intelligence agencies, and summarizes them for the Co-ordinator of Intelligence Security, the Prime Minister's personal advisor on intelligence affairs, whose job is to submit the information to the policy-makers on the

Joint Intelligence Committee (JIC), a watchdog with oversight of all covert matters touching British interests. Quite clearly, neither the JIC nor its political masters in the government decided to act to respond to the fears expressed in the Ministry of Defence document.

According to the *Sunday Times* (10 May 1998), Lt. Col. Spicer provided detailed tactical plans of the proposed counter-coup to an officer of the Defence Intelligence staff which prepared the original memorandum, a "Defence Intelligence staff report to defence secretary George Robertson". In it, Sandline is accused of shipping 35 tons of arms to Liberia, West Africa, in breach of UN resolution 1132, and of delivering the guns into the hands of the Nigerian military junta, whose appalling human rights record had been repeatedly condemned by Britain. According to the news report, the Foreign Office claimed that President Kabbah's restoration to power was a victory for Britain and for democracy in Sierra Leone, but it was actually accomplished by the Nigerian-led intervention force, ECOMOG, whose previous campaigns had been bywords for savagery. Critics, led in particular by senior officials in the US State Department, commented that as a result, Sierra Leone will now become a Nigerian puppet regime.

Sandline's lawyers also claim the company kept the British High Commissioner in Sierra Leone, Peter Penfold, fully informed of its role in the developing drama. Penfold, one of diplomacy's stormy figures, had already survived two coups in Uganda, a revolution in Ethiopia, and war in Nigeria. For four years, he had been Governor of the British Virgin Islands, where Sandline is incorporated.[13] Sandline is 100 percent controlled by Adson Holdings. Asked by Judge Andrew to identify Adson's shareholders during a Commission of Inquiry into Sandline's operations in Papua New Guinea, Lt. Col. Spicer refused to name them.

Ministry of Defence investigators ran into a similar wall of silence when they looked at Executive Outcomes' corporate structure in 1997. "The structure is far from clear," they complained. "It is possible that the Palace Group, whose directors are Buckingham, Mann and Michael Gunsberg, is the holding company for Heritage Oil and Gas, Branch Energy and EO, all of which are operating in Africa. Other associated firms are GJW Government Relations, Capricorn Air and Ibis Airlines . . . " GJW Government Relations is a political lobbying firm with excellent connections in Whitehall and the Palace of Westminster. Its senior director, Andrew Gifford, sits on the board of Buckingham's company, Heritage Oil and Gas. Ibis Air owns the Russian-built MI-17 and MI-18 HIP helicopters—capable of delivering bombs, torpedos and depth charges—which were given repair and refueling facilities aboard *HMS Cornwall*, a Royal Navy frigate, during Sandline's intervention in Sierra Leone.

Sandline company literature boasts that Ibis provides it with what amounts to a small air force, including Czech L-39 ground attack jets, Boeing 727 transports and a fleet of executive jets. Sandline provided and crewed a Russian MI-24 Hind helicopter gunship—widely used by the Soviets during the Afghan War—for the government of Sierra Leone. Another subsidiary, Alba Marine, sent a former Royal Navy gunboat and a fleet of fast launches to

Sierra Leone for landing operations. Like Executive Outcomes, Capricorn Air is ostensibly based in South Africa, but its registered offices are actually at 5 Warren Yard, Wolverton Mill, Milton Keynes, England. It is reportedly named after the Capricorn Africa Society, founded by the late Sir David Stirling as a British intelligence front. Stirling based his own mercenary companies on the offshore island of Guernsey. Capricorn had been accused by South Africa's National Intelligence Service of supplying 70 napalm bombs to the government of Angola during its war with Jonas Savimbi's UNITA rebels.

The MoD assessment sent to the Cabinet Office acknowledged that EO's dogs of war made victory over the Angolan rebels "quicker and more sure," it also linked Tony Buckingham's "apparently innocuous" mining interests directly to the financing of EO operations. These, it said, generated "substantial profits and disproportionate regional influence" for the mining magnate, who won diamond concessions and access to Angolan goldfields as a result. The MoD report noted that under the terms of the Lome Protocol, which was supposed to end the fighting in Angola, the use of foreign mercenaries became illegal under international law and indicated that mercenaries provided by Executive Outcomes had been concealed on the staffs of private industrial security firms operating in Angola.

If British intelligence can't unravel the complex network of interests and ownership surrounding Executive Outcomes, if the Royal Navy lets Ibis Air's Russian helicopters land and refuel on its decks, and if the MPLA Angolan government is proud of EO's contribution, one can seriously wonder if EO doesn't have its thumb in all the juiciest pies in Africa.

## SOME CONCLUSIONS

Concerning the military aspects, a tactical analysis of witness reports of Executive Outcomes' activities indicates that counter-insurgency operations conducted in a blitzkrieg fashion and supported by massive firepower has been the key to EO's military successes. Highly professional intelligence provided the multiplier compensating for limited numerical strength. Ground reconnaissance and aerial photography with state-of-the-art photo interpretation, communications intercepts, the use of tribal informants, prisoner interrogation and enemy asset analysis together enabled EO commanders to guide their troops to swift attacks on pinpointed targets, with crippling effects. This is the kind of warfare no African rebel force or army is prepared for, except the South African military. The use of sophisticated infrared and radio jamming capabilities enabled EO-led forces to conduct nighttime assaults, sowing confusion among the enemy. The *Armed Forces Journal* quoted a UNITA soldier in Angola explaining their defeat: "We used to know we could sleep well at night. In this recent war, new tactics meant that fighting continued at night and that light infantry units led by these Executive Outcomes guys would come from deep behind our lines. We could no longer rest. It weakened us very much. It is the new tactics in which they trained the FAA that made the difference. They introduced a new style of warfare to Angola. We were not used to this."

With the certainty that low intensity conflicts will remain endemic on the African continent, corporate mercenaries will probably continue to prosper. The demise of Apartheid ironically opened up the entire continent to the South African whites, who are accepted by African populations as no European or Yankee ever will be. EO's successes demonstrated that, in a situation where military might is customarily based on sheer terror exerted by paper tiger armies with severe maintenance problems and poor discipline, a small but highly-effective force can achieve almost anything. While some might like to think that this can mean peace and democracy where once repression reigned, this seems somewhat unlikely; it is more likely to be the repressors themselves who have the resources to do the hiring, with a view to stifling domestic dissent.

Looking deeper, it can result in an even more cunning theft of a country's natural riches than practiced during the colonial period, through the instrument of a mock government which sells out to an unaccountable corporate power. As long as African states cannot develop lasting democracies which enjoy the support of their domestic populations, organizations such as Executive Outcomes may rule supreme. Plans for a permanent stand-by intervention force, controlled by the African Union, and supported by the US, are unlikely to materialize. With the world community failures in Somalia, Chad and Liberia in mind, some argue that corporate mercenaries such as Executive Outcomes herald the privatization of international peace enforcement. They point out that in both Angola and Sierra Leone, the local population appeared enthusiastic about EO's presence, and that the South Africans didn't recruit child soldiers, didn't have to loot in order to eat, didn't hold the ethnic prejudices that have led to genocide and, when they left after three years, a democracy was left in place. While the human rights record of Executive Outcomes didn't attract much specific attention, there were accounts of EO officers who intervened to stop torturing and looting by government troops in Sierra Leone, which would appear a reason for hope.

On the other hand, references in several articles to the use of anti-personnel mines, cluster bombs and Fuel-Air Explosives, may indicate a higher level of indiscriminate violence than can be surmised from the press reports so far. When *Harper's Magazine* reporter, Elizabeth Rubin, questioned EO pilots, Arthur Walker and Carl Alberts, on their missions over the Sierra Leonean bush in 1995, they told her how the Sierra Leone military commander had advised them not to worry about distinguishing between rebels and civilians sheltering under the canopy of vines and trees. Instead, they were told to simply "kill everybody," which they did. Such stories were confirmed by Medecins Sans Frontières personnel. Martha Carey, an American hospital worker interviewed by *Harper's Magazine*, spoke of EO's pilots as indiscriminate and racist killers.

Perhaps the paramount question is: is peacemaking to be valued if it simply silences opposition and entrenches oppression? To many, the presence of mercenaries, even those of the relatively civilized EO variety, in fact only prove that whoever has the gold makes the rules. Dictators no longer have to worry about popular support: they can plunder and sell out their country. And, if violence erupts, EO will restore order for them as legitimate rulers.

Thus, from the point of view of foreign businesses which may prioritize a state's internal stability over social justice concerns, groups similar to EO could become a significant factor contributing to regime stability in Africa, considering that at least in theory, a ruling clique only needs to secure control over a country's mineral resources such as diamonds, metal ores or oil for a certain time span to be able to engage corporate mercenary services. Once the "legitimate government" of the day has secured the safety of its main sources of income with the aid of such an operator, the chance of its being overthrown by rebellious armed elements is considerably reduced compared to the classic situation in Africa in which a regime had to rely for its survival on clan loyalty and on being accepted by the cadres in the military forces.

There is a pragmatism in this new corporate colonialism. But while the government leaders of small, resource-rich countries can afford to hire corporate mercenaries' troops to quell domestic problems, we are unlikely to see corporate mercenaries operate in a region that's totally devoid of mineral resources. In EO's business philosophy, the presence of oil, but especially of gold and diamonds, was the best guarantee that ultimately the bill would be paid. Returning to the nineteenth century where private companies hired adventurers to secure deals, regardless of state interests, corporate mercenaries represent the ultimate of neo-liberalism: defending free enterprise without country or kingdom, with arms in hand, on a for-profit basis. In this sense, Executive Outcomes, MPRI, Stuart Mills International, Alpha Five and other private mercenary armies discovered in Iraq recently represent the logical outcome of corporate capitalism. Africa has known large corporations surviving for over a century as well-protected profit islands in an environment of general instability and deprivation. In French-speaking regions, it has always been difficult to distinguish between the interests of the French state and corporate enterprises such as Elf. The trend now is for private corporations to eschew the intermediary role of neo-imperialist governments, and actively reach out to "establish" compliant governments that will then make their decisions with an eye first on corporate interests. Instead of a country's citizens having a primary claim on their governments, as those to whom its primary responsibilities are owed, foreign shareholders become the real beneficiaries of sovereignty.

## SHUTTING DOWN MEDUSA

After officially having been "legislated out of existence" by the ANC-dominated government of South Africa in 1998, one can even wonder if Executive Outcomes has really disappeared. On 18 November 2002, a strange appeal was issued in South Africa by Raymond van Staden:

An urgent appeal is being made to mainly African governments and their representatives in South Africa to go to the police with information about bogus companies that fraudulently obtain multi-million rand contracts by posing as the military advisory company, Executive Outcomes, that closed its doors in 1998.

The appeal is being made by the sole remaining director and owner of Executive Outcomes, Mr. Nico Palm."[14]

That was indeed a very strange announcement for a company which "closed its doors in 1998" but still has enough marketability to win contracts from African governments. With a full-scale civil war in the Ivory Coast, and several other minor armed conflicts smoldering on the continent, there is— and there will remain—a market for mercenaries.

But as for keeping track of who they are, and whose interests they represent—it's a virtual hall of mirrors.

# Endnotes

## Introduction: *Intelligence* and the ADI

1    See "Western Europe: WEU Intelligence Problem Is 'US', Not The U.S.", INT, n. 306 1.
2    INT, n. 288 40.
3    See "France: Rocket-Ramjet Propels US Cooperation", INT, n. 262 43
4    See "France: US NIF Trouble Spells Trouble for Megajoule", INT, n. 303 33.
5    INT, n. 259 51.
6    INT, n. 270 49.
7    INT, n. 251 10, n. 264 49, n. 267 42, n. 268 2, n. 271 47, n. 274 53, and n. 286 54.
8    "Open source intelligence" is not just press clippings from the major media but also includes analysis and surveillance of scientific literature, the alternative or even underground press, court cases, public discourses and even filings for patients.
9    See "USA: DataNet Sets the Pace in Internet Security", INT, n. 304 1.
10   INT, n. 410 7.
11   See document "SHAEF/C1/30X", dated 7 June 1944 and signed by H.G. Sheen, Chief Counter-Intelligence Officer, G-s Division, Supreme Headquarters Allied Expeditionary Force, and Commandant Palliole, Head of the Service de Securite Militaire [*sic*].
12   Fabrizio Calvi and Olivier Schmidt, *Intelligences Secrètes: Annales de l'Espionnage*, Hachette, Paris, 1988,  309 pp.
13   INT, n. 323 2.

## Chapter One:  Car-bombed Environmentalists and the FBI: COINTELPRO Resurrected?

1    *San Francisco Chronicle*, 11 June 2002.
2    INT, n. 277 12.
3    INT, n. 277 12.
4    INT, n. 306 13, n. 320 1.
5    INT, n. 306 13.
6    INT, n. 49 10.
7    INT, n. 299 10.
8    *San Francisco Chronicle*, 11 June 2002. Other sources include: *Sacramento Bee*, *SF Gate News*, *IMC/SF*, *Arm the Spirit*, *Press Democrat* (Santa Rosa, CA), *Oread Daily*, and, especially, http://www.judibari.org/.
9    Jim Herron Zamora, "FBI to Pay $2 Million In Earth First! Suit. Activists were arrested, called eco-terrorists after bomb exploded in their car", *San Francisco Chronicle*, April 23 2004.

## Chapter Two:  The Secret History of the Wildlife Conservation Movement

1    C.A.W. Guggisberg, *Man and Wildlife*, 1970, Evans Brothers Ltd., Montague House, Russell Square, London WC1; foreword by Dr. F. Volmer, Secretary-General of the World Wildlife Fund; title page endorsed "Recommended by The World Wildlife Fund".
2    Canadian Royal Commission on Aboriginal Peoples, 1994.
3    See http://www.sis.pt/historia/pide-dgs.htm. In English, see Henrik Kruger, *The Great Heroin Coup:  Drugs, Intelligence and International Fascism*, South End Press, 1980; and Tom Gallangher, "Controlled Repression in Salazar's Portugal", *Journal of Contemporary History*, 14, July 1979.  Original documents can be found at the pide-dgs website and in Frédéric Laurent, *L'Orchestre Noir,* Stock, Paris 1978, as well as at http://web.tiscali.it/almanaccodeimister/sentenzaordinanzapiaza Fontana.htm the document "LiAttivita'di Guerin Serac e dell'Aginter Press" (Italian court document, in Italian.)

4  John Stockwell, *In Search of Enemies: A CIA Story,* W. W. Norton, 1978. Stockwell was the chief of the CIA Angola Task Force and worked directly with Henry Kissinger.

5  J. Larteguy, "Jonas Savimbi–comment j'ai vaincu les Russes d'Angola", *Paris-Match,* 8 March 1988. See also S. Ellis, "Defense d'y voir; la politisation de la protection de la nature", http://www.politique-africaine.com/numeros/pdf/048007.pdf.

6  Raymond Bonner, *At the Hand of Man: The White Man's Game,* Vintage Books, 1994, and particularly "Prince Bernhard and the World Wildlife Foundation (WW)", pp. 66-71. See also http://www.panda.org.za/article.php?id=261.

7  Bonner's work did appear in the US in 1994, see note 6.

8  INT, n. 323.

9  INT, n. 323. The figures were provided by the Truth Commission in South Africa.

10  For general information on British imperialism related to Africa and the conservation movement, see J. Macgregor, "The Paradox of Wildlife Conservation in Africa", *Africa Insight,* vol. 19, n. 4, 1989, pp. 201-212; J. MacKenzie, *The Empire of Nature: Hunting, Conservation and British Imperialism,* Manchester & New York: Manchester University Press, 1988.

## Chapter Three: Switzerland: Anti-Money Laundering and Domestic Surveillance

1  INT, n. 392 18.

2  "Switzerland: 'Under the Wire' on Dirty Money", INT, n. 319 40.

3  INT, n. 326 24.

4  "Switzerland: Ongoing Intelligence Reorganization", INT, n. 326 41.

5  INT, n. 335 1.

6  In September 1998, *Intelligence* published a Special Report, "Switzerland: Bupo & New Law On Internal Security.

7  INT, n. 360 17.

8  INT, n. 371 20.

9  INT, n. 374 28.

10  Further information is available at: "Fischenfritz", n. 28 (March 1997) and 32 (March 1998); "Bundesgesetz zur Wahrung der Inneren Sicherheit" (Federal Internal Security Law), adopted by Parliament in March 1998; *WochenZeitung,* n. 20, 14.5.98; *Neue Zuecher Zeitung,* 21.11.97, 8.4.98, 7.5.98, 23/24.5.98, and interviews with Heiner Busch, Bern, 17.8. and 19.8.98; *Fortress Europe?-* Circular Letter", n. 6, pp.1-5, n. 9, p. 6, n. 10, p. 5, n. 13, p. 7, n. 23, p. 7, n. 26, p. 3, n. 35, p. 11, n. 36, p. 10. *Fortress Europe?-Circular Letter* monitors European developments in the field of Justice and Home Affairs (Blomsterv. 7, S 791 33 Falun, Sweden; tel/tax 46 23 799940; email nbusch@falun.mail.telia.com).

## Chapter Four: "Son of Star Wars"—Alive and Well . . . in Norway!

1  See in *Intelligence*: "Norway: 'Have Stare' Keeping 'Star Wars' Alive" (n. 333 1); "Norway: Globus II Is Have Stare ... Is 'Star Wars'" (n. 363 32); and "Norway: Radar Cover Story Reveals USA Nuclear Plans" (n. 367 35).

2  Since then, the earth has experienced some of the most severe solar activity known.

3  This is extremely unlikely, given similar Pentagon intelligence postings abroad in Great Britain, Australia and Japan which employ many US military and civilian experts. In most cases, it is an American officer who commands the station.

4  This could be an early reference to what became the Bush administration's failed attempt to obtain Congressional authorization to make "mini-nukes" or "bunker busters".

5  According to one specialist consulted by *Intelligence,* Norway's Globus II radar would simply be "taken out" by the first wave of Russian nuclear cruise missiles against which neither Norway nor the US have existing defenses

6  The "Pentagon hawks" referred to here could well be some of the neo-

conservatives of the Bush administration that simply found it more convenient to scuttle the ABM treaty all together, and also invade Iraq.

7        Duncan Campbell, *The Unsinkable Aircraft Carrier,* Paladin/Grafton Books, London, 1986.

8        Frances Fitzgerald, *Way Out There In The Blue*, Touchstone, New York, 2001.

## Chapter Five:  The Trumped-up Proof of Libyan Terrorism

1        Extensive translated excerpts from *Manipulations africaines* (Plon, Paris, 2001) were used in this chapter with the permission of Pierre Pean who has also published, with Editions Fayard: *La Diabolique de Caliure* (1999); *Vie et Mort de Jean Moulin* (1998); *TF1, un pouvoir* (with Christophe Nick), (1997). See also *Le Monde diplomatique* (March 2001) which published similar excerpts from *Manipulations africaines*.

2        Director of the PFLP—GC, a Palestinian organization based in Damascus and opposed to Yasser Arafat.

3        A "serial bomber", see following footnote.

4        See *Inside the Scandals of the FBI Lab*, by John F. Kelly and Philipp K. Wearne, Free Press, New York, 1998.

5        http://www.mebocom-defilee.ch.

6        *Le Temps*, Friday, 30 June 2000.

7        *L'Attentat*, Fayard, Paris, 1992.

8        http://washingtontimes.com/upi-breaking/20040616-094642-4680r.htm.

## Chapter Six:   Secrecy Rights for Citizens:
## The Fight for Public Encryption

1        INT, n. 214 2, n. 225 2.

2        "Codes: P. Zimmermann Still Fighting", INT, n. 253 8.

3        SAMS Publishing, Carmel, IN, isbn 00 672 30293 4.

4        "Codes:  Getting Started", INT, n. 51 7.

5        "Codes:  French Decision on Publicly Legal Encryption", INT, n. 275 8.

6        "Codes:  Microsoft on 'PGP Sniffer' Contract for NSA", INT, n. 304 5.

7        INT, n. 304 1.

8        INT, n. 306 26.

9        "France:  European & World Model For Code Policy", INT, n. 306 26.

10       INT, n. 306 5.

11       INT, n. 282 55.

12       INT, n. 281 48.

13       "Britain's TTP 'Trojan Horse' European Encryption Program", INT, n. 281 3, n. 289 42.

14       "Codes: Major Up-Dated PGP Resources & FAQs", INT, n. 316 5.

15       INT, n. 303 4, n. 305 15 and n. 313 2.

16       "Feds Trying to Lock Pandora's Encryption Box", INT, n. 316 24.

17       "USA:: Congress Barely Avoids Bloody Code Showdown", INT, n. 317 24.

18       "Codes: Europeans Reject U.S. Plan", INT, n. 319 10.

19       "Codes: GCHQ Claims Public Key Encryption", INT, n. 324 8.

20       "USA: FBI Drowns in Encryption-Electronic Commerce Flood", INT, n. 327 26.

21       "Worldwide:  France Breaks Ranks with USA & Against USA on Codes", INT, n. 342 1.

22       INT, n. 342 1.

23       INT, n. 346 11.

24       INT, n. 347 5.

25       The Weizmann Institute Key Locating Engine, http://jya.com/twinkle.eps.

26       http://www.counterpane.com.

27       INT, n. 349 5.

28       INT, n. 349 11.

29       INT, n. 301 6.

30       See "USA: Microsoft-NSA Collusion Destroys Code Export Limits", INT, n. 353 10.

| | |
|---|---|
| 31 | INT, n. 357 6. |
| 32 | INT, n. 358 6. |
| 33 | See "Lose Your Code Keys & Go Straight to Prison", INT, n. 362 3. |
| 34 | See above and INT, n. 308 21, n. 316 24 & n. 349 11. |
| 35 | INT, n. 363 8. |
| 36 | INT, n. 365 7. |

## Chapter 7: Pinochet Today, Kissinger Tomorrow?

1    Operation Condor: state-sponsored terrorism, spearheaded by the Chilean secret police, DINA, which included the assassination Chilean General Carlos Prats Gonzalez and his wife in Buenos Aires in 1974. Gen. Prats had been Army Chief-of-Staff from 1970, when Salvador Allende assumed office, until 23 August 1973. He resigned two days after several hundred wives of military officers clashed with Carabineros during a protest demonstration in Santiago. Prats' loyalty to Allende was regarded as the chief obstacle to earlier attempts by the Chilean armed forces to oust Allende.

2    On 3 April 1982 the British Conservative government of Prime Minister Margaret Thatcher, supported by Parliament, decided to send an all-services military Task Force to the Malvinas, a group of tiny islands in the South Atlantic, to defend British sovereignty against Argentinean troops. This cost more than 1,000 lives and approximately $10 billion. On 2 July 1982, Mrs. Thatcher, during an election speech in Cheltenham, said the Falklands Factor was "a symbol of a nation that built an empire."

3    Documents were posted at http://www.gwu.edu/=AAnsarchiv/latin-america/chile.htm.

4    La Moneda, facing the Plaza de la Constitucion, was designed by the Italian architect, Joaquin Toesca, in the late 1700s, and was originally used as the Royal Mint. Since 1841, it had housed the Presidential Offices, the Interior Ministry and the Foreign Ministry.

5    The ruling junta consisted of Army Chief-of-Staff Pinochet, the Commander-in-Chief of the Chilean Navy, Admiral Jose Merino Castro, Air Force Commander Gustavo Leigh Guzman, and General Cesar Mendoza Duran, director of the Military Police.

6    Documents were posted at http://www.gwu.edu/=AAnsarchiv/latin-america/chile.htm.

7    Joined the Foreign Office's Information Research Department (IRD) in 1950. Served in Jakarta, Copenhagen and Ottawa prior to his appointment to Santiago. He ended his diplomatic/intelligence career as ambassador to the Holy See in 1985.

8    Punta Arenas, 1500 miles south of Santiago, near the Straits of Magellan. Third Naval Zone commanded by Rear Admiral Horacio Justiniano; the base was one of nine Internal Security Jurisdictional Area Commands following the coup on 11 September 1973.

9    David Rolland Spedding, who took over as Second Secretary in Santiago in 1974, died in London on 13 June 2001 after a long battle against lung cancer.

10    Prior to his appointment as Buenos Aires station chief in 1980, Mark Heathcote had served in Northern Ireland during the MI6/MI5 turf wars of the early 1970s.

11    See Frederick H. Gareau, *State Terrorism and the United States,* Clarity Press, Atlanta, 2004.

12    *Guardian* (London), 3 March 2000.

13    *The Observer* (London), 5 March 2000.

14    *Ibid.*

## Chapter 8: Losing a Spy Elite: The Chinook Crash and Operation Madronna

1    Sinead Swift, Evidence to the Scottish Fatal Accident Inquiry (SFAI) 1996.

2    David Murchie, Evidence to the SFAI, 1996.

3    Apart from the RAF crew, those police officers who died included:

- RUC Assistant Chief Constable Brian Fitzsimons, head of the Special Branch since 1989, where he had served for 21 years. Responsible for coordinating Special Branch operations with the SAS, he was also RUC liaison officer with British Military Intelligence, Garda Special Branch in the Irish Republic, MI5, Interpol, the CIA and the FBI.
- Detective Inspector Steven Davidson, appointed as Special Branch staff officer shortly before the crash, former head of an "organization desk" within the Special Branch, where he had served for 14 years.
- Detective Chief Superintendent Maurice Neilly, head of Special Branch northern region (from Antrim to the Donegal border) with overall responsibility for running informers throughout the province.
- Detective Chief Superintendent Dennis Conroy, head of Special Branch in the Belfast region, based at RUC HQ, Knock, East Belfast.
- Detective Superintendent Ian Phoenix, former member of the D Company 3 Para. Special Branch liaison officer with British Army HQ, Thiepval Barracks, Lisburn:
- Detective Superintendent Phil Davidson, served with Special Branch for 22 years. Special operations coordinator, he was tipped to succeed ACC Fitzsimons.
- Detective Superindent Robert Foster, divisional head of Special Branch, responsible for coordinating covert tasks with E4A surveillance units, which carried out several shoot-to-kill operations in the early 1980s, leading to the Stalker inquiry.
- Detective Superintendent William Gwilliam, joined Special Branch in 1970. Based at RUC HQ, Knock.
- Detective Chief Inspector Dennis Bunting, joined Special Branch in 1978. Based at RUC HQ, Knock.
- Detective Inspector Kevin Magee, joined Special Branch in 1980. Based at RUC Malone Road Barracks, Portadown, the heartland of hardline loyalist paramilitary organization, the Ulster Volunteer Force (UVF).

The British Military Intelligence personnel included:

- Colonel Christopher Biles, Assistant Chief of Staff at British Army HQ, Thiepval Barracks, Lisburn. Formerly with the Devon and Dorset Regiment.
- Lieutenant Colonel Richard Gregory Smith, Intelligence Corps.
- HQNI Lieutenant Colonel John Tobias, Intelligence Corps.
- HQNI Lieutenant Colonel George Williams, Intelligence Corps.
- HQNI Major Richard Allen, Royal Gloucester, Berkshire and Wiltshire Regiment. Attached to HQNI Major John Dockerty, Prince of Wales Own Regiment, 8th Infantry Brigade, Derry.
- Major Anthony Hornby, Queen's Lancashire Regiment, based at 3rd Infantry Brigade, Portadown.
- Major Roy Pugh, Intelligence Corps.
- HQNI Major Gary Sparks, Royal Artillery HQ 39th Infantry Brigade, Lisburn.

The MI5 officers, who were described as "security specialists" and "figures from the Northern Ireland Office's terrorist finances unit" included:

- John Deverell, whose career prior to his Northern Ireland posting included head of MI5 F5's section, where he was responsible for Operation WARD, an attempt (blown by the IRA) to recruit informers from the expatriate Irish community in Germany, parallel to an MI6 operation codenamed SCREAM which involved Army Intelligence Corps Int & Sy Group (Germany), and the Joint Irish Section of the British Security Services Organisation (BSSO) responsible for the security of British forces overseas. Following the WARD/SCREAM debacle, Derevell was appointed head of K Branch, dealing with counter-espionage reorganization following the arrest of MI5 agent Michael Bettaney.
- Stephen Rickard, Deverell's deputy Int/Sec coordinator in Ulster, and

four other MI5 agents, Michael Maltby, John Haynes, Martin Dalton and Anne James.

4      See in *Intelligence* (19 June 2004): "Great Britain: A Decade of Chinook Crash Questions" (n. 441 16).

5      Dr. Marjorie Black: Evidence to the SFAI, 1996.

6      *The Phoenix* (Dublin), 15 July 1994.

7      Proceedings of the Board of Inquiry into the Accident of Chinook HC2 ZD576, 1994/95 Part 1 pp. 2-37, para. 61.

8      *Ibid.* pp. 2-42, para. 67.

9      *Ibid.* pp. 2-42, para. 68.

10      Proceedings of the Board of Inquiry into the Accident of Chinook HC2 ZD576, 1994/95, Part 4 pp. 2-4, para. 2.

11      *Ibid.* pp. 2-4, para. 4.

12      House of Commons debate, 15 June 1995, pp. 597-8.

13      Phoenix: *Policing the Shadows*, Jack Holland & Susan Phoenix, Coronet Books, 1997.

14      *The Guardian*, 27 May 1997.

15      House of Commons Select Defence Committee, Fourth Report, 18 May 1998.

16      House of Commons 45th Select Committee on Public Accounts, Comptroller & Auditor General (C&AG) Report: Introduction/Summary/Conclusions, December 2000, para. 3.

17      *Ibid.*, Evidence pp. 1-2.

18      C&AG Report, Box 5 para. 2.

19      Evidence, C&AG Report, Appendix 2, Response to Q8, p. 47.

20      *Ibid.*, Appendix 1, response to Qs 182, 198-200, pp. 37-38, para. 2 & 6.

21      *Ibid.*, Appendix 1, response to Qs 188, 198-200, pp. 37-38, para. 2 section 1.

22      *Ibid.*, Appendix 2, response to Q9 pp. 47-48, para. 3.

23      *Ibid.*, Appendix 2, response to Q4 p. 44, para. 2.

24      *Ibid.*, Appendix 1 response to Qs 182, 198-200 pp. 37-38, para. 1.

25      *Guardian,* 30 November 2001.

26      *The Phoenix* (Dublin), 17 June 1994.

27      *Inverness Press and Journal*, 8 June 1994.

28      INT, n. 346 13.

29      *The Phoenix* (Dublin), 1 July 1994.

30      *An Phoblacht/Republican News*, 4 August 1994.

31      *Private Eye* (London), 20 August 1999.

32      *An Phoblacht/Republican News*, 9 June 1994.

## Chapter Ten: "Bloody Sunday": The Search for the Truth Continues

1      Under the terms of the peace agreement, the Provisional IRA, on 23 October 2001, announced that a significant part of its arsenal had been decommissioned. The process was witnessed and verified by the chairman of the International Commission on Decommissioning, Canadian General John de Chastelain, the former Finnish president, Martii Ahtisaari, and the former secretary of the African National Congress (ANC), Cyril Ramaphosa.

2      During a parliamentary debate in the Commons, on Tuesday, 1 February 1972, after Prime Minister Edward Heath had announced the setting up of an inquiry to be conducted by the Chief Justice, Lord Widgery, the Minister of State for Defence, Lord Balniel, replying to an MP's question about responsibility for the decision allowing a highly-trained, elite battalion of soldiers to enter the nationalist Bogside area of Derry City to detain civil-rights demonstrators, stated that "the arrest operation was discussed by the Joint Security Council. Further decisions had been taken by ministers here." However, in an internal briefing headed "Was Arrest Operation Approved by Ministers" prepared by the Ministry of Defence (MoD) to coincide with the publication of the Widgery Tribunal Report, in April 1972, army press officers, if questioned by journalists, were told to answer: "Ministers approved the general concept of the operation. (Note: Lord Balniel said on 1st February that 'the operation was discussed by the Joint Security Committee

[*sic*] before decisions were taken by ministers here.' *Daily Hansard* is inaccurate: Lord Balniel has asked that a change should be made in the bound volume)." Mr. Clarke told the tribunal that the MoD briefing paper suggested that the arrest operation was discussed by the JSC after ministerial decisions had already been taken, while the *Hansard* version suggested that further decisions had been taken by ministers after the planned operation had been discussed by the JSC. The MoD memo wanted to have the official *Hansard* account altered to show that no decisions were taken after the JSC "approved" the operation. However, according to the official minutes of the JSC meeting in question, held in London on 27 January 1972, and attended by Unionist ministers from the Stormont Parliament in Northern Ireland, British security advisors and senior military officers, there is no reference to a specific arrest operation to be conducted by the Paras, only a proposal to block the routes into William Street (on the perimeter of the Bogside) and stop the march at that point, is mentioned. In a statement to the Saville inquiry, prior to Mr Clarke's summary, Lord Crawford (formerly Lord Balniel) said the word "further" was used in the daily version of *Hansard* instead of "after"—an error which altered the meaning of what was said. He also stated: "The alteration in *Hansard* was not made by myself and I do not know who did it. Furthermore, I am unable to explain to what decisions I was referring, as I cannot remember."

3       Paul Foot, *London Review of Books*, 26 March 1992.

4       The former O/C of 1 Para, Lt.Col. Derek Wilford, speaking on Channel 4 News, on 19 January 1998, claimed members of his battalion had behaved "according to the best standard of keeping the peace" and warned Prime Minister Tony Blair not to apologize on his behalf, or on behalf of his soldiers, for the deaths of the 14 unarmed civil rights demonstrators.

5       Details of the post-mortem examinations are available in Dr. Raymond McClean's book, *The Road to Bloody Sunday*, Appendix F, (revised paperback edition 1997). Available from Unit 4, Community Service Units, Bligh's Lane, Derry BT48 0LZ, Northern Ireland. Email: info@ghpress.com.

6       Eamonn McCann (with Maureen Shiels and Bridie Hannigan), *Bloody Sunday in Derry: What Really Happened*, Brandon Books (Ireland), January 1992.

7       The Irish government's report may be available through Government Information Services, Upper Merrion Street, Dublin 2, Republic of Ireland.

8       Dr Raymond McClean, *The Road to Bloody Sunday, supra.* note 5.

9       The Provisional IRA emerged following a split in the Republican Movement in December 1969 on the issue of the use of force to defend nationalist areas in Northern Ireland, as opposed to setting up a "national liberation front" with Irish Socialist and Communist organizations, and seeking reform in the parliaments of Dublin, Belfast and London. The Provisionals immediately won the support of the majority of the IRA's Belfast members. The Official IRA responded to Bloody Sunday by exploding a bomb at the Aldershot (Hampshire, England) HQ of the Parachute Regiment, in which seven people, including five female canteen workers, were killed. On Monday, 29 May 1972, the Official IRA announced a ceasefire. The Provos' military campaign, which became known as "the Long War", widened to include targets in Britain and the European mainland, and continued (despite several attempts to negotiate a ceasefire) until July 1997.

10      Dr. Raymond McClean, *The Road To Bloody Sunday, supra.* note 5.

11      *Ibid.* See Appendix F for Dr. Raymond McClean's notes on the fatal wounding of Mr. McGuigan.

12      Details of British Army equipment used in Northern Ireland between 1969 and 1973 from *The British Army in Ulster, Vol. 1,* by David Barzilay, Century Books, Belfast, 1973.

13      Rauiri O'Bradaigh, former president of Sinn Fein, left the Republican Movement in 1986 following a decision to contest elections in both Northern Ireland and the Irish Republic. He was succeeded by Gerry Adams, MP.

14      *The Times*, 1 February 1972.

15      *Guardian,* 31 January 1972.

16      During his two-year tour of duty as British Army GOC and Director of Operations in

Northern Ireland from 1971 to 1973, Gen. Harry Tuzo was directly involved in the introduction of internment in August 1971, Bloody Sunday, January 1972 and the "casual brutality" of Operation "Motorman", the massive armored assault on the Republican "no go" areas in Belfast and Derry six months later. An estimated 160 civilians of all ages died as a direct result of British Army operations while Tuzo was in charge. From 1973 until he retired in 1976, he was NATO deputy Supreme Commander (Europe) under US General Alexander Haig. He later became chairman of Marconi Defence Systems, and chairman of the Royal United Services Institute for Defence Studies. Born in India in 1917, educated at Wellington School and Oriel College, Oxford, he served with the British Army in Europe, Kenya and North Borneo, before his Northern Ireland appointment. He died at his home in Norfolk, England, on 7 August 1998. Commenting on the death of the former O/C(NI), the author of *Eyewitness Bloody Sunday*, Don Mullen, said it was unfortunate that Tuzo hadn't lived to see "justice and truth established" and that he had "undoubtedly taken secrets to his grave."

17      Liz Curtis, *Ireland: the Propaganda War*, Pluto Press, London, 1984.

18      *The Times*, 1 February 1972.

19      The Social Democratic and Labour Party, usually described as the "moderate voice" of the nationalist community, founded on 21 August 1970, by several prominent civil-rights activists, including John Hume, Ivan Cooper and Westminster MP Gerry Fitt. Mr Fitt would later lose his Westminster seat to Sinn Fein president Gerry Adams, while Mr Hume would be awarded the Nobel Peace Prize (with Unionist leader David Trimble) for his part in the conflict resolution negotiations which resulted in the current "cessation of hostilities" between the Provos and the British Army.

20      Gen. Rose was a captain and press officer in the Coldstream Guards on Bloody Sunday. Educated at Oxford and the Sorbonne in Paris, he had been involved in the Iranian Embassy siege at London in 1980, the Falklands War in 1982, and later commanded the UN Protection Force in Bosnia.

21      In an interview, on 4 February 1972, with journalist Brian Moyniham—part of the *SundayTimes* archive.

## Chapter Eleven: New Europe's Old Belgium:
## Murder, "Passive Corruption" and the Pink Ballet

1       Sources for this article included: court transcripts translated by the author, previously used in a series of articles, including "Killing Puts Spotlight on Belgium Corruption" and "Belgium Goes GUBU" published in the *Sunday Business Post*, Dublin. Also see *De Bende*, by Paul Ponsaers & Gilbert Dupont, EPO, Berchem, Belgium, 1986; *De Bende & Co.* by Hugo Gijsels, Kritak, Leuven, Belgium, 1990; *Het Leugenpaleis van VDB* by Hugo Gijsels, Kritak, 1990; *De Bende Tapes*, by Danny Ilegems/Raf Sauviller/Jan Willems, Kritak, 1990, previously published in Panorama/De Post between May 1988 and May 1990; *Les Dossiers X —Ce que la Belgique ne devait pas savoir sur l'affaire Dutroux*, by Annemarie Bulte/Douglas De Coninck/Marie-Jeanne Van Heeswijk, Houtekiet & Fontein, 1999; *Dear Theo*, by Irving Stone, The New American Library, 1969. Related articles appeared in: *Het Laatste Nieuws, De Morgen, De Standaard, Le Soir, La Dernière Heure, Humo, Knack, Le Soir Illustré, La Libre Belgique*

2       See the Belgian weekly magazine, *Humo*, 17 September 1996 and 4 March 1997. Also see Hugo Gijsels, *De Bende & Co.*, Kritak, Leuven, Belgium, 1990.

3       *De Morgen*, 1 December 1998, carried accusations to this effect made by Christine Doret, a woman supposedly involved in the "Pink Ballet" parties. Doret later withdrew her accusations and the case was thrown out of court by a judge, but the dossier backing up the original story appeared quite well documented by the investigating journalists who contributed to it.

## Chapter Twelve: Bull's "Supercannon" and Moyle's "Suicide"

1       William Lowther, *Arms and the Man*, Ivy Books, US 1991.

2      Kenneth Timmerman, *The Death Lobby: How the West Armed Iraq*, Barnes&Noble, 1991.

3      Chris Cowley & Robin Blake, *Guns, Lies and Spies*, Penguin Books, UK 1992.

4      Lowther, *supra*, note 1.

5      *Ibid.*

6      *Ibid.*

7      *Ibid.*

8      Cowley and Blake, *supra*.

9      *Ibid.*

10     Richard Norton Taylor, *Truth is a Difficult Concept,* Guardian Books, UK 1995.

11     *De Morgen*, 15 April 1998.

12     Stephen Dorril, *The Silent Conspiracy,* Heinemann, UK 1993.

13     *The Sunday Times*, 3 June 1990; *Independent on Sunday*, 20 May 1990.

14     Dorril, *supra*.

15     *Time Magazine*, 27 August 1984.

16     Timmerman, *supra*.

17     Wensley Clark, *The Valkyrie Operation*, Blake, UK 1998.

18     Dorril, *supra*.

19     *The Times,* 27 February 1998.

20     Dan Raviv and Yossi Melman, *Every Spy a Prince,* Houghton Mifflin Co., 1991.

21     David Hooper, *Official Secrets,* Coronet Books, UK, 1987.

## Chapter Thirteen: The FBI's Wen Ho Lee Scandal:
## Much Ado About Something Chinese

1      See, "USA: China Spying Case 'Goes Off The Deep End'", INT, n. 349 1.

2      *Journal of Palestine Studies*, vol. 27, n. 4, 1998, pp. 20-35.

3      See,"USA: FBI Finally Goes After Wen Ho Lee", INT, n. 360 11.

4      INT, n. 358 17.

5      INT, n. 363 23.

6      See, "USA: Lee Case & Silicon Valley Give FBI Bad Press", INT, n. 366 22.

7      INT, n. 345 10, n. 346 10, n. 347 10, n. 348 11, and n. 349 1.

8      INT, n. 351 13.

9      See, "USA: Few Surprises As Case Against Lee Falls Apart", INT, n. 371 26

10     INT, n. 372 13.

11     See http://www.brillscontent.com/features/china1_1199.html.

12     See http://slate.msn.com/code/chatterbox/chatterbox.asp?Show=9/14/2000&idMessage=6064.

13     The full transcript of the astonishing proceeding was posted by the *Albuquerque Journal* at http://www.abqjournal.com/news/wenhotxt09-13-00.htm.

14     See http://www.fas.org/irp/ops/ci/whl_reno.html.

15     See http://www.fas.org/sgp/othergov/joint_policy.html.

16     See http://washingtonpost.com/wp-dyn/articles/A17740-2000Sep16.html.

17     See http://www.washingtonpost.com/wp-dyn/articles/A18623-2000Sep16.html.

18     See http://www.nytimes.com/2000/09/18/national/18FBI.html.

19     See http://www.fas.org/sgp/congress/2000/s091800.html.

20     See http://www.washingtonpost.com/wp-dyn/articles/A32693-2000Sep18.html. and http://www.usnews.com/usnews/issue/000925/lee.htm.

21     The testimony of the witnesses was posted by the FAS at http://www.fas.org/sgp/congress/2000/index.html#whl.

22     The *Times* statement has been critically analyzed by many, including *Salon* magazine at http://www.salon.com 80/news/feature/2000/09/27/lee/index.html.

23     See http://www.nytimes.com/2000/09/26/national/26EDNO.html.

24     See http://www.washingtonpost.com/wp-dyn/articles/A30129-2000Sep27.html.

25     See http://www.cnn.com/2000/US/09/29/missing.secrets.ap/index.html.

26     See "USA: Lee-Los Alamos Case Rolls On And On", INT, n. 373 18.

27     Robert Young was a federal counter-intelligence officer, according to Intelcenter.com (October 2002) citing 4 October 2000 articles in the *New York*

*Times*, *Washington Post* and *Washington Times*.

28    See http://www.fas.org/sgp/congress/2000/index.html#whl2.

29    See the *Albuquerque Journal*, http://www.abqjournal.com/news/151776news 10-17-00.htm.

30    "USA: More FBI 'Whistle-Blowing', 'Cut-outs' & Lee Affair", INT, n. 374 19.

31    "USA: FBI Overlaps With the CIA, Lee Case & Carnivore", INT, n. 375 11.

32    "USA: FBI Going After Lee & Cubans", INT, n. 378 15.

33    See http//washingtonpost.com/wp-dyn/articles/A56620-2000Dec11.html. Also see http//seattletimes.nwsource.com/cgi-bin/WebObjects/SeattleTimes.woa/wa/gotoArticle?zsection_id=268448413&text_only=0&slug=wenholee10&document_id=134252805.

34    See http://www.sfgate.com/cgi-bin/article.cgi?file=/chronicle/archive/2000/12/24/MN168708.DTL. Also see http://www.latimes.com/news/nation/20001224/t000122586.html.

35    See "USA: War with China Today, Not Tomorrow!," INT, n. 388 11.

36    24 July 2001, Federation of American Scientists (FAS), Wen Ho Lee book under review; 6 August, FAS, Wen Ho Lee and Prepublication review; 14 August, The DoE and FBI investigation that led to the arrest of Los Alamos physicist, Wen Ho Lee, has received scathing criticism from a review of the investigation by a federal prosecutor [Randy Bellows]; 15 August, FAS, Bellows report faults DoE; 24 August, A hearing was to be held into the unsealing of documents used in the Wen Ho Lee case; 24 August, FAS, Excerpts from the Bellows report, Chapter 6 http//www.fas.org/irp/ops/ci/bellows_chap6.html, Chapter 7 http//www.fas.org/irp/ops/ci/bellows_chap7.html; 27 August, The FBI's espionage investigation of Los Alamos National Laboratory; 27 August, *Washington Post*, Report details more FBI blunders in Wen Ho Lee probe.

## Chapter Fourteen: Terrorists' Networks and Traffic Analysis Before and After September 11

1    Seumas Milne, "Terror and tyranny: What powerful states call terrorism may be an inevitable response to injustice", *Guardian* (London), 25 October 2001.But this definition is problematic because "foreign countries" serves to exclude the extensive use of state terrorism against what are purported to be domestic insurgencies—perhaps the most normative application of state terrorism. See Frederick H. Gareau, *State Terrorism and the United States: From Counter-insurgency to the War on Terrorism*, Clarity Press, Inc., Atlanta, 2004.

2    Ralph W. McGehee, *Deadly Deceits: My 25 Years in the CIA*, 1983, Sheridan Square Publications, New York.

3    *Ibid*, p. 116.

4    US Department of the Army, Fundamentals of Traffic Analysis (Radio-Telegraph), 1948, Department of the Army Technical Manual TM 32-250 and Department of the Air Force Manual AFM 100-80, reprinted with glossary and index by Aegean Park Press, Laguna Hills, CA.

5    *Guardian*, 31 October 1990.

6    See chapter 11, "New Europe's Old Belgium : Murder, 'Passive Corruption' and the Pink Ballet".

7    "Belgium: Declared and Real Priorities of the Sûreté d'Etat", INT, n. 254 32, 12 December 1994.

8    "Link Analysis Data Mining with Alta's Netmap", INT, n. 287 2, 13 May 1996.

9    *Ibid*.

10    "Mobile Phone Technology Makes It to the Courts," INT, n. 308 4, 21 April 1997.

11    *Ibid*.

12    "Network Analysis Makes the Big Time in Intelligence", INT, n. 327 2, 30 March 1998.

13    "Russia: Internet & Economic Security under new FSB Chief", INT, n. 334 29, 7 September 1998.

14    See chapter 6, "Secrecy Rights for Citizens: The Fight for Public Encyption".

15      "More NSA Technology Information", INT, n. 358 3, 13 December 1999..

**Chapter Fifteen: Now You See Them, Now You Don't:**
**Executive Outcomes and Sandline International**

1       INT, n. 279 68.
2       INT, n. 292 4.
3       INT, n. 258 3, n. 268 11, n. 292 4 and n. 296 46.
4       Headquartered in the United States, the logo of MPRI (Military Professional Resources Incorporated) displays a medieval sword piercing through the company's acronym. Its advertising slogan proclaims MPRI to be "the greatest corporate assemblage of military expertise in the world." This international firm provides basic training, doctrinal analysis, war-gaming operations and non-military services in Europe, Africa, Asia, and the Middle East. Founded in 1987 by eight former US senior military officers, MPRI says it only operates in areas approved by the US State Department. MPRI has very close ties to the US government. Several former high-ranking US military officers were employees of MPRI, including Gen. Carl E. Vuono, US Army Chief of Staff (1987-1992), and Gen. Crosby E. Saint, commander of the US Army in Europe (1988-1992). MPRI gained notoriety through its training of the Croatian army in 1995, and later won a contract to provide instruction to the Bosnian armed forces. This description is based on information published in November 1997 by the Center for Defense Information in a monograph, "Soldiers of Fortune Ltd.: A Profile of Today's Private Sector Corporate Mercenary Firms", by David Isenberg.
5       *Harper's Magazine* journalist Elizabeth Rubin in a 1997 report.
6       See a mid-1990's study by Khareen Pech in *Le Monde diplomatique* and also the *Sunday Independent*, 7 July 1996.
7       See "Sierra Leone: Brits Allegedly Armed Both Sides", INT, n. 376 34.
8       Murdoch, Lindsay and Philip van Niekerk. "Mercenaries who show no mercy," *Asia OnLine,* 25 February 1997.
9       This was documented in the report of the Andrew Commission of Inquiry into the Engagement of Sandline International, commissioned by the Independent State of Papua New Guinea (March 1997), led by Mr. Justice Warwick John Andrew, CBE.
10      See the *Sunday Telegraph* (10 May 1998).
11      Saxena hasn't made the news since May 1998 when he was awaiting trial in Vancouver on charges of defrauding the Bank of Bangkok of £55 million and traveling on a passport in the name of a dead Yugoslav, according to a 10 May 1998 *Sunday Times* article.
12      See "Sierra Leone and new Labour's supposedly ethical foreign policy," at http://www.wpb.be/lalkar/lalkar07/08.htm.
13      Although it has been widely reported as "Bahamian-based", the company was originally registered in the Virgin Islands as Castle Engineering, on 2 July 1993, and changed its name to Sandline only on 2 December 1996 (registration n. 89683).
14      INT, n. 412, 25.

# Index

## A

administrative detention 124
Aerospatiale 158, 159
Africa 16, 17, 23, 24, 25, 29-33, 37-49, 51, 74, 75, 103, 170, 172, 192, 202-208, 210-222
African National Congress (ANC) 24, 204, 221
Aftergood, Steven 188, 189
Agent Orange 37, 49
agents provocateurs 21
Agusta 158, 159, 160, 164, 166, 167
aircraft carrier 71, 128, 135
Al Shamal bank 54
al-Majid, Hussein Kamil 171
al-Qaeda 83
Alexandra, Princess 41
Allende Gossens, Salvador 98, 99, 100, 105, 106, 111
Alta Analytics 197
American Indian Movement 20
*American Journalism Review* 190
Amnesty International 104, 209
Ancia, Veronique 158-161, 164, 167
Anderson, Robert O. 41, 50
Angola 170, 192, 202-207, 211, 213-215, 219, 220 MPLA 170, 203, 204, 206, 219
Annesley, Sir Hugh 113
Anonymizer 92
anthrax 178
Anti-Ballistic Missile (ABM) Treaty 67, 68, 70, 73
anti-money laundering 53, 54, 56, 57, 62
anti-terror 12, 53, 85, 97, 112, 117, 123, 124, 192, 210
apartheid 24, 43, 44, 45, 51, 203, 205, 213, 215, 220
Arellano Stark, Sergio 100
Argentina 98, 103, 106
Armscor 45, 170
Artaza, Mario 109
artillery 15, 169, 170, 171
Arundel, Arthur "Nicky" 38
Aspen Institute 39, 41, 50
Associated Press 105
Association pour le Droit à l'Information (ADI) 15, 16
Astor, David 40
Astra 172, 174, 175, 179
Atlantic Richfield (ARCO) 41
Attenborough, Sir David 39, 49
*Aviation Week* 10
Aylwin, Patricio 98, 178

## B

Baker, Stewart 12
Baldini, R. 158, 166
Ballistic Missile Early Warning System (BMEWS) 68
Barclays 34, 48
Barclay-Smith, Phyllis 34

Bari, Judi 18, 19, 20, 21, 22
Barril, Paul 85
Barros, Fernando 107
Bartle, Ronald 107, 108, 109
Baumel, Jacques 9, 10
BBC 41, 49, 103, 143, 147, 148, 170, 177, 179 "Panorama" 170, 179
Belgium 16, 105, 110, 111, 156-67, 172, 173, 174, 180 Gemeente-politie uniformed community police 156 Gendarmerie (Rijkswacht) 156, 162, 163 Socialist Party 157, 158
Bernard, Charles 36, 37
Bernstein, Daniel 93, 97
Bevan, John 34
Bhopal 37
Big Brother 85, 201
Bilderberg Conference 39
birds 34, 40, 48
bison 27
Black Orchestra 105, 157
Black Panther Party 20
Blair, Tony 104, 140, 143, 151
blood 137, 138, 139, 140, 141, 142, 144, 145, 146, 148, 151, 152, 153, 154, 177, 207
Boeing 74, 75, 112, 114, 115, 118, 119, 121, 176, 207, 218
Bohlen, Curtis "Buff" 23, 24, 37, 47
Bollier, Edwin 76
Bond, James 34
Bonner, Ray 47, 48
Bradshaw, Thornton 41
Branch Energy 206, 208, 213, 214, 215, 216, 217, 218
breast cancer 18, 21
Breglio, Robert 139
Bridge International 212, 213
British Aerospace 101
British Museum of Natural History 32, 41
Brookings Institute 68
Bruguière, Jean-Louis 74, 76-81
BSA Machine Tools 176
Buck, Stockton 19
Buckingham, Anthony 204, 206, 213, 214, 215, 216, 217, 218
Bull, Gerald Vincent 169-176, 178-180
*Bulletin of the Atomic Scientists* 69
Busch, Nicholas 61
Bush, George H.W. 23, 57, 202
Bush administration 47, 57, 66, 67, 72, 73, 97

## C

CACI 202
Calvi, Fabrizio 13, 15
Calvi, Roberto 15
Camp X 33
Campbell, Duncan 71
Campusano, Alejandro 111
Canada 29, 33, 88, 169, 170, 172, 175, 178, 195, 196, 211, 214 Royal

Canadian Mounted Police (RCMP, "the Mounties") 195
Capricorn Society 213
Cardoen, Carlos 176, 177, 178, 179, 180
Carson Gold 214
Casey, William 15
Castano, John 128
Castellon, Manuel Garcia 98
CBC 170
CEPIC 163
Chan, Sir Julius 208, 209, 210
Cherney, Darryl 18, 19, 20, 21, 22
Chile 24, 98, 99, 100, 102-111, 176, 177, 178, 180 Christian Democratic Party 105 Departamento de Inteligencia Nacional (DINA) 104, 105, 106, 108 Popular Unity Party 105
China 10, 33, 38, 69, 70, 128, 135, 171, 181-188, 190 National Defense Science and Technology Information Center (DSTIC) 184
Chinook 16, 112, 114, 115, 116, 117, 118, 119, 120, 121, 122, 123, 124, 125
Christopher, Warren 50
Church, Frank 99
Cisco 201
civil liberties 21, 144
civil rights 18, 96, 126, 137, 139, 145, 146, 152, 154
Claes, Willy 159, 160, 166, 167
Clark, Wensley 177, 178
Clarke, Christopher 137, 138, 152
Clarke, Kenneth 35
Clinton, Bill 12, 85, 86, 87, 88, 89, 90, 97, 133, 167, 182, 183, 186, 189, 201, 205
Clipper Chip 85
Clockwork Orange 15, 106
cluster bomb 176, 205, 220
Coeme, Guy 158, 159, 160, 166
Cohen, Herman 205
COINTELPRO 18, 20
Colby, William E. 194
Colt 172
CommerzBank 159
*Computer Weekly* 118, 119, 124
Contragate 15
Cook, Robin 109, 111, 217
Cools, André 157-161, 166
Copine Bank 162
copper 208, 216
corruption 16, 43, 53, 124, 156, 157, 158, 159, 164, 166, 167
counterfeiting 57, 58
counter-insurgency 113, 116, 126, 144, 194, 207
credit card 84
Credit Lyonnais 54
Credit Suisse 165
cryptology 194
Cuba 134, 170, 203
Cuban Nationalist Movement (CNM) 105
currency 142
Cylink 196

**D**

*Daily Mail* 17

*Daily Telegraph* 147
D'Alessandro, Roberto 159
Dalhousie, Lord 39
Dalton, Hugh 36
Dalzell-Payne, Harry 150
Dassault, Serge 164, 165, 166, 167
David, Ruth A. 12
Day, John 115, 117, 120, 125
De Beers 32, 40, 217
De Boccard, Pierre 165
de Feo, A. 15
De Gaulle, Charles 9, 10, 13, 14, 15
de Klerk, F.W. 43, 204
De La Haye, Brian 123
de Rothschild, Baron 32
death squads 15
Dedecker, Jean-Marie 168
Delle Chiaie, Stefano 15, 105, 106
Deutch, John 12
Deverell, John 113
Di Pietro, Antonio 159
diamonds 44, 47, 205, 207, 208, 213, 214, 217, 219, 221
DiamondWorks Ltd. 214
Direction de la Surveillance 77
Donovan, William "Wild Bill" 13, 38
Dowling, Kevin 17
drugs 42, 44, 53, 90, 91, 113, 161, 162, 163
Dubois, Jean 158
Duits CommerzBank AG 159
Dulles, Allen 12, 13, 15
Dutroux, Marc 156, 167, 168
Dyncorp 202

**E**

Earth First! 18, 19, 20, 21, 22
Echelon 201
economic warfare 10, 24, 40, 47, 74, 82
Eitan, Rafi "Dirty" 15
El Almi, Abdelmajid 161
El Baradei, Mohamed 72
*El Mercurio* 106
El-Al 174
Electronic Privacy Information Center (EPIC) 87, 89, 90, 97
elephants 23, 24, 26, 31, 33, 37, 42, 44, 45, 48, 49, 73
Elf 221
Environmental Fund 50
Eskimo 29, 30
Etchpare, Gustavo 106
eugenic 23, 28, 34
European Union (EU) 9, 25, 54, 58, 84, 85, 156, 157, 159, 200, 201
Europol 58
Evans, Harold 145
*Evening Standard* 216
Executive Outcomes (EO) 16, 202-222
Eyadema 211

**F**

F-16 164
famine 30, 33, 42
Fascist 15, 34, 41, 43, 105, 157, 162, 164
Faulkner, Brian 144, 149
Federation of American Scientists (FAS) 65,

69, 71, 72, 169, 184, 188, 189, 190
Feingold, Russell D. 88
Feinstein, Diane 185
Fernandes, Andrew 93, 94
filing card 194
*Financial Times* 42
Fisher, Stanley 210
fleas 32
Fleming, Ian 34
Fleming, Peter 34
Forbes, Malcolm Graham 113
Fortress Europe? 61
France 9-17, 42, 55, 60, 61, 69, 73, 74, 75, 77, 78, 79, 80, 82-85, 87, 88, 90, 91, 94, 95, 105, 128, 135, 156, 157, 158, 161, 164, 165, 167, 176, 197, 199, 211, 213, 221 Direction de la Surveillance du Territoire (DST) 10, 13, 77, 78, 79, 81 Direction Générale de la Sécurité Extérieure (DGSE) 9, 75
fraud 167, 172, 185, 199, 200, 221
Freeh, Louis J. 188, 189, 190
Frost, Malcolm 41
Fuel-Air Explosives (FAE) 205, 220

**G**

Gareau, Frederick H. 109
Garzon, Baltazar 98, 99, 103, 107, 109
Gates, Bill 84
Gelli, Licio 15
General Electric 34
genocide 98, 103, 220
Germany 30, 31, 39, 41, 42, 55, 57, 61, 69, 77, 78, 87, 94, 134 Gestapo 33 Stasi 76
Gertz, Bill 187
Giallombardo, Mauro 158, 159
Gladman, Brian 96
God 28, 32
Golistine, Anatoli 15
Gore, Al 51, 86
gorilla 38, 49
Gorbachev, Mikhail 135
GPS 114, 115, 117
Grassley, Charles E. 186, 189
Great Britain 10, 15, 16, 17, 26, 29-32, 34-41, 43, 45, 47-49, 69, 83, 87, 94-96, 98, 101-103, 106- 109, 111, 113, 114, 118, 124-126, 137-147, 149-155, 159, 170, 171, 174-179, 194, 195, 198, 199, 201, 203, 204, 210, 213-219 D Notice 113, 179 GCHQ 217 Interception of Communications Act 198 Joint Intelligence Committee (JIC) 218 Joint Intelligence Organisation (JIO) 217 MI5 (Security Service) 15, 32, 35, 40, 41, 106, 113, 123, 124, 137, 151, 152, 153, 155, 174, 175, 192, 194, 195, 200, 217 MI6 (Secret Intelligence Service or SIS) 32, 33, 35, 36, 40, 102, 103, 117, 124, 125, 170, 171, 173, 174, 175, 176, 177, 178, 179, 180, 214, 217 Ministry of Defence (MoD) 139, 150, 151, 152, 154, 155, 174, 176, 179, 215, 218, 219 Royal Navy 101, 128, 218, 219 Scotland Yard 98, 124 Special Air

Service 43, 102, 117, 124, 174, 213
Special Boat Squadron (SBS) 102, 124
Special Branch 98, 113, 155
Green, Thomas C. 185
Greenpeace 30
*Guardian* 134, 148, 204, 213
Gulf-Chevron 204
Gumbley, Christopher 172, 174, 175, 179

**H**

Hardin, Garrett 50
*Harper's Magazine* 220
Hastings, Max 147
Hawker Hunter 102
Heath, Edward 102, 144, 149
Heath, Mark 102
hedgehog 41
Held, Richard W. 20
helicopter 49, 111, 112, 114, 116-119, 121, 125, 138, 144, 146, 147, 158, 159, 164, 166, 176-179, 205, 207, 210, 211, 218, 219
HELIOS 178, 179
Helms, Richard 99
Heritage Oil & Gas 204, 206, 213
High Altitude Research Project (HARP) 169, 170, 171
Hitchens, Christopher 104
Hitler, Adolf 14, 39, 40
Hoffman, Lord 103, 104, 106
Holden, James S. 170
Holdness, Roger 175
holism 33
Hollis, Roger 15, 40
Hong Kong and Shanghai Bank 216
Hoon, Geoff 153
Howard, Edward 15
Humphrey, Derek 144, 145
Hussein, Saddam 85, 169, 171, 172, 173, 175, 176, 178
Huxley, Julian 33, 34, 36, 40

**I**

I.G. Auschwitz 39
Ibis Air 212, 213, 218, 219
Inman, Bobby 87
*Intelligence* 10, 11, 12, 13, 15, 16, 18, 84, 86, 89, 91, 92, 93, 94, 184, 186, 188, 191, 197, 200, 202, 210
*Intelligence Newsletter* 15
International Atomic Energy Agency (IAEA) 72
International Monetary Fund (IMF) 23, 207, 209, 210
Interpol 57, 98
Inuit 29, 30, 36
IRA 106, 112, 114, 123, 124, 125, 137, 138, 140, 143, 144, 145, 147, 150, 151, 152, 153, 154, 155, 192, 194, 195, 200
Irangate 15
Iraq 11, 23, 45, 69, 70, 74, 79, 81, 82, 154, 169, 171, 172, 173, 174, 175, 176, 177, 178, 179, 180, 193, 202, 203, 221 General Intelligence Department (Da'irat al-Mukhabarat al-'Amah) 173, 178, 179, 180 Ministry of Industry

and Military Indistrialization (MIMI) 171, 174, 179
Ireland Garda 124, 125, 147, 195
Israel 15, 45, 61, 92, 95, 170, 171, 173, 174, 178, 179, 184, 192 Mossad 15, 173, 174, 178, 179, 180
Italy 37, 42, 88, 105 P2 masonic lodge 15 Italian Socialist Party 158, 159
Ivens, Matt 133
ivory 23, 24, 25, 42, 43, 44, 45, 47

**J**

Jack, Ian 174
Japan 65, 72, 88
Japan MITI 88
Jardine Fleming bank 216
Jeaniau, Josianne 162
Joiret, Marie-H. 157
Johnson, Lyndon 50
Jones, Alun 107, 108
Jospin, Lionel 90, 91
journalists 13, 17, 42, 48, 62, 109, 123, 133, 134, 135, 138, 140, 143, 144, 145, 147, 148, 154, 155, 163, 168, 175, 176, 177, 178, 179, 187, 196, 207, 209, 212, 213, 214, 215

**K**

Kabbah, Alhaji Ahmad Tejan 207, 217, 218
KAL 007 15
Kelly, Jim 72
Kennedy, Edward 193
Kennedy, John F. 15, 87
Kertzner, Sol 46
Kim Jong-il 15, 72
Kissinger, Henry 16, 98, 99, 100, 101, 104
Kitson, Frank 144, 145
Klerks, Peter P.H.M. 16
Knight, Maxwell ("The Man Who Was M") 40, 41
Kock, Stephan 174, 175
*Kursk* 127, 128, 129, 130, 131, 135, 136
Kyushu Institute of Technology 93

**L**

*La Dernière Heure* 159
*La Libre Belgique* 161
La Moneda 99, 100
Lacoste, Pierre 9, 10, 11
Lagan, Frank 144
Lamont, Norman 99, 107
Lansdale, Edward 38
Latinus, Paul 162, 163
Lee, Wen Ho 22, 181, 182, 184, 186-191
*Le Monde* 211
*Le Monde du Renseignement* 15
*Le Point* 77, 80
*Le Soir* 211
*Le Soir Illustré* 161
Ledeen, Michael 15
Leighton, Bernardo 105, 106
Letelier, Orlando 104
*Libération* 211
Libya 15, 16, 74-82
Lifeguard 207, 208, 214
Livingstone, Ken 177

Lockerbie 74-82
Loeb, Vernon 188, 190
Loftus, John 15
London Zoological Society 40
Lonrho 41
*Look* 41
Los Alamos National Laboratory 181, 182, 183, 186, 187
Louvigny, Bob 162

**M**

MacBride, Sean 44
MacDermott, Eamon 147
machine gun 101, 114, 143, 152
Machon, Annie 153
Maclean, Raymond 139
Maclellan, A.P. 144
Madsen, Wayne 89
Mafia 15, 23, 44, 157, 161
Major, John 143, 175
malaria 42
mammals 32
Mann, Simon 204, 213, 215, 216, 218
Mansfield, Michael 154
Marconi Underwater Systems 176
Massachusetts Institute of Technology (MIT) 83
Mathot, Guy 158, 159, 160, 161, 163
Matra, Frank 10
Matra 176
Matrix Churchill 175, 176
Matutes, Abel 109
MBK 158
McCain, John 91
McCann, Eamonn 140
McCowan, Rupert 216
McGehee, Ralph W. 184, 193, 194, 195
McGuinness, Martin 124, 151, 152, 153, 154, 155
McKinney, William 155
McNamara, Robert Strange 50
Medecins Sans Frontières 220
Megajoule 9, 10, 11
Melissa computer virus 91
MF-45 171
Mi-17 205, 207
Mi-24 205, 207, 211
Microsoft 84, 91, 92, 93, 94
Midland Bank 174
MiG-23 205, 207
migrant trafficking 57
Military Professional Resources Incorporated (MPRI) 202, 205, 221
Mink, Patsy 190
Mintz, John 135
Mitterand, François 211
money laundering 197, 200
Morris, John 103
*Moscow Times* 133
Mountford, Guy 34, 39
Moyle, Jonathan 16, 116, 124, 175-180
Murchie, David 112
murder 15, 16, 31, 46, 49, 156, 157, 158, 161, 166, 167, 169, 173, 174, 176, 177, 178, 179, 180, 199

**N**

N. M. Rothschild Bank  32
napalm  219
NATO  67, 70, 73, 117, 127, 130, 131, 135, 136, 156, 157, 166, 167, 176
Navrotskii, Vladimir  131
Nazi  15, 16, 30, 39, 41, 87
NBC  41
negative coaching  10
nerve gas  178
network analysis  194-197, 199-201
Network Associates  90
New York Police Department (NYPD)  139
New York Times  47, 89, 188, 189, 191
New York Zoo  41
New Yorker  47
Newsweek  54, 206
Nicolson, Harold  33
Nijvel Gang  157, 161, 162, 163, 164
Nixon, Richard  99, 100, 101
Nkomo, Joshua  44
noise reduction  191
North, Oliver  15
North Korea  65, 69, 71, 72
Northern Ireland  16, 17, 25, 88, 106, 108, 112, 113, 114, 116-118, 122-126, 137-145, 147, 149, 151, 152, 180, 192, 194, 195, 200  Northern Ireland Civil Rights Association (NICRA) 139 Northern Ireland Office (NIO)  113, 145 RUC  113, 124, 125, 126, 137, 138, 139, 143, 144, 147, 152, 154, 155, 195, 200 RUC Special Branch  124, 125, 126 SDLP  152
Norway  16, 63, 64, 65, 66, 67, 68, 70, 71, 73, 83, 128, 130  Norway Intelligence Service (NIS)  45, 70 Norwegian Defense HIgh Command (DHC) 64, 65, 66, 67 Norwegian Military Intelligence  64, 71
nuclear explosion  10, 63
nuclear stewardship  10
nuclear test  23, 182, 183
nuclear weapons  9, 10, 11, 70, 72, 87, 181-183, 185-191

**O**

Oakland Police  18, 19
Oatley, Charles  124
Observer  40, 41, 42, 133, 153, 216
Obshaya Gazeta  131
Office of Naval Intelligence  134
Office of Special Services (OSS)  11, 13, 15, 38
Official IRA  145
Ogilvy and Mather  34, 41
oil  41, 50, 114, 204, 205, 206, 211, 213, 218, 221
Operation Madronna  16, 112, 124
Opus Dei  107
Organization for Economic Cooperation and Development (OECD)  85, 87, 88
organized crime  12, 53, 56, 57, 58, 59, 61, 85
Orogen Minerals  209
Owen, Chris  142

**P**

Pacific Bell  95
Palermo, Carlo  15
Palestine  74, 78, 80, 178, 192
Palm, Nicolaas  212, 214, 216, 222
PanAm  74, 75
panda  26, 33, 38
Pappas, Alexander  171
Parapolitics  15
Paris-Match  44
pattern recognition  200
Pazienza, Francesco  15
Peace Research Institute of Oslo (PRIO)  71
Pean, Pierre  16
Pech, Khareen  207, 212, 214
Pelton, Ronald  15
Penfold, Peter  218
Pennsylvania State University Science and Power Systems Division  131
Peter The Great  128, 129
Peulinckx, Alfons-Hendrik  164, 165
Pike, John  65, 69, 71, 72
Pilatus  207
Pincus, Walter  185
Pink Ballet  16, 156, 162, 163, 168
Pinochet Guarte, Augusto  98-111
pipe bomb  19
plastique  75, 76
plutonium  72
Policy Research Institute (PRI)  142
Pollard, Jonathan  15
polygraph  184, 185, 190
Pope, Edmond Dean  131-136
Pour  162
Pourchot, Gaston  12, 13, 14, 15
Portugal PIDE (International Police for the Defence of the State)  43
Poudreries Réunis de Belgique (PRB)  171, 172, 174, 175
Pretty Good Privacy (PGP)  83, 84, 86, 87, 90, 94
Prince Bernhard  34, 39, 43
Prince Philip  41, 46, 48
Princess Diana  12
Privacy International  201
privatization  214, 220
Provisional IRA  106, 112, 123, 124, 137, 144, 145, 147, 151, 152, 153, 154, 194 see also IRA
public key encryption  83, 86, 87, 89, 92
Putin, Vladmir  127, 128, 133, 134, 135, 136

**Q**

Qadhafi, Mu'ammar  15, 75, 77, 79, 82
Queen of England  30, 139
Quilligan, Michael F.  16

**R**

Racal Avionics  114
Rainbow Warrior  9
Ranger Oil  204
RCA  41
Reagan, Ronald  63, 73
Red Brigade  157, 192
Reid, Richard  83

Rembrandt-Rothmans-Reemtsma Corporation 39
RENAMO 44
Renault 172
Reno, Janet 183, 188, 189, 190
Reuters 42, 89, 192
rhino 24, 26, 42, 43-49
Rhodes, Cecil 30, 31, 32, 33
Rhodesia 31, 39, 43, 44, 47, 203, 213, 215
   Rhodesian SAS 44, 215
Richardson, Bill 182, 187, 190
Rifkind, Sir Malcolm 99, 115, 122
Rimington, Stella 113
RIPOL 57
Roberge, Therese 16
Robinson, James 189
rocket fuel 129
rocket-propelled torpedo 127
Rondot, Gen. 79, 81
Roosevelt, Franklin Delano 13, 14, 15
Roosevelt, Kermit 38
Roosevelt, Theodore 27, 28, 31, 38
Rothschild, Lord 32
Rowland, Tiny 41
Royal Ordnance 101
Royal Society for the Protection of Birds
   (RSPB) 34, 37, 40, 41
rubber 39, 143
Rubin, Elizabeth 220
Rupert, Anton 39, 45, 48, 49
Russia 10, 15, 23, 39, 127-136, 200, 201,
   208, 211, 218, 219 Federalnaia Sluzhba
   Bezopasnosti (FSB) 131, 132, 133,
   134, 200, 201 KGB 15, 23, 40, 133,
   200 SVR 131, 146
Rust, Matthias 136
Rutskoi, Alexander 128
Ryoichi, Sasahawa 15

**S**

Sandline Holdings 216
Sandline International 16, 202, 208, 210,
   213, 215
Sankoh, Foday, 207
Santovito, Giuseppe 16
Saracen 212, 214, 215
Savimbi, Jonas 205, 219
Schmidt, Olivier 9, 16, 84, 85
Schneier, Bruce 92, 93
Scotland 98, 112, 117, 123, 124
*Scotland on Sunday* 195
Scud missile 178
Secord, Richard 15
selective internment 124
Selous Scouts 44
Sergo Ordzhonikidze Aviation Institute 127
Service & Security 211
SHAEF 39
Shamir, Adi 92
SHAPE 174
Sharon, Ariel 179
Shayler, David 153, 155
Sheffield Forgemasters 174
Shelby, Richard 183
Sidley & Austin 185
Sierra Club 21, 37
Sierra Leone 202, 206, 207, 208, 211, 214,

215, 217-220
SIGINT 70, 71, 103
Silva Enriquez, Raul 107
Singh, Karat 50
Sinn Fein 124, 140, 147, 151, 152
Skorzeny, Otto 16
slaves 39, 44
Smith, Dan 71
Smith, Ian 44
Smith, Jeffrey H. 188
Smith, Richard M. 91
Smuts, Jan Christian 33
Socialist International 158
Sodano, Angelo 107
*Soldiers of Fortune* 212
South Africa 23, 24, 32, 33, 38, 39, 40,
   42-49, 51, 103, 170, 172, 192, 202-
   208, 211-216, 219-221 Civil Coopera-
   tion Bureau 203; 32nd Battalion 203; 5th
   Reconnaissance Regiment 204
South Korea 72
Space Research Corporation (SRC) 170, 171,
   212, 213, 214, 215
Specter, Arlen 186, 189
Spedding, David 102
Spicer, Tim 215, 216, 217, 218
Spitaels, Guy 158, 159, 160, 164, 166
Stalker, John 124
START 1 and 2 69
*Statesman* 214
Steele, Robert 11
Stevenson, William ("A Man Called Intrepid")
   33
Steyl, Crause 213
Stirling, Sir David 39, 43
Strasser, Valentine 206, 207
Strategic Resources Corporation (Pty.) Ltd.
   (SRC) 212
Straw, Jack 95, 96, 103, 104, 110, 111
strip mining 32
submarine 35, 64, 65, 66, 71, 127, 128,
   129, 130, 131, 135, 136, 181, 191
Submarine-Launched Ballistic Missile (SLBM)
   64, 70, 71
suicide 16, 108, 176, 177
*Sun* 195
Sun, Brian A. 185
*Sunday Express* 125
*Sunday Independent* 214
*Sunday Times* 42, 144, 145, 152, 218
Sweeney, John 133
Switzerland 13, 36, 37, 38, 42, 53-62, 76, 78,
   84, 103, 111, 164, 207 Bundespolizie
   (Bupo) 54-59, 61 Groupe des
   Renseignements Stratégiques (GRS) 62
   Services de Renseignements
   Stratégiques (SRS) 62

**T**

Tapper, Jonathan 112, 115, 116, 117, 122,
   123, 125
Taryoun (TY) 77, 78
Tate, Jon 88
Tavernier, Christian 211
tax evasion 53
terror 126, 133, 138, 150, 192, 193, 210,
   220

terrorism  80, 81, 82, 85, 86, 90, 97, 192, 193
terrorist  133, 138, 150, 192, 193, 210
Thatcher, Margaret  98, 104, 174, 175
Thatcher, Mark  177
The 1001  32, 39, 41, 43, 45, 48
*The Phoenix*  195
Third Force  49
Thurman, Tom  74, 75, 76, 77, 78
*Times*  40, 188
Titan  202
Torricelli, Robert  183
torture  98, 100, 103, 107, 108, 109,  203, 220
Townley, Michael Vernon  104, 105, 106
Trilateral Commission  39
Trulock, Notra  182, 186, 187, 189, 190
Truman, Harry  33

**U**

UK/USA security agreement  201
UNESCO  33, 36
Union Carbide  37
Union Suisse des Journalistes  62
UNITA  43, 44, 204, 205, 206,  211, 219
United Nations (UN)  37, 47, 72, 82, 102, 106, 110, 111, 192, 213
United States of America (USA) 10, 16, 19, 22, 26, 31, 33, 36, 37, 48, 61, 68, 69, 71, 74, 76, 79, 82, 83, 84, 95, 127, 128, 129, 130, 131, 132, 133, 134, 135, 136, 170, 173, 175, 176, 177, 178, 180, 181, 182, 183, 184, 185, 186, 187, 189,  191, 192, 193, 194, 196, 197, 200,  201, 202, 203, 204, 205, 206, 207, 209, 214,  218, 220  US Army 14, 27,  64, 170, 193, 194, 197  US Air Force (USAF)  124, 134  Central Intelligence Agency (CIA) 11, 12, 13, 15, 16,  20, 23, 24, 38, 44, 47, 50, 75, 79, 83, 98, 99, 100, 101, 106, 134, 167, 170, 171, 173, 174, 175, 181, 183, 184, 187, 188, 193, 194, 200, 205, 206  US Congress 12,  27, 28, 43, 85,  86, 87,  95, 170, 182, 185, 186,  189, 190  Defense Intelligence Agency (DIA) 131, 136,  197, 205  Department of Energy (DoE)  181, 182, 186  Department of Defense (DoD or Pentagon) 15, 53,  64, 66, 67,  68, 69, 73, 101, 121, 131, 136, 169, 170, 172, 181, 191, 205, 206, 123  Federal Bureau of Investigation (FBI) 10, 18,  19, 20, 21, 22, 28, 74, 75, 76, 77, 78, 80, 83, 85-91, 97, 98, 104, 105, 106, 181, 182, 184, 185, 186, 187, 188, 189, 190, 191, 200, 201 First Amendment  19, 20, 93  National Ignition Facility  9, 10, 11 National Intelligence Service (NIS)  45, 219 National Missile Defense (NMD)  63, 64, 65, 66, 67, 68, 69, 70, 71, 72 National Security Agency (NSA)  11, 12, 15, 71, 83, 84, 85, 87, 88, 91, 93, 94, 100, 101, 104, 201 National Security Council (NSC) 98,  99, 100

Senate  81, 86, 88,  89, 91, 181, 183, 186, 189 Space Command  64
State Department 100, 101,  175, 218
Strategic Defense Initiative  73
USENET  200
UTA  74, 75, 76, 77, 78, 79, 80, 82

**V**

van der Biest  158, 160, 161
Vanden Boeynants  162, 163, 164
Verbruggen, Emile  164, 165
Verges, Jacques  85
Vodafone  199
Voest Alpine  171
Vrooman, Robert  187, 189, 190

**W**

Waldorf Astor, Hugh  40
Walker, John  15
*Wall Street Journal*  42, 87
Wallyn, Luc  164, 166
Walter Sommers Ltd.  174
*Washington Post*  135, 185, 188, 189, 190, 191
weapons  9, 10, 11, 23, 44, 45,  70, 72, 87, 104, 128, 129, 135, 138, 140, 143, 145, 155, 177, 178, 181, 182, 183, 184, 185, 186, 187, 188, 189, 190, 191, 205, 215
*Weekend Australian*  208, 210
Western European Union (WEU)  9, 10, 11, 84
Westland New Post  162, 163, 196
Wheatley, Dennis  34
Whitlam, Gough  16
Widgery, Lord  138-146, 151, 154
Wilken, Claudia  19, 20
Williams, Daryl  40
Williamson, Craig  43
Willis, Dave  131
Wilson, Harold  106
Wilson, Ian  124
wind tunnel  169
*Wired*  92
World Bank  209
World Economic Forum  84
World Wildlife Fund (WWF)  33, 34, 37, 39-43, 45-50

**Y**

Yeltsin, Boris  133
Yurtchenko, Vitali  15

**Z**

zebra  26, 32
Zimmerman, Philip  83, 86